'Bailey draws on, and synthesises, a wealth of schol~ ~ ~
over the last few decades. Easy to read and f
and informative text.'– **Emily Honig**, *Univers*

Paul J. Bailey provides the first analytical study
China's turbulent twentieth century. Incorporat
upon Chinese cinema and autobiographical men

- explores the impact of political, social and cultural change on women's lives, and how Chinese women responded to such developments
- charts the evolution of gender discourses during this period
- illuminates both change and continuity in gender discourse and practice.

Approachable and authoritative, this is an essential overview for students, teachers and scholars of gender history, and anyone with an interest in modern Chinese history.

Paul J. Bailey is Professor of Modern Chinese History at the University of Durham. His previous publications include *Gender and Education in China* (2007) and *China in the Twentieth Century* (2001).

Gender and History

Series editors: Amanda Capern and Louella McCarthy

Published

Forthcoming

Gender and History Series
Series Standing Order ISBN 978–14039–9374–8 hardback
Series Standing Order ISBN 978–14039–9375–5 paperback
(*outside North America only*)

You can receive future titles in this series as they are published by placing a standing order. Please contact your bookseller or, in case of difficulty, write to us at the address below with your name and address, the title of the series and one of the ISBNs quoted above.

Customer Services Department, Macmillan Distribution Ltd Houndmills, Basingstoke, Hampshire RG21 6XS, England

Women and Gender in Twentieth-Century China

Paul J. Bailey

First published 2012 by
PALGRAVE MACMILLAN

Palgrave Macmillan in the UK is an imprint of Macmillan Publishers Limited, registered in England, company number 785998, of Houndmills, Basingstoke, Hampshire RG21 6XS.

Palgrave Macmillan in the US is a division of St Martin's Press LLC, 175 Fifth Avenue, New York, NY 10010.

Palgrave Macmillan is the global academic imprint of the above companies and has companies and representatives throughout the world.

Palgrave® and Macmillan® are registered trademarks in the United States, the United Kingdom, Europe and other countries

ISBN: 978–0–230–57776–3 hardback
ISBN: 978–0–230–57777–0 paperback

This book is printed on paper suitable for recycling and made from fully managed and sustained forest sources. Logging, pulping and manufacturing processes are expected to conform to the environmental regulations of the country of origin.

A catalogue record for this book is available from the British Library.

A catalog record for this book is available from the Library of Congress.

10 9 8 7 6 5 4 3 2 1
21 20 19 18 17 16 15 14 13 12

Printed in China

Contents

Acknowledgements

This book would not have been possible without the valuable and pathbreaking scholarship (past and present) on which it is primarily based. I would also like to express my appreciation to the students ('class of 1994–1995') who were adventurous enough to take my course on gender and sociocultural change in twentieth-century China that I first taught in 1994–1995 at the University of Edinburgh (History department), the first course on modern gender history that the department had ever offered. The students' enthusiasm, commitment and interest were a wonderful motivator for me. I thank also the editors at Palgrave Macmillan, Sonya Barker and Amanda Capern, for their kind advice and support. Finally, but not least, I would like to thank my wife, Dawn – a constant source of love and encouragement.

Introduction

Towards the end of the 1956 Chinese film *New Year's Sacrifice* (*Zhufu*), based on a 1924 short story by the celebrated author Lu Xun (1881–1936), the protagonist – a widow who has been exploited by her mother-in-law, forced to remarry and then to suffer the death of her new husband and young son, and who finally is contemptuously dismissed as a domestic servant because of the purported 'bad luck' (as a remarried widow who has experienced the death of both husbands) she brings to the household – stumbles in the snow as a lonely beggar woman. Abandoned by her former employers and ignored by the local community, she dies a pitiful death (Lyell, 1990, pp. 219–41).[1] A voiceover commentary (not part of the original 1924 story) then portentously declares that the widow, despite being an honest and hardworking woman, endured countless sufferings and humiliations before dying tragically; however, the voiceover continues, such a phenomenon happened 'forty-odd years ago' and was a feature of the 'old society' (i.e. pre-Communist China). 'Happily for us,' the voiceover concludes, 'such a time has gone forever and will never return.'

Such assertions clearly reflected the assumptions of Chinese Communist Party officials in the 1950s concerning the 'dire' situation of women in 'pre-Liberation' China and the inevitable improvement in their lives since the accession to national power of the Chinese Communist Party (hereafter CCP) in October 1949 (Edwards, 2000a). It is also significant that the voiceover commentary at the end of the film, *New Year's Sacrifice*, specifically identifies the 'suffering and humiliations' of a *woman* as the quintessence of the 'old society' that was frequently described in propaganda and educational texts of the time as 'feudal', 'backward' and 'exploitative'. Such an identification constituted only the latest example of a longer discursive tradition in twentieth-century China that had appropriated women as a trope for larger concerns and anxieties (e.g. over cultural and national identities, or the pace of modernising change).

This book sets out to problematise this conventional image of Chinese women in the twentieth century as the helpless and victimised sufferers of 'feudal' and 'reactionary' forces before the communist revolution of 1949 and then afterwards simply the recipients of emancipation and freedom bestowed on them by the omnipotent (and male-dominated) CCP. It aims, in other words, to explore the complexities of women's lives, as well as the evolution, paradoxes and continuities in gender discourse, during the course of the twentieth century. This was a period of dramatic, turbulent and often traumatic change. The experiences of Chinese women, in addition to changing gender discourses and practice, constitute an absolutely crucial and significant aspect

1

of this history, an acquaintance with which is essential for an understanding of China's modernisation process itself during the twentieth century. In fact, one could argue that Chinese women – what was said about them, what they did, how they both impacted upon and were affected by revolutionary movements and state policy – were at the very heart of political, social and cultural change during the course of the century.

Chinese women, for example, played a role in the early twentieth-century nationalist and revolutionary movement (which culminated in the overthrow of China's last imperial dynasty and its replacement by a republic in 1912) as activists, publicists and suffragists (Chapter 2). Discourses of the 'new woman' from the 1910s to the 1930s (in women's and current affairs journals, literature and film) were a central focus of cultural and intellectual debate – a debate in which women were associated with conflicting and contradictory attitudes towards (and definitions of) tradition, modernity and national identity (Chapters 3 and 5). Furthermore, in terms of the economy, industrialisation (in the shape of textile factories) in large urban centres such as Shanghai during the first half of the twentieth century relied to a great extent on a female workforce (Chapter 5). During the 1920s and 1930s both the CCP and *Guomindang* (Nationalist Party) incorporated 'women's issues' (e.g. family reform, free-choice marriage, inheritance and other legal rights) as a central plank in their political agendas (Chapter 4). Women continued to be a significant focus of social and economic transformations as well as political movements during the first two decades of the People's Republic in the 1950s and 1960s (Chapters 6 and 7). Finally, women and gender issues have been at the core of the post-Mao reform agenda. Since the 1980s, for example, a virtually unprecedented official attempt to extend the reach of the state into people's private lives has specifically targeted women and their fertility, while since the 1990s new discourses of femininity and masculinity underpin contemporary debates on the meaning of modernity (Chapter 8).

This history begins with the last decade of the nineteenth century, when what was to become known as 'the woman question' (*funü wenti*) first began to be widely discussed at a time of unprecedented crisis felt by male reformers in the wake of internal decay and external threat (see Chapter 2). The male reformers of the 1890s were the first to urge an improvement in women's lives as a primary task of *national* self-strengthening. For them, the subordinated, housebound, ignorant and economically unproductive Chinese 'woman' represented all that was wrong about Chinese society and culture, and a major obstacle to the country's much-needed modernisation. Ironically, they drew on the ideas of nineteenth-century western missionaries, who had their own agenda of validating western notions of progress and legitimising their presence in China. As the first westerners to write in detail about Chinese women, they too highlighted their lowly and 'degraded' status as a core symbol of China's cultural 'backwardness'. They also assigned responsibility for such a state of affairs to a monolithic Confucian ideology and, in particular, to notions of womanhood that had been expounded in ancient classical texts (Teng, 1996,

pp. 120–1). The first American female missionary to China, Henrietta Shuck, who arrived in 1836, for example, noted that:

> The sad condition of our sex in China can never be alleviated until Christianity triumphs in this cruel land. In connexion [*sic*] with anything else than Christianity there is no hope; for it is that alone that assigns to women her proper rank in society, and secures her against encroachments of the stronger sex. (Beahan, 1976, p. 39)

The 'sorry state' of Chinese women, in other words, *demanded* the missionary presence in the country. Of course, the instrumentalist use of 'native' women to legitimise an ever-intrusive western presence was not unique to the case of China. British colonial rule in India, for example, was justified by frequent reference to the necessity of eliminating 'atrocities' imposed on women by an entire body of scriptural teachings and ritual practices (Chatterjee, 1989, pp. 622–33).

The aforementioned image of women in 'traditional' China underpinned later discourse during the 1910s and 1920s, when Chinese male radicals, in associating modernity with the reform of women's status and perceiving women as the principal victims of an oppressive and stifling cultural tradition, claimed to speak up on their behalf (see Chapter 3). The victimised and helpless Chinese woman, in effect, became the symbol of China itself, brutalised and exploited by foreign powers (Ko, 1994a, p. 2). This image also influenced western scholarship up until the 1970s and 1980s. The opening words of a history of Chinese women in the twentieth century (published in 1983), for example, was fairly representative of those modern histories of China that described women's lives in 'pre-modern' China: 'Few societies in history have prescribed for women a more lowly status or treated them in a more routinely brutal way than traditional Confucian China' (Johnson, 1983, p. 1).

The problem with such a one-dimensional description of women in 'traditional' Chinese society is that it completely overlooks the nuances and complexities of their lives (and of gender discourse), which research in the last twenty years has done much to uncover (Ropp, 1994).[2] Chapter 1 thus provides a general overview of this research into the lives and roles of women in pre-twentieth-century China, an acquaintance with which will allow a more sophisticated understanding of the continuities, disjunctures and transformations in Chinese women's lives and in gender discourse overall during the course of the twentieth century. By the same token, more space is devoted in the book to the first half of the twentieth century in order to better appreciate the significance of developments after 1949; too often studies of women in the Mao and post-Mao eras provide only the most peremptory discussion of this crucial period. It is also, I believe, the period on which the most significant and fascinating research has been produced in recent years.

1
Women in Pre-Twentieth-Century China

During the last two decades or so more attention has been paid to how political, economic, legal and even technological change impacted upon women's lives and gender discourse (Ebrey, 1990, 1993; Bray, 1997; Bernhardt, 1999; Birge, 2002).[1] Women's experiences, roles and status are now seen as very much influenced by age (life cycle), class and ethnicity, as well as fluctuating over time. Influencing much of this research is the aim of highlighting the ways in which women's lives were shaped by their *own* choices and participation in family and social life, in other words attributing some form of *agency* to women rather than portraying them simply or only as the passive, voiceless and exploited victims of an unchanging Confucian patriarchy.

In early imperial China (206 BCE–220 CE), for example, maternal power was quite pervasive, and many elite women had considerable control over their personal finances (both early law and custom concurred that a wife *owned* her dowry).Women were also dominant in all forms of textile work in early China, which gave them a powerful role in the household (and wider) economy since cloth was exchanged as a *de facto* currency and used to pay taxes to the state. The most precious textile, silk, which supplemented metal coinage and was sometimes used to pay armies, was produced in weaving workshops run by the state or important families that employed hundreds of women. Furthermore, biographies of women at this time all refer to elite women who excelled in reading and writing. Aristocratic women at court, as well as imperial consorts and dowagers, were famed for their patronage of scholarship and literature, and some of them contributed significantly in their own right to historical scholarship or other forms of literature (Hinsch, 2002, pp. 55–61; Lewis, 2007, pp.156–65, 169–73). Didactic texts especially written for women – the first of which was actually written by a woman, Ban Zhao (49–120 CE), a court tutor to empresses and palace women who also contributed to the writing of the history of the reigning Han dynasty – were regularly produced throughout China's imperial history, indicating that it was *expected* women should be literate.

Recent studies have also shown that representations of women in early China ranging from the eighth century BCE to the tenth century CE (in historical annals or life-history narratives, for example) frequently praised women for their sagacity, expertise, political acumen and rhetorical skill. In fact, there

were as many references in pre-Han dynasty texts to women giving wise polit-
ical counsel and positively influencing government through their behaviour
(as wives and mothers) as those that highlighted the negative influence of
'jealous', 'wicked' and 'conspiratorial' women that might cause the downfall
of states (Goldin, 2000).[2] It was only after the eleventh century that defini-
tions of proper feminine virtue in didactic texts and biographies became more
narrowly and stringently defined as increasing emphasis was placed on chastity,
filiality and motherhood (Raphals, 1998; Mou, 2004). Significantly, historians
have argued that the cosmological concepts of *yin* and *yang* formulated in early
imperial China (and which came to represent the essence of femaleness and
maleness respectively) were originally viewed as *complementary*, rather than
indicating a hierarchical relationship in which *yang* (associated with the sun,
heat, light, dryness, activity) was superior to *yin* (associated with the moon,
cold, dark, wetness and tranquillity) (Raphals, 1998, pp. 153–62; Hinsch,
2002, pp. 152–7; Mou, 2004, pp. 7–8).

Perhaps the most dramatic illustration of women's 'oppression' in trad-
itional China was the custom of footbinding. Originally practised by lower-
class dancers at the Tang dynasty court in the eighth or ninth centuries (and
thus not a product of the neo-Confucian puritanism that prevailed during
the succeeding Song dynasty in the eleventh and twelfth centuries), by the
thirteenth century the custom had been embraced by the wives and daugh-
ters of officials.[3] In subsequent centuries the practice spread to commoners
as footbinding became the hallmark of feminine beauty and respectability.
The emergence of the custom has been linked to new ideas of elite status
and redefinitions of masculinity, as the Tang aristocratic ideal (including
expertise in hunting and horsemanship) gave way to the more refined and
sedate masculine ideal of the Song scholar–official (by making women
more 'delicate' and stationary, elite men thus masked their own 'effem-
inate' and sedentary image) (Ebrey, 1990, p. 221; 1993, pp. 37–42). These
new constructions of masculinity and femininity also served to distinguish
Chinese 'civilised' customs from those of the non-Han 'barbarians' who
constituted an ever-present security threat during the Song period. At the
same time, revisionist studies have highlighted the active participation of
women themselves in the practice, as mothers sought to make their daugh-
ters more attractive so as to compete with courtesans and concubines (it was
always mothers who carried out the task of binding their daughters' feet)
(Ko, 2001; 2005).[4] As an intimate practice carried out amongst women,
footbinding cemented mother–daughter ties and valorised their partici-
pation in genteel culture (*wen*); also, the elaborate needlework involved in
the making of shoes for bound feet was a means of expressing individual
creativity and positively demonstrating women's handiwork (Ko, 1994a,
pp. 166–71).[5]

It should also be noted that footbinding was not a uniform practice, nor did
it possess an unchanging meaning (Ko, 1997a). The custom was never prac-
tised, for example, by ethnic minorities in China such as the Manchus, who
conquered China and established the Qing dynasty in 1644, or even amongst
Han Chinese communities such as the Hakkas (from the Chinese term *kejia*

meaning 'guest people', the Hakkas were descendants of migrants from north China who over the course of several centuries settled in the south in provinces such as Guangxi, Guangdong and Fujian, and whose spoken language, cuisine and domestic architectural style distinguished them from their indigenous neighbours).[6] As part of a wider policy compelling the Han Chinese population to wear clothes and adornments conforming to Manchu styles – including male adoption of the Manchu hairstyle of shaving the forehead and arranging the hair in a long braid, or queue, at the back – early Qing rulers such as Kangxi in the 1660s even attempted to ban footbinding. Significantly, however, such attempts ultimately failed to dislodge the strongly held belief amongst Han Chinese elite men that footbinding was a key expression of Confucian civility, an ornament of the appropriately 'concealed' body that distinguished Chinese culture (*wen*) from that of 'barbarians' with their unadorned bodies and naked feet. Thus, while succeeding in imposing the adoption of the queue amongst Han Chinese men, Qing rulers accommodated themselves to the practice of footbinding (although Manchu women did not physically bind their feet, they adopted a form of 'platform' footwear hidden by a long gown that gave the outward impression of small and bound feet);[7] Manchu sensitivity to possible Chinese ridicule over this issue was illustrated by the memoirs of Der Ling (1885–1944), daughter of a Manchu bannerman (and Qing diplomat) and lady-in-waiting to the Empress-Dowager Cixi in 1903, who remembered how hurt and upset she had felt when Chinese visitors to the household criticised her for having 'big feet' (Wang, 2008, p.77).[8]

Another 'traditional' gender practice associated with Confucian patriarchy was the segregation of the sexes, by which men were expected to operate in the public or outer sphere (*wai*) while women were to be confined to the 'inner quarters' (*nei*) of the household. Quite apart from the fact that women might have experienced material divisions of domestic space differently (e.g. the inner quarters were where women were 'confined', but for women such a space might be thought of as a realm of independence and privacy to which men did not have access), gender historians have recently stressed the complementarity of the two spheres as two poles on the same spectrum; this is because the ethical and behavioural training ground for public life was clearly located *within* the family household (Ko, 1994a, p. 13; Bray, 1997, pp. 52–3, 95; Mann, 1997, p. 15). Far from being irrelevant or marginal as far as public affairs were concerned, therefore, women's work as wife and mother (which included the education of young children) was intimately tied to the world *beyond* the inner quarters.

Thus, as portrayed in the *Book of Odes* (or *Classic of Poetry*), a text edited by Confucius (551–479 BCE), a model wife or mother was not simply someone who submissively obeyed her husband and diligently nourished her son but rather one 'who participates in bringing about the kind of universal moral transformation that the Confucian tradition upholds as the ultimate purpose of humanity' (Goldin, 2000, p. 140).[9] This meant that, although women were not allowed to participate in the civil service examinations (dating from the Sui dynasty 581–618 CE) or to attend official and community (i.e. 'public') schools, they could still be educated at home. Daughters (at least of the

upper classes and the well-to-do) from the age of four or five were taught the Confucian classics and histories (principally by fathers or private tutors) along with their brothers. Sometimes special tutors, who could be male or female, were hired to teach girls in a separate family school. It was only after the age of ten that the education of elite girls diverged from that of their brothers, as formal instruction became more narrowly focused on the teaching of 'womanly' skills such as needlework or weaving while boys were given training in prose and essay competition in preparation for the civil service examinations (Hsiung, 2005, pp. 186–93, 205–17). Over time, too, the father–daughter relationship (at least in elite families) may have become closer and more intimate (Lu, 2010).[10]

With the development of the civil service examination system, especially after the Song period, a mother's most important contribution came to be viewed as the education of her children. This can be demonstrated by male biographies compiled between the tenth and fourteenth centuries, for example, which often credited mothers with teaching the Confucian classics to their sons; during the Ming dynasty (fourteenth to seventeenth centuries) this role was recognised by the state when it conferred honorary titles on the wives and mothers of scholar–officials (Pei-yi Wu, 1989, p. 318; Bray, 1997, pp. 347–8). By the late imperial period, in fact, an elite woman's most important contribution lay in the education of a child ('social motherhood'), a role distinguished from that of 'biological motherhood' which could be fulfilled by a secondary wife (Bray, 1997, pp. 347–9). The fact that upper-class women at this time in China *were* educated (and that education for both sexes often used the same texts) indicates that in pre-modern China there was no exact equivalent of the Victorian assumption that women were intellectually inferior to men (Holmgren, 1981, p. 155).[11]

Growing literacy amongst women stimulated vigorous debates on women's morality and learning, especially during the late Ming and early Qing dynasties (sixteenth to eighteenth centuries) (Handlin, 1975; Rowe, 1992; Mann, 1994b). By the seventeenth century, commercially prosperous regions such as Jiangnan (south-central China) witnessed the emergence of elite women's writing communities and networks; often with the help of fathers, brothers or husbands, they published their literary works, for the most part poetry (conventionally viewed as a male activity). By the eighteenth-century anthologies of women's poetry were actually being edited by women (works by more than 3,000 female poets have survived).[12] Women's writings, in effect, became a profitable commodity at this time, and a woman's literary reputation thus a considerable economic asset to the family; not surprisingly, accomplished and educated girls during the course of the eighteenth century constituted a source of symbolic capital (Mann, 1997, p. 34).

It might also be noted that recently discovered evidence (in 1983) has indicated the existence of a literary tradition amongst *commoner* women. A particular 'women's script' (*nüshu*), a phonetic representation of a local village dialect in the central province of Hunan, was used to compose verses (rhymed ballads) designed for singing or chanting (and was in use up until the middle of the twentieth century). Circulating amongst rural women, these verses

exalted women's ability to overcome adversity such as leaving the natal home to get married, or widowhood (letters or songs of felicitation sent to a bride by her friends and relatives might also be publicly displayed). While chaste loyalty to one's husband is depicted as the most prized virtue in these verses, women are often depicted as 'strong' characters whose courage, wisdom and initiative contrasts with the timidity and incompetence of male characters. *Nüshu*, in the form of letters or verses written on the back of fans, also cemented non-kin relationships between girls of the same age from different villages. Although extant examples of *nüshu* only date from the late nineteenth century, there is a possibility that it might go back as far as the fifteenth century (Silber, 1994; McLaren, 1999).[13] During Mao Zedong's Cultural Revolution in the 1960s *nüshu* would be condemned as 'witches' script' (Liu, 2001, p. 1054).[14]

The discussions and debates that broke out during the course of the seventeenth and eighteenth centuries, however, did *not* revolve around whether women should be educated or not, but rather focused on the purpose and content of their learning (and, by extension, on the exact meaning and significance of women's 'talent') (Mann,1994b). Some male writers, such as the scholar Lü Kun (1536–1618), anxious to maintain clear gender distinctions at a time of increasing commercial development, urbanisation and social mobility, wrote didactic texts on 'correct' behaviour within the inner quarters that were specifically aimed at a wider audience of women (thus testifying to increasing literacy amongst them). A widely distributed didactic text by Lan Dingyuan (1680–1733) asserted that the orderly management of the family began with women (Mann, 1997, p. 29). Furthermore, the historian Zhang Xuecheng (1738–1801) argued that a woman's proper sphere of learning was a strict classical education that would include (as well as knowledge of the histories and other classical texts) the actual practice of moral conduct within the household prescribed by such classic didactic texts as Ban Zhao's *Prescriptions for Women* (*Nüjie*), which stressed the importance of women's modesty (in words and behaviour) and frugality, their deference and service to in-laws, and their skill in household work such as spinning and weaving.

The poet Yuan Mei (1716–98), by way of contrast, championed women's literary 'talent' and their engagement in the literary arts. He especially praised the intuitive and spontaneous nature of their poetry (compared with men's) and encouraged publication of their works. Yuan, in other words, saw no contradiction between virtue and talent (the writing of poetry). For Zhang Xuexcheng, this was not the kind of 'talent' he had in mind, since it was precisely what he perceived as the ambitious, vainglorious and competitive pursuit of literary fame in the *public* sphere of men that would contribute to the degradation of women's moral integrity (Ko, 1992; Mann, 1992b; Chang, 1997). Significantly, a century earlier the newly coined adage 'in a woman lack of talent is a virtue' (*nüzi wucai bianshi de*) summed up the viewpoint of those male critics who believed that literary excellence (and competing in the 'public marketplace' for literary fame) and moral virtue were incompatible. Such an adage, however, was actually a reaction to *real* growth of women's literacy and learning at this time; it certainly did not represent, as early twentieth-century Chinese reformers were to insist, an age-old Confucian

belief in the non-education of women. In any event, research has demonstrated that whatever was written (usually by men) about what women should or should not do/be did *not* always reflect social practice. Thus chastity cults (see later) and stricter rules against widow remarriage might be interpreted as male reactions to 'aggressive' behaviour in women (often portrayed in popular fiction) or to the expansion of opportunities for women living in urban centres (Handlin, 1975, p. 14; Bray, 1997, p. 247). Women's growing literacy after the sixteenth century, as has been mentioned, was just one such illustration of dramatic cultural change.

These ongoing discussions about the nature of women's learning should also be linked to a wider debate over gender relations amongst male scholars and writers, especially in the post-Song period (i.e. from the thirteenth century onwards). Thus, while it is generally recognised that a Confucian revival during the Song dynasty (960–1279) – referred to as neo-Confucianism – led to increasing importance being placed on a strict segregation of the sexes and women's confinement to the 'inner quarters' (represented by the *nei/wai* binary) (Eastman, 1988, p. 19), such views were always countered by those (equally pointing to the classical tradition to support their case) who claimed that wives were the active partners of their husbands and not mere acquiescent subordinates (Bray, 1997, p. 42). The important Han-dynasty text (thought originally to have been compiled by Confucius) and one of the five classics of the Confucian canon, the *Book of Rites* (*Li ji*), for example, in outlining the distinctions between *nei* and *wai*, noted that the marital relationship had to be viewed in terms of partnership, affection and shared responsibility (Mann,1991, pp. 208–9).

Furthermore, the dominant view of 'traditional' Chinese women secluded within the 'inner quarters' and whose sole *raison d'être*, according to Confucian orthodoxy, was to serve as a dutiful and loyal daughter-in-law, wife and mother does not take into account a variety of other activities in which women were involved. For example, women were the principal supporters of popular religion and were active participants in ritual life, both within the household and as worshippers at village temples (the eighteenth-century official Chen Hongmou bewailed the number of women parading openly in temples and monasteries, as it was thought they might indulge in adultery and 'orgies' with 'promiscuous' Buddhist monks). Such a phenomenon would later be highlighted by late nineteenth and early twentieth-century reformers in order to demonstrate women's supposed vulnerability to 'superstitious' beliefs and practices (see Chapter 2).[15]

It was not uncommon either for large groups of women to embark on pilgrimages to sacred sites, many of which were associated with the worship of female deities. Pilgrimages to the shrine of the Buddhist Goddess of Mercy (Guanyin), for example, might comprise mothers and their children as well as unmarried women.[16] Other female deities who attracted a huge following amongst women seeking protection and good fortune were Mazu and the Eternal Mother (Sangren, 1983).[17] Mazu, the patron goddess of fisherpeople, seafarers and maritime merchants, who was widely worshipped along the south China coast from the tenth century onwards (and still is today in Taiwan), was

originally a woman who had refused marriage and died young during the tenth century and was later believed to have possessed supernatural powers especially beneficial for seafarers in distress; like Guanyin, however, she also had a special relationship with spinsters and unmarried women (in the eighteenth century she was formally incorporated into the state religion when she was officially bestowed with the title Tianhou [Empress of Heaven], symbolising – for the state and local elites – territorial control and social stability) (Watson, 1985).

The Eternal Mother, or Venerable Mother of Unborn Eternality (*wusheng laomu*), was a Buddhist deity who, as the progenitor of the cosmos and trans-formative force in the universe, was portrayed by the sixteenth century as the matriarch of all the gods and immortals, and the compassionate saviour of the faithful; female believers, in particular, may have derived a sense of equality and worth through their worship of the deity. It is significant that the lay Buddhist sects who worshipped the Eternal Mother (known collectively as the White Lotus) were the only voluntary organisations in imperial China with a sizeable female membership.[18] Another celebrated female deity was Linshi furen ('Lady of the marshes'), the name given to Chen Jinggu (767–90), a shamaness who was canonised in 1241 and celebrated as the protector of women and children (and the performer of miracles). Originating in the province of Fujian, the cult centred on Chen Jinggu is still practised in the province today as well as in Taiwan – where many from Fujian migrated after the seventeenth century (Baptandier, 2008).

In some cases, worship of a female deity might be perceived as dangerous by official authorities. One such cult was that devoted to a Daoist deity, Bixia Yuanjun (Goddess of Taishan), who was worshipped in Shandong province from the mid-Ming period to the early twentieth century (Pomeranz, 1997). During its heyday worship of Bixia Yuanjun, which centred on a huge temple complex, attracted 400,000 visitors annually (most of whom were women). Described as having the power to grant children as well as good harvests, Bixia Yuanjun, like many other female deities, was perceived as especially merciful in granting requests from the common folk, especially women. In the eyes of officials, however, worship of Bixia Yuanjun was regarded with a certain amount of suspicion; as a deity who most closely resembled the human female form (unlike other desexualised goddesses), she was associated with the dangerous sexual powers of young wives and daughters-in-law.[19]

Women might also assume the role of spirit-mediums or become Buddhist (or Daoist) nuns, in some cases being the active founders of temples as well as members of Buddhist-inspired lay religious and vegetarian sects and communities; such sects often assumed the form of chastity-avowing sisterhoods (Ropp, 1994; Grant, 2008).[20] Female heads of religious communities or Buddhist nuns also served as ritual experts and healers, and their services were eagerly sought by women to pray for sons or even arrange abortions. Buddhist nuns, in fact, were one of several groups of relatively *mobile* women in society (others included peddlers, midwives, shamanesses, female physicians and itinerant healers, collectively often referred to as the *liupo*/six kinds of old crone) whom suspicious patriarchs regarded as potential 'defilers' of their household's inner quarters. The 'household instructions' (*jiaxun*) they regularly issued constantly

warned against 'their' women coming into contact with 'vice' as represented by these groups of mobile women (Mann, 1991, pp.220–1).[21]

Significantly, (male) Confucian ideas concerning women were more influenced by other religious traditions than previously assumed. The Buddhist notion of the 'uncontaminated body', for example, may have influenced the Confucian notion of chastity, which appears to have undergone a transformation in meaning after the sixth century from one that focused primarily on the enactment of wifely duties and loyalty rather than physical virginity *per se* to one that highlighted a woman's successful defence against sexual violation or defilement (Grant, 2008, pp. 5–6).[22] On the other hand, as far as women were concerned, since Buddhist scriptures (*baojuan*) represented childbirth as a karmic sin (because it prolonged the endless cycle of suffering) and described the ideal Buddhist heroine as one who remained chaste even in marriage, exposure to such scriptures may have prompted them to question marriage or childbirth itself (Bray, 1997, pp. 342–3).

The mid-seventeenth century also witnessed the appearance of indigenous *Catholic* single lay women, known as *zhen'nü* (chaste women) or *zhujiadi* (those who dwell at home). The Catholic proselytising enterprise had begun in China with the arrival of the Jesuits in the late sixteenth century.[23] The earliest evidence of these Chinese Catholic women comes from the southern province of Fujian, where Spanish Dominicans introduced the *beata* (blessed [virgins]) system from the 1630s onwards. Unlike the Jesuits, the Dominicans were more willing to work and interact directly with local women, who responded enthusiastically to the notion of virginity as a prerequisite to a consecrated religious life (not entirely unprecedented, since other Chinese religions such as Buddhism offered religious chastity as a means to avoid marriage). By the mid-eighteenth century, despite occasional anti-Christian campaigns spearheaded by central and provincial government officials – but never fully supported by local elites – there were 250 *beatas* in Fu'an, north-east Fujian; the number continued to grow in the nineteenth century with the establishment of 'Holy Childhood' orphanages and elementary schools in which *beatas* were employed. By the 1940s there may have been up to 800 *beatas* in Fu'an, and not all were necessarily from privileged families, as had been the case in the beginning (Menegon, 2004; 2009, ch. 8).[24]

In the eighteenth century, missionaries from the *Missions étrangères de Paris* established an 'institute of Christian virgins' in the western province of Sichuan (Entenmann, 1996; Tiedemann, 2008).[25] Adopting vows of chastity and continuing to live with their families (in some cases a dwelling and land were set aside for them by their parents), these Catholic virgins – many of whom came from well-established Chinese Catholic families – were employed as catechists, chapel helpers and welfare workers (in 1784 regulations were issued forbidding them from preaching to assemblies of men, which suggested that they in fact also engaged in evangelical work) (Entenmann, 1996, p. 185). By the end of the nineteenth century there were over 1,000 Christian virgins in Sichuan alone, many of whom were engaged in instructing nearly 3,000 female pupils in schools set up in private homes (Entenmann, 1996, pp. 188–9, 192). It has been suggested that little hostility was shown towards

these women because of similar traditions amongst the non-Christian Chinese population (such as the lay Buddhist vegetarian sisterhoods) (Tiedemann, 2008). Ironically, it was *foreign* Catholic missionaries and administrators returning to China in the nineteenth century after Christianity had been officially proscribed and the Jesuits expelled during the latter half of the eighteenth century who criticised the virgins (one missionary complaining that they rarely prayed, and were quarrelsome and disobedient) (Tiedemann, 2008, p. 506), and who sought to control their autonomy. In the words of a German Capuchin friar in Gansu province, however, their assistance was invaluable:

> The experienced virgin is a good support to the missionaries in the administration of the district, a reliable adviser who alerts him to disorder, grievances and dangers that can threaten him from various directions. (Tiedemann, 2008, p. 514)

Another group of women in 'traditional' Chinese society who, like the chastity-avowing sisterhoods, eschewed normative marriage (at least for some of their lives) were courtesans, who became especially celebrated during the Ming dynasty (fourteenth to seventeenth centuries) for their artistic accomplishments and literary talents (they edited books of scholarship, for example, and published volumes of poetry and letters); others were noted painters.[26] They also travelled widely and were the constant centre of attraction amongst male literati (Cass, 1999, pp. 25–7).[27] Courtesans had their origins in the troupes of trained singing girls (*nüyue*) maintained by the Zhou court (eleventh century BCE – 256 BCE). By the time of the Tang dynasty (618–907) they had begun to share in literati culture when court entertainers came under the supervision of the Office of Music Instruction. During the Tang period, in fact, the most successful poets were courtesans, although it was not until the Ming period that the courtesan–poet emerged as the ideal 'talented woman'. The celebrated 'pleasure quarters' (*qinhuai*) in the imperial capital of Nanjing (much referred to in poetry) was officially established by the first Ming emperor (r. 1368–98). Courtesans might even own property in their own right, and some of them maintained elaborate villas and residences to entertain elite men (and perhaps acquire a useful marriage partner).

For male literati at this time courtesans were the true embodiment of *qing* (heroic love or passion) since they were perceived as 'free' and 'unrestrained' (Berg, 2008, p. 29).[28] The pairing of the male scholar and the courtesan, encapsulated by the term that came to describe a literary genre, *caizi jiaren* (man of talent and woman of excellence or 'scholar–beauty romances') and which represented the ideal companionate relationship, became a ubiquitous theme in poetry and drama of the time (Chang, 1997; Ropp, 1997; Ko, 1997b). Some dubbed themselves 'female knight errants (*nüxia*), although this did not necessarily mean they took up a sword or practised martial arts; the appellation was used more to describe their aloof or impulsive natures (although, like the early twentieth-century female revolutionary Qiu Jin, they might adopt a masculine guise by wearing men's clothes and calling themselves 'younger brother' [*di*] (Cass, 1999, p. 37).[29] One courtesan who described

herself as a 'knight errant' (referring to her bold, generous, loyal and chivalrous character) and who *did* perform martial skills such as archery and horseriding was Xue Susu (ca.1565–1650), a renaissance woman who also gave public readings of her poetry, painted, and played the lute (Berg, 2008, p. 20).

The heroic status of courtesans was further consolidated by the fact that a number of them were associated with Ming 'loyalism' after the dynasty was overthrown by the invading Manchus in 1644. During the course of the eighteenth century, however, elite women's writings came to supplant those of the courtesans in status and official patronage, as a classical revival at this time valorised the role of the *guixiu* (refined elite woman) as the guardian of household propriety and stability (Mann, 1997, pp. 49–50, 53).[30] State patronage of courtesans was ended during the Qing period, while the famous Nanjing pleasure quarters fell into disuse. The courtesan at the height of her celebrity at the end of the Ming dynasty represented an intriguing paradox; although of low status, she gained recognition as an artist and poetess that placed her above an elite woman, while her condition of servitude was matched by a certain amount of autonomy and the freedom to travel (Berg, 2008, p. 29).

Women assumed a number of other unconventional roles in society. They might be itinerant teachers (Ko, 1994b), medical practitioners and doctors (Furth, 1999, pp. 266–78; Leung, 1999), active (and even leading) members of secret societies and religious cults,[31] participants in peasant rebellions such as that of the mid-nineteenth century *Taiping tianguo* (Kingdom of Heavenly Peace) that nearly toppled the dynasty, and even pirate chiefs.[32] In the Chinese cultural imaginary, too, women were a potent presence. The most dramatic example is that of the 'female warrior', such as the semi-legendary Hua Mulan. Thought to have lived during the Northern Wei dynasty (386–534), Hua Mulan was the subject of an anonymous ballad probably compiled sometime during the sixth century.[33] In the ballad Mulan is depicted as a filial daughter who disguises herself as a man in order to replace her sick father in the army, and eventually achieves success by leading the army that defeats 'barbarian' invaders on the northern frontier. Crucially, however, on her return Hua Mulan declines an official post and returns home to resume her role as the filial daughter (Edwards, 1995; Lai, 1999).[34] In other words, at a time of chaos and disorder it was not necessarily considered inappropriate for a woman to assume a male-gendered role; once the world was restored to its 'proper place' such women were expected to resume their 'true' sexual identity.

Hua Mulan's actions, moreover, as was the case for most female warriors, were all lauded in very Confucian terms such as filiality, loyalty and 'righteousness' (*yi*). As one study has noted, female warriors in China reflected a patriarchal culture that perceived 'women's strength and potential as something to be subdued and appropriated' (Lai, 1999, p. 104).[35] Hua Mulan, nevertheless, was to be an inspiration for early twentieth-century female revolutionaries such as Qiu Jin (see Chapter 2),[36] as well as being the subject of a number of Chinese films in the 1920s and 1930s, when Hua Mulan was utilised as a specifically *patriotic* symbol in the wake of increasing Japanese aggression in China (see Chapter 5); she continues to play that role today (which has witnessed a resurgence of official and popular Han Chinese nationalism) with a

big-budget film epic of her exploits being produced in 2009 (and starring the popular actress and pop singer Zhao Wei).

The heroic image of the female warrior contrasted with the ubiquitous, and sometimes more negative, presence of the female ghost or fox-spirit (Kang, 2006),[37] who, in certain circumstances, represented either a danger to vulnerable or weak men or a vengeful 'fury' determined to wreak punishment (usually on men) for past wrongs.[38] Such male imaginings were perhaps linked to the suspicion and hostility that at times greeted newly married women; as 'outsiders' to their husbands' families, they potentially posed a threat to family and lineage harmony (with marriage a woman literally became 'nameless', losing her given name and referred to only in terms of her relationship to others in the family) (Watson, 1986). Polluting substances associated exclusively with women (menstrual blood and birth fluids) symbolised the dangerous reproductive power (harmful and beneficial) of newly married women (Ahern, 1975). On the one hand, they brought new children into the patriline, but on the other they might weaken their husbands' family ties (especially to parents) or advance the interests of their uterine family at the expense of the families of their sisters-in-law. Pollution beliefs also meant that menstruating or married women were excluded from important ritual performances such as ancestor worship or particular tasks such as planting rice seedlings and tending silk cocoons; at the same time, however, married women traditionally were heavily involved in ritual worship and ceremonies focused on the household (McLaren, 2004, pp. 169–72).[39]

In terms of the 'traditional' economy, women played a more significant role than conventionally assumed. The economy of farming households, in fact, always depended on the *combined* labour of men and women. While agricultural treatises and local custom by late imperial times attested to a clear gendered division of labour – encapsulated by the classical aphorism, *nangeng nüzhi* (men till, women weave) (Goodman and Larson, 2005, p. 3) – which indicated that much of the farm labour on the eve of industrialisation in the late nineteenth century was performed by men, it was not uncommon for peasant women to work outside the home; they might, for example, be involved in the transplantation of rice seedlings (at least in the southern regions of the country where rice was predominantly cultivated) or other forms of outside activity such as tea-picking (Lu, 2004).[40] Furthermore, women's work 'inside' and men's 'outside' were perceived as complementary and mutually supportive, contributing equally to both household and social prosperity (Mann, 1992a, pp. 243–4).[41]

In fact, the household (at least until the late sixteenth century) was tied *directly* to the state. Since women's work within the home was classically defined as the making of textiles, and state taxes were collected until the Ming period (sixteenth century) in grain and cloth, women's contribution to the household economy as well as to fulfilment of the household's responsibility to the state was clearly and publicly recognised (Bray, 1997, pp. 183–7).[42] Growing commercialisation and specialisation after the Song period (eleventh century), however, as well as the monetisation of tax payments after the late sixteenth century, meant that women's roles in textile production became

increasingly marginalised as weaving (especially of silk) became a specialised male task in outside workshops (Ebrey, 1993, pp. 145–7). Women's activity within the home became confined to the making of yarn and, in the case of elite households, embroidery (Fong, 2004a).[43] Such a process broke the acknowledged interdependence between women and the state, leading to a revised interpretation of female roles that stressed various forms of reproduction rather than productive work; women's contributions to material production consequently were devalued and even made 'invisible'.[44]

Yet women continued to play a role in the raising of silkworms and the production of raw silk for urban workshops. Also, women continued to be involved in cotton production (which expanded considerably from the thirteenth century onwards), in which they spun and wove raw cotton distributed by 'putting out' merchants who then had it dyed and calendared in urban workshops. Since this activity, however, involved the production of a relatively low-value commodity requiring no specialised skills or large investment in technology, it did not bring women much recognition – although it has been suggested that in the eighteenth century the earnings of rural female textile producers were quite close to those of male farmers (Pomeranz, 2005, p. 243).[45] In the eighteenth and nineteenth centuries, however, the Qing state – increasingly concerned with the impact of commercialisation and the attraction of artisanal trades to lure men away from the land, hence endangering the survival of the household – promoted the virtues and importance of 'women's work' (*nügong*) within the home (handicrafts, weaving) as the guarantor of household survival, prosperity and stability (Mann, 1992c; 1997, pp. 148–51). The symbolic importance that the Qing state attributed to 'women's work' within the home was demonstrated in its revival of ceremonies honouring the Goddess of Sericulture (*Lei Zu*).

An attention to class differences amongst women, however, reveals their very different experiences in terms of the position they held within the household. Thus wives of elite husbands might manage the household and estate (if their husbands were officials posted elsewhere), keep accounts, deal with tenants, and even make investment decisions while not having physically to produce children (which might be carried out by a secondary wife or concubine). Wives of poor men, on the other hand, had no alternative to their own fertility; if they bore no sons this was seen as disastrous, no matter how well they performed other wifely duties (Bray, 1997, pp. 362–6).[46]

Yet *both* elite and commoner women were more mobile in pre-twentieth-century China than is usually thought. Mention has already been made of pilgrimages and gatherings at sacred sites in which women participated. Also, sojourning men, who might travel long distances to sit provincial or metropolitan examinations, or to take up teaching posts and official posts (in imperial China, local officials could not serve in their home districts) often took with them their wives, daughters or daughters-in-law (Mann, 2005).[47] Although seemingly a transgression of the *guixiu* ideal (the refined elite woman remaining quiescent within the inner quarters), the travel diaries recorded by women portrayed such action as lying within their normative duties towards home and family (rather than describing scenery or stressing the delights of

the trip). The early nineteenth-century anthologist and poet Wanyan Yun Zhu was an inveterate traveller who made her son take her to various places, while poetry clubs often brought *guixiu* together (Fong, 2008). Family duty, nevertheless, remained the most respectable motive for travel. A married woman might travel regularly to visit her natal family (contrary to the accepted wisdom that once a woman was married she had to cut all ties to her natal family since she was henceforth solely identified as a member of her husband's household) (Mann, 2005, p. 60),[48] while, if her sojourning official husband died while he was away, his widow might travel to escort his body to its burial place in the husband's ancestral home. In 1847–8, for example, Zhang Wanying travelled nearly 1,500 miles escorting her husband's body to his native place (Mann, 2005, p. 66).[49]

It may be, as has recently been pointed out, that the spatial divisions and gendered differentiation of work (i.e. strict distinction between *nei* and *wai*) called for in Confucian texts such as the *Book of Rites* continued to influence the behaviour and attitudes of elite and commoner women alike in the modern period (Goodman and Larson, 2005, p.4), but this did not prevent the latter, for example, from seeking work outside the home if circumstances demanded it. Thus a poor rural woman from Shandong province, Ning lao taitai ('old Mrs Ning'), whose life was recorded in 1936–7 by a western missionary, Ida Pruitt, left her feckless and opium-addled husband in 1889 (with daughter in tow) to work as a servant in an official household; it was to be the first of several such moves seeking work as a domestic servant (Pruitt, 1967).[50] As in the case of footbinding, maintaining the *nei–wai* boundary was as much a marker of refined status and respectability as anything else, a perspective that continued to influence household or community self-representation during the first half of the twentieth century. For example, surveys carried out in the 1920s amongst 'middle-class' men in Shanghai working in trade and banking and originally from Ningbo (south of Shanghai in north-east Zhejiang province) recorded them as insisting that 'their women' (i.e. women from Ningbo) never worked outside the home (and hence were 'respectable'), despite the fact that relatively large numbers of women were employed in Ningbo's two cotton mills, while just as many had migrated to Shanghai to work in factories there (Mann, 1994c).

Perhaps one of the more important avenues of enquiry explored by gender historians of imperial China in recent years has been to highlight the extent to which women perceived themselves actively participating in Confucian culture, as well as to demonstrate how they exercised agency in appropriating Confucian ideology for their own self-empowerment (however partial or limited) and development of their own subjectivities. Gender ideology, of course, had always been of the utmost importance for the imperial state. It played a crucial role, for example, in the Confucian 'civilising mission' in border and frontier zones, where the state, including that of the non-Han Chinese Qing dynasty – and not unlike western missionaries who stressed the superiority of western civilisation by pointing to the status and treatment of its women – promoted Confucian marriage rituals and normative gender relations amongst non-Han ethnic communities (including the strict gendered division of space and labour) as the hallmark of superior Han Chinese culture. In effect,

the 'Confucian wife' became the quintessential emblem of the Confucian civi-
lising process (Mann, 1997, p. 219; Perdue, 2009, p. 252).

Such a belief, however, was always underpinned by a suspicion and fear of
'barbaric' customs amongst ethnic minority peoples, especially when it came to
gender and sexual relations. Invariably included in Han Chinese official cata-
loguing of such 'barbaric' customs amongst the Miao peoples of the south-
west, for example, was the practice of unbound feet amongst the women,
free association between the sexes, immodest clothing, premarital sexual rela-
tions, and flexible post-marital arrangements (which might involve a married
woman remaining with her natal family until the birth of the first child). The
constant anxiety that Han Chinese men might fraternise with Miao women
and be assimilated into their culture, as well as the dread of their perceived
unrestrained sexuality, gave rise to rumours dating from the Ming period (and
still prevalent today) that Miao women uniquely practised a form of magical
poisoning (*gu*) designed to exact revenge or exert control over sexual partners.
Thus, despite the rhetoric of the Confucian civilising mission, such folklore in
many ways was aimed at enforcing ethnic boundaries (Diamond, 1988; 1995;
Schein, 2000, pp. 60–1).[51]

During the Qing dynasty the state became more active than ever before
in regulating gender relations amongst the population as a whole – consid-
ered a crucial task given the fact that 'improper' gender and sexual relations
were often associated with suspect political tendencies in popular culture
(Sommer, 2000, p. 32).[52] In the eighteenth century, for example, the state
became more intrusive in the regulation of sexuality in its quest to defend
a certain Confucian vision of a family-based order, the principal threat to
which was the unmarried and 'rootless' male. As a potential sexual predator
(targeting young men as well as women), he represented, in the words of one
historian, a specifically 'phallic' threat to the social order (Sommer, 2002, p.
68). With the scarcity of marriage-aged women in a number of regions, which
resulted in a continuing upward pressure on marriage price, many poorer male
commoners had to resign themselves to lifelong bachelorhood; with no oppor-
tunities to fulfil gender expectations (getting married), such 'frustrated bach-
elors' often resorted to antisocial behaviour such as banditry (Ownby, 2002,
pp. 241–2). Other poor male commoners, however, might resort to uncon-
ventional (in terms of state-mandated Confucian norms) arrangements such as
uxorilocal marriage (in which the man married into the woman's family, even
taking his wife's surname) or variations of a *ménage à trois*. An example of the
latter was a practice known as *zhaofu yangfu* (getting a husband to support
a husband) – a kind of non-fraternal polyandry in which a woman took on
an 'extra' husband (short or long-term) to ensure the economic survival of
the household (Sommer, 2005).[53] Such a practice contravened the Qing legal
code, which criminalised 'abetting and tolerating one's wife or concubine to
engage in illicit sexual intercourse with another man' (in contrast, of course,
polygyny amongst elite men was legal).

It is no coincidence either that it was during the eighteenth century – a
time of economic growth, increasing social and geographical mobility, and
an expansion of literacy – that the state became more actively involved in

the promotion of female chastity (initially referring to 'faithful' widows who refused to remarry), which amounted to a virtual cult (Theiss, 2004a).[54] In many ways 'women's virtue', broadly defined in terms of sexual chastity, modesty in dress and speech, and obedience to family superiors and husbands, became for the state an emblem of moral refinement and cultural identity (as well as symbolising loyalty to the new imperial social and political order) (Theiss, 2002, p. 48).[55] Although imperial 'testimonials of merit' (*jingbiao*) had begun to be awarded to chaste widows at the beginning of the fourteenth century (in the early sixteenth century such honours began to be bestowed on chaste 'martyred' women who had died while resisting rape), it was only during the Qing period that the state became the principal patron of the chastity cult; during the previous Ming dynasty, for example, the state had simply given its approval to localised chastity cults promoted by male gentry elites to honour women in their families or communities by means of commemorative arches and shrines.[56] By the eighteenth century the cult had become, in the words of one historian, a 'bureaucratic tool of moral reform', which encouraged the establishment in every community of shrines to the 'chaste and filial' that would contain the ancestral tablets of officially 'canonised' women (Theiss, 2004a, p. 7).[57]

During the Qing, not only was the canonisation system considerably expanded to include larger numbers of both commoner and non-Han ethnic women, but also violence (in the form of suicide) became increasingly integral to definitions of female virtue (Theiss, 2004b, p. 514).[58] Early Qing rulers had initially taken issue with the valorisation of widow suicide (in evidence especially since the late Ming), viewing it as both politically problematic – a woman's loyalty to her dead husband could be allegorised into a symbol of loyalty to the previous dynasty – and an abdication of a widow's duty to care for in-laws and children.[59] The practice was also regarded with suspicion since it was thought to be motivated by dangerous emotional feelings of 'spontaneous passion' (*qing*), much in vogue amongst poets and dramatists during the late sixteenth and early seventeenth centuries but whose connotations of sexual (and conjugal) love might threaten hierarchical loyalties and duties within the larger family.[60]

By the early eighteenth century, however, with the Qing state determined to assert its primacy in the interpretation of gender norms, widow suicides began to be officially canonised in certain cases (those resisting rape or pressure from in-laws to remarry). In the process, another act of suicide was valorised, that of betrothed girls ('faithful maidens') who starved themselves to death or hung themselves after the demise of their fiancés in order to maintain their chastity (Lu, 2008). At the same time, as part of the state's ongoing concern to transform people's values and behaviour, an increasing number of legal substatutes added to the penal code dealing with illicit sex, adultery and prostitution included several (the first dating from 1733) that prescribed capital punishment for anyone who caused a woman to commit suicide (out of humiliation) as a result of attempted rape, sexual assault and even 'improper' or 'flirtatious' behaviour (which might include indecent remarks or obscene gestures). In effect, this meant that the Qing state criminalised sexual harassment if it caused

a woman's suicide (Theiss, 2004a, p. 51).[61] Furthermore, village headmen and clan elders were liable for punishment if their inaction or attempt to cover up charges of sexual harassment brought before them by a woman and her relatives resulted in the woman committing suicide (for many patriarchs and family authorities the maintenance of social order required the concealment from all outsiders, including the magistrate's court, of any such scandal – referred to as 'disgraceful matters').

Suicide (which might occur days or weeks after the alleged 'insult' or 'harassment') was thus a woman's last resort in the event her plaint had not been addressed or avenged; it was very much a *public* act that brought to light her sense of humiliation and ultimately ensured vindication, since those held responsible for her suicide were subsequently punished (at the same time, the ghost of a wronged woman seeking revenge became a ubiquitous motif in popular culture) (Theiss, 2004a, pp. 192–204).[62] Neither an act of resistance *per se* against dominant gender norms, nor an expression of accommodation to them, 'humiliation' suicides constituted a distinctly *female* form of moral agency and a 'uniquely female form of righteous indignation' (Theiss, 2004b, p. 530).[63]

Such a scenario was even more dramatically in evidence with the cult of 'faithful maidenhood', which first emerged at the turn of the sixteenth century and by the time of the Qing dynasty was centred in the lower Yangzi region in the south. Between 1644 and 1850 the Qing court officially canonised – by means of 'testimonials of merit' (*jingbiao*) and commemorative arches and shrines – 5,000 'faithful maidens' (*zhen'nü*) who remained celibate after the death of their fiancés and 1,000 more who decided to commit suicide (Lu, 2008, p. 5).[64] In making such a choice, based on their *own* understanding of honour, duty and love, 'faithful maidens' thus 'asserted their self-adopted identity as loyal and responsible wives' (Lu, 2008, p. 132).[65] Whether deciding to remain celibate or committing suicide, a 'faithful maiden' often acted against the wishes of her parents (in effect, state valorisation of such action meant, paradoxically, that it undermined parental authority); in other cases, one who remained celibate might move in with her deceased fiancé's family – a situation not always to the liking of her in-laws, since she was legally permitted to adopt an heir from her deceased fiancé's lineage (e.g. amongst the sons of brothers or cousins) to ensure the continuity of his line, thereby gaining potential control over any property to which the heir was entitled (Lu, 2008, p. 123). A recent study has argued that the single-minded determination displayed by 'faithful maidens' to pursue their own ideal, often in the teeth of parental opposition, can be compared to that of female radicals in the early twentieth century who forsook family to pursue their revolutionary calling (Lu, 2008, p. 254).

Quite apart from suicide, widows who had inherited property from deceased husbands often *appropriated* official chastity discourse for their own advantage in order to maintain their independence and livelihood. This was crucial, since after the Song-Yuan period (tenth–fourteenth centuries) widows who remarried forfeited their dowries and any rights to their former husbands' property, thus providing an incentive for in-laws to pressure (or even coerce) them to remarry (Holmgren, 1985; Sommer, 1996).[66] In combating such

pressure – often in court – widows were able to claim the moral high ground by insisting they embodied the chastity ideal (amongst ordinary folk, however, in cases where property claims were not necessarily an issue, widow remarriage was far more common and acceptable). Given the fact also that from the Ming period on (fourteenth–seventeenth centuries) more emphasis was placed than ever before on patrilineal succession (which came into play if a man had no birth sons), widows who did not remarry gained more leeway in managing property; under the 'mandatory nephew succession' ruling first promulgated in 1369, all sonless families had to designate a lineage nephew to be the patrilineal heir, a process in which widows over time were centrally involved. In some ways widows were disadvantaged by this change, since during the Tang–Song period widows with no sons were entitled to inherit their deceased husbands' share of family property (and even those with sons received a share equal to that of their sons); from the Ming period onwards a widow only had custodial powers over her deceased husband's property on behalf of the legally adopted heir. Yet, with the growing valorisation of chaste widowhood during the Qing, a widow gained more influence in the designation of an heir (even to the extent of being able to reject her deceased husband's closest nephew and freely choosing one from amongst all lineage nephews); in recognition of their virtue, chaste widows over time were also granted larger custodial powers (Bernhardt, 1999, p. 48).[67]

Scholars have also explored the ways women used their close relationship with sons (their 'uterine family') to enhance their status and influence within the extended family (Wolf, 1972; Hsiung, 1994).[68] Such ties, however, could have traumatic consequences. During the North China Famine (1876–9), which claimed the lives of ten million people, contemporary narratives in local gazetteers and family handbooks testified to the survival of mothers with grown sons because the latter were willing to sacrifice wives and children (and even themselves) in order to feed their elderly mothers (Edgerton-Tarpley, 2004, pp. 124–8).

Just as a woman's uterine family brought her a certain empowerment within the family, so elite women through their embroidery and literary skills were able to create a space for themselves within the patriarchal system. In fact, it has been argued that the Confucian gender system was perpetuated precisely because of women's vested interests in it (Ko, 1994a, pp. 8, 296).[69] Thus writing networks of elite women that emerged in the prosperous Jiangnan region in the seventeenth century exchanged poetry that positively embraced Confucian values, exalting motherhood and their role as the transmitters of Confucian culture (Ko, 1994a, pp. 51–2, 66–6).[70] In other words, elite women perceived themselves as *active participants* in Confucian culture (*wen*), using the power of their writing voice to assert and extend their authority within the family (Mann, 1994b, p. 32; 1997, p. 120).[71] Their poetry (often describing grief or loss) was a means to display their moral authority and did not necessarily signify alienation or dissent (or even an attempt to assert autonomy).

In a similar vein, the practice of *nüshu* (often sung amongst women of a bride's marital family) gave rural commoner women about to be married a 'space' to vent feelings of loss or even resentment without challenging the

system.[72] Ballads composed in *nüshu* might draw attention to the inequity of socially sanctioned gender relations, but ultimately they concluded that such relations were a given and could not be transgressed (at least not in the living present); some texts also spoke of a woman's fantasy of being reborn as a man. Performing a similar function, bridal laments (*kujia*) sung by peasant women since very early times gave them the opportunity (and cultural authority) to speak out in a ritualised way at the time of their marriage, expressing doubts about their abilities as well as their mixed feelings towards their parents (gratitude for having raised them, but slight resentment for forcing them to leave the natal home).[73] Such a ritual, usually performed over three days in front of family and neighbours, seemingly contravened totally the Confucian male elite ideal of the passive and silent woman.[74] Intriguingly, bridal laments were not dissimilar to the practice of 'speaking bitterness' (*siku*) that the CCP encouraged village women to perform during their marriage reform campaigns of the 1940s and early 1950s (see Chapters 5 and 6) (McLaren, 2004b).[75]

Finally, account must be taken of what might be termed 'dissent within tradition', an indigenous and critical discourse concerning the treatment of women that *predated* the coming of the West in the nineteenth century. In arguing, for example, that men and women equally possessed a rational and intuitive intelligence that each ought to be able to develop, and that women's lives were unfairly restricted to domestic affairs, the dissident Ming scholar Li Zhi (1527–1602) has been described as a 'Confucian feminist' (Lee, 2000).[76] Li proposed that women should be given the same opportunities as men to engage in 'self-cultivation' as a means to develop their innate rational and moral capabilities. In terms of marriage and the family, he also underlined the central importance of the conjugal bond (based on emotional reciprocity rather than domination or obedience) rather than the conventional Confucian emphasis on the father–son relationship (Lee, 2007, pp. 34–5). During the eighteenth century there was a flowering of what one scholar has termed a 'male feminist criticism' as a number of scholars – mainly from the economically prosperous Jiangnan region – questioned the morality of concubinage, footbinding and widow chastity (Ropp, 1976).[77] Scholars such as Wang Chong (1745–94) and Yu Zhengxie (1775–1840) took issue with ritual teachings (*lijiao*) pertaining to women, condemning, for example, the hypocrisy of the chastity ideal as one invented by men to be solely applied to women. They equally condemned footbinding as an inhumane practice that could not be justified by early classical texts. Another prominent eighteenth-century critic of oppressive customs affecting women (such as the taboo placed on widow remarriage) was Yuan Mei, although his criticism did not apparently extend to concubinage.

An avenue of dissent was also provided by fiction, in which accepted gender stereotypes and assumptions were satirised or undermined. The collection of stories published in 1679 by Pu Songling (1640–1715), *Liaozhai zhiyi* (Strange Stories from a Chinese Studio), has been described as the first work of Chinese fiction having 'feminist implications' (with its portrayal of women as stronger-willed, and more intelligent and courageous, than their husbands) (Ropp, 1976, p. 11).[78] The stories also undermine the stereotype of the helpless and victimised widow by depicting alert widows whose knowledge of the

law enables them to outwit men who try to rob them of their property or reputation (Spence, 1978, pp. 61–2). Strong-willed women are a feature of the famous eighteenth-century novel *Rulin waishi* (The Scholars) written by Wu Jingzi (1701–54); the novel also presents an image of marital relationships based on intellectual and social companionship (Ropp, 1976, pp. 12–13).[79] Of course, less flattering images of women also pervaded Chinese popular fiction, such as the stereotype of the jealous, aggressive and bullying wife (or 'shrew') who constantly 'henpecks' her hapless husband.[80]

Another genre in popular fiction that satirised male treatment of women was the allegorical portrayal of an imaginary land in which male–female roles were reversed, the most celebrated example of which is the early nineteenth-century novel *Jinghua yuan* (Flowers in the Mirror) by Li Ruzhen (1763–1830). In the novel, set at the time of the Tang dynasty Empress Wu Zetian (r. 684–705), who had usurped the throne from her son, one of the protagonists, Merchant Lin, visits the Kingdom of Women,[81] where he dramatically experiences the reversal of sex-roles by undergoing a painful 'beautification' process (which includes having his ears pierced and his feet bound) in preparation for an audience with the 'king', who lusts after him to be her concubine:

> Before he knew what was happening, Merchant Lin was being stripped completely bare by the maids and led to a perfumed bath. Against the powerful arms of these maids, he could scarcely struggle. Soon he found himself being anointed, perfumed, powdered and rouged, and dressed up in a skirt. His big feet were bound up in strips of cloth and socks, and his hair was combed into an elaborate braid over his head and decorated with pins. These male 'maids' thrust bracelets on his arms and rings on his fingers, and put a phoenix headdress on his head (Li, 1965, p. 110).

After two weeks:

> his feet lost much of their original shape.... Responding to daily anointing, his hair became shiny and smooth, and his body, after repeated ablutions of perfumed water, began to look very attractive indeed. His eyebrows were plucked to resemble a new moon. With blood-red lipstick and powder adorning his face, and jade and pearl adorning his coiffure and ears, Merchant Lin assumed, at last, a not unappealing appearance (Li, 1965, p. 113).

Unfortunately, Merchant Lin is so traumatised by the experience that he proves to be a very unsatisfactory lover.

Furthermore, the novel also describes the achievements of the one hundred talented female incarnations of the heavenly 'flower spirits' in passing the civil service examinations and then (with their husbands and brothers) participating in successful military campaigns against Empress Wu that restore the legitimate rule of her son, Zhongzong. Ultimately, however, such dramatic depictions of gender role reversal conclude with a return to the status quo (which includes 'settling down' to a conventional marriage) once peace and normative order are restored – much in the same way as Hua Mulan returns to her normative role of filial daughter after her successful military campaigns

have saved the dynasty. The 'emancipation' of women that Li Ruzhen had in mind was very much influenced by early Confucian ideals that advocated women's welfare, valorised female education and stressed the importance of marriage. Significantly, in the preface to the novel, Li Ruzhen approvingly referred to the ideals of female behaviour as propounded by the Han dynasty female scholar Ban Zhao (which included fidelity to husbands and obedience to in-laws) (Brandauer, 1977).[82] This did not prevent the novel later, in the 1920s and 1930s, being hailed as a shining example of an *indigenous* Chinese tradition of feminism. In 1924, for example, the prominent May Fourth intellectual and educator Hu Shi (1891–1962) published an article in English entitled 'A Declaration of the Rights of Women', which highlighted the novel's pioneering role in promoting equality between the sexes;[83] in 1935, an article by the cultural critic Lin Yutang (1895–1976) observed that *Flowers in the Mirror* was China's first 'feminist' novel.[84]

It is important to note, moreover, that women themselves contributed to this literary subversion of gender roles. In a particular literary genre, the *tanci* (drama in prose and verse that was sometimes performed orally), often written by and for women and which became popular during the course of the nineteenth century, a re-imagining of gender identity might underpin the drama. One such example was *Zaishengyuan* (*Destiny of Rebirth*), published in 1821, in which the heroine, Meng Lijun, in male disguise, succeeds in the civil service examinations and actually becomes prime minister (Widmer, 2003).[85] Such a scenario was not complete fantasy; there was a venerable tradition of cross-dressing women who adopted male personae (as noted earlier in the case of courtesans), while daughters in elite households that had no sons might be raised as sons (Finnane, 2008, p. 91).[86] Buwei Yang (1889–1981), for example, who studied medicine in Japan in the 1910s and later became a celebrated writer of Chinese cookbooks, noted in her 1947 autobiography that she had been adopted at birth by a childless aunt and uncle who dressed her as a boy and treated her as a male (Yang, 1970, p. 38).

Notwithstanding this 'dissent within tradition', the profound political and cultural crisis afflicting China by the end of the nineteenth century was to change radically the context in which gender discourse and practice played out. For much of the nineteenth century (at the time of the Self-Strengthening movement in the 1860s and 1870s, for example, when officials sought to appropriate western military technology to bolster the Confucian socio-political order), male leaders saw no 'problem' with the organisation of the Chinese family or the place of women within it (Mann, 2009). During the 1890s internal political decay and an ever more intrusive western imperialist presence led to a crisis of confidence amongst the elite; henceforth, the need to address what became known as the 'woman question (or problem)' would become inextricably linked to the very survival of the polity itself.

2

Reform, Nationalism and the 'Woman Question' (1897–1912)

In 1905 Qiu Jin (1875–1907), a female Chinese overseas student in Japan who two years later became a 'revolutionary martyr' when she was executed for being implicated in an anti-dynastic uprising, began writing a prose/verse narrative (known as a *tanci*, a traditional literary genre usually recited and sung and which was popular amongst female audiences).[1] In the preface to this utopian tale of the political awakening of five 'beauties' transformed into revolutionary heroines, Qiu Jin drew a bleak picture of China's current womanhood, trapped in a 'world of darkness, as though drunk or dreaming'. She continued:

> Let me ask you, of our 200 million women, how many shall grovel at the feet of tyrannical men? Alas, today they continue to powder and paint themselves, chatter about their hairdos and bind their feet, adorn their heads with gold and pearls, and drape their bodies with brocade.... They are no more than the servile and shameless playthings of men. (Dooling and Torgeson, 1998, pp. 43–4)

As with many reformers and revolutionaries of the time, Qiu Jin highlighted the 'failings' of Chinese women in order to explain the country's weakened state.

During the course of the nineteenth century the Qing dynasty (1644–1912) had to confront massive internal rebellions as well as continuing pressure from western imperial powers for commercial privileges (granted by a series of 'unequal treaties'). China's geopolitical situation became dramatically worse during the 1890s. An attempt by the Qing court to reassert China's traditional influence in Korea brought it into conflict with Japan, which had its own political and economic ambitions in the region. Tensions led to full-scale war in 1894–5, in which China suffered a humiliating defeat, especially as hitherto the Chinese scholar–official elite had conventionally viewed Japan condescendingly as a respectful disciple of Chinese culture. The Treaty of Shimonoseki ending the war compelled China to cede the island of Formosa (Taiwan) to Japan as a formal colony; Japan was also granted the same privileges enjoyed by the western imperial powers in China (as well as additional economic concessions

such as the right to establish manufacturing enterprises in the treaty ports). The Treaty, furthermore, obliged China to pay Japan a large indemnity, which only exacerbated the country's growing indebtedness.

With the onset of fiercer competition amongst the powers for economic influence and advantage in China, the end of the 1890s witnessed the 'scramble for concessions' in 1897–8. This referred to the acquisition of leased territories (in which Chinese sovereignty was effectively extinguished) by Russia, Germany, Britain and France along China's coast as each power sought to boost its 'sphere of influence' and check the ambitions of its rivals. For many Chinese officials and scholars of the time it seemed that the country itself was on the verge of extinction, to be 'sliced up like a melon' by the powers in the same way that Poland had been partitioned by its more powerful neighbours in the eighteenth century.

It was against this background of profound national crisis that Chinese male reformers in the 1890s began to address the 'woman question' as part of a wider exploration of why and how the country had 'declined' to its present state. A primary reason was thought to lie with China's 'uneducated' and 'economically unproductive' women. Arguing very much on instrumentalist grounds, reformers initially focused on the need to educate women so that they could contribute to economic prosperity, social cohesion, and the cultivation of a future healthy and patriotic citizenry. From the very beginning, therefore, discussion of the 'woman question' was intimately linked to the wider issues of social rejuvenation and national self-strengthening; such a general outlook was to influence one way or the other all participants in the debate – conservatives, reformers, anti-monarchical revolutionaries – during the last years of the Qing.[2] However, as women themselves (like Qiu Jin) came to participate in the discourse at the turn of the twentieth century (although several had been earlier involved in the creation of China's first public school for girls in 1898 at the height of the reform movement in the 1890s, as well as advancing a different agenda from that of their male counterparts), emphasis was also placed on the necessity for women to struggle for political rights and to be actively involved in public affairs. Furthermore, by the time the Qing dynasty was overthrown in 1911–12 women had become more publicly visible in society as teachers and students, contributors to a women's press, revolutionaries and suffragists. Another striking example of women's entrance into the public sphere was the appearance of female doctors practising western medicine; many of them were products of western missionary education and/ or missionary-sponsored overseas study. This chapter therefore begins with a discussion of the pioneering role played by missionaries in the development of women's education in China – a role that has often been overlooked (or denigrated) in the past because missionaries were identified with imperialism (Dunch, 2009).

Western missionaries and Chinese women

Although traditionally daughters (at least of the elite) had been educated within the household, the reformers of the 1890s uniquely addressed the

need for *public* education of girls. They were not strictly the first to do so. Earlier in the century western Protestant missionaries who began arriving in China during the 1840s,when the official Chinese ban imposed on Christianity since the 1730s was lifted, had championed female education; mention must also be made of the Catholic-organised Christian virgins in Sichuan province (see Chapter 1), who provided basic instruction for girls (often carried out in private homes) as part of their church welfare duties, a tradition that persisted throughout the nineteenth century. In 1844 Mary Aldersey (1797–1868), a founder member of the interdenominational Society for Promoting Female Education in the East (established in 1834), opened a girls' school in Ningbo, one of the five treaty ports forcibly opened to western trade, residence and Christian proselytisation following the Anglo-Chinese (Opium) War of 1839– 42. Other missionary girls' schools were subsequently opened in Shanghai (1849), Fuzhou (1851), Guangzhou (1853) and Amoy (1861). These early missionary girls' schools were primarily aimed at training girls to be church helpers, Bible women or the future wives of Chinese pastors (Kwok, 1992, p. 104).[3] Initially, they tended to enrol only foundlings or daughters of the destitute – especially as they did not charge tuition fees and provided free food and lodging. Pupil numbers were small, while local hostility and suspicion amongst elites and commoners alike (due to a long anti-Christian tradition dating back to the late seventeenth century), in addition to financial restraints, meant that these schools led a precarious existence (Burton, 1911, pp. 44–51; Lewis, 1919, pp. 18–25).

From the 1880s onwards, however, missionary schools for girls began to attract a wider social constituency, especially when the curriculum was broadened to include the teaching of English – hitherto the curriculum had primarily consisted of Chinese-language instruction in simplified Christian and Confucian texts (in some cases Christian texts incorporated traditional Confucian values such as filial piety) (Dunch, 2009, pp. 84–9),[4] as well as training in needlework and embroidery. In making this change, missionaries were, in fact, responding to the demands of some Chinese elite families in the late nineteenth century who viewed a knowledge of English as an emblem of 'modern' status that would enhance their daughters' marriage prospects. The curriculum broadened to such an extent that by the 1890s a prominent missionary school for girls, the Shanghai McTyeire School, was offering instruction in western languages, literature and sciences (Beahan, 1976, pp. 44–5).[5] The number of girls in Protestant missionary schools increased from nearly 200 in 1860 to over 7,000 in 1897 (Kwok, 1992, p. 17).[6] By 1910 this total had increased to 16,910; to this total should be added the nearly 50,000 girls in Catholic-run schools in 1912 (Lewis, 1919, p. 25), about which much less has been written by western scholars.

The increasing attention missionaries paid to female education was very much the consequence of what has been called the 'feminisation' of the Protestant missionary force from the 1870s onwards (Hunter, 1984, xiii).[7] In 1851 there had been just 18 single women employed in China missions, and it was only in 1878 that the China Inland Mission (one of the largest Protestant missionary organisations), for example, began sending single women into the

interior. By 1890 there were over 300 single female missionaries, and, together with the wives of missionaries, they outnumbered their male counterparts. Amongst American missionaries, in particular, the predominance of women was especially noticeable; married women employed by general missionary boards and single women belonging to women's boards together in 1890 comprised 60 per cent of the total missionary force. In 1900 there were 811 single women in the field (compared with 400 single men), while by 1919 13 percent of all missionary centres in China were staffed entirely by single women (Beahan, 1976, p. 37; Hunter, 1984, pp. 3, 52; Kwok, 1992, p. 19). Since Chinese women were especially targeted by missionaries because it was felt their traditional involvement in popular indigenous religions would make them susceptible to conversion (after which, because of their central role in the household, they would exert a significant influence on their menfolk), female missionaries became indispensable, given the conventional taboos in China against informal mixing of the sexes.[8]

Many of these American Protestant missionary women were college-educated, originating from rural areas and towns of the mid-west; coming from such a conservative environment back home, it was not entirely surprising that in China they sought to instil in their pupils the 'virtues' and ideals of Victorian and middle-class domesticity, as well as Victorian notions of masculinity and femininity and what constituted 'appropriate' behaviour. This 'evangelical domesticity' often assumed, furthermore, that the ideal missionary home would transform the 'backward' Chinese environment – assumed not to have any 'home life' as such (Hunter, 1984, p. 116). In fact, missionary women came to adopt the social arrangements of an overseas colonial community, symbolised by the walled mission compound, and in their 'bossy' treatment of indigenous people (e.g. servants) around them they created a form of 'domestic empire' (Hunter, 1984, p. 128).[9] As independent and single professional women, however, these missionary women represented a dramatically novel role model for their Chinese pupils – ironically, these missionary women exercised more autonomy and initiative in China than they would ever have been able to do back home, where the church was male-dominated and where they would have been much more constrained in their actions as independent professional women.[10]

The 'feminisation' of the Protestant missionary force also brought in its wake a more sensitive attention to Chinese women's 'suffering' (Kwok, 1992, p. 105); thus, after an initial reluctance on the part of male missionaries to condemn footbinding out of concern not to alienate Chinese male elites, the practice was increasingly condemned after the 1870s. In 1874 an anti-footbinding society was founded in Amoy by John MacGowan and his wife (of the London Missionary Society). As is evident from a book he later published, *How England Saved China* (London, 1913), MacGowan had no hesitation in attributing a pioneering role to western missionaries (especially those from England like himself) in the opposition to footbinding:

> Amongst all the triumphs that England can point to in the uplift of nations with whom her arms have brought her in contact, there is none more glorious than

the deliverance of the women of China...from the terrible bondage and suffering that footbinding had inflicted upon them during the long ages of the past. (MacGowan, 1913, p. 101)[11]

In so doing, MacGowan simply ignored (or perhaps he was not aware of) the indigenous tradition of dissent that had condemned footbinding as sadistic and inhumane (see Chapter 1). In any event, it was not until the 1890s that a more concerted western-run campaign against footbinding took off, when in 1895 Alicia Little, the wife of a British merchant, assembled a group of non-missionary European women to establish the Natural Foot Society in Shanghai (in 1908 the Society was handed over to the control of Chinese women) (Drucker, 1981; Croll, 1990). Significantly, Alicia Little actively sought the support of Chinese officials and ensured that meetings of the Society were not held on mission property so as to avoid an overtly 'foreign' image of the campaign, a campaign that associated the elimination of the practice with improvements to women's health rather than with their emancipation *per se*.[12] By this time, however, Chinese reformers were already urging an end to the practice in connection with their championing of female education (see later).

In the eyes of pragmatic missionary educators, an end to footbinding would facilitate the recruitment of more mobile and less secluded girls for their schools (although the process could work the other way, since missionary schools increasingly insisted that prospective female pupils have unbound feet). In the late nineteenth century, missionaries also pioneered the introduction of physical education into the curriculum (along with the concept of competitive sports); in their view sport and physical education in general would 'reform' Chinese gender practices and male–female interactions, regarded as crucial in Christianising the Chinese (Graham, 1994, p. 24). While missionaries antici-pated that physical education would make Chinese boys more 'manly' and physically robust (they believed upper-class Chinese men were 'effeminate' because of the 'nefarious' influence of the Confucian masculine ideal associ-ated with the long-robed scholar), for Chinese girls physical education was part of a larger missionary project to make them more active in the church and in social reform (and hence, missionaries hoped, would enhance their moral authority within the home and in society at large) (Graham, 1994, pp. 30–1). The introduction of physical education, however, was not meant to subvert the gender conventions of white, middle-class America. Education for girls, in the missionary view, was above all to train them as 'model homemakers'; as one female missionary explained in 1899, the ideal Christian woman was a 'conscientious, judicious and self-controlled' carer of her children and the hard-working helpmate of her husband (Bailey, 2007, p. 13).[13]

It was also made clear that sports and physical drills would be taught differ-ently to boys and girls (in the late nineteenth century most American school-girls did not participate in track events, considered too strenuous for their physiology). To the consternation of missionaries, Chinese schoolgirls took their message of equality of the sexes (i.e. that there should be no differ-ences between them) to heart by engaging in 'unseemly' and 'unfeminine' activities such as track athletics and riding bicycles; yet it had never been

intended that equality should undermine 'real' differences and boundaries (missionaries preferred, for example, that girls practice calisthenics and other 'moderate' physical exercises rather than participate in team and competitive sports) (Graham, 1994, p. 38). In 1899 the principal of the Shanghai McTyeire School confessed that she shuddered with 'a nameless dread at the thought of Chinese women on bicycles', which she regarded as most unfeminine (Graham, 1994, p. 44).[14] Notwithstanding such concern on the part of missionaries, by the early twentieth-century missionary schools (for both boys and girls) – as well as Chinese government and public schools for girls that began to be established after 1902 (see later) – were holding field meets and other athletic competitions. Female pupils of missionary schools would also later participate in the Far Eastern Olympics in Shanghai (1921) and in the Philippines (1927). As late as 1926, however, a physical education teacher at a missionary college for women condemned the tendency of women's athletic programmes to resemble men's, or women playing basketball according to men's rules (Graham, 1994, pp. 41–2).[15]

Overall, although missionaries in China championed women's greater social involvement, it was more in terms of building upon their 'natural' roles as nurturers and carers. Thus China's first female western-trained doctors were the products of missionary education in China and missionary-sponsored medical training in the US (furthermore, they had either been adopted by missionaries or were the daughters of Chinese Christians). By the same token, missionaries did not meet with overt Chinese male resistance to women training as doctors, since such training was under the guidance of *female* missionaries, fulfilled a need to cater to female patients, and was considered an extension of their nurturing roles as mother or midwife. The most celebrated of the five Chinese women attending medical school in the US during the years 1885–1905 (and funded by the Women's Foreign Missionary Society, the women's board of the Board of Missions of the Methodist Episcopal Church founded in 1869) were Kang Cheng (1873–1931) and Shi Meiyu (1872–1954).[16] Kang Cheng (English name Ida Kahn) had been 'adopted' as a two-month-old baby by a Methodist missionary, Gertrude Howe (1847–1928), one of the first single women missionaries in the China field (having arrived in 1872), ostensibly to raise her to become an exemplary Christian wife and mother.[17] When Shi Meiyu's father, a Methodist pastor, asked Howe to provide his daughter instruction to enable her to study medicine in the US, Howe started to give classes in English and science to both Kang and Shi – another example of how missionary educational initiatives were often contingent upon *indigenous* demands and perceived self-interests; later Gertrude Howe accompanied the two young Chinese women to the US, where they studied medicine at Michigan University from 1892 to 1896.

On successful completion of their studies, Kang and Shi – both of whom remained unmarried for the rest of their lives, to demonstrate their total commitment to God and to China – returned to China and set up a medical dispensary in Jiujiang (Jiangxi province), during which time they attracted the enthusiastic attention of Chinese male reformers (see later), who hailed them as the embodiment of 'new Chinese women' dedicated to improving the lot of

their countrywomen.[18] While Shi Meiyu (English name Mary Stone) became the director of a new hospital in Jiujiang (from 1900 to 1920),[19] Kang Cheng after 1900 began practising medicine in Nanchang (capital of Jiangxi province), establishing a dispensary and a nurse training school. Significantly, Kang sought funding from local gentry elites rather than the Women's Foreign Missionary Society (although she and Gertrude Howe visited the US in 1908–11 to secure additional funds to develop the dispensary into a larger medical complex); by 1905 Kang's dispensary was serving over 5,000 patients annually (Shemo, 2009).

While female western missionaries hailed Kang Cheng and Shi Meiyu as the harbingers of Chinese Christian womanhood, and their medical service as a shining example of women's potential contribution to society,[20] they were much less enthusiastic about Chinese women's growing political activism during the last years of the dynasty (see later), which they regarded as a transgression of appropriate gender boundaries (it is possible also that non-Christian Chinese women's political activism may have influenced Chinese female church workers and Bible women to demand the right to preach in church, a development about which some missionaries had decidedly ambivalent feelings) (Kwok, 1992, p. 84).[21] Later, missionaries were to welcome the suppression of the Chinese women's suffrage campaign during the first years of the Republic (see Chapter 3), with one of their number noting that the female suffragists had 'offended against the laws of the land and humanitarian nature of womanhood' (Hunter, 1984, p. 265).

In a sense, Kang Cheng imbibed this attitude. In 1912, shortly after the revolution that had toppled the Qing dynasty and ushered in a republic, Kang wrote a short story (in English, since it was aimed primarily at an American audience) entitled 'An Amazon in Cathay', in which she illustrated two kinds of contrasting national service for Chinese women. It is the story of two female cousins, one of whom is described as 'gentle' and 'cultured' and who, after attending a missionary school, dedicated her life to working in a hospital for women and children (clearly meant as a reference to Kang's own hospital in Nanchang). The other cousin, virtually her polar opposite, is not missionary-educated and decides to join a women's military regiment during the revolution; even by cutting her hair short and donning a soldier's uniform, the story implies, the cousin had already transgressed 'normal' gender boundaries, a transgression that later rebounds on her when she is brutally raped by her fellow male soldiers. She attempts suicide but is conveyed to her cousin's hospital, where she miraculously 'sees the light' and decides that she will also study in a missionary school and train to be a nurse, a profession she considers more apposite in improving the lives of women and children (Shemo, 2009, pp. 120–1).[22] Yet, while the story advanced the idea that women could best contribute to the creation of a strong nation through a healing and nurturing role (rather than political activism or military participation) – an idea with which western missionaries would have been in perfect agreement – by depicting a *Chinese* (and female) controlled institution within which these healing activities would take place, Kang was sending a message to her American audience that Christianity had as much transformative impact

upon what Kang herself called 'the yellow people' as the Anglo-Saxon 'white' people. In this way, Kang sought to convince her audience that Chinese and western women could be *equal* partners in evangelising both China and the world (Shemo, 2009, p. 122).

Education for the nation?

During the 1890s Chinese male reformers and scholars likewise addressed the treatment of women, especially in terms of education. One such reformer was Liang Qichao (1873–1929), whose 1897 essay on women's education is conventionally regarded by historians as the first major proposal calling for the urgent improvement of women's status. Liang Qichao, who was to be a major participant in the reform movement of 1898 (known as the One Hundred Days of Reform) and later became a pioneer of journalism and historical scholarship who introduced western political thought to a Chinese audience, insisted that the root cause of China's weakness was the lack of education amongst women.

Influenced to a certain extent by earlier writings of western missionaries such as Timothy Richard (1845–1919) of the Baptist Missionary Society, which characterised Chinese women as idle consumers, Liang Qichao – completely overlooking, for example, the crucial roles peasant women had always played in the rural economy – bewailed the fact that China's entire female population was unproductive and hence a drain on the household and national economy. Liang also pointed out that Chinese women's 'unproductivity' was a constant and debilitating source of anxiety for men compelled to support them. Furthermore, Liang claimed, 'entrenched' Confucian adages such as 'in a woman lack of talent is a virtue' (see Chapter 1) had led to the widespread assumption that a woman could only be deemed virtuous if she was illiterate. For Liang, 'parasitic', 'ignorant' and 'physically weak' (due to the practice of footbinding) Chinese women were not only a major contributor to the country's decline but also constituted a threat to the country's future because of their inability to bear healthy and public-spirited sons (Bailey, 2007, pp. 16–18).

At the same time Liang dismissed the tradition of elite women's culture and learning as frivolous, trivial and self-indulgent, which bore no relation to 'real' learning that contributed to national well-being. For Liang, the *cainü* ('talented woman', a common description used in the eighteenth and nineteenth centuries to refer to elite female poets) or the *guixiu* (the 'refined and cultivated elite woman within the inner quarters'), far from being a source of pride, were a source of national embarrassment (Mann, 2007, p. 8). In effect, Liang had set a precedent that was to be followed by scholars, writers and educators (male and female) in the early years of the twentieth century and during the May Fourth era who marginalised and belittled Chinese women's learning of the past, which for them represented everything that was 'backward' in China's cultural tradition (Hu, 2002, pp. 185–6; Judge, 2002a, p. 165). Liang insisted that education for Chinese women had to provide them with both practical literacy and an occupation, as well as instilling in them

a concern for the public good. It is significant that in his 1897 essay Liang praised the 'inspiring' examples of Kang Cheng and Shi Meiyu as the kind of 'new women' he wished to see emerge in China. In Liang's view, such women represented public-minded citizens devoting their lives to the well-being of the people. In a separate essay on Kang Cheng, Liang described her as the embodiment of a new model of womanhood because of her dedication to *national* rejuvenation, contrasting her favourably with Wang Zhaoyuan (1763–1851), a textual scholar, poet and essayist, whom he belittled as a typical *cainü* (Hu, 2000, pp. 6–8, 123–6; 2002, pp.185–91; Zurndorfer, 2008).

At the same time as Liang Qichao advocated education for women, he and other reformers denounced the practice of footbinding – motivated principally by the instrumentalist aim of national self-strengthening. Campaigners, as has already been noted, could draw on the example of western missionaries, who had been condemning the practice since the 1870s, as well as on an earlier and indigenous tradition of dissent that had denounced the custom as inhumane. In 1883 the prominent late nineteenth-century scholar and reformer, Kang Youwei (1858–1927), had already proposed setting up an anti-footbinding society in Guangzhou (which got off the ground several years later); two others were launched in 1894 (in Guangdong province) and 1895 (in Shanghai). Campaigners emphasised the deleterious physical weakness amongst Chinese women caused by footbinding, and advanced the eugenicist argument that this posed a threat to the viability of the Chinese race; the abolition of the practice was also seen as an absolute prerequisite for the spread of women's education. Significantly, some reformers, like Zheng Guanying (1842–1923) and Kang Youwei, urged an end to the practice because of the western ridicule it caused (noting that foreigners often took photographs of bound feet to titillate audiences back home). In fact, the first images of bound feet were produced by commercial photographers in Shanghai during the 1860s, and it became customary to include at least one image of a Chinese 'vice' (e.g. opium-smoking, footbinding) in the photo albums sold to foreign visitors. The anti-footbinding campaign of the 1890s was also not averse to making extensive use of such visual images in its public rallies (Ko, 2005, pp. 41–2).

Between 1897 and 1911 over forty anti-footbinding societies appeared, most of them located in urban areas and founded by men. Many of them were initially set up by informal groups of friends to solve the 'problem' of finding marriage partners for their daughters who had unbound their feet.[23] In 1902 the Empress-Dowager Cixi issued an edict banning the practice (just as the early Qing emperors had done, without success), and by 1904 the governors and governor-generals of eighteen provinces had promulgated similar bans. In some ways the anti-footbinding campaign at the turn of the twentieth century was guilty, as a recent study has observed, of a certain misogyny, as male reformers persistently infantilised and humiliated women with bound feet (portraying them as pathetic victims) in public rallies and displays (Ko, 2005, p. 68). The custom largely disappeared in the urban areas during the 1910s, but persisted in rural areas until the 1930s.[24] Personal testimonies and memoirs also reveal that young girls themselves in the early twentieth century might have taken the initiative in rejecting footbinding. Zhang Mojun (1884–1965),

for example, the daughter of a Qing official who later joined Sun Yatsen's revolutionary organisation, the Alliance League (*Tongmenghui*), while she was studying in Japan recalled in her autobiography (published in 1953) that at the tender age of nine she convinced her mother not to bind her feet on the grounds that the female Buddhist saints (boddhisattvas) worshipped by her mother all had 'natural feet' (Chang, 1992). Zheng Yuxiu (1891–1959), who gained a doctorate in law at the Sorbonne in Paris in the 1920s and became China's first female practising lawyer (in Shanghai), remembered in her 1943 autobiography that she created such a commotion after her feet were bound that her grandmother (who had the final decision) gave in and let her unbind her feet (Croll, 1995, pp. 22–3).[25]

Although the late nineteenth and early twentieth-century campaign against footbinding was now uniquely associated with a *patriotic* impulse to strengthen the country, it is important to bear in mind that welfare provision for women and girls had always been an important symbol of Confucian moral reform (Rogaski, 1997, p. 57). In the late eighteenth century, for example, gentry elites in the Jiangnan region, in order to combat the activities of organised gangs who abducted young widows for future sale as wives or concubines, opened a number of widows' homes (*qingjie tang*) (Leung, 1993). Significantly, women themselves (often widows) from the eighteenth century onwards participated in such philanthropic endeavours, helping to establish, finance and even manage clan charitable estates and more public institutions for needy widows; in so doing, women helped bolster and even spread official Confucian ideology throughout society (see Chapter 1), since the protection of young widows was very much motivated by a concern that they should continue to fulfil their family duties, such as caring for their in-laws and educating their children (Leung, 1993, p. 22).

One of the largest welfare institutions for women and young girls in north China at the turn of the twentieth century was the Hall for Spreading Benevolence (*guangren tang*), originally opened in 1878 by officials from south China stationed in Tianjin for widows and orphans following the calamitous north China famine. The institution also functioned as a shelter for adolescent females who had been abused or sold as sexual commodities. The premises ran a workshop, in essence a primitive textile factory, which by 1912 was divided into weaving, embroidery, towel-making and machinery sections. Women and young girls earned small amounts of cash for each towel or blanket produced (which were sold in local Tianjin department stores) (Rogaski, 1997, pp. 75–6). Anticipating action taken by the newly established communist government after 1949 to rehabilitate prostitutes (see Chapter 6), the Hall for Spreading Benevolence 'released' widows to the care of adult sons (who had been brought up and educated within the institution), while marriages were arranged for 'charity girls' to men approved of by the Hall administration (Rogaski, 1997, p. 77).

The culmination of 1890s reformist discourse on women occurred in 1898 – on the eve of the 'One Hundred Days of Reform' during which the Guangxu Emperor (r. 1875–1908) issued a number of edicts proclaiming his intention to rejuvenate the monarchy and bureaucracy – when a group of male reformers

and their wives (and in some cases their mothers and daughters) launched the Chinese Girls' School in Shanghai, the first Chinese *public* school for girls. With an initial enrolment of twenty, by the time the school was forced to close down in 1900 as a result of official conservative opposition up to seventy students had been registered. Reflecting its elite origins, prospective students (to be aged between 8 and 15) were to be 'well-behaved' girls from 'respectable families' (boarding students were allowed to bring their own female servants with them, but had to be lodged in separate buildings). The curriculum was relatively broad, calling for instruction not only in reading, writing and embroidery skills, but also in history, art and law. Although the school had an external board of male directors responsible for hiring personnel and arranging the curriculum, it also had an all-female teaching staff, with Li Huixian (the wife of Liang Qichao) serving as the principal, and the wife of the missionary Timothy Richard acting as one of the consultants.

Discussions surrounding the aim of the school intriguingly revealed clear gender differences. Whereas male reformers such as Liang Qichao denigrated the 'talented women' (*cainü*) of China's past and supported women's education in strictly utilitarian terms of benefiting the nation, household economy, and men's ease of mind, the poet Xue Shaohui (1855–1911), one of the female founders of the Chinese Girls' School, *celebrated* the achievements of China's *cainü*, and envisioned education for women as an opportunity to build on, and further develop, their poetic and creative talents (she also wanted the school to enshrine the female scholar Ban Zhao, rather than Confucius, as the patron of women's learning). In making use of educational opportunities, Xue believed, women would bring benefits to themselves as well as to the nation (Qian, 2003). Significantly, Xue also refused to blame women for causing China's 'backwardness', arguing that women had had to endure a stifling political and social environment not of their making. It should be noted, however, that other female reformers discussed women's education in terms similar to those of their male counterparts; Kang Tongwei (1879–1974), the daughter of Kang Youwei, for example, insisted that women's education was needed in order to produce 'worthy mothers' who could instruct their sons and 'capable wives' who could assist their husbands (Bailey, 2007, p. 20).

Nevertheless, contributors to the pioneering women's journal that female reformers launched in 1898 to publicise their project of women's education – the *Nüxue bao* (literally *Journal of Women's Learning*, although given the English title *Chinese Girls' Progress*) – advocated women's rights and urged women to embark on the study of science, medicine, art and literature. Anticipating later May Fourth discourse in the 1910s (see Chapter 3), one contributor suggested implementing equal gender relationships that existed in the West, especially in the realm of marriage:

> In the West, they do not discriminate very much between men and women, but enforce strict rules against illegal [marriages]. Women enjoy high social status, and no-one may seduce them into a marriage with money or goods. People wed according to their own free will. (Qian, 2003, p. 435)[26]

Another extraordinary article in the journal suggested that the Qing government establish an assembly of upper-class women (principally the wives of officials) that would discuss the development of female education and the creation of women's public and artistic associations; such an assembly, furthermore, would elect members from among its ranks to become 'officials' of a special 'Board of Women's Education' to oversee the founding of girls' schools in all the provinces (Bailey, 2007, pp. 22–3).

There were even more radical visions at this time. In 1884–1885 Kang Youwei wrote the first draft of a utopian work, *Datong shu* (*Book of the Great Commonwealth*), which was completed in 1902. Boldly envisioning a future world of harmony and unity in which national, ethnic and gender boundaries no longer existed, the work was not published in its entirety until eight years after Kang's death in 1927 (although the first two parts were published in 1913).[27] In his description of the various forms of human suffering that Kang believed would eventually disappear with the coming of his 'One World', he referred specifically to the travails of being a woman (in contrast to the positive views of women's status in the West, noted earlier, that some reformers held in the 1890s, Kang observed that women suffered equally in the West and China because in both cases they were men's 'private possessions') (Thompson, 1958, pp 72–3). Furthermore, the family itself as an institution, in Kang's view, was an example of a 'boundary' (*jie*) that contributed to separation and difference amongst humans, and thus needed to be abolished. Kang also criticised 'sex boundaries' that had developed in China due to strict and rigid sexual and gender norms, which had led to the unnatural and inhumane treatment of women.[28] Kang proposed that women should be allowed access to all public office and should be free to choose their own marriage partners (after the age of twenty). Marriage, in Kang's vision, would be a contract (which he referred to as an 'intimate relations contract') freely entered into by both parties and would be renewed on an annual basis (he also insisted that the western custom of a married woman taking her husband's surname would be abolished).[29]

While railing against all customs that either physically harmed women's bodies (footbinding, ear-piercing, and compressing the waist) or sought to make them invisible (veiling the face), Kang made it clear that his future world would avoid encouragement of western-style 'promiscuity':

> [Such customs as] baring the shoulders and unclothing the body, and dancing with men in the western style (literally: 'rubbing together') are barbarous, and arouse lewd thought. All [such customs] will be strictly prohibited. (Thompson, 1958, p. 161)

Anticipating the androgynous dress style of the Cultural Revolution in the 1960s (see Chapter 7), Kang insisted that in the future men and women should dress the same; with women looking like, and subsequently acting like, men, they would not suffer discrimination in public:

> There being no distinctions of form or colour, there will of course be no difference in their manner of behaviour. This being so, women will not be regarded

as different [from men] when, as teachers, superiors, officials or rulers, they hold office and perform their duties. (Thompson, 1958, pp. 162–3)[30]

However, Kang's utopian musings had a darker side. The very description of his future world was a curious mixture of naïve utopianism and ruthless social Darwinism:

within this next hundred years all the weak and small states will certainly be entirely annihilated, all monarchical and autocratic forms of government will certainly be completely swept away...The peoples of civilised nations will be increasing in knowledge and the inferior races will be gradually diminishing. (Thompson, 1958, p. 89)

Furthermore, Kang's ideas were underpinned by a eugenic obsession with improving the 'quality' of the people. He anticipated that in the future the poor, vagrants and unemployed would be 'taken off the streets' and housed in special institutions until they found work (those who were incarcerated in such institutions more than once would be publicly shamed by having to wear a special uniform). Ominously, Kang also envisioned a scenario in which 'insane' people would be located to 'special islands' and forbidden from procreating (Thompson, 1958, pp. 200–1). Furthermore, all children in Kang's future would be publicly brought up and educated in a series of public institutions, thus making the family redundant; all pregnant women would give birth in a 'human roots institution', after which the infant would be transferred to an 'infant-rearing institution' (Thompson, 1958, pp. 174–85, 191). Significantly, Kang stated that all women would serve in human roots and infant-rearing institutions before they were eligible to hold high office (Thompson, 1958, p. 194).

In the final analysis, moreover, even Kang's radical views on women were tempered by a negative assessment of the current state of (Chinese) woman-hood typical of the time – and underpinned by a paranoid anxiety about what might happen if women were granted too much freedom. Cautioning that his future world of absolute gender equality would require a long time to be real-ised, Kang observed that women at present were too ignorant and immature to enjoy the fruits of independence; in such a situation, he gloomily continued, 'they would be free to indulge their feelings of revolt against their husbands, or their lustful passions, this would be the road to great disorder' (Thompson, 1958, pp. 166–7).

The female student as a new social category

The pioneering Chinese Girls' School that had opened with such fanfare in 1898 soon fell foul of the conservative reaction that gripped the court later that year; Kang Youwei and Liang Qichao were forced to flee the country with prices on their heads, most of the reform edicts were annulled, and Emperor Guangxu placed under virtual house arrest within the Forbidden City (Imperial Palace) by his aunt, the Empress-Dowager Cixi, who took over the reins

of government until her death in 1908 (Cixi was only one of three women throughout Chinese history who exercised supreme power, the others being Empress Lü during the Han dynasty in the third century BCE and Empress Wu during the Tang dynasty in the eighth century).[31] Cixi and her supporters at court subsequently decided to support the virulently anti-foreign Boxer movement (1899–1900), which had begun with attacks by Boxers – north Chinese peasants practising martial arts, spirit possession, and invulnerability rituals – on the lives and property of western missionaries and their Chinese converts in the province of Shandong and culminating in the Boxer siege of the foreign legations in Beijing during the summer of 1900 (during the turmoil of that year the Chinese Girls' School was closed down). Tacit support for the Boxers, hoping to ride on a popular tide of anti-foreignism and thereby secure the expulsion of the foreign presence from the country, proved disastrous for the dynasty. A nine-power allied military expedition rescued the legations and resulted in the foreign occupation of Beijing (Cixi and her retinue fled the capital and took refuge temporarily in Xian to the west). The Qing government was compelled to accept a series of humiliating conditions imposed by the powers; these included the payment of a colossal financial indemnity, the punishment of court and local officials who had supported the Boxers, and the stationing of foreign troops between Beijing and Tianjin.

With the very survival of the dynasty in question, Empress-Dowager Cixi in January 1901 issued an edict (in both her name and that of Emperor Guangxu) bewailing the plight of the empire and promising to implement institutional reform. Over the next few years, with the aim of shoring up the foundations of dynastic rule and co-opting the support of increasingly outspoken reformist gentry elites, the government inaugurated a constitutional programme with the eventual aim of establishing a national assembly, sanctioned the drafting of new civil, criminal and commercial legal codes, and began the process of forming a unified and well-equipped national army. Educational change was also on the agenda. The traditional civil service examination system was abolished in 1905 in favour of a national system of higher, middle and primary schools overseen by a Board of Education (*xuebu*).

Initially, however, the court and other important government officials such as Zhang Zhidong were reluctant to sanction public schooling for girls. Such a prospect was considered too dangerous, as it would threaten to undermine the traditional segregation of the sexes and permit young girls to 'wander about the streets in large numbers'. Furthermore, Zhang Zhidong warned in 1903, attendance at schools would expose girls to western books and foreign customs, which would 'encourage them to act independently and have contempt for their parents as well as their future husbands and parents-in-law' (Bailey, 2007, pp. 27–8).

Notwithstanding the central government's reluctance, local gentry elites (sometimes with the support of local officials) after 1900 became increasingly involved in the setting up of girls' schools. This was part of a wider campaign to promote the spread of education amongst the people designed to 'reform' their 'backward' customs and 'superstitious' beliefs, which, in the view of the elites, had been so graphically illustrated by the recent Boxer movement. Since

the end of the nineteenth century, in fact, reformers such as Kang Youwei, attributing the West's strength to the quality of its peoples, had called for the training of a similarly hard-working, disciplined and frugal citizenry in China as the basis of social order and national economic prosperity. Given the widespread condemnation of 'ignorant', 'backward' and 'superstitious' women as the root cause of China's weakness that had been such a feature of elite discourse since the 1890s, it was not surprising that they would be considered a primary object of this early twentieth-century 'behavioural modernisation' drive (which was to recur throughout the twentieth century).

Elite paranoia concerning the backwardness of Chinese popular culture would not have been assuaged by women's participation in the Boxer movement. In early 1900 a separate organisation of female Boxers appeared in Zhili province; referred to as the Red Lanterns (*hongdengzhao*) and comprising teenaged girls and unmarried women, they were said to possess magical powers which provided indirect assistance to male Boxers (such as flying above the field of battle and hurling bolts of fire against their enemies). The Red Lanterns could also apparently control the direction of the wind (and thus facilitate the burning of churches and Christian homes), and even fly to foreign lands to wreak damage on buildings and homes (Cohen, 1997, pp. 125–8; 2003, pp. 113–17).[32] Drawing on traditional notions of pollution associated with women, however, male Boxers often explained the inefficacy of their own magic (such as invulnerability to bullets) by pointing to the polluting presence of 'unclean' women (referring to menstrual or fetal blood).[33] The Red Lanterns were to achieve celebrity again during the Cultural Revolution in the 1960s, when they were compared to the Red Guards (see Chapter 7).

Such elite concern about the 'backwardness' of popular culture, in conjunction with the widely held assumption that 'ignorant' Chinese women constituted a brake on the country's progress, spurred on male and female activists to open public schools for girls after 1902. In 1905, for example, there were a reported seventy-one girls' schools nationwide (enrolling nearly 2,000 students); one year later, the total had increased to 245 (enrolling nearly 7,000 students), most of which were concentrated in urban areas. One such school, opened in 1906 in the city of Tianjin, was the Beiyang Women's Normal School, reflecting the importance now attached to the training of female teachers.[34] The Qing central government itself finally sanctioned public education for girls, when the Board of Education in 1907 issued regulations on girls' primary and teacher training (normal) schools, as much to coordinate efforts already being undertaken in the domain of female education and bring already established girls' schools under closer official supervision as anything else. The Board of Education, in effect echoing the words of Liang Qichao in 1897, clearly associated women's public education with successful government:

> The Kingly Way (i.e. virtuous rulership) begins with an upright household. If women's education is not undertaken and women's morality is not cultivated, then there will be wives who cannot assist husbands and mothers who are unable to guide sons. (Bailey, 2007, p. 30)[35]

Qing officials at this time were also influenced by developments in Japan, where the new Meiji state was in the process of redefining women's role as part of its nation-building project. Official Chinese missions that began to visit Japan after 1896 to investigate the causes of Japan's apparent successful modernisation drive were impressed with the thought and practice of female educators such as Shimoda Utako (1854–1936) in developing a unique Japanese/Asian style of women's education that would combine the inculcation of traditional Japanese feminine virtues with instruction in western technical skills (Harrell, 2004, p. 117).[36] Born into a samurai family, Shimoda became a lady-in-waiting at court in 1872, and travelled widely in Europe and North America (1893–5) before founding her own school, the Practical Arts Girls' School (*jissen jogakkô*), in 1899. Championing the new gender ideology promoted by the Meiji state, encapsulated by the traditionalist-sounding slogan *ryôsai kenbo* (good wife and worthy mother), Shimoda believed that women's education – by producing efficient, productive and skilled household managers and responsible carers of children – was the foundation of a strong nation (significantly, before the nineteenth century in Japan women from upper-class samurai families were *not* expected to be intimately involved in raising their children or to be especially productive at home, while in peasant and merchant families men and women were involved in both productive and reproductive work) (Uno, 1991).[37]

The 1907 regulations issued by the Board of Education likewise prescribed curricula that combined instruction in general knowledge (history, geography, arithmetic, science) with an emphasis on the teaching of traditional feminine skills (such as embroidery) and virtues such as 'steadfast chastity', 'obedience' and 'modest demeanour'. This late Qing rationalisation of women's education – to equip girls to fulfil their ordained role as competent, hard-working and efficient household managers – was to inform the views of officials and commentators during the early Republic (see Chapter 3).

During the last years of the dynasty before it was overthrown in 1911–12 and replaced by a republic, the number of girls' schools increased slowly but steadily. Often located in a variety of improvised sites (including private homes, rented buildings, former Confucian academies and even appropriated Buddhist temples), girls' schools were funded by a combination of private donations and official subsidies. Women were also actively involved in the founding of schools, especially the mothers and wives of officials and educators (for example, they might request that after their deaths money and property accruing from dowries be used to open a girls' school). Male founders of girls' schools in some cases also relied upon women to help with administration and teaching (Bailey, 2007, pp. 37–40).[38] In 1909, the last year for which official statistics were issued before the dynasty's demise, there were a reported 722 girls' schools (and 26,465 students). Images of female students at this time (which included depictions of girls even with bound feet undergoing military training) also began to appear in New Year woodblock prints (*nianhua*) used in domestic ritual or as common household adornments (McIntyre, 1999, pp. 53–64; Flath, 2004, pp. 128–32). As a highly visible presence, female students at this time represented an entirely unprecedented phenomenon, constituting

a virtually new social category. As such, they soon became the object of public discourse quite out of proportion to their actual numbers compared with male students (in 1907 there was a reported total of 928,775 male students in modern schools).

Girls' schools attracted attention with the organisation of public exhibitions to display students' work (such as written essays and handicraft objects) and give demonstrations of physical education drills. One such school in 1910 held a public gathering at which packed crowds of up to 2,000 people witnessed displays of students' manual dexterity and physical fitness. At the same time, both girls' schools and their students aroused controversy; schools might be maliciously slandered as unruly places of moral decadence in which students (and even teachers) behaved and dressed inappropriately and indulged in reckless talk of freedom (it was also feared that girls' schools were being 'infiltrated' and used as a front by prostitutes). Female students, in particular, were condemned in the newspaper press for their 'haughty' and 'ostentatious' manner as they walked to and from school, engaging in 'loud chatter' and sporting 'fancy silk clothes and leather shoes'. For someone like Jiang Weiqiao (1874–?), a prominent school textbook compiler and later an educational official during the early Republic, women's education was proving to be a disappointment; in 1910 he expressed dismay that female students were 'getting above their station' and exhibited an alarming lack of interest in the acquisition of domestic skills (Bailey, 2007, p. 55).

The beginnings of female education in early twentieth-century China possessed another kind of significance not always noticed by historians. With the creation of girls' schools, new-style textbooks and ethics readers began to be published, aimed specifically at a female audience. The term used for 'girls' or 'women' in the titles of these readers (*nüzi*) connoted a *universal* category comprising all women, as opposed to the usual and more relational term, *funü*, which identified women only as members of a patrilineal kinship system (the word *funü* combined the term for 'married wife' with that for 'daughter') (Barlow, 1994; 2004, pp. 42–51).[39] These readers also introduced foreign model exemplars as well as Chinese ones in illustrating women's service to the nation, in effect assimilating foreign models to Chinese traditional values of feminine virtue (embodied by ancient Chinese models rather than more recent *cainü*).[40] Thus both Joan of Arc and Florence Nightingale on the one hand, and the mother of the Confucian philosopher, Mencius, on the other, were alike portrayed as influencing public affairs through their private actions as wife, mother or daughter. Yet tales of these very same foreign heroines (such as Joan of Arc) by other writers and translators suggested *new* opportunities for women in public affairs unencumbered by domestic ties (Judge, 2004; 2008, pp. 12–14; 2009, pp. 54–60).

Transgressing gender space

Female students attending public school were not the only example of women's growing visibility in society. In a metropolis such as Shanghai, embryonic industrialisation during the late nineteenth century had resulted in the

emergence of a female workforce (see Chapter 5). Again in Shanghai, from the late nineteenth century onwards, courtesans were beginning to occupy an ever-expanding public space as they became the objects of an emerging periodical and pictorial press. Visual representations of Shanghai courtesans in pictorials or 'gossip' peddled in sensationalist popular newspapers drew attention to their *public persona* as the embodiment of a new urban lifestyle moving freely across the city and interacting openly with male lovers (see Chapter 5) (Yeh, 2003; Pang, 2005, pp. 60–3).

In a sense, though, women had *always* been visible at street level. In the inland city of Chengdu (Sichuan province), for example, female peddlers and vendors were a ubiquitous presence, conveying baskets of flowers, cheap jewellery and even small foreign items to teahouses and night markets (Wang, 1998, p. 39). In a survey of the city's population compiled in 1909–10, the male reformer Fu Chongju criticised the public behaviour of women in general, complaining that they spent most of their time watching local plays or visiting temples; with so many women 'out and about' in public, the exasperated Fu exclaimed, men supposedly watching local opera on the street were in fact gawping at the women passing by. Ironically, urban reforms that began to be implemented by modernising elites and local officials in cities such as Chengdu during the last decade of the Qing dynasty may have actually contributed to the *diminution* of women's public presence. For example, on the basis of maintaining 'public order', a new police force in Chengdu cracked down on women's overnight visits to temples, while a new-style theatre opened in 1906 was subject to official regulations that prohibited women from entering (Wang, 1998, pp. 44–5, 49, 50, 52).[41] Contemporary accounts from the mid and late nineteenth century describing life in the smaller city of Suzhou (Jiangsu province) likewise referred to the phenomenon of fairly well-to-do women frequenting shops, outdoor markets and gardens without male chaperons. As in the case of Chengdu, official attempts had been made since the 1860s to prohibit women from frequenting teahouses; officials in Suzhou also imposed sex segregation amongst theatre audiences as well as prohibiting men and women performing together on stage (Carroll, 2006, pp. 53, 56, 61–2).[42]

Despite such restrictions, in the early twentieth century stage actresses *were* becoming more publicly visible after a long period during which they had been formally banned from performing. Before the seventeenth century, when Qing officials imposed such a ban (part of a wider backlash against courtesan culture at this time), it was not uncommon for mixed troupes of men and women to travel from village to village, while during the Yuan and Ming dynasties (thirteenth to seventeenth centuries) it was not considered problematic for women to appear on the public stage with men (women might also play male roles) (Cheng, 1996, pp. 198–9).[43] By the late nineteenth century, actresses began to reappear in major cities such as Beijing, Tianjin and Shanghai, as theatreowners and tea-house managers sought to use them to attract audiences from a growing population (such as new migrants from the countryside). Female entertainers became visible in a wide variety of public performances, whether it be the more formal Peking opera (*jingju*) or the less informal rendition of popular songs and 'bawdy ballads' (*shidiao*) or the 'drum-song' (*dagu*), a folk

art combining storytelling with singing.[44] By the second decade of the twentieth-century women were once again appearing with men on stage in Beijing (again despite official proscriptions, issued in 1912, which were not formally abandoned until the 1920s); at the same time, all-female acting troupes continued to attract large audiences, especially in teahouses and smaller theatres (Cheng, 1996, pp. 220, 228).[45]

The clearest transgression of gendered space in the early years of the twentieth century, however, was the presence of Chinese female students in Japan (Judge, 2005). Although previously women had indeed travelled within China (see Chapter 1), the last decade of the Qing dynasty witnessed unprecedentedly large numbers of women travelling overseas. The first such women were the few western missionary-sponsored women like Kang Cheng who had travelled to the US for medical training, and the wives of Chinese diplomats sent abroad to staff the new consulates opened from the 1870s onwards. One celebrated diplomatic consort was Sai Jinhua (1872–1936), the secondary wife of Hong Jun (1840–93), Chinese Minister to Germany from 1887 to 1891.[46] After Hong Jun's death Sai Jinhua opened brothels in Shanghai and Tianjin, while in 1900 during the foreign occupation of Beijing to quell the Boxer uprising she apparently used her sexual charms and previous acquaintance with the German commander-in-chief of the allied forces (Count Waldersee) to facilitate peace negotiations and thus forestall further foreign pillaging and looting of the city. Imagined subsequently in the public eye as either an erotic fantasy figure or a debased prostitute, by the 1930s – a time of increasing Japanese aggression in China – Sai Jinhua was transformed into a national heroine, epitomised by a 1936 play portraying her (in men's clothes) as the courageous defender of Beijing against the onslaught of foreign soldiers (clearly an implied critique of the ineffectual stance taken by the contemporary Nationalist government in confronting Japan) (Wu, 2009).[47]

A more conventional diplomat-wife was Shan Shili (1858–1945), who in the years 1899–1903 accompanied her husband Qian Jun, first to Japan and then to Europe. Travelling frequently between China and Japan, she wrote a travelogue (published in 1904), itself a significant act, since previous writings by elite women on their travels within China had comprised mostly poetry. In her travelogue Shan Shili represented herself as a role model for other women, since, in her view, travelling abroad had *not* led to a loss of morality, femininity, or Chinese-ness. Just like elite women in the past, who had legitimised their travels within China as an extension of their family duties, so Shan Shili implied that the crossing of cultural, racial or sexual boundaries did not necessarily entail a loss of cultural or sexual identity (as an upstanding Confucian wife) (Hu, 1997, pp. 88–9, 92, 93).[48]

Many of the Chinese female students who went to Japan during the first decade of the twentieth century had quite a different outlook. As early as 1896 Chinese (male) students were studying in Japan; in 1898 the Chinese official Zhang Zhidong promoted the idea of Japan as a location for Chinese overseas study. In Zhang's view, Japan – as an Asian country that had successfully modernised by appropriating western knowledge while still retaining its cultural identity – was a model to be emulated (Zhang also advanced more

practical advantages, such as the country's proximity, the cultural affinities between the two countries, and access to western knowledge via Japanese translations). Japan's victory in the Russo-Japanese War of 1904–5 – the first modern example of an Asian country defeating a western power – only strengthened the country's appeal as a destination for overseas study. In what has been described as the first large-scale migration of students abroad anywhere in the world (Harrell, 1992, p. 2), numbers of Chinese students in Japan increased from approximately 400–500 in 1902 to nearly 9,000 in 1906. Most came from scholar–official families (and from virtually every province of China); some went to Japan on central or provincial government stipends, but the majority were self-financing. The Qing government officially encouraged this student migration, anticipating that it would lead to the training of a future corps of administrators, military officers and teachers to staff the new government offices, military units and western-style schools that had begun to be established as part of the government's reform programme set in motion after 1901.

Chinese women also participated in this initiative, albeit their numbers were small compared to their male counterparts. In 1902 seven Chinese women enrolled in the Women's Practical Arts School (*jissen jogakkō*) founded by the Japanese female educator Shimoda Utako (see earlier), for whom the education of Chinese women would contribute to the revival of the race and hence contribute to her pan-Asianist agenda of fortifying the region *vis-à-vis* the West (Judge, 2001, p. 772).[49] By 1907, according to Japanese Foreign Ministry figures, there were 139 Chinese female students in Japan (Judge, 2005, p. 138, fn 7). The first amongst these female students tended to accompany male family members (husbands or fathers), but after 1903 they began to travel to Japan unaccompanied – a dramatic transgression of gender space, since women travelling alone outside the country was a completely new phenomenon. While in Japan they had more opportunities to interact socially with male counterparts, and some of them became highly politicised, joining associations, engaging in public speaking (again, an unprecedented phenomenon), editing and contributing to women's journals. At the Chinese Overseas Students' Hall in Tokyo in 1903 female students joined with their male colleagues to condemn the continued Russian presence in Manchuria (Russian troops had entered the region in the wake of the Boxer uprising), implicitly criticising the Qing government's weakness *vis-à-vis* the foreign powers. In the same year they angrily demonstrated on hearing reports that China would be represented in the 'Races of Man' pavilion at the Osaka Trade Fair by bound-footed women (Judge, 2005, p. 128; Harrell, 1992, pp. 127–8).[50] Much to the chagrin of Shimoda Utako (in whose school many of the Chinese female students were enrolled), they also joined in Chinese student strikes in 1905 following the Japanese government's attempt to restrict their movements and activities.

Qiu Jin was one of the most flamboyant of these young Chinese women who went to Japan. From a scholar–gentry family in Zhejiang province, she had married a minor bureaucrat and moved to Beijing in 1902 or 1903, not long after foreign troops had entered the city in the wake of the Boxer

uprising.[51] During this time she composed poetry expressing her dismay at China's decline, bemoaning the fact that the Chinese people were 'asleep' and needed to be goaded into action to save the nation.[52] In 1904 she virtually abandoned her husband (and two children) to go to Japan, where she initially enrolled in Shimoda Utako's school. She soon became involved in political activity, while also experimenting with a variety of self-identities transgressing gender and national boundaries; photographs of the time capture her dressed in a Japanese kimono, the long gown of the Chinese male scholar (*changpao*), and even a western-style male suit (Finnane, 2008, p. 88). In 1905 she joined Sun Yatsen's new anti-Qing political organisation, the *Tongmenghui* (Alliance League), which called for the establishment of a republic. For Shimoda Utako (and western missionaries for that matter) such political activism was aberrant and 'unfeminine'.

Another female student – the first, in fact, to join the *Tongmenghui* – was He Xiangning (1878–1972), who accompanied her husband to Tokyo in 1902 (she was later to be one of three female delegates to the first congress of the *Guomindang*, or Nationalist Party, the successor to the *Tongmenghui*, in 1924 and the first director of the *Guomindang*'s Women's Bureau). Yet, even amongst Chinese female students in Japan, the transgression of gender space might have its limits. The home that He Xiangning and her husband set up in Tokyo became a popular meeting place for Chinese radical students; in a later memoir, she recalled that one of her most exciting and satisfying experiences as an anti-Qing revolutionary in Japan was learning how to cook, thus providing her with an opportunity to engage in menial work (Ho, 1992).

Of course, not all Chinese women transgressing gender space at this time necessarily became anti-Qing revolutionaries. By 1911, for example, there were fifty Chinese women studying in the United States (the first group of officially sponsored female students to go to the US went to Wellesley College in 1907). This 'second cohort' of Chinese female students going to the US (the first comprising Kang Cheng and the others who had gone to study medicine in the late nineteenth century) were more inclined to emphasise the compatibility of modern education and domesticity. On their return many took up teaching, championing the cause of professional household management that would bring modernity to the home (Ye, 2001, pp. 129–36). Unlike more politically radical female students in Japan, such as Qiu Jin, someone like Hu Binxia – who had studied in both Japan (1903–7) and the US (1907–14), and was to become a contributor to women's journals in the early Republic as well as an assistant editor of one of the most important of these journals, *Funü zazhi* (*Ladies' Magazine*) – imbibed quite different lessons from her sojourn abroad. On her return to China in 1914 she became a passionate advocate of professional domesticity modelled on American-style home life (Ye, 2001, pp. 136–41).

One extraordinary woman who carved out an independent career trajectory at this time was Lü Bicheng (1883–1943). Like Qiu Jin, she came from a scholar–gentry family and was educated in the Confucian classics. In 1904 she became an assistant newspaper editor before becoming the principal of Beiyang Women's Public School in Tianjin, one of the first girls' schools to receive

government financial support. Intriguingly, she met with Qiu Jin just before the latter's departure for Japan, but declined her invitation to accompany her. Lü later studied art and literature in the US and travelled widely in Europe, becoming a celebrated poet and artist (Fong, 2004b). Another woman who successfully shaped a new public role for herself was Zhang Mojun (1883–1965). She joined the *Tongmenghui* while studying in Japan, and went on to pursue a career as an educator and publicist after the 1911 revolution. She later toured Europe and the US to investigate education and became the director of a women's normal school in the 1920s.

Women and the 1911 revolution

Chinese female students in Japan pioneered the creation of a women's press as editors and contributors. The first of these women's journals was launched by Chen Xiefen (1883–1923) in 1903 soon after she had arrived in Japan with her father. She had earlier edited a women's supplement to her father's newspaper in Shanghai, which she then transformed into a specialist women's journal, *Nüxue bao* (*Journal of Women's Learning*). By 1911 sixteen more had been founded, either in Japan or Shanghai; financed by founders and their friends, they were generally short-lived. Nevertheless, they constituted a unique phenomenon, addressing women directly (as 'sisters' or 'women compatriots') and calling for an improvement in their lives (Beahan, 1975).[53] A particular stress was placed on women's equal rights to education, often justified by the benefits that would accrue to the nation. As with Liang Qichao in 1897, female contributors to this women's press belittled China's past tradition of women's culture and learning, arguing that only full political participation in the national 'present' would empower women and provide a meaningful self-identity. Yet, while male reformers often advocated women's rights in terms of allowing them to play a crucial role as 'mothers of citizens', female radicals in Japan imagined women as public citizens taking an active part in national affairs (Judge, 2001, pp. 765–68).[54]

Qiu Jin, for example, believed that only by taking part in the anti-Manchu revolution would women emancipate themselves and ultimately gain equal rights as citizens. On her return to China in 1906 she launched a women's journal in Shanghai – *Zhongguo nübao* (*Chinese Women's Journal*) – that sought to 'awaken' women from their 'stupor'. In the opening article she wrote for the first issue ('An Urgent Announcement to My Sisters'), Qiu Jin decried the abject subservience and ignorance of women fated to lead lives of 'obsequious servility'.[55] Clearly, she was thinking of elite women, since she referred to the helplessness of such women '…with their feet bound so small, their combed hair glossy and inlaid with flowers, their bodies wrapped in silks and satins and their white-powdered faces smeared with rouge'. Presided over by their chief gaoler (i.e. husband), Qiu Jin declared, such women did not realise that 'the flowers in their hair are like jade padlocks and gold cangues, while their silks and satins are like brocade ropes and embroidered girdles binding them even tighter'. For Qiu Jin, Han Chinese women were doubly enslaved, firstly by the Manchus (and other foreigners) and secondly by men (she used the striking

phrase that women were 'prisoners in their own boudoirs'). Unlike earlier male reformers such as Liang Qichao, moreover, Qiu Jin highlighted the need for women to achieve economic independence and autonomy, and by so doing reduce their dependence on men and reinforce their own self-worth (although, paradoxically, she added that women would thereby also gain men's approval).

At the same time, as her manifesto of the *Zhongguo nübao* implied, Qiu Jin assumed that it was up to individuals such as herself to 'awaken' women from their self-induced slumber and, like 'lamps in the darkness', to shed light in their 'dark prison of ignorance' and thereby goad them into action.[56] In the final analysis, therefore, she believed that only the heroic and self-sacrificing action of dedicated individuals would inspire others to join the revolution. After establishing two girls' schools in her home town of Shaoxing (Zhejiang province), Qiu Jin was implicated in an anti-Manchu plot and executed in 1907. It may be the case that she actively sought death and perceived herself at the end as a self-sacrificing heroine in the Hua Mulan mould (in her poems she frequently referred to herself as a female knight-errant) (Rankin, 1975, pp. 61, 65–6; Hu, 2004, pp. 119, 132).[57] Her heroic reputation quickly grew after her death; Hu Lanqi (1901–94), a later CCP activist, recalled in her memoirs that as a young child she had been regaled with stories of Qiu Jin told to her by her mother (Stapleton, 2008, pp. 159–60).

Qiu Jin's later image as the first female 'martyr' of the revolutionary movement to overthrow the Qing dynasty should not obscure the fact that other female contributors to the women's and periodical press in the early years of the twentieth century advanced equally radical views. Chen Xiefen, for example, in a 1903 article on the importance of physical education for women made it clear that it should be seen primarily as a source of their *own empowerment* (i.e. by taking charge of their own bodies) rather than an activity to benefit the nation *per se* or ensure the health of future progeny (Gimpel, 2006, pp. 334–5).[58] She also exuded a voluntarist faith in the potential of Chinese women, insisting in another article that they possessed unique characteristics borne of centuries of oppression – such as 'resoluteness and perseverance', empathy for others, and an unshakeable hatred of injustice. This, in Chen's view, made Chinese women both more reliable and steadfast revolutionaries and more committed to equality and solidarity than their male counterparts (Chen also believed that Chinese women, if given opportunities, would achieve more than their western sisters) (Beahan, 1976, pp. 217–20; Bailey, 2007, p. 58).[59]

Another Chinese female activist in Japan, He Zhen, published (along with her husband) an anarchist journal in which she not only denounced Confucian ideology for patriarchal and misogynistic teachings but also warned of women's future exploitation by the capitalist system (represented by modern factories). In effect, He Zhen in her writings 'decoupled' feminism and nationalism by insisting that women's liberation was a moral necessity that constituted a wider movement towards the liberation of society as a whole. Uniquely for her time, He Zhen also highlighted the plight of Chinese working women, vulnerable to exploitation by other women as well as by men (Zarrow, 1988).

In the years preceding the 1911 Revolution women in China became more politically active. As early as 1901 two women (uniquely) addressed a mass rally

in Shanghai protesting against the continuing presence of Russian troops in Manchuria, while during the anti-American boycott of 1905 in response to US immigration policy Cantonese women played a key role in refusing to purchase traditional mooncakes (an essential element of the upcoming Moon Festival) since they were made with American milled flour. In 1907, at the height of the 'rights recovery movement' (a campaign to 'buy back' railroad and mining concessions granted to foreign investors and governments), women partici- pated in the campaign to redeem the Shanghai–Ningbo railroad from foreign interests, creating associations to encourage financial contributions from a female constituency now specifically referred to as *nüjie* (women's circles) or *nüguomin* (female citizens) – symbolising the growing recognition of a *public* collectivity of women transcending class or kin (Bailey, 2007, p. 72).[60] During the monarchy's final year in 1910–11, girls' schools also organised anti-opium associations and enthusiastically staged performances of patriotic songs and speeches.

Even in rural areas women were beginning to make their presence felt, although the context might be very different, since their actions represented fierce opposition to elite modernising reforms during the last decade of the monarchy. In the district of Chuansha (south of Shanghai), for example, female cotton weavers – many of whom belonged to a lay Buddhist vegetarian sister- hood – denounced attempts by local notables to raise miscellaneous taxes to fund the building of new schools, police bureaux and self-government offices. For poor rural women of the region the household spinning or weaving of raw cotton was a key source of livelihood (they frequently travelled to market towns to sell the cloth themselves); a local government directive forbidding the drying of cloth on river embankments (now considered 'unsightly' by modern- ising elites), with heavy fines for transgressors, was perceived by the weavers as a direct tax on home-woven cloth (since they had nowhere else to dry the cloth). When local elites also attempted to close down a lay Buddhist temple managed by the vegetarian sisterhood (like the CCP after 1949, they regarded such institutions as a symbol of feudal 'backwardness') in early 1911, female cotton weavers joined with small landholders and other tradesmen in a mass protest that resulted in the destruction of over fifty buildings and residences (Prazniak, 1986).[61] In a district in Guangdong province rural women in 1910 were involved in another protest against modernising change when they angrily confronted a government census team, believing that its hidden agenda was to prepare for the imposition of additional taxes. Over 1,000 women converged on the office of the district magistrate, forcing the abandonment of the census investigation (Prazniak, 1999, pp. 220–2; Bailey, 2007, p. 196, fn 90).

During the revolution itself – which began when an army mutiny in Wuchang (Hubei province) in October 1911 ignited anti-dynastic uprisings in central and southern China, and provincial assemblies in alliance with military commanders declared their independence from Beijing – women organised their own military units and mobile Red Cross teams in support of the revo- lutionary cause. All of these military units (e.g. the Women Citizens' Army and the Women's Northern Expeditionary Force) were disbanded after the revolution in February 1912, but not before they had played a role in local

skirmishes; one unit, the Zhejiang Women's Army, took part in a large-scale attack on the city of Hangzhou (Ono, 1989, pp. 73–80). A foreign observer in 1913 remarked on the Chinese women's 'warlike spirit' in the recent revolution, noting that it was 'never suspected that the gentle-spirited submissive women of China would rise as they have done to fight for their freedom' (Chin, 2006, p. 509).

In the wake of the revolution China's first female suffrage associations were also formed, many of whose leaders, such as Lin Zongsu (1878–1944), Tang Qunying (1871–1937) and Wang Chang'guo (1880–1949) had studied at Shimoda Utako's school in Japan and joined Sun Yatsen's revolutionary *Tongmenghui*. In January 1912, after the establishment of a provisional republican government based in Nanjing, Tang Qunying unified a number of these associations to create the Women's Suffrage Alliance, calling for not only political and educational rights (education was considered crucial since it brought moral virtue and hence the right to wield political influence) but also freedom of marriage and divorce.[62] In the same month representatives of the Alliance met with Sun Yatsen (who had been elected provisional president in December 1911), an encounter widely reported in the press; they also lobbied the provisional National Assembly, which was in the process of drawing up a constitution. Claiming that the granting of female suffrage was a symbol of national progress and a patriotic imperative, Tang Qunying and other female activists exuded a boundless confidence in Chinese women's potential to enhance the political development of the new republic (Bailey, 2007, pp. 76–7). They had not taken into account, however, that the early years of the Republic were to be marked by a wave of gender conservatism, which represented a reaction against women's growing public visibility and activism that had characterised the last decade of the imperial monarchy.

3

Gender Discourses in the Early Republic

The euphoria that women had felt in the wake of the 1911 revolution did not last long. During the republican transition period, the vigorous call by women's suffrage organisations for equal political rights evoked derision amongst mostly male commentators. In March 1912, following the promulgation by the National Assembly of a provisional constitution that pointedly omitted any reference to *gender* equality, members of the Women's Suffrage Alliance stormed the assembly buildings (in Nanjing) in angry protest. The hostile male reaction to the women's suffrage campaign that followed was part of a wider conservative gender discourse that characterised the early years of the Republic, especially pertaining to education.

Furthermore, the early Chinese Republic quickly disintegrated politically. The man to whom Sun Yatsen conceded the presidency in March 1912, Yuan Shikai (1859–1916), had been a key figure in the *ancien regime* and evinced little commitment to constitutional republicanism. He gradually alienated provincial military governors as well as local gentry and merchant elites with his attempt to reassert centralised bureaucratic rule. Following his death in 1916, after his ploy to resurrect the monarchy (with himself as emperor) as a way of bringing recalcitrant provincial and local leaders to heel had disastrously failed, political power increasingly gravitated into the hands of regional, provincial and local militarists (or 'warlords') – many of whom had risen to prominence during the 1911 Revolution – who assumed the reins of civilian power. During the period 1916–28 the Republican government in Beijing itself, although still headed by a president assisted by a cabinet and parliament (and which was formally recognised by the powers), was subject to the machinations of whatever militarist clique or faction held sway in the region. The situation was further complicated in 1917 when Sun Yatsen and his supporters in the *Guomindang* (GMD) refused to recognise the legitimacy of the Beijing parliament, and set up a rival regime in Guangzhou (Guangdong province) in the south. Even Sun's quasi-regime, however, was fatally dependent on the fickle support of local militarists, and it was not until the early 1920s that he was able to begin concrete preparations for the attainment of national power.

The political fragmentation of the country at this time, however, did not halt the continuing development of civil society (emergence of civic groups

and professional organisations, the expansion of a newspaper and periodical press, and the growth of general and higher education). Widespread disillusionment with the deleterious *political* consequences of the republican revolution stimulated an intellectual movement that probed deeper causes for the Republic's failures other than the overweening ambitions of individuals, factionalism or political corruption. In what became known as the New Culture Movement (or May Fourth Movement), heralded by the publication of a radical new journal, *Xin qingnian* (*New Youth*) in 1915, a number of outspoken intellectuals condemned China's cultural traditions, arguing that the continuing influence of 'traditional' values (such as those valorised by Confucianism) explained the absence of any meaningful and progressive social change after 1911 and had, in fact, stunted the development of individualism, democratic thought and a scientific world-outlook. Such a critique extended also to the very embodiment of Confucian high culture, the classical language (*wenyan*), with critics proposing that literature and educational texts should be written in the more accessible vernacular (*baihua*). Central to this intellectual onslaught on China's cultural heritage was a condemnation of the family system, of which the subordinate and oppressed status of women was highlighted as one of the principal features (now specifically referred to as 'the woman question'). Radical intellectuals (for the most part male) thus called for the overthrow of patriarchal authority and the emancipation of women – a stance that symbolised concerns other than a simple championing of women's rights *per se*. The New Culture movement also brought in its wake new medical discourses of sexuality (drawing on western theories and concepts) that in some ways *essentialised* gender difference (based on biological sex).

Although the women's suffrage campaign came to an end in 1913 (it was to be revived in the early 1920s), and the discourse on women's education during the early years of the Republic was often characterised by a conservative approach that contrasted with the more radical ideas expressed on women's rights during the May Fourth Movement, the numbers of female students in public school continued to grow (if somewhat slowly compared with the number of male students), and by 1920 women gained access to higher education when they were allowed for the first time to audit classes at China's most prestigious institution of learning, Beijing University. Female students also took part in the demonstrations and school strikes that began on 4 May 1919 to protest against China's treatment at the Versailles Peace Conference. This was not entirely unprecedented, since female students had already participated in a number of strikes and protests during the last years of the Qing monarchy, but 1919 represented a significant development in terms of the numbers involved, the setting up of all-female student organisations that coordinated activity across different schools, and the uninhibited joining together of male and female students on the streets.[1] As with Chinese female students in Japan in the early years of the twentieth century, during the May Fourth protests in 1919 female students participated in public speaking; in her memoirs Hu Lanqi remembers seeing a female student addressing a crowd of 10,000 people in a Chengdu city park (Sichuan province) (Stapleton, 2008, p. 161).

This chapter will explore the nature of gender conservatism amongst officialdom and in the press in the wake of the 1911 Revolution before discussing seemingly more radical gender discourses during the New Culture movement, the social impact of female students throughout the early years of the Republic, and the emergence of a 'women's literature'.

Gender conservatism in the new Republic: education, dress and politics

The new republican school system finally promulgated in September 1912 continued with the changes begun during the last years of the Qing monarchy in expanding educational opportunities for girls and young women. Thus co-education at lower primary school level (i.e. up to the age of 10) was sanctioned, while separate secondary, vocational and higher normal schools for girls were to be opened. Guidelines on such schools, as well as the proposed curricula, likewise revealed a *continuing* concern dating from the last years of the monarchy that girls should receive an 'appropriate' education. While the general aim of primary education was to instil 'citizen morality' (respect and love for one's parents, boldness and initiative, sincerity and honesty, diligence, frugality and cleanliness), additional regulations in November 1912 made it clear that 'with respect to male and female students, attention must be paid to their particular natures and their different futures, so that an appropriate education can be carried out'. Girls at primary school, for example, were to be instructed in the traditionalist-sounding virtues of 'chastity and gentleness' (*zhenshu*), and embroidery and domestic science (*jiazheng*, literally 'household management') were to constitute a significant element of the curriculum in both primary and secondary schools for girls (Bailey, 2007, pp. 67–9, 187, fn 8,9).

A similar concern to maintain strict gender difference characterised the new republican government's guidelines on dress, but again this reflected changes already underway during the last years of the Qing dynasty. Before the early twentieth century in China there had not been 'sartorial bifurcation' based on gender comparable to that which had begun to emerge in Europe from the fifteenth century onwards. Elite men and women alike, for example, wore long gowns and robes (although there were gendered differences in colour, cut, and width of collars and sleeves). By the early years of the twentieth century, however, such a bifurcation was becoming increasingly evident, as clothes worn by the two sexes were more sharply contrasted (Harrist, 2005, p. 175). It is significant, moreover, that discussion tended to focus on men. As early as 1890 the reformer Chen Qiu criticised the robes worn by men as both inconvenient and presenting an image of weakness; in 1898 Kang Youwei also linked dress with a nation's fitness to compete in a changing world. For reformers such as Chen and Kang, Chinese dress for men was not only 'backward' but also 'effeminate'. Thus, while Chinese male dress was increasingly labelled as 'feminine', western dress was defined as 'masculine' since it was associated with modernity and progress. The western-style two or three-piece suit, by the time of the Revolution, was also associated with western ideals of manly vigour and energy (Harrist, 2005, pp. 172, 179, 182).

Shortly after the establishment of the Republic, the government in August 1912 issued guidelines on formal clothing amongst the political class – thus continuing the tradition of imperial times, when each new dynasty promulgated its own regulations on official attire. Yet, although it was now expected that men adopt an entirely new mode of dress (in the same way as they were expected, if they had not done so already, to adopt a 'modern' hairstyle by cutting off their queues, now specifically condemned as 'un-Chinese' and thus not in accordance with a new 'nationalistic visuality') (Gerth, 2003, p. 68), there was not always consensus on what exactly constituted the most appropriate form of dress. The 1912 guidelines, for example, recommended four different European models of suit and one Chinese-style option of the *changpao* (long scholar robe) over which was worn the *majia* (riding jacket), with headwear constituting either a top hat or a bowler. A supplementary clothing law of October 1912 actually revised the policy of promoting western styles, encouraging instead the use of Chinese-style clothing and fabrics; thus men's formal dress would consist of a frock coat and trousers (made of Chinese black silk) while everyday wear could also include the *changpao* (Gerth, 2003, pp. 110–11).[2] Most of the political class during the early years of the Republic, in fact, chose to wear the *changpao* anyway, since it represented for many quintessential Chinese-ness (as well as being a signifier of virtue because of its association with the scholar) (Edwards, 2007a, pp. 43, 46–7).[3] Others, such as the provincial military governors, wore elaborate western-style military garb.[4]

As for women, the August 1912 regulations prescribed only one mode of formal wear, designed to maintain the Han Chinese elite style as it had evolved during the last years of the Qing (close-cut high-collared silk jacket worn over a long pleated skirt) (Harrison, 2000, pp. 58–9; Finnane, 2008, pp. 95–7).[5] In other words, much as in the case of early Meiji Japan, where men, especially officials, were expected to abandon their samurai dress in favour of western-style suits, while women were to continue to wear the traditional kimono, women in early Republican China would be associated with the *status quo* – providing stability and continuity at a time of dramatic political change. In fact, some attempt had already been made during the last years of the Qing monarchy to lay down guidelines (in 1907 and 1910) on 'appropriate' dress for female students in the wake of social and cultural changes then underway. In neither case, however, were official authorities successful in preventing a bewildering array of dress styles being adopted by young women (especially students). New western-style high-heeled shoes and silk stockings, for example, became increasingly popular (Ko, 1999).[6] Such sartorial boldness could draw inspiration from pre-1911 revolutionaries such as Qiu Jin, who had experimented with a variety of sartorial styles, from western-style men's clothing and Japanese-style kimono to the male-style *changpao* (Edwards, 2007a, p. 52).[7] A new style gradually emerged, a variation of the style already being adopted by female students, in which the skirt was shortened to just below the knee, exposing newly stockinged calves and feet clad in leather shoes rather than embroidered cloth shoes, and worn under a fitted jacket with a simple round neck and three-quarter sleeves and the hem finishing above the hips.[8] After 1914, advertising calendar posters (*yuefenpai*), dating from the early years

of the twentieth century and usually distributed during Chinese New Year, catered to a growing public interest in women's dress styles by featuring large-scale figures of 'fashionable' women as the major image promoting a wide range of products (anything from household accessories to cigarettes and liquor).[9] Cigarette cards printed from the early years of the twentieth century and given as gifts to business customers likewise depicted fashionably dressed women engaging in 'modern' social activities (playing tennis or western musical instruments, for example).[10]

Much to the concern of male observers, women also adopted a variety of hairstyles at this time, including the bob (Finnane, 2008, pp. 98–9). Again, this represented continuity with trends already developing during the last years of the monarchy. A woodblock print (dating from around 1910) originating in the western province of Sichuan depicted a female student with unbound feet on her way to school; she not only wears a long skirt and jacket with short sleeves (as well as a western-style and 'masculine' straw boater) but also has her cut short in a bob (Laing, 2000, pp. 145–6; Bailey, 2007, p. 49).[11] In 1910 a worried commentator in a Beijing newspaper decried the fashion amongst urban women to ostentatiously imitate men in their dress, hats and hairstyles (made worse, in his view, by women insisting on adopting more suitably male habits such as wearing spectacles and smoking cigarettes) (Cheng, 2000, p. 128).[12] By the early 1920s female students, like their male counterparts, were wearing the *changpao* (also known as *qipao* or *cheongsam*), which connoted education and learning; for male critics this smacked of dangerous gender-blurring, which, in their view, would lead to social and moral anarchy – a fear that had already been expressed as early as 1912 (Bailey, 2007, p. 81). Ironically, the *changpao* was later appropriated (and altered) by the fashion world (when it would become known as the *qipao*) and would contribute to the sexualisation of the female image (see Chapter 5).

It was not only the proclivity of some women apparently to dress like men that aroused the ire of male critics. A founder member of the National Products Preservation Association (*guohuo weichi hui*), established in December 1911 to promote the sale and use of indigenous products and manufactures, warned that Chinese women's attraction to western fashion had resulted in them wearing all kinds of 'strange and garish' clothes despite the 1912 regulations (according to a 1913 newspaper report, in the city of Guangzhou adolescent girls were disporting themselves in 'outrageous' dress styles such as scarlet stockings and trousers that did not go below the knees) (Bailey, 2007, pp. 80, 82).[13] In other words, women's seemingly rapacious penchant for western products was perceived as a potential threat to the national economy, a criticism that had been made as early as 1906, when a newspaper commentator blamed the parlous state of the economy on Chinese women's 'vulgar' attraction to foreign clothes, cosmetics and jewellery (Bailey, 2007, p. 49).[14]

Conservative disquiet in the newspaper and periodical press in the wake of the 1911 Revolution over women's 'reckless' and 'unrestrained' behaviour was exacerbated by the Chinese suffragist campaign for political rights and, in particular, by the angry response by Chinese female activists to the decision taken by the provisional National Assembly not to include a specific reference

to gender equality in the Provisional Constitution announced in March 1912 (which stated that the 'people' of the Republic were uniformly equal without distinction based on race, class or religion). Foremost amongst the critics of this omission was Tang Qunying (1871–1937), leader of the Women's Suffrage Alliance (Strand, 2011, pp. 38–51, 97–145). Originally from a scholar–official family in Hunan, Tang had gone to Japan to study in 1904 after she was widowed, and there she joined Sun Yatsen's Alliance League (*Tongmenghui*); during the 1911 Revolution she was a commander of the Women's Northern Expeditionary Force. Shortly after the announcement of the Constitution, Tang and twenty other suffragists (who, it should be noted, were well acquainted with the contemporaneous suffragette campaign in Britain, regularly reported on in the Chinese periodical and women's press) entered the assembly building in Nanjing; refusing to sit in the observers' section, they took their seats amongst the delegates themselves, heckling speakers and registering their protest against women's lack of political rights. The following day they staged noisy demonstrations outside the assembly building, in the process smashing windows and scuffling with assembly security guards (one of whom was apparently knocked to the ground). Later in the month they stormed the assembly building again, coming to blows with security guards. In August 1912 the suffragists' worst fears were confirmed when electoral laws were passed specifically excluding women as voters or candidates (a further attempt to lobby parliament, which had meanwhile moved to Beijing, similarly failed in December 1912).

The national 'betrayal' of women was paralleled by that of the *Tongmenghui* itself. Although its political programme in March 1912 included a clause on equal rights between men and women, by August 1912 the party was in the process of reorganising itself as the Nationalist Party (*Guomindang*), in alliance with several smaller, more conservative parties. A price of this new arrangement was the elimination of the equal rights clause from the new programme. In August Tang Qunying, along with Wang Chang'guo (1880–1949) and Shen Peizhen, sat in on the coalition discussions being held by the Beijing branch of the *Tongmenghui*, again heckling speakers and physically assaulting the *Tongmenghui* leader, Song Jiaoren. At the inaugural meeting of the newly formed *Guomindang* in Beijing later that same month, Tang and the others again registered their anger, jostling the hapless Song Jiaoren and interrupting the chair of the meeting (which had to be adjourned).

The one glimmer of hope for the women's suffrage movement was also quickly extinguished. In the wake of the Revolution, the provisional assembly of Guangdong province (in southern China) had allocated twenty seats to the *Tongmenghui* (ten of which were to be reserved for women). A constitution adopted by the provincial assembly in February 1912 also potentially allowed for equal rights (since it noted that the reference to 'the people' in the claim that 'all people are equal' meant both men and women). In April 1912 three women (Li Peilan, Lun Yaohan and Wang Zhaoqiang) were elected to the Guangdong Provincial Assembly, making them in effect the first female political representatives in China's modern history (Edwards, 2008, p. 88). Yet by the end of 1912 the Assembly had promulgated electoral laws that brought

them into line with those of the national parliament (i.e. they specifically excluded women). In many ways the suffragists, by hitching their cause before 1912 to the anti-Manchu struggle in order to enhance their status (as Han Chinese women), were in a precarious situation after 1912 with the establishment of a Han Chinese Republic. The 'racialising narrative' (in the words of a recent study) used so effectively before 1912 was now turned against them when women were expected to adhere to appropriate gender roles sanctioned by Han Chinese tradition and culture (i.e. their primary duty as Han Chinese women was to ensure domestic harmony and prosperity) (Edwards, 2002).[15]

Suffragist actions in 1912 confirmed in the eyes of male critics women's unfitness for government (not unique to China, of course; *at the same time* the suffragette campaign in Britain was arousing male outrage and condemnation). Suffragettes were derided as 'hooligans' lacking decorum and respect for public order and civility (Strand, 2002, pp. 56–63; Edwards, 2008, pp. 80–3, 90–2). Furthermore, critics insisted, they had wilfully transgressed appropriate gender boundaries by behaving in an outrageously 'unfeminine' way and claiming the right to participate in a male 'space' (i.e. politics). Their behaviour was cruelly satirised in so-called 'unofficial histories' (*yeshi*) of the time – popular 'faction' that titillated its audiences with lurid tales of scandal, corruption and illicit sexual affairs – in which female political activists were depicted as loud, aggressive, immodest and vulgar bullies forever intimidating men (Dong, 2005, pp. 173–5).[16]

Although Chinese suffragists continued to maintain links with the international suffrage movement – in September 1912, for example, they invited Carrie Chapman Catt, chairperson of the American branch of the International Women's Suffrage Association, to visit and give public talks in Shanghai, Nanjing and Beijing on her way back to the US from the Philippines[17] – by 1913 the Chinese women's suffrage campaign was over. With a newspaper editorial in early 1913 insisting that the moral health of society was virtually totally dependent on suitably 'well-behaved' women, and the newly elected parliament in Beijing in May 1913 declaring that 'chaste' and 'filial' behaviour amongst women was an essential prerequisite for the restoration of social order and an end to what it perceived as the current malaise of 'moral confusion', all talk of women's political participation was considered inappropriate. The following year, in 1914, Yuan Shikai's government issued new public order regulations that specifically banned women (along with other social categories such as soldiers and monks) from joining political associations (Bailey, 2007, p. 94). Not coincidentally, in the same year the Education Ministry proposed reviving the Confucian virtues of *zhong* (loyalty), *xiao* (filial piety) and *jie* (chastity), very much targeting women; in 1915 President Yuan Shikai mandated the reintroduction of key Confucian texts into the primary school curriculum (in 1910–12 the Confucian classics had been eliminated from the primary school curriculum), an initiative that did not, however, long survive Yuan's death in 1916.

Perhaps the most extraordinary example of early Republican gender conservatism was the announcement of a 'commendation' system in 1914 designed specifically to foster 'virtuous' behaviour amongst women and modelled

explicitly on practices followed during the Ming and Qing dynasties, when chaste widows were awarded imperial testimonials of merit (*jingbiao*) and local ceremonial arches erected in their honour (see Chapter 1). Various categories of women (either living or dead) were listed as eligible candidates for 'commendation', with names being submitted by sons, grandsons or other relatives to local magistrates, who would then pass them on to the President. The latter would thereupon issue an inscribed plaque (similar to the *jingbiao*) stamped with the President's seal in gold or silver to the nominee or her kin. In 1915 women considered worthy of commendation included those who exhibited outstanding filial behaviour, were 'chaste and upright', and embodied 'hard work and thriftiness'. In 1917 the regulations were reissued with added criteria for commendation (merit in 'arts and crafts', and an ability to 'maintain harmonious relations' with in-laws and relatives). This commendation system lasted well into the 1920s; in 1922 an article appearing in a women's journal claimed that the Internal Affairs Ministry each year received several thousand commendation proposals for 'chaste' and 'loyal' behaviour. Reports from district magistrates on such commendation proposals in the metropolitan province of Zhili between 1915 and 1924 indicated a wide variety of appropriately loyal behaviour towards husbands, parents and in-laws. Thus, on the one hand, women were commended for committing suicide after the death of a parent or husband, while on the other, women who remained single to look after aged parents and manage the household were equally commended (Bailey, 2007, pp. 94–5).

The 'transgressions' of female students

After 1912 the number of girls' schools continued to grow, albeit at a slower pace than boy's schools. The total number of female students in Chinese-run schools increased from just over 141,000 in 1912–13 (constituting nearly 5 per cent of the school population) to nearly 42,000 in 1922–3 (comprising just over 6.9 per cent of the school population).[18] In 1912–13, also, for the first time the total number of girls in Chinese-established schools outnumbered those in Protestant and Catholic missionary schools combined. Furthermore, the growing demand for female teachers meant that female students at normal (teacher training) schools comprised a larger proportion of the normal school enrolment; in 1923, for example, there were nearly 7,000 students at women's normal schools, constituting over 17 per cent of the total attending normal school. Whereas during the last years of the Qing dynasty many teaching positions in girls' schools had been filled by men, it became increasingly common to have virtually an all-female teaching staff. Attendance at a women's normal school and subsequent employment as a teacher, in fact, became one of the few legitimate avenues for rural and inland women to gain some kind of social and economic independence (Cong, 2007, p. 17). The phenomenon of young women travelling to different regions within a province or even the country to take up teaching posts was significant enough for them to be referred to as 'new pioneers' in a 1915 women's journal article on contemporary migration trends among Chinese women. Over 100 female normal school graduates, the

article noted, for example, had recently arrived in the north-eastern province of Heilongjiang from as far afield as Sichuan province in western China (Bailey, 2007, p. 89).

The increasing public presence of female students continued to stimulate discussion in the newspaper and periodical press, just as it had done during the last years of the Qing dynasty. Also, early republican discourse on women's education was closely linked to the wider campaign of 'behavioural modernisation' begun during the late Qing. After 1912 such a campaign involved the creation of popular education associations that would supervise all forms of popular entertainment and reading matter, as well as a wide network of officially sanctioned popular lecture institutes aiming to 'enlighten' the people and 'reform' society. Significantly, women were once again, as during the late Qing, a primary target of this campaign (Bailey, 2006). Not coincidentally, reports on the 'evil' and 'backward' customs (that needed to be stamped out) in the periodical and women's press during the early Republic invariably referred to *women*'s activities and pastimes (such as 'wasting' money on incense for religious worship and 'irrational' beliefs in the efficacy of geomancy, fortune-telling and other forms of divination). Likewise, discourse on the rationale for women's education stressed the importance of domesticity and the need for skilled, knowledgeable, modest and diligent household managers to ensure stable, harmonious and prosperous families and the proper education of children – such a role was increasingly portrayed by educators at this time as a profession like any other (Bailey, 2007, pp. 95–9).[19]

Nowhere was this particular discourse of female education and the promotion of 'professional' domesticity more prevalent than in early republican women's journals. Two of the most popular and durable of such journals were the *Funü shibao* (*Ladies' Times*), which began publication on the eve of the 1911 Revolution and ran until 1917, and the *Funü zazhi* (*Ladies' Magazine*), which appeared between 1915 and 1931. Circulation of the latter increased from 3,000 to 10,000 during the May Fourth period, although these figures do not represent actual readership, as any one issue would have been read by several or more people.[20] These journals, to which both men and women contributed articles, provided information on such matters as children's psychology, household budgeting and hygiene, and culinary techniques, as well as translating articles from American and British middle-class women's magazines that promoted the virtues of skilled and frugal housewifery. In the view of many of the contributors, girls' schools would be the primary site in which students would acquire the appropriate skills and imbibe the demeanour and outlook necessary for successful household management in the future.

Yet, much to the consternation and outrage of officials, educators and commentators, female students did *not* behave in ways prescribed for them. Their dress, attitudes and behaviour were a constant source of condemnation in the periodical press. Official attempts to regulate female student dress, for example, foundered on the rocks of youthful exhibitionism. While the suggested dress was cotton padded jackets and black cotton skirts, students in Shanghai were criticised for preferring 'foreign styles' (e.g. high collars, ornate buttons and dress patterns), sporting gold-rimmed spectacles and high-heeled

leather shoes, as well as experimenting with an 'outlandish' variety of hair-styles. In their apparent 'vain quest for beauty', female students were ridiculed on the one hand for wearing tight-fitting undergarments in order to flatten their breasts (which, according to critics, impaired their future reproductive role and, ultimately, the future of the race), and on the other hand were likened to prostitutes because of their 'conspicuous ostentation' and 'garish' appearance. Instead of dutifully and modestly learning domestic skills, critics bewailed, female students wallowed in 'extravagance and showiness', behaved in a 'haughty' and 'arrogant' manner (which included being disrespectful to parents and teachers), and were more interested in discussing international affairs.

Also, well before the 1919 student demonstrations of May Fourth, in which women participated, female students organised school strikes and protests following the establishment of the Republic (just as they had done during the last years of the monarchy). One such protracted protest took place in 1912–13 at the Beijing Women's Normal School, where students vigorously condemned the male principal for his 'reactionary' views on the purpose of women's education and his attempt to restrict the number of newspapers students could read at the school (students also published an open letter in the press calling into question the principal's personal morality, alleging that he kept a concubine, abused his wife and had embezzled funds in his last educational post). As dissatisfaction with the behaviour of female students became more evident in the early years of the Republic, critics warned in almost apocalyptic terms that their reckless disregard for the necessary acquisition of domestic skills threatened the very future of society itself (Bailey, 2007, pp. 99–104).

May Fourth and the woman question

In contrast to the gender conservatism exhibited by officials and educators in the early Republic, a more radical discourse on the 'woman question' began to take shape in the late 1910s during the New Culture (May Fourth) movement.[21] The journal, *New Youth* (*xin qingnian*), which began publication in 1915 and was edited by Chen Duxiu (1880–1942), who was to become the first secretary-general of the Chinese Communist Party (CCP) in 1921, denounced traditional morality and practices and advocated wholesale cultural and intellectual change. In the first issue of the journal, for example, Chen Duxiu's article 'A Call to Youth' condemned traditional Confucian beliefs, which he maintained had stunted the growth of individualism, democracy and a scientific spirit in China. Although his article did not make any distinction between the sexes, in the following year Chen directly addressed women's situation with an article critiquing the Confucian family system and women's place within it.[22] Noting that individual independence was the basis of all ethics and economic life (and was the prerequisite of all political activity), Chen condemned Confucian family norms for extinguishing the autonomy of wives (and, significantly, sons) as a result of their subordination to patriarchal authority. He also ridiculed 'outmoded' Confucian taboos on both

widow remarriage and free and unfettered social interaction between the sexes. For Chen, therefore, women's inferior status within the family and their lack of personal autonomy constituted a crucial feature of Chinese tradition that needed to be eliminated.

Chen was joined in his intellectual campaign by other male intellectuals and writers such as Li Dazhao (1888–1927), Hu Shi (1891–1962) and Lu Xun (1881–1936), who contributed articles to the *New Youth* and other May Fourth journals on the subject of women's emancipation, in particular advocating free-choice marriage and equal education rights, as well as lambasting traditional attitudes concerning female chastity (not unprecedented, it should be noted, since these issues had already been raised in the early years of the twentieth century).[23] In 1920 two male intellectuals, Tang Jicang and Yun Daiying, published articles proposing the establishment of public child-care services and communal dining halls so as to free women from domestic tasks (Lan and Fong, 1999, pp. 28–36, 78–81), measures that were to be implemented during the Great Leap Forward in the 1950s (see Chapter 7). Of course, some women *did* participate in this May Fourth discourse on the 'woman question'. One prominent example was Yang Zhihua (1900–73), who joined the Chinese Communist Party in 1924 and was to be one of only four women accorded official delegate status at the Party's Fifth Congress in 1927 and the only woman to be elected to its Central Committee. During the May Fourth period she wrote several articles calling for more free and public interaction between the sexes and for women's unconditional right to divorce (Lan and Fong, 1999, pp. 44–6, 49–51).

A recent study has described the discourse on the 'woman question' at this time as 'liberal feminist' – with its emphasis on the importance of independent 'personhood' (*duli renge*), autonomy in terms of marriage, equal educational opportunities, and the right of women to participate fully in public life as modern citizens, which provided women with new subjectivities and life trajectories (Wang, 1999, p. 16).[24] Lu Lihua (1900–97), for example, who attended school at the age of six dressed as a boy (since Lu's parents had no sons they brought her up as a boy), went on in 1922 to establish and manage one of the first women's physical education teacher training schools in China (Wang, 1999, pp. 145–86);[25] three years later she organised the first Chinese national women's basketball team, which toured Japan in 1931 (the first time a Chinese women's sports team had gone abroad, although a Chinese women's volleyball team had been part of the Chinese delegation to the Sixth Far Eastern Games held in Japan in 1923). This is significant when one considers that between 1910 and 1919 women had been excluded from participating in three national and seven regional athletic competitions in China and had been prohibited from taking part in the first four Far Eastern Games (held in the Philippines in 1913 and 1919, China in 1915 and Japan in 1917) (Hong, 1997, pp. 134–6).[26] Zhu Su'E (1901–?), who also initially studied at a boys' school, went on to study law in Shanghai in the late 1920s, after which she became a practising lawyer. Wang Yiwei (1905–93) rejected marriage to pursue a career in journalism. Chen Yongsheng (1900–97), who like Lu Lihua attended

elementary school dressed as a boy, likewise rejected marriage in order to train as a physical education instructor; at the age of twenty she became head of the physical education department at Beijing Women's Normal University before taking up teaching posts in Hubei and Guangdong provinces (interestingly, she recalled in the early 1990s that 'back then it was not unusual for a young woman to travel alone') (Wang, 1999, pp. 190–1, 225, 261, 273).[27]

In many ways, however, male radicals were drawn to 'the woman question' as a way of subliminally addressing their *own* frustrations; in particular, by highlighting the 'oppressed' status and victimisation of women in society they expiated their personal feelings of powerlessness. Not coincidentally, many of the May Fourth male intellectuals who championed women's rights were the 'victims' of tradition themselves. While studying in the US, for example, Hu Shi may have had an affair with an American woman, but he eventually deferred to parental wishes by agreeing to marry a woman back home to whom he had been betrothed at the age of twelve. Lu Xun also felt obliged to go through a parentally arranged marriage. In many of their writings women were consistently portrayed as 'victims' of family and social pressure, consigned to a pitiful death through illness or suicide. Hu Shi's 'Biography of Li Chao' (December 1919), for example, which constituted a new literary genre of the biographical 'case study' focusing on the plight of 'unfortunate' women (which nevertheless drew on the traditional genre of biographies of 'virtuous women' recorded in dynastic histories), recounted the sad tale of a young woman whose desire to study in Beijing was thwarted by her tyrannical family wanting her to get married; unable to realise her ambition, the young woman fell ill and died at the age of twenty-four. Hu noted that he felt compelled to write the portrait of such a 'pitiful' woman, who, in his view, represented countless numbers of Chinese women (Lan and Fong, 1999, pp. 89–100).[28] Another notorious case of a victimised woman in 1919 was that of twenty-three-year-old Zhao Wuzhen. Forced by her parents to marry a man she did not love, she committed suicide on the day of her wedding (she slit her throat as she was being transported by sedan to the groom's house). Her suicide attracted much comment in the newspaper press, including a series of articles on the affair and its meaning by the young Mao Zedong (who himself had fled from a family-arranged marriage). Mao declared that Miss Zhao had been so oppressed by society and family that she no longer had free will or personhood; her only resort was suicide, at the time of which, Mao observed, she briefly gained personhood – although he went on to point out that 'real courage' lay in ceaselessly struggling against social evil even if it meant being killed in the process (Witke, 1967).[29]

Another significant aspect of May Fourth male discourse was the valorisation of the western-style conjugal family (*xiao jiating*), which was believed to encourage independence and self-sufficiency on the one hand, and produce happier and more productive family members on the other. Such a view had as much to do with the concern of young adult males to free themselves from patriarchal control and to assert their own self-identities as 'modern' men as anything else (Glosser, 2002, pp. 121, 139).[30] For them, also, a companionate

marriage based on free choice (preferably to an 'educated' woman) would enhance their credentials as enlightened and civilised individuals; significantly, such a scenario was closely linked with *national* social and economic progress. Male intellectuals, however, did not want to destroy patriarchal or state authority *per se*; rather, they wanted to create a space for themselves within the patriarchal order in order to gain control over their own lives and families. This identification of the *xiao jiating* ideal with the cause of national prosperity and strength was to characterise both GMD and CCP policies on the family.[31]

It was also during the May Fourth period that the term 'new woman' began to be commonly used. What exactly did the term connote? It had originally made an appearance in Japan, where the writer and educator Tsubouchi Shôyô gave a series of lectures in 1910 entitled 'The New Women in Modern Plays'. Citing western plays by Henrik Ibsen (1828–1906), Hermann Sudermann (1857–1928) and George Bernard Shaw (1856–1950), Tsubouchi noted that the 'new women' (*atarashii onna*) depicted in them were characters who rejected the conventional roles of wife and mother in favour of self-discovery and more egalitarian relationships. In 1911 Tsubouchi's literary society staged the first Japanese production of Ibsen's *A Doll's House* (originally written in 1879, the play depicts the travails of Nora Helmer within a suffocating and hypocritical middle-class marriage; she eventually asserts her independence by leaving her husband and children to seek her own way), after which Japanese feminists (especially those associated with *Seitô* or the Bluestocking Society) were soon dubbed 'Japanese Noras' and 'new women' (although such descriptions in the Japanese press were used in a negative sense, denoting frivolous and immature women with destructive natures) (Lowy, 2007, pp. 21–39).[32] The following year Tsubouchi staged a public performance of Sudermann's play *Magda* (originally written in 1893 with the German title *Die Heimat*), which depicted a defiant daughter who rejects marriage with a man chosen by her father in her quest for professional and economic independence. By the 1920s the expression *atarashii onna* had dropped out of use as a new generation of feminists attempted to disassociate themselves from *Seitô's* scandalous image by using the more neutral term *shin fujin,* connoting a more 'responsible' new woman. By this time, moreover, as in China, the figure of the 'new woman' possessed multiple meanings (suffragist, socialist activist, revised 'good wife and wise mother', fashionable 'modern girl').

Chinese intellectuals (especially those who had studied in Japan) would have been aware of this discourse; Japanese feminist writings, in fact, were introduced to Chinese readers during the May Fourth period. Zhou Zuoren (1885–1967), for example, the younger brother of Lu Xun, published in *New Youth* his translation of a 1918 essay ('On Chastity') by the Japanese feminist and poet Yosano Akiko (1878–1942) in his attack on Chinese family and gender ideology. The term 'new woman', however, was first used in the Chinese context by Hu Shi in his discussion of American womanhood. In a speech he gave at Beijing Women's Normal School in 1918 (and published in *New Youth*), Hu described the 'new woman' as someone with high-minded

morals who transcended traditional gender spheres and displayed intellectual and economic independence:

> 'New woman' is a new word, and it designates a new kind of woman who is extremely intense in her speech, who tends towards the extreme in her actions, who does not believe in religion or adhere to the rules of conduct, yet who is an extremely good thinker and has extremely high morals. (Edwards, 2000, p. 124)[33]

Yet there was no consensus about the meaning or value of the 'new woman' at this time, anticipating the discourse of the 1920s and 1930s (see Chapter 5). Thus, one year before Hu Shi's speech, a contributor to *Funü zazhi* insisted that China did not need a 'western-style modern woman', but rather a 'circumspect, intelligent and courteous housewife' who would expertly oversee all aspects of domestic life. In 1920 an article in the same journal argued that the 'true new woman' was one who had successfully transformed herself from a worthy mother and good wife totally under her husband's control to a genuine 'wise mother' who exercised autonomous and skilful management of the household (Bailey, 2007, pp. 115, 218, fn 55).

In his own promotion of the 'new woman', Hu Shi discussed the significance of Ibsen's *A Doll's House* in the pages of *New Youth*, which published a special issue on Ibsen in 1918 (including a translation of the play). Focusing on Ibsen's role as a social critic rather than as a dramatist *per se*, Hu Shi highlighted the play's importance in delineating the struggle of the individual in society to escape the confines of the traditional family and confront the hypocrisy of the law and religion. For Hu the heroine of the play, Nora, symbolised this struggle (Eide, 1987). The publicity given to the play and its heroine in May Fourth discourse was such that a new term was coined as a synonym for female emancipation, *nuola zhuyi* (literally, 'Nora-ism'), although the figure of Nora represented emancipation for young men as much as for women. The message of women's emancipation was also reinforced at this time by foreign visitors. Thus Dora Black, who accompanied her husband, the British philosopher Bertrand Russell, to China in 1920, lectured at the Beijing Women's Higher Normal School on women's education and economic independence (Witke, 1970, pp. 168–72). Perhaps more dramatically, three years earlier in 1917, the American aviator Katherine Stinson (1891–1977) – the first woman to carry the US mail by air in 1913 – attracted huge Chinese press interest when she gave a flying exhibition over Beijing; Chinese press reports quoted her as saying women were potentially better flyers than men because of their greater self-discipline (Bailey, 2007, p. 71).

Such was the multiplicity of discourses at this time, however, that, while articles in May Fourth journals might cite the writings of the German Marxist August Bebel (1840–1913) or the American anarchist Emma Goldman (1869–1940) in their critiques of the oppressive nature of marriage, other uses of foreign sources highlighted quite different agendas. Thus, excerpts from the writings of the Swedish feminist Ellen Key (1849–1926), which valorised motherhood and insisted that marriage and family be the central focus of a

woman's life, appeared in such journals as *Funü zazhi* (*Ladies' Magazine*) in the early 1920s (Bailey, 2007, p. 116). Moreover, even the liberal educator Cai Yuanpei (1868–1940), who championed the right of women to study at Beijing University while chancellor there from 1916 to 1926 (see later), insisted that education for girls should primarily aim at perfecting household and domestic skills (through modern knowledge) (Bailey, 2007, p. 112).

A graphic illustration of the unease that the figure of the 'new' or 'modern' woman (in the sense of the educated, self-sufficient career woman) aroused at this time amongst mostly male commentators was the debate surrounding the suicide in 1922 of a twenty-three-year-old secretary in the office of an economic journal. Xi Shangzhen, who had graduated from a girls' vocational school, in many ways typified the 'modern' woman (she had broken off an arranged marriage and vowed to remain single); on the recommendation of her employer she had invested in the Shanghai stock market (opened in 1920–1) and lost heavily. Her suicide raised questions about the risks women ran by operating in the public realm (her employer, a married man, had also apparently propositioned her to be his mistress), with some arguing that women were more easily tempted into foolhardy actions, the product of a modern education that instilled materialist desires in women. Others suggested that Xi Shangzhen's desperate action meant that in the final analysis she had been unable to transcend a traditional mindset. On the other hand, some commentators – positively citing the traditional valorisation of female purity – claimed that her suicide actually represented a kind of 'heroic martyrdom' (Goodman, 2005a, b). The dilemma of the woman seeking autonomy was raised one year later in 1923 when Lu Xun, in a talk given at Beijing Women's Normal College (entitled 'After Nora Walks Out, What Then?'), posed the question of how the independent woman ('Nora') would survive after she 'left home'. Without the opportunity of gaining genuine economic independence, Lu Xun suggested, she was destined either to return home or to fall into prostitution (he used the metaphor of the 'caged bird' suddenly set free and vulnerable). For this reason, he surmised, the struggle for women's economic autonomy was more urgent than that for political rights.[34]

A final feature of early Republican (including the May Fourth period) gender discourse that actually contrasted with the advocacy of equal rights was the growing interest in medical and scientific theories of sex (sexology), drawing primarily from western sources. Such discourses more clearly than ever before defined (and essentialised) the sexual binary, since it was seen to be based on essential biological and anatomical differences rather than role. In the process an inherent and naturalised gender hierarchy came to be assumed in which the man was the 'active' worker in the public domain and the women his 'passive' counterpart in the domestic sphere with the primary responsibilities of reproduction and motherhood (Dikotter, 1995, pp. 9–11, 17, 25–9).[35] Western sexology was also drawn upon in a 'scientific' critique of female same-sex love, about which there was growing concern in the early years of the twentieth century – closely associated with conservative disquiet over the stated ambition of some women to remain unmarried (referred to in Chinese as *dushen zhuyi* or 'single-ism'). While before the twentieth century such a phenomenon

had been dismissed as simply amoral, female same-sex love was now demon-ised as perverse and aberrant (Sang, 2003, pp. 6–7, 23, 102).[36] In a number of women's journals in the 1920s, too, hygienic discourse increasingly iden-tified women with their reproductive role, and motherhood was scientifically constructed as women's natural duty in the service of nation and race improve-ment (Stevens, 2004; Chiang, 2006). All of this, of course, neatly dovetailed with the ongoing discourse of the 'professional' domestic manager that had originated during the last years of the Qing.

The 'emergence' of the female writer

It was during the May Fourth period that the female writer became a *public* persona (Feuerwerker, 1975; 1977). For the first time women wrote and had their works published as individuals, in contrast to the past when 'serious' literature was considered the domain of men and elite women generally had to rely on fathers or sons to have their poetry published, if at all (and it was sometimes published under a man's name). Although an embryonic 'women's literature' had emerged in the early twentieth century with a women's press in which women published essays, fiction and poetry, by the time of the May Fourth period the very act of writing had become an indispensable element in an educated woman's modern identity and constituted a questioning of conventional notions of femininity (Dooling and Torgeson, 1998, p. 14). The first short story to be written in the vernacular (as opposed to the classical language), and conventionally thought to be Lu Xun's 'Diary of a Madman' in 1918, was actually written by a woman, Chen Hengzhe (known in the West as Sophia Chen, 1890–1976). When Boxer indemnity scholarships were made available to Chinese women in 1914 (the scholarship programme had origin-ally been launched in 1909 to enable Chinese overseas study in the US and was funded by the US share of the indemnity the Qing government had been compelled to pay the foreign powers in the wake of the Boxer uprising), Chen was able to enrol at Vassar College (New York) in 1915, and later went on to study history at the University of Chicago (forty-four more Chinese women were to go to the US on this scheme before it ended in 1923). While at Vassar she published a short story in a Chinese student magazine in 1917; entitled 'One Day' and primarily in the form of (seemingly banal) dialogue, the story was a snapshot of student daily life and the interaction between Chinese and American students at a women's college in the US.[37] It might very well be the case that it was easier for women to distance themselves from the classical language and embrace the vernacular in their writings, since the former had always been associated with governance and 'high culture' – domains monopo-lised by men.

During the May Fourth period 'women's literature' (*funü wenxue*) was much discussed as a specifically gendered aesthetic category uniquely exploring inner emotions and feelings. It is no coincidence, for example, that autobiog-raphy (or semi-autobiographical fiction) became a popular genre for women at this time as a way of asserting their own subjectivity (women's autobiog-raphy, in fact, represented an entirely new phenomenon); many began with

the description of escape from the patriarchal household and the adoption of a new identity (Ng and Wickeri, 1996, pp. 7–8, 10–11).[38] The short story 'Diary of Miss Sophia' written in 1927 by Ding Ling (1904–86) was hailed as a major event in the development of 'women's literature', with one male critic describing the author as the first Chinese writer who 'speaks out about the dilemmas of the liberated woman in China' (Liu, 1993, p. 200). The story is an intimate self-portrait of one woman's inner thoughts and confused sexual feelings in her relationship with two very different kinds of men. Crucially, it is the *woman* who is the subject, with the men portrayed as the *objects* of the female gaze and of female desire (rather than the other way around) (Louie, 2002, pp. 102–6). This represented something quite new, especially when compared, for example, with the stories of Lu Xun at the same time. While in some of his stories it is the female character who sees through male hypocrisy,[39] ultimately the women – always depicted from the male perspective – are portrayed as the victims of a heartless and cruel society (see, for example, 'New Year's Sacrifice', mentioned in the introduction) who are cowed by the power structure to bear their suffering with a stoical passivity (Lyell, 1976, pp. 211–18, 259).[40]

Other significant female writers at this time included Lu Yin (1898–1934), who in her novellas and short stories described the disillusionment and disappointments of being a 'modern woman in society'; Shi Pingmei (1902–28), one of the few writers of the time to focus on the plight of poor and uneducated rural women who were victims of the free-marriage ideal, abandoned or divorced by 'modern' husbands; and Ling Shuhua (1900–90), who dissected the nature of 'romantic love' as well as exploring intense relationships between women.[41] Some were able to acquire a certain amount of economic independence through their writings. Chen Xuezhao (1906–91), for example, used the income derived from her writing in 1927 to finance overseas study in France, where she eventually earned a doctorate in literature.[42]

Yet while in the 1920s some male commentators may have valorised the 'feminine' in 'women's literature' because of its honest and open expression of innermost emotions, by the early 1930s – a time of growing national and international crisis – critics increasingly called for a literature that was more socially and politically engaged. In the process 'women's literature' came to be perceived as limited, subjective and sentimental (Larson, 1988; Lee, 2007, pp. 118–21). Women writers, however, continued to write about the problems women faced in a patriarchal society, as well as depicting the defiance of Confucian gender ideals in their personal lives; nowhere was this more so than in Japanese-occupied Manchuria during the 1930s and 1940s (Smith, 2007).

New vistas for women

At the height of the May Fourth movement, in 1920, women gained access for the first time to the country's most prestigious higher-level educational institution when Cai Yuanpei, chancellor of Beijing University (Beida, originally founded in 1896 as Imperial University), allowed nine women to audit classes at the university – which signalled official sanction for co-education

at the tertiary level. All aged between nineteen and twenty-eight, and hailing from provinces as far afield as Guizhou (in the south-west) and Gansu (in the west), their reactions to this momentous decision, as reported in the contemporary periodical press, indicated they were very conscious of their role as a pioneering vanguard. The numbers of women in tertiary level education grew only slowly thereafter, however. By 1923 there were only 850 women in university or higher specialist schools (comprising 2.5 per cent of total enrolment); in 1928 the proportion had increased to 8.5 per cent (Bailey, 2007, pp. 108–10). On the other hand, by 1922 there were over 200 Chinese female students enrolled in colleges and universities in the US, many of whom were majoring in previously 'masculine' professional fields such as banking, chemistry, journalism and political science (Ye, 2001, pp.114–15, 141–3).

As women gained access for the first time to Beijing University, an equally significant event occurred when, in the same year, Cai Yuanpei invited Chen Hengzhe to join the Beida faculty as professor of history and English literature – the first female member of staff at the university. As the writer of textbooks on western history (she also wrote a history of the European Renaissance), Chen very much saw herself as a cultural mediator, 'translating' western history for a Chinese audience. Interestingly, some time before the term became fashionable, Chen portrayed the world since the nineteenth century as one characterised by 'globalisation' (*shijiehua*) of European culture (Gimpel, 2010).[43]

While Chen Hengzhe's experience studying in the West prepared her for an academic career, the trajectory pursued by another woman who went overseas followed quite a different path. At the end of 1919 Xiang Jingyu embarked for France on a work–study scheme organised by Chinese anarchists (altogether over 1,500 Chinese students went to France on the scheme in 1919–21).[44] Xiang, from a relatively well-off family (her father was the head of the local chamber of commerce in her hometown in Hunan province), had received a modern education and even opened a co-educational primary school in her hometown before she left for France. While in France (1919–21), during which time she worked in a textile factory and a rubber plant, she became increasingly politicised, contributing articles that criticised the 'bourgeois' nature of the female suffrage campaign and insisting that women's emancipation was inseparable from social liberation in general; she also acquainted herself with Marxist writings. In 1920 she and another work–study student, Cai Hesen (who was to become a leading member of the early Chinese Communist Party), declared themselves to be 'married' (without going through a formal ceremony). 'Wedding' photographs they sent to friends back home pictured them sitting side by side reading a copy of Marx's *Das Kapital*. Xiang returned to China in 1921 and was to become a pioneering leader of the CCP women's movement.

In contrast to conventional historical accounts of the early Chinese Republic, which have highlighted the significance of the New Culture (or May Fourth) movement in championing women's emancipation, the period was in fact characterised by a multiplicity of gender discourses, much of which – both radical and conservative – represented continuity with ideas and attitudes

originating in the early years of the twentieth century; at the same time, by way of contrast, early Republican gender discourses were more likely to draw on foreign sources (western and Japanese). The period was also marked by a steady growth in female education and the appearance of professional female intellectuals (like Chen Hengzhe) and writers; as the case of Xiang Jingyu illustrates, however, other women were drawn into the more dangerous sphere of radical politics.

4

'A World Turned Upside Down': Mobilising Women for the Revolution

On 1 May 1928 the thirty-three-year-old Xiang Jingyu, first director of the Chinese Communist Party's Women's Bureau, was publicly executed in Wuhan (capital of Hubei province) on the orders of the newly established Nationalist (*Guomindang*) regime. Xiang's execution marked the final and tragic end to an extraordinary period in the twentieth-century history of Chinese women, when they had been mobilised in unprecedented numbers to participate in the cause of national revolution, a revolution led by an alliance (the United Front) that had been forged in 1923 between the Nationalists and the Chinese Communist Party in the quest to rid the country of provincial and local warlords and reunite the country under a more legitimate government. With the breakup of the United Front in 1927 and the violent suppression of the CCP by the Nationalists, Xiang had had to operate underground before finally being apprehended in the French Concession area of Hankou (one of the three 'sub-cities' making up Wuhan, the others being Hanyang and Wuchang) and handed over to Nationalist authorities. Like her predecessor, Qiu Jin, Xiang's death earned her subsequent mythologisation in Chinese communist historiography as a martyred heroine who unflinchingly sacrificed her life for a grand cause – in Xiang's case the communist revolution.

Xiang's revolutionary career symbolised dramatic gender-specific political and social change during the 1920s. The continuing influence of May Fourth 'feminism', for example, ensured that on the founding of the Chinese Communist Party in 1921 a commitment to improving the status and lives of women was incorporated into its programme. The *Guomindang* was also committed to focusing on the 'woman question' and to mobilising women for the coming national revolution, especially after the formation of the United Front in 1923. Like the CCP, the *Guomindang* set up its own women's department, in which communist women like Xiang Jingyu played a significant role. This unprecedented mobilisation of women was greatly facilitated by two other developments: the revival of the women's suffrage movement, in limbo since the mid-1910s, and an increasing activism amongst the female labour force that constituted a major proportion of the industrial proletariat in

cities such as Shanghai. During the course of the Northern Expedition (1926–7), a military campaign launched by the *Guomindang* and its communist allies from their base in Guangzhou (Canton) to defeat the warlords, women were highly visible as propagandists, combatants and nurses. For many conservatives (especially in the rural areas) women's public visibility, their political activism and 'bobbed' hair represented a grotesque aberration and a graphic illustration of how social and moral norms had crumbled – a world 'turned upside down'. When the United Front ultimately ended in 1927 as the political and social agendas of the two parties became irreconcilable, an inevitable and horrific backlash occurred against all such publicly visible women. Even after 1927, however, gender issues remained very much on the agenda for both the *Guomindang* regime and the CCP struggling to survive in its rural base areas.

Women and the early CCP

The influence of May Fourth feminist thought on the early male leaders of the CCP such as Chen Duxiu was profound, and from the party's beginnings the agenda of women's emancipation was incorporated into its political programme. During the Party's early years, in other words, and in contrast to a later period when 'feminism' (*nüquan zhuyi*: literally, ideology of women's rights) was condemned as a 'bourgeois' obsession that distracted attention away from the core task of class struggle, Marxism and feminism were not perceived as necessarily incompatible (as they were sometimes perceived in the West). During the May Fourth period, in fact, involvement in the critique of the traditional family system and the treatment of women radicalised many future leaders of the CCP *before* their conversion to Marxism–Leninism (Stacey, 1983, p. 75). The gender ideology of early CCP leaders like Chen Duxiu therefore combined May Fourth feminism (an attack on the Confucian family system and a call for women's emancipation) with the Marxist materialist analysis of women's oppression, which drew primarily from Friedrich Engels' *The Origins of the Family, Private Property and the State*, excerpts from which had been translated into Chinese as early as 1907 and which likewise located the source of women's oppression within the family. This meant that the early CCP supported the women's suffrage campaign (see later) and participated in a nationwide organisation set up in 1922, the Women's Rights League (*nüquan yundong tongmenghui*); in so doing, the Party played an important role in bringing women's groups together and facilitating women's social mobilisation on a hitherto unprecedented scale. In many ways, also, the CCP at this time represented a kind of 'radical subculture' in which members sought to reconstitute social relationships (including gender ones) along egalitarian lines (Gilmartin, 1989; 1993; 1995, pp. 2–3).[1] This made the Party especially attractive as a potential haven for young women, especially those who desperately wanted to escape the control of their families or to avoid the fate of an arranged marriage.

At the same time, it is clear that, like non-communist male intellectuals who had championed women's emancipation, early CCP leaders highlighted women's oppression and identified with women's social predicament as a

way of expressing their own fears about the plight not only of the nation but also of their personal situation and sense of powerlessness within a patriarch-controlled family system. By presenting themselves as the pioneering champions of women's rights, they could at once demonstrate their 'modern' credentials, rid themselves of unwanted wives and engage in unconventional relationships. Thus, Chen Duxiu, as early as 1910, abandoned his 'arranged' wife and lived openly with her more educated sister, Gao Junman, a graduate of Beijing Women's Normal School; Chen Wangdao, a prolific CCP writer on women's issues, divorced his rural wife; and Zhang Tailei, another future CCP leader, allowed his 'divorced' wife to retain her marital status while marrying someone else (Gilmartin, 2002).

Moreover, conventional gender patterns and attitudes continued to exist within the party organisation. From the start, there were very few women visible in the party (and certainly not in its higher echelons). Of the fifty-three known members of the CCP at the time of its first congress in July 1921, only two were women – Miao Boying, a Hunanese student at Beijing Women's Normal School, and Liu Qingyang, who had been recruited in January 1921 while she was in France on the work–study scheme; one year later there were four 'official' female members of the CCP (out of a total of 195), one of whom was Yang Kaihui (1901–30), Mao Zedong's first wife (Gilmartin, 1995, p. 105).[2] Female membership grew slowly thereafter, by 1925 totalling about one hundred. Many of this first generation of female communists came from recently impoverished elite families who had attended either middle or normal school; gender issues were an important factor in their decision to join the party. By the end of 1926, in the wake of the dramatic May Thirtieth Movement of 1925 (large-scale protests and strikes targeting foreign imperialism in China following the shooting of striking Chinese workers by the British-controlled police in the Shanghai International Settlement), which had radicalised increasing numbers of students and workers, female membership of the CCP had jumped to nearly 2,000 (in 1927 total party membership was estimated to be about 60,000) (Gilmartin, 1995, pp. 309, 325 fn 8).

The personal files/testimonies of ninety-six Chinese communist women studying in Moscow in 1928–9, which are located in the Russian state archives, provide further information on the social background of early female Chinese communists. Mostly aged from 18 to 27, they had joined the party in 1925–6 out of patriotic feelings or concern with women's issues. The stated backgrounds of their fathers included those of landlord, schoolteacher or local educational official, small shopkeeper or trader, and peasant. Those who mentioned their schooling (50 per cent of them) indicated they had received some kind of education beyond elementary school, while the most common profession amongst them was that of an elementary or rural schoolteacher. The many more personal files of male Chinese communists indicated they were older than their female counterparts, and more likely to have come from a worker–peasant background (but also more likely to have received a higher education) (Eiermann, 2007).

Nevertheless, women comprised only a small proportion of CCP-sponsored students sent abroad to *leadership* training institutions in the Soviet Union

during the 1920s. Thus, out of the 100 Chinese students who graduated in 1924 from the Communist University of the Toilers of the East in Moscow, no more than ten were women. Sun Yatsen University, which replaced the Communist University of the Toilers of the East as the most important institution for Chinese students in the Soviet Union, instructed up to 600 between 1926 and 1930, of whom only forty were women. Significantly, also, the curriculum of the Peasant Movement Training Institute set up in Guangzhou under GMD auspices in 1924 (but which came under the direction of communists such as Peng Pai and Mao Zedong) to train cadres for rural mobilisation work did not feature women's issues in any substantial way; the number of female students at the institute, moreover, was minimal (in the three years of its operation between 1924 and 1927, only thirty out of a total of 996 graduates of the Institute were women) (Price, 1975; Gilmartin, 1995, p. 170).

Furthermore, although the CCP soon after its first congress in 1921 began to map out a programme for women – which included the publication of a women's journal and the establishment of a girls' school – the two women placed in charge of the programme were not formal party members; significantly, both women (Gao Junman and Wang Huiwu) were personally involved with male leaders.[3] Gao and Wang were also empowered to work with an existing feminist organisation, the Shanghai branch of the Federation of Women's Circles (*nüjie lianhehui*), one of several independent women's organisations that had appeared in the wake of the May Fourth movement (in addition to the Shanghai branch set up in 1919, other branches were created in Guangzhou in 1919, Zhejiang in 1920 and Hunan in 1921) (Gilmartin, 1995, p. 46). As a measure of the easygoing cooperation that existed between the CCP and women's groups at this time, the Shanghai branch of the Federation of Women's Circles – which called for free marriage, equal educational opportunities and women's suffrage, as well as an improvement in working women's lives – allowed communists such as Gao and Wang to develop their women's programme under the auspices of the Federation.

Through this cooperation, Wang Huiwu and Gao Junman were able to oversee two projects in Shanghai, the publication of a women's journal, *Women's Voice (funü sheng)* in 1921 and the establishment of the Commoners Girls' School, which opened in 1922. Not only was *Women's Voice* the first CCP-sponsored journal to publicise feminist issues, but it also drew attention to the sorry plight of working-class women and reported on strikes in which they were involved. Wang Huiwu also contributed articles on the benefits of birth control, at a time when the prominent American birth control campaigner, Margaret Sanger (1879–1966), was visiting China as part of a world tour.[4] The Commoners Girls' School aimed to provide academic instruction as well as vocational skills such as tailoring and weaving; ironically, although the school's *raison d'être* was to foster cross-class collaboration, it failed to attract female workers.[5] Wang Huiwu's bold attempt to organise a school support team in aid of 3,000 striking female textile workers in Shanghai in 1922 likewise did not succeed, principally because most of the students found it difficult to communicate with the workers.

When Wang Huiwu's husband, Li Da, failed to get re-elected to the Central Committee at the party's second congress in July 1922, her influence, not coincidentally, began to wane. Both *Women's Voice* and the Commoners Girls' School were closed down by the end of 1922. When the Party's second congress decided formally to establish a Women's Bureau (possibly due to pressure from the Comintern),[6] Wang Huiwu was passed over and the position of the Bureau's first director went to Xiang Jingyu (whose husband, Cai Hesen, had just been elected to the Central Committee). With this official post (the *first* explicitly female leadership appointment in the party), Xiang Jingyu emerged as the most significant CCP women's leader in the early 1920s, yet she was never an *elected* official of the Central Committee or an official delegate to the party congresses she attended.[7] Not only did Xiang Jingyu have to endure gender discrimination within the Party, but some studies have claimed that she herself subordinated the cause of women in general to that of proletarian revolution, and that she had nothing but disdain for what she perceived as a 'bourgeois' women's movement divorced from the real needs of working-class women.[8] Other studies, however, have noted that she embraced the feminist orientation of the early CCP, was more sympathetic to feminist issues than hitherto assumed, and was keenly aware of, and took a stand against, sexism within the Party.[9]

Furthermore, although she had written an article while in France that was sceptical of the women's suffrage campaign in China (an element of her wider disillusionment with western-style parliamentarianism), on her return and throughout her time as director of the Women's Bureau Xiang devoted much effort to connecting the women's movement with the workers' cause. In seeking to create a tactical alliance with the independent women's movement, and hoping to attract its members to the cause of proletarian revolution, Xiang would always insist that women had to be incorporated into the revolution as agents of their own emancipation (while at the same time never denying that specific issues concerning women had to be addressed by the revolution).

Xiang Jingyu's concern to cement links among different political and women's groups was especially evident during the years 1922–5. After 1923, for example, when the CCP's third congress (meeting in Guangzhou) formally approved the idea of a United Front with the *Guomindang*, Xiang aimed to use her position as head of the CCP's Women's Bureau to contribute positively to the new arrangement. The *Guomindang* itself had recently reaffirmed its commitment to gender equality, as promulgated in its party constitution of January 1923 (thus reversing the 1912 decision to omit the reference to women's rights in the party platform), and, like the CCP, had created its own Central Women's Department in 1924. Xiang took on the editorship of a weekly supplement to a *Guomindang* newspaper (*The Republican Daily*), in which she referred positively to the women's rights movement, and in 1924 she became head of the *Guomindang*-created Women's Movement Committee in Shanghai (the CCP and GMD also collaborated in establishing Shanghai University in 1923, which attracted ambitious young women like Ding Ling and Yang Zhihua). At the CCP's third congress Xiang also drafted a resolution insisting that one of the key tasks of the party's Women's Bureau was to gain

influence over the 'general women's movement' (including the campaign for women's suffrage). Just as Qiu Jin had argued in the years before 1911, Xiang claimed that it was imperative for women to participate in the revolutionary movement to further their own cause.

Xiang's tactic of seeking an alliance with the women's movement was given a boost by the revival of the women's suffrage campaign after 1919, when the first branches of the Federation of Women's Circles were established. The campaign became especially active in 1921–2 as it sought to take advantage of the 'federalist' movement that had emerged in several provinces calling for provincial autonomy and elected provincial assemblies. Suffrage activists, in giving notice that they would lobby hard to ensure any future provincial constitutions or legislation would incorporate sex equality in political rights, also played the 'global card' by attempting to shame any male politicians opposing female suffrage into thinking they were 'behind the times' and not up to date with international trends (Edwards, 2008).[10] Significantly, the various women's groups belonging to the Federation of Women's Circles advocated a broad unity amongst women (transcending class differences) based on their 'unity of disadvantage', and declared that since women were different from men they had the collective right to represent themselves. The Guangdong branch of the Federation, for example, allowed concubines to join in 1920 after it had originally excluded 'women of dubious morals' such as concubines and prostitutes.

During this phase of the suffrage campaign Federation branches were able to mobilise large numbers of women. In February 1921 in Guangdong, 700 women marched on the provincial assembly demanding civil rights (as in 1912, some activists entered the debating chamber and were involved in scuffles with members); one month later 1,000 women lobbied the assembly with petitions. In Hunan province in May 1921 up to 2,000 women demonstrated outside the provincial legislature in the provincial capital, Changsha, in response to attempts by male members to block suffrage legislation (Edwards, 2008, pp. 117–22). A number of provinces (Guangdong in 1921, Zhejiang in 1921, Hunan in 1922), in fact, promulgated constitutions that included provisions for sex equality in political and civil rights (the Hunan constitution, for example, gave sons and daughters equal rights to own and inherit property, a measure that the new *Guomindang* government would implement in 1929–30 (see Chapter 5).

During the suffrage campaign, also, another women's organisation was founded in 1922 by students from Beijing Women's Normal School, the Women's Rights Alliance (with branches created in the provinces as well as in Shanghai); in addition to constitutional gender equality, the Alliance looked further afield, emphasising rights for female workers (e.g. wage equality, maternity leave). Significantly, a founder member of the Women's Rights Alliance was the first female member of the CCP, Miao Boying (1899–1929), who helped set up branches in Shanghai and Nanjing. While Xiang Jingyu supported such CCP interaction with women's groups, not all her male colleagues within the party were quite so enthusiastic. Some condemned the Women's Rights Alliance as 'unrevolutionary' and 'bourgeois' since it lacked

a class outlook. Xiang responded by presenting a draft resolution on the women's movement to the party's third congress in 1923, urging colleagues not to scare women's leaders away with strident rhetoric of class struggle; her resolution also underlined the political importance of the women's movement. Buoyed by a voluntarism that would characterise the thought of Mao Zedong, Xiang was confident that *all* women potentially could respond to revolutionary influences. Crucially, also, Xiang was not inhibited from drawing the attention of her party colleagues to sexism amongst male workers and their hostility to their female compatriots (Gipoulon, 1986, pp. 113–14).[11]

Another women's mass campaign in which CCP members such as Xiang Jingyu were involved was the response to an initiative taken by Sun Yatsen in 1924 to call for the creation of a National Convention that would begin the process of national reunification. The Convention would comprise representatives of professional groups (but with no specific representation for women); Xiang and others argued that only women could truly represent women's interests. Hundreds of women attended meetings in several metropolitan centres to demand such representation. The target of the campaign was widened in 1925 when Duan Qirui (who headed the government in Beijing) sanctioned draft regulations for a new national parliament that awarded voting rights only to men. The failure of the campaign marked the virtual end of Xiang Jingyu's involvement with women's suffrage groups.

Although Xiang played a key role during the strikes and protests of 1925 known as the May Thirtieth Movement, helping to create an umbrella organisation for women (Chinese Women's Alliance) that called for an end to foreign exploitation of Chinese workers and the abolition of the unequal treaties, she ultimately, just as in the case of Wang Huiwu, fell victim to gender bias within the party, and her standing within the party waned once her marriage to Cai Hesen ended; she created a scandal by leaving him to live openly with another party member, Peng Shuzhi, in 1925, convincing her prudish and hypocritical male colleagues that she lacked appropriate moral virtue. She lost her position on the central executive committee and her directorship of the Women's Bureau. In 1926 she left for Moscow to study at the Communist University of the Toilers of the East and did not return to China until 1927, at a time when the United Front was about to be definitively ended.

The Nationalist revolution

While Xiang Jingyu was beginning her revolutionary career in Shanghai as the head of the CCP's Women' Bureau, the southern city of Guangzhou (in Guangdong province), headquarters of Sun Yatsen's fledgling Nationalist government that opposed the militarist-dominated 'national' governments of the north in Beijing, also became a centre of the women's movement. He Xiangning, who had been the first woman to join Sun Yatsen's republican revolutionary organisation, the *Tongmenghui* (Alliance League), in 1905, was head of the GMD's Women's Bureau, which championed gender equality in education and employment and sponsored the creation of women's associations at the local level. As in Shanghai, such activity was characterised by

cooperation between the GMD and the CCP; He Xiangning was assisted, for example, by a number of female communists such as Deng Yingchao (1904–92) and Cai Chang (1900–90). Deng had been a student leader in Tianjin during the May Fourth Movement, while both she and Cai Chang had participated in the work–study movement in France in 1920–1. Both women were to become leaders of the CCP-sponsored Women's Federation after 1949.[12] Under the auspices of the United Front, they promoted the creation and spread of women's associations in Guangdong province. During the course of the Northern Expedition in 1926–7, as the GMD National Revolutionary Army under the command of Chiang Kai-shek (1887–1975) – who had emerged as the dominant leader of the GMD following Sun Yatsen's death in 1925 – marched through the central provinces of Hunan and Hubei as part of the military campaign to defeat the warlords and create a unified national government, many more women's associations were created, enrolling nearly 300,000 members by 1927 (Gilmartin, 1995, p. 98).[13]

Female students who accompanied the Northern Expedition as members of propaganda and medical units encouraged association members to speak out against an oppressive patriarchal system. In this they echoed Mao Zedong's thoughts on the subject in a report on the peasant movement in Hunan he submitted to the CCP leadership at the end of 1926. In his report Mao pointed out that, in addition to the three kinds of domination experienced by men (by the state system, clan system and religious superstition), women suffered from a fourth kind of domination, that of men (the authority of the husband) – together representing the 'four great cords that have bound the Chinese people and particularly the peasants'.[14] Yet, although Mao spoke of both peasant associations (which had begun to be established by communist activists like Peng Pai in Guangdong province) and women's associations sweeping away all feudal and patriarchal ideologies and institutions, he also underlined the need for peasants initially to wage political struggles against landlord authority; once victory in political and economic struggles had been achieved, Mao concluded, the abolition of the clan system, superstition and inequality between men and women would naturally follow.[15] The potential contradiction between the aims of peasant and women's associations (one targeting class enemies and the other the authority of husbands and in-laws) would trouble communist cadres for the next two decades. In fact, already during the Northern Expedition the enthusiastic attempts by young outside female activists to force peasant women to adopt the 'civilised hairstyle' (i.e. the bob) and denounce their arranged marriages began to arouse opposition from peasant associations (Leith, 1973, p. 61).

A Nationalist government was proclaimed in Wuhan (Hubei province) by the left wing of the GMD (in alliance with the communists) in January 1927, and for a brief few months, before it was dissolved and the United Front terminated in the wake of Chiang Kai-shek's brutal repression of the left (the 'White Terror'), a series of legislative measures were implemented granting women marriage and inheritance rights that have recently been described as the most enlightened attempt to tackle women's issues in the entire twentieth century (Gilmartin, 1995, pp. 181–94).[16] Laws were passed, for example, giving

women the right to choose their own husbands and to petition freely for divorce, the first such legislation in modern China. The first Hubei Provincial Women's Representative Conference, which brought together delegates from local women's associations, was also sponsored by the Wuhan government; it called for equal pay, an end to polygamy, and 'absolute freedom' of marriage and divorce.[17] The American journalist Anna Louise Strong (1885–1970), who visited Wuhan in May 1927, captured the extraordinary political atmosphere of the time when she described a meeting with a twenty-year-old female trade union delegate; although she 'seemed like a fourteen year-old in a grammar school', Strong observed, yet she 'held 2,000 workers spellbound by her fiery denunciation of Chiang Kai-shek' (Strong, 1928, p. 105).

The Wuhan government also celebrated International Women's Day in March 1927, a tradition first established by the Guangzhou-based Nationalist government in 1924;[18] as part of its agenda to construct a new social and cultural order, the Guangzhou regime had incorporated the event into its repertoire of political rituals and festivals. Up to 3,000 women participated in the first Chinese celebration of the event in 1924, and in 1927 (according to the later testimony of Huang Dihui, who chaired the preparatory committee to organise the event) 100,000 women gathered in the city centre. As further evidence that the women's movement was very much perceived in internationalist terms at this time, it is significant that in both Guangzhou and Wuhan celebratory articles were written every year about the German Marxist and feminist, Rosa Luxemburg (1871–1919), on the anniversary of her death.

During the celebration of Women's Day in 1927 crowds witnessed a parade of nearly 200 female cadets (in army uniform) from the Wuhan Central Military and Political Institute, which had been established by Song Qingling, the widow of Sun Yatsen and a prominent member of the Wuhan government, as a training ground for propaganda work. One of the cadets was the novelist and essayist, Xie Bingying (1906–2000), who recalled in her autobiography how she and her classmates (mostly students from middle or normal school), dressed in army uniform, carrying arms, and even training with male soldiers, perceived themselves as carrying on the Hua Mulan tradition (Xie, 2001).[19] Huang Dihui (1907–?), who had joined the Northern Expedition to escape an arranged marriage, remembered in the 1990s that she had been so inspired by the legendary female knight errant that she had actually changed her name to Mulan (Wang, 1999, pp. 296–305).[20]

The backlash

The dissolution of the left-wing GMD in Wuhan during the summer of 1927 brought an end to the United Front; the GMD, now once more unified under the leadership of Chiang Kai-shek, continued with the Northern Expedition that culminated in the occupation of Beijing and the inauguration in 1928 of a new Nationalist government (with its capital in Nanjing). The CCP, its urban networks smashed by brutal repression, was forced to go underground or retreat to the countryside.

The end of the United Front also had horrendous consequences for women, as a conservative backlash targeted female activists (especially those with bobbed hair) in a particularly vicious way. Whereas in 1926 the shock value of violence against women, illustrated by the killing of two female students from Beijing Women's Normal College (out of a total of 47 killed) when soldiers under the command of Duan Qirui (who controlled the Beijing government) fired on a demonstration protesting against Japanese imperialism, had been fully exploited by revolutionaries as proof of the immorality and illegitimacy of warlord administrations,[21] violence against women in 1927–8 was perceived by conservatives as the means of restoring the 'natural' gender order recently turned 'upside down'.

Cai Chang later recalled that in 1927 over 1,000 women were killed; many were subjected to unbelievably sadistic sexual violence. When young women were arrested in Hunan, Cai observed:

> They were stripped naked, nailed on crosses and their noses and breasts cut off before they were killed…. (Diamond, 1975, pp. 6–7)

Even women who had demanded a divorce or resisted an arranged marriage were killed. The 'execution' of female activists was invested with political meaning, while the mutilation of their bodies was designed to illustrate in graphic terms how 'unnatural' female activism had been (Gilmartin, 1995, pp. 198–9, 212). In some areas violence against women was just one element of a larger scenario involving ferocious class warfare that had gripped the countryside in the wake of the Northern Expedition. Thus, during the White Terror the local strongman of Macheng county in northern Hubei slaughtered male peasant activists in similar 'horrific, ghoulish and highly theatrical ways', designed to restore social order and 'rectify' the people's minds (Rowe, 2007, pp. 274–6).

One of the most prominent victims of the backlash was Xiang Jingyu. On her return from Moscow she had made her way to Wuhan, where the United Front was still holding (rather precariously), and was appointed head of propaganda for the Wuhan General Trade Union. After the dissolution of the Wuhan government she refused to leave the city and continued to operate underground until she was inevitably arrested (a scenario strikingly similar to Qiu Jin's last days) in the French Concession area of Hankou in early 1928. In a cruel twist of fate, this female revolutionary, who had matured as an activist while studying and working in France, was limply handed over by French officials after a travesty of a trial (during which she condemned the betrayal of French ideals of liberty) to the GMD authorities. She was executed shortly afterwards.

In the wake of the breakup of the United Front both the GMD and CCP, concerned that each would accuse the other of encouraging sexual immorality, sought to distance themselves from the radical activity of feminists during the course of the Northern Expedition and the brief period of the left-wing GMD government in Wuhan. A key aspect of GMD anti-communist propaganda, for example, was the charge that the CCP encouraged sexual

debauchery (including the 'collectivisation' of women) (Hu, 1974, p. 476).[22] In 1928 the GMD Women's Bureau was closed down, and during the 1930s the Nationalist regime increasingly valorised 'traditional' feminine virtues of self-sacrifice, loyalty and perseverance as emblems of cultural identity and the prerequisites for national order and economic well-being. The CCP, on the other hand, at its sixth Congress in 1928 (held in Moscow) denounced the 'bourgeois feminist' programme of the previous eight years, particularly calling into question the wisdom of creating independent women's associations (Gilmartin, 1995, pp. 212–15). Henceforth, the targeting of class exploitation was to take priority over tackling gender inequality. This did not prevent both the GMD and CCP in the 1930s from implementing legislation that granted women considerable marriage and divorce rights (see Chapter 5).

The GMD campaign to promote traditional feminine virtues was a central element of the New Life Movement in 1934–5. Drawing on both Prussian-style military values and Confucian ethics, the movement aimed to instil amongst the populace habits of discipline and hard work, as well as 'civilised' ways of behaving and dressing. The ideal 'modern' woman promoted by GMD ideologues – defined as a skilled, loyal and conscientious domestic manager and nurturer who provided loyal support for her husband, and very much perceived as a *new* kind of 'virtuous wife and good mother' – represented a reaction against *both* the politicised woman *and* the urban 'modern' woman associated with western-style fashion and consumerism (Yen, 2005). In some urban centres women who wore make-up or western clothes were sometimes physically assaulted (anticipating a similar occurrence during the Cultural Revolution in the 1960s), while a series of regulations were issued in cities like Nanchang (the headquarters of the New Life Movement) to ban 'outlandish' dress (which included over-exposure of bare legs). Elsewhere, as in Guangdong, young women were forbidden to wear permanent waves or high heels.

All such official attempts by the GMD regime to regulate women's dress and behaviour, just as those of officials in the late Qing and early Republic, could not stem the tide of economic and social change in China that had impacted women's lives since the turn of the twentieth century. Politically, the mobilisation of large numbers of women during the Nationalist Revolution of the mid-1920s had been one of the most dramatic events of China's twentieth-century history. Notwithstanding the 'backlash' of 1927, gender issues had been forcefully imprinted on the political agenda for both the GMD and the CCP, and both would tackle them by legislative means over the course of the subsequent decade.

5
Women in the City and Countryside before 1949

In 1934 an extraordinary silent film entitled *The Goddess* (*Shen'nü*) and starring the famed Shanghai actress Ruan Lingyu (1910–35) drew attention to the temptations, dangers, cruelties and human tragedies of city life through its depiction of the travails endured by the eponymous heroine, a single mother compelled to earn a living in Shanghai as a prostitute in order to bring up her son. As a devoted mother committed against all the odds to ensuring the education of her son, the heroine incarnated the traditional ideal of the virtuous, nurturing and self-sacrificing mother; as a streetwalker she embodied a popular and ambivalent perception of the cosmopolitan metropolis, represented by Shanghai, as a site of potential moral and human degradation amidst a relentlessly alluring and hedonistic consumer culture.[1] Exploited and abused by a local thug and pimp, the Goddess attempts to keep money aside (without telling her pimp) to pay for the schooling of her son. After the pimp discovers the hidden cache of money and spends it all, the Goddess in desperation and anger kills him. The film ends with her being sent to prison, but not before the kindly principal of the school which her son had attended offers to adopt the child and guarantee his continued education. The Goddess is happy to accept that she will never see her son again (instructing the school principal to tell her son that she is dead) as long as she knows that the child will succeed in life.[2]

The Goddess was one of many films produced in the 1930s in which filmmakers explored the nature of urban modernity, its dangers and pitfalls as well as its allure and glamour, through the figure of the Woman (in her various guises).[3] In fact, the multiple and contradictory images of the 'new woman', a figure first discussed by Hu Shi in 1918 (see Chapter 3), became a ubiquitous trope in 1920s and 1930s literature and cinema that spoke to primarily male anxieties concerning the pace and impact of modernising change on gender roles and interactions, as well as on moral values in general. While *The Goddess* used a woman's experience to portray Shanghai literally and metaphorically as a dark and dangerous place (which is contrasted throughout the film with the simple, homely and safe environment of the heroine's small abode), other films used women as emblems to critique urban cosmopolitanism and western-inspired bourgeois culture in general, and to contrast such phenomena (described by one historian as 'western spiritual pollution')

with a supposedly simpler and purer cultural essence (Pickowicz, 1991). On the one hand, a certain kind of 'new' or 'modern' woman, typified by the patron or hostess of a dance club who smokes, drinks, wears make-up and revealing fashionable clothes, and dances to western music, represents a potential source of moral decline for a gullible man caught in her beguiling web. Such a scenario comprises the plot of the 1932 film, *A Dream in Pink* (*Fenhongse de meng*), which depicts the moral decline of a writer who abandons his more traditionalist schoolteacher wife (who is portrayed as loyal, obedient and innocent) for the charms of a 'modern' woman he meets in a night club. Not surprisingly, the writer is forgiven by his virtuous former wife after he is abandoned by his flirtatious new partner (Pickowicz, 1991, pp. 45–6).

On the other hand, the woman might represent an alternative cultural identity (often located in the countryside), one unsullied by the corrupting values of the city. In the 1931 film, *Peach Blossom Weeps Tears of Blood* (*Taohua qixue ji*), for example, Ruan Lingyu plays the role of a simple, hardworking rural woman who is cruelly deceived by an egotistical rich man from the city. Another dramatic example of this rural–urban gendered contrast in early Chinese cinema is *Queen of Sports* (*Tiyu huanghou*), directed by the leftist film-maker Sun Yu in 1934. Focusing on the experiences of an innocent and wholesome rural girl (albeit from a well-off family) who arrives in the city to attend a school for female athletes, the film charts how she becomes spoilt and morally damaged (illustrated by wearing make-up and fashionable clothes, and fraternising with western-educated college boys).The film ends with her renunciation of her egotistical and hedonistic lifestyle and her vowing to serve society as an ordinary teacher of physical education (Pickowicz, pp. 49–50). One year earlier, Sun Yu had directed an equally powerful film, *Daybreak* (*Tianming*), and starring another celebrated actress, Li Lili (1915–2005), that portrayed the degradation of a young village woman who has optimistically migrated to Shanghai to work in a textile factory; forced to become a prostitute, she embraces the role as a means of financially helping her fellow workers, and ultimately sacrifices her life for the cause of the Nationalist revolution (significantly, she asks her executioners to allow her to wear simple peasant garb before she is shot).

To what extent did these films capture the reality of women's lives in the city and countryside during the first half of the twentieth century? This chapter will focus on how economic, social, political and legal changes since the turn of the twentieth century affected the lives of women, as well as on the ways in which women responded to such changes. In a large urban centre such as Shanghai, for example, women constituted a large proportion of the working class, principally in the textile industry. Many of these female workers were rural migrants, illustrating how economic change was providing increasing opportunities for young women to work outside the home and even beyond their native place. Although in many ways these female workers, as a source of cheap labour, were exploited and abused, this did not prevent them from exerting some agency and control over their lives. In some cases, also, the financial independence which factory employment afforded

some rural women facilitated marriage practices in which women either did not reside with their husbands for a period of time or rejected marriage altogether.

Outside the cities, in the vast rural hinterland, women's lives differed from region to region. Nationwide, for example, there was considerable variation in female participation rates in agriculture. Selected surveys carried out in the 1920s and 1930s by John Lossing Buck – an agricultural economist and missionary based in Nanjing, and whose wife, Pearl Buck, author of the 1931 novel *The Good Earth* about a stoical Chinese peasant dealing with natural and human calamities, was to win the Nobel Prize for literature in 1938 (the first woman to do so) – indicated that 80 per cent of all farm labour was performed by men, 13 per cent by women, and 7 per cent by children. In the rice-growing regions of the south, however, women's participation rate was higher (16 per cent), compared with the wheat-growing north (9 per cent). Even in the south there were differences; thus, in the double-cropping rice areas of Guangdong, southern Jiangxi and northern Fujian, 29 per cent of farm labour was performed by women (on the other hand, surprisingly, in the spring wheat area of the far north, where footbinding was still prevalent, women's participation rate might be as high as 14 per cent at the time of sowing and harvesting) (Davin, 1976, pp. 117–20; Croll, 1985b, pp. 15–20). In the cotton cultivation regions of the Yangzi delta, such was the importance of female labour that women formed 33 per cent of the hired agricultural labour force (Walker, 1993, p. 369).[4] A recent study has argued that the value of women's overall economic contribution to the peasant household in the Yangzi delta at this time was similar to men's (Hung and Lee, 2010).

Just as socio-economic change in the cities spawned an embryonic industrial proletariat amongst which women were a highly visible presence, so it also led to a marked increase in the number of prostitutes – another group of publicly visible women – and a dramatic change in the profile of prostitution itself as population growth (principally due to increasing numbers of incoming migrants) fuelled the 'commercialisation of sex' in which growing numbers of licensed and unlicensed prostitutes catered to the demands of emerging middle and working-class clienteles. As in the case of female workers, moreover, prostitutes (at least those on the higher rungs of what has been called a 'hierarchy of prostitution') (Hershatter, 1997), exercised a certain agency *vis-à-vis* their clients and madams (brothel owners). Significantly, contemporary Chinese cinema, such as the 1934 film *The Goddess* referred to earlier, while portraying prostitutes as victims, also depicted them as autonomous characters capable of 'heroic' self-sacrifice for a virtuous cause.

For middle-class women in urban centres the new Nationalist (*Guomindang*) regime after 1928 represented considerable promise as far as legal rights were concerned. The new *Guomindang* Civil Code promulgated in 1929–30 gave women (in theory) equal rights in marriage, divorce and property inheritance, although the results of such legislation did not always prove beneficial for certain groups of women. Meanwhile, in the rural soviets that the CCP had set up in south-central China following the breakup of the United Front in 1927, more concrete steps were taken to improve women's lives (through

marriage legislation) as well as to encourage women's political activism. At the same time, the Party sought to balance the demands and needs of the class revolution (symbolised by peasant associations) with those of the gender revolution (symbolised by the women's associations that were set up by the party in each locality), something the Party found increasingly difficult once it had been forced to move its operations to the more remote and conservative rural region of the north-west in Shaanxi province.

Women and socio-economic change

Economic modernisation in cities such as Shanghai during the early twentieth century had a profound impact on the gender composition of the labour force. As early as 1899 it was estimated that, out of 34,500 factory workers in Shanghai, 20,000 were women – all employed in the cotton spinning and silk reeling industries. By 1929, 72 per cent and 75 per cent of the labour force working in the Shanghai cotton spinning and silk reeling sectors, respectively, comprised women; the total number of women employed in Shanghai factories (principally in textiles, food processing and tobacco manufacture) in 1929 amounted to 175,000, constituting more then one-third of Shanghai's proletariat (Honig, 1986, p. 24; Perry, 1993, p. 60; Smith, 1994, p. 143; 2002, p. 18).[5] In other cities where industrialisation took off later, such as Tianjin in north China, women did not enter the cotton mills in large numbers until the 1930s; even in Tianjin, however, women comprised 5 per cent of the factory workforce by the end of the 1920s (and 9 per cent of the cotton mill workforce) (Hershatter, 1986, pp. 48–57).[6] In Ningbo (south of Shanghai in Zhejiang province), relatively large numbers of women (mostly from poorer households and despite a strong local tradition that accorded women's work *within* the home as the dominant marker of social respectability) were employed in the town's two cotton spinning mills; by 1919, one (founded in 1895) employed 1,000 women, while the other (founded in 1905) employed just under 2,000 – equal numbers of Ningbo women also migrated to Shanghai to work in the factories there (Mann, 1992a, pp. 263–8). A similar development occurred in late nineteenth-century Japan, where industrialisation was fuelled by the textile industry, in which the workforce was predominantly female.

In central and southern China, moreover, women continued to be highly visible in a wide range of occupations outside the home. Reports on local economies in the women's periodical press during the early years of the Republic, for example, indicated that in provinces such as Jiangsu and Zhejiang women were not only involved in silkworm breeding, fishing and agriculture (even 'renting out' their labour individually or in groups if their husbands had no land), but also ran small-scale enterprises (restaurants, food stores, wine shops, cigarette kiosks) and small businesses (e.g. making tools or fishing nets) (Bailey, 2007, p. 91). With the appearance of the department store in cities such as Shanghai (Wing On, a subsidiary of the Hong Kong Wing On Company launched by a group of Cantonese investors, opened its doors for business on Nanjing Road in 1918), young women were employed in an entirely new occupation, as sales assistants (Yeh, 2007, pp. 56–63).

From the beginning, female factory workers were highly combative and were not in the least inhibited from protesting against ill-treatment and demanding redress. Of the thirty-three recorded strikes in Shanghai between 1895 and 1910, 76 per cent were launched by unskilled female workers; significantly, also, Shanghai cotton mills, in which the workforce was predominantly female, witnessed nearly two hundred strikes between 1918 and 1927 (in 1922 alone, a massive wave of strikes involving 20,000 workers from forty silk filatures was led by the Shanghai Women's Industrial Progress Union) (Smith, 1994, p. 144; 2002, pp. 55–6). For the most part female workers resorted to what one might call 'defensive' strikes when wages were cut or withheld, for example, or when mills prohibited working mothers from taking their babies into work; another cause of strikes was the decision by some mills (especially Japanese-owned ones in the 1920s) to replace a daily wage with a piecework system (Perry, 1993, pp. 60–2). Such protests often led to violence and might involve destruction of machinery and attacks on company offices. In August 1911 4,000 women employed in four Shanghai silk filatures walked out in protest against wage cuts, in the process coming into conflict with police, while protestors at one filature in 1914 hauled the company accountant to the local police station in order to demand back wages owed to them (Smith, 1994, p. 149). Wage parity with men did not constitute a demand amongst female strikers at this time, perhaps because it was not considered a priority by contemporary male strikers. It is no coincidence either that women at this time did not join formal (male-dominated) unions in large numbers (a phenomenon that male labour activists often cited as evidence – along with the apparent volatility and spontaneity of female protest – demonstrating women's lack of political consciousness and 'inability' to undertake long-term and 'rational' action), since they did not address concerns that were of particular relevance to women, such as sexual harassment at work.

Although they did not join unions in large numbers – on the eve of the breakup of the United Front in 1927 women comprised only 15 per cent of total union membership, even though they comprised 52 per cent of the industrial workforce (Honig, 1986, p. 209) – female textile workers in Shanghai often formed 'sworn sisterhoods', sealed by burning incense before the statue of a Buddhist deity and pledging loyalty to one another. Based on native-place origins (in most cases 'sisters' came from the same village), these sisterhoods constituted a vital survival tactic ensuring mutual protection and assistance. In the factories, where women worked a twelve-hour day with only one short break, 'sisters' would cover for one another if one needed to take a longer break; they might band together to confront either sexual harassment perpetrated by overbearing male overseers inside the factory or neighbourhood hoodlums on the streets; on their one day off they would socialise together; and they would help each other out financially in order to prevent any of them being exploited by unscrupulous moneylenders (Honig, 1985).[7] The formation of sisterhoods was facilitated by the regional segmentation of the female labour force in Shanghai. Most female textile workers, for example, came from rural districts and villages in the provinces of Jiangsu (in which Shanghai was located) and Zhejiang (south of Shanghai). A clear (and discriminatory)

distinction was made between those who hailed from the poorer region of Jiangsu north of the Yangzi River (Subei) and those who originated from the relatively wealthier region south of the Yangzi River (Jiangnan). Subei women, perceived as 'uncouth' and 'ignorant', tended to be allocated the lowest-paid and dirtiest tasks in the cotton mills, while the more skilful and higher-paid jobs were performed by women from Jiangnan, thought to be more intelligent and adaptable (Jiangnan women also predominated in the silk weaving industry).[8] This meant that departments and workshops within the mills were often staffed by women from the same native place (Honig, 1986, pp. 70–1).[9]

Workshop forewomen (known as 'Number Ones') might also ensure that women under their supervision came from the same native place, thus creating 'clientelistic' ties which were sometimes formalised when sisterhoods pledged loyalty to their 'Number Ones' (whom they addressed by the proto-kinship term of 'godmother'). These ties were strengthened by the fact that 'Number Ones' were often married to labour contractors, who recruited many of the potential female workers. This 'contract labour system', which became more entrenched in the late 1920s (and which operated outwith the control of mill management), involved contractors targeting poorer rural areas where cash-strapped peasant families were willing to 'sell' their daughters for a certain number of years during which the contractor would arrange for their employment in a Shanghai mill; contractors would also be responsible for their accommodation, either renting rooms or paying mill owners for dormitory space (mill owners built dormitories to house their other female workers). During the time of the contract most of the women's wages would belong to the contractor to offset the sum of money advanced to the families. By the 1930s the labour market in Shanghai had virtually been cornered by the city's most powerful underworld organisation, the Green Gang, with labour contractors (and even 'Number Ones') being gang members (Honig, 1983).[10]

Such a situation – the segmentation of the female labour force in the cotton mills, and its division along the lines of native-place ties, as well as the controlling influence of 'Number Ones' and labour contractors often linked to the Green Gang – may have inhibited working women's solidarity in the cotton mills (Honig, 1986, pp. 4–6),[11] but this was not the case in the silk industry, especially amongst the more skilled and better-paid female silk weavers. As early as 1922 female workers in Shanghai were involved in a citywide silk filature strike, which had been spearheaded by the Shanghai Women's Industrial Progress Union under the control of Mu Zhiying, a female silk worker and a member of the Green Gang. Four years later, a strike by female workers in forty-six filatures broke out in protest *against* Mu Zhiying's union, which had tried to deduct money from workers' wages to fund its activities (Perry, 1993, p. 178). In the wake of an economic downturn after 1929, female silk weavers became highly politicised, initiating large-scale strikes in 1930, 1934 and 1937. In the strike of 1934 at one of the larger silk filatures in Shanghai, one of the demands included *equal* pay for men and women (Perry, pp. 167–8, 188).[12]

Not only did female workers predominate in the Shanghai silk industry, but it was also peasant women who were principally involved in the 'production' of the raw material (i.e. cocoons) required for the industry. In Wuxi county

(lower Yangzi delta in southern Jiangsu province), which had been a centre of handicraft silk production since the sixth century, most peasant families by the turn of the twentieth century had switched from cotton weaving as a form of sideline activity to the growing of mulberry leaves and raising of silk-worms, tasks performed for the most part by women (Bell, 1999, p. 50).[13] Steam-powered silk filatures also began to be established in Wuxi (the first one opened in 1904, and by the 1930s there were fifty), which also employed mainly young peasant women (seen as a source of cheap labour); by 1930 there were 19,000 women (mostly aged between fourteen and thirty) working in these filatures (as in Shanghai, they were housed in company-owned dormitories). Even here, however, there were signs of labour unrest. An official report in 1930 expressed alarm that female silk workers in Wuxi had begun to demand shorter working hours and higher wages (in 1926 they actually went on strike) (Bell, 1999, pp. 97–8, 103–4).

The tobacco industry, in which large numbers of women were employed, also witnessed labour militancy. The largest employer of tobacco workers in Shanghai, British-American Tobacco (BAT), which had begun operations in China in 1902, employed mostly women in its leaf (removing tobacco leaves by hand) and packing departments. In 1917 over 1,000 women in the packing department walked out in protest against reduction in their piece rates, destroying production materials and preventing other workers from entering the factory premises. Of the twelve strikes in BAT factories before the arrival of communist labour activists (who initially tended to focus on mobilising skilled male mechanics) in the early 1920s, ten were launched by women. As with the cotton textile industry, however, the workforce was divided along regional lines and specific task allocation (e.g. most workers who performed in the lowest-paid and more laborious tasks in the leaf department were from Subei, whereas those employed in the packing department at slightly higher wages were from Shaoxing in the Jiangnan region). Joint protests were rare and protest tended to be defensive and small-scale. Unlike in the cotton industry, however, where CCP labour activists in the 1920s and 1930s were unwilling (since they focused on male workers) or unable to gain influence amongst worker sisterhoods, the CCP *did* gain some foothold amongst female tobacco workers when Yang Zhihua (1900–73), who became one of the leading members of the Shanghai General Labour Union in the wake of the May Thirtieth Movement in 1925 and was to succeed Xiang Jingyu as head of the CCP Women's Bureau at the party's Fifth Congress in 1927, formed a 'sisterhood' with some of her fellow provincials in the packing department (Perry, 1993, pp. 149–50).[14]

Yang was therefore somewhat of a pioneer, since CCP activists were not to engage in more serious and sustained efforts to 'infiltrate' sisterhoods amongst female textile workers in places such as Shanghai and Tianjin until the late 1940s, when CCP women cadres formed sisterhoods of their own, and issues that were of specific relevance to women, such as the demand for factory-based nurseries and maternity leave, finally became part of the agenda of the labour movement. Ironically, the first 'outsiders' to work with female factory workers were often Chinese representatives of the YWCA, who set up a number of night schools in Shanghai factories in the 1920s (Honig, 1986, pp. 217–21,

225–30). One of the most prominent of these YWCA activists was Deng Yuzhi (Cora Deng, b.1900), who became head of the Labour Bureau of the YWCA in 1930. The product of both a missionary and a Chinese education (she attended the same Chinese girls' school as Xiang Jingyu), Deng embraced Christianity, equating it with social activism and international sisterhood; in many ways the YWCA night schools she directed for female workers were more radical than the missionary school she herself had attended (Honig, 1996).

In addition to formal strike action, moreover, female factory workers in the Shanghai cotton mills often resorted to 'everyday forms of resistance' such as sabotage, go-slows or pilfering. Elsewhere, in Tianjin for example, female textile workers engaged in an ingenious go-slow stratagem to ease their work; known as 'soaking mushrooms', the ploy involved smearing oil on the machine belt to make it go more slowly (and hence making it less likely that the thread would break) (Hershatter, 1986).

While economic modernisation in urban centres brought changes to the nature of the workforce, socio-economic change also had an impact on women's lives in the countryside. Recent research (focusing on villages in the north-western province of Shaanxi) suggests, for example, that increasing imports into the region of cheap factory-made cotton cloth and yarn – facilitated by the arrival of modern transportation links – were closely linked to the rapid disappearance of footbinding during the 1930s; although footbinding had traditionally been carried out amongst peasant girls and young women in order to confine and train them in the sedentary labour of handicraft textile production, rural households now no longer saw the necessity to bind daughters' feet, since such handwork had become economically unviable by this time (Bossen *et al.*, 2011). Furthermore, the accelerating commercialisation of the rural economy during the first decades of the twentieth century, especially in the cotton producing regions along the Yangzi in central China (and where cotton cultivation, and not just home-based cotton spinning, had largely become the work of women), led to the growth of a female labour market (both unfree and free). Daughters from poorer families might be 'mortgaged' to a landlord or rich peasant to serve as farm labour (with parents having the option of 'buying' them back when they reached marriageable age); at the same time, cotton mills that began to be established at the turn of the twentieth century in the Yangzi delta (in places such as Nantong, just north of the Yangzi), as in the case of modern silk filatures in Wuxi, mostly employed young peasant women. On the other hand, by the 1920s, as increasing numbers of male members of peasant households (in the Jiangnan region, for example) sought off-farm jobs or became migrant agricultural labourers, women assumed more and more responsibility for running family farmholdings (Walker, 1999, pp. 192, 195, 214, 237).[15] In other cotton producing areas such as Ningbo, south of Shanghai, where home-based cotton spinning was threatened by machine-manufactured yarn produced in Shanghai mills, peasant women demonstrated considerable ingenuity in switching to new kinds of home handicraft production to take advantage of the export market, such as lacemaking (handkerchiefs, cushions) and the weaving of straw or bamboo hats (Mann, 1992a, pp. 256–60).

In other regions of the Yangzi delta, such as the sericulture region around Wuxi, the impact of socio-economic change on women's lives might be equally ambivalent. With the increasing importance of sericulture in Wuxi – by the early twentieth century it had become the cocoon marketing capital of the entire Yangzi delta region, especially after 1904 when it was linked to Shanghai by rail – peasant women took on the major responsibility for raising silkworms at home (Bell, 2000). Such a role, however, did not necessarily bring them more autonomy or enhanced social standing; they had little choice over whether or not to be involved in the time-consuming and arduous task of raising silkworms, nor did they have control over the income generated by the sale of the cocoons, the income from which was deemed absolutely essential to keep peasant households afloat and avoid potential subsistence crises. Furthermore, silkworm raising represented a double-edged sword for peasant households. Potentially profitable, it was also a highly risky business, since the cultivation of silkworms depended on such stringent conditions (e.g. huge amounts of mulberry leaves on which the silkworms fed, and exactly the right temperature at all times in the storage sheds) that there was always a danger of crop failure. If any disaster did occur, continuing adherence to traditional beliefs in female ritual pollution (via menstrual or fetal blood) meant that women were often perceived as its source (Bell, 1994). The precariousness of raising silkworms and how this affected women is captured in a 1932 short story by the left-wing writer Mao Dun (1896–1981), *Spring Silkworms*, which describes the village ostracisation of a peasant wife after her family cocoons perish.

In the Pearl River delta further south in Guangdong province, however, the silk industry could have quite different consequences for women. In this region an 'alternative' marriage system had existed since at least the eighteenth century, in contradistinction to what has been termed the 'major marriage system' (and its minor derivatives such as uxorilocal marriage, in which the husband lived with the wife's family, and minor marriage, in which a young girl was adopted into a family and was married to a son on reaching marriageable age) (Wolf and Huang, 1980, pp. 1–15, 70–107). In this 'delayed transfer marriage' (in Chinese, *buluojia*, literally 'not cohabiting with the husband'), the bride after the wedding (unlike the 'major marriage' system) did not take up residence with the husband but rather remained with her natal family, visiting her husband's family only on special occasions such as the celebration of her in-laws' birthdays; normally, it was only on becoming pregnant that the bride moved in permanently with her husband and his family (Stockard, 1989).[16] Since this was a customary arrangement in the region, it was not a form of 'marriage resistance' as previously thought (Topley, 1975). Although the evolution of delayed transfer marriage in the Pearl River delta may have been the result of the fusion of non-Han practice (ethnic minorities such as the Yao in Guangdong or Zhuang in neighbouring Guangxi had long-established traditions of delayed conjugal residence, institutionalised same-sex bonds, and a certain sexual freedom in courtship practices) with mainstream Han Chinese culture – thus indicating that 'sinicization' of non-Han ethnic minorities was not always a one-way process but rather might involve a mutually interactive

cultural encounter (Stockard, 1989, p. 171)[17] – it should be noted that in another region of China it seems to have been a purely Han Chinese practice from the start. North of Guangdong in Hui'an, eastern Fujian province, wives did not live permanently with their husbands until the birth of a child, a custom referred to as *changzhu niangjia* (extended natal residence marriage).[18]

Socio-economic change in Guangdong from the late nineteenth century onwards, however (in the shape of the silk industry), had an intriguing impact on delayed transfer marriage, the result of which might very well be viewed as a form of 'marriage resistance'. Steam-powered silk filatures had first appeared in the Pearl River delta in the 1860s, and by 1890 nearly 75 per cent of all silk exported from Guangzhou (Canton) was being produced in these filatures. By 1904, in just one county alone (Shunde) in the region, eleven market towns had silk filatures employing up to 1,000 women (Topley, 1975, p. 75).

The opportunity for young women to earn income in these silk filatures (much valued by natal families anxious to garner as much extra income as possible) facilitated the creation of 'sworn spinsterhoods' as well as the adoption of a marital arrangement known as 'compensation marriage'. In villages throughout the region bonds between adolescent girls were forged in 'girls' houses'; with increasing economic opportunities it was not uncommon for vows of spinsterhood to be taken, preceded by hairdressing rituals (hence such women were known as *zishu nü*, 'women who dress their own hair'), which in many cases meant that they remained unmarried and continued to live with their natal families.[19] Such sworn spinsterhoods could also draw on the example of traditional Buddhist lay women's communities or vegetarian halls (see Chapter 1). Because of the financial benefits they brought to the household, most natal families were happy to have at least one daughter who was a *zishu nü*; on reaching old age many were accommodated in 'spinster houses' established by rural lineages (with the decline of the silk industry in the late 1920s and 1930s, many 'sworn spinsters' sought employment in domestic service in Hong Kong and Macau, or even further afield in Singapore) (Stockard, 1989, p. 169).[20] After 1949, in line with the new communist government's determination to eradicate what it perceived to be 'feudal' or 'aberrant' practices, spinster houses were closed down and their occupants forced to live in the homes of their kinsmen (see Chapter 5) (Topley, 1975, pp. 84–5).

For female silk workers who did marry, an arrangement known as 'compensation marriage' often became the norm in the early years of the twentieth century. This involved the bridedaughter paying her husband's family for an extended period of separation; in effect, this meant she would acquire a secondary wife or concubine for the husband, herself only moving in with her husband in old age or when approaching death. Such a practice inevitably implied a refusal to bear children, although 'compensating' bridedaughters retained the status of first wife and mother (in relation to children borne by the secondary wife). Since many of these acquired 'secondary' wives were marriageable girls previously sold by poorer families into domestic servitude (who would then be 'sold off' when they reached marriage age), known as *mui-tsai* (or *mooi-jai* in Cantonese), such an arrangement illustrated how the

abusive 'trade' in females apparently benefited certain women at the expense of others.[21]

Socio-economic change in urban centres such as Shanghai also changed the face of prostitution (Hershatter, 1997; Henriot, 2001). At the turn of the twentieth century high-class courtesans (referred to as *shuyu,* named after their private residences), who traced their pedigree to the glory days of the Ming period, became in effect China's first public celebrities (Yeh, 2003; 2006).[22] Taking advantage of new technologies in the print and visual media (such as photography), they had their portraits taken, which were then circulated in albums to advertise their services and personas (Pang, 2005; 2007, pp. 75–6).[23] Increasingly occupying a *public* space and travelling freely throughout the city (often in the company of male lovers) (Yeh, 2005) – the first women to do so – their dress, behaviour and relationships became the subject of an emerging tabloid press that exploited the voyeuristic interests of a growing reading public. In the process the image of the courtesan was transformed from that of 'secluded cultured beauty' to 'urban public beauty' (Yeh, 2003, p. 397).

Catering principally to literati clients, courtesans even mimicked their status, being transported by sedan and preceded by a servant carrying a lantern on which was inscribed 'chief magistrate on public business' (Hershatter, 1989, p. 467). Until the 1920s clients would organise polls to decide who was considered the best courtesan, echoing the practice during the Ming when male literati played the 'flower register game', which ranked courtesans in the same way as male examination candidates. By the late nineteenth century, too, courtesans had become central characters in popular fiction; the 1894 novel *Sing-Song Girls of Shanghai* (or *Lives of Shanghai Flowers*), for example, portrayed courtesans as wily businesswomen as well as the symbol of the city's power to corrupt.[24]

The status of courtesans, however, began to change from the late nineteenth century onwards as a result of demographic change in Shanghai (Henriot, 1996). With a growing population mainly comprising rural migrants and refugees, the number of ordinary prostitutes catering more to the sexual needs of the working class grew dramatically. In effect, a 'hierarchy' of prostitution developed (structured by the class background of clients, as well as the native place of both clients and prostitutes) in which the streetwalkers (referred to as *yeji,* or 'wild chickens') became the majority.[25] The increasing commodification of sex meant also that from the 1910s onwards courtesans 'slipped down' the hierarchy and became identified with the sexual services they provided (which had not been the case before). While there may have been up to 6,000 prostitutes in Shanghai at the end of the nineteenth century, by 1935 the combined estimates of both licensed and unlicensed prostitutes suggested a total of 100,000 (Hershatter, 1991, p. 145, fn 1; 1997, pp. 39–41). In other cities such as Guangzhou, by way of contrast, the number of prostitutes may not have increased significantly after the early twentieth century (Ho, 2005, pp. 226–9). Although frequently condemned by Chinese male reformers (for whom prostitution was now a social evil and the symptom of national degradation and weakness), provincial and municipal governments found prostitution

extremely profitable, with taxes imposed on the business helping to fund modernisation projects; in Guangdong, for example, revenue from prostitution taxes helped to finance not only (ironically) prostitution rehabilitation centres but also the construction of roads and schools. In the capital, Nanjing, tax revenue to 'regulate' prostitution in 1927 constituted 12 per cent of the total tax revenue of the city (Remick, 2003; Ho, 2005, p. 287; Lipkin, 2006, pp. 167–9).

Although streetwalkers led miserable lives, prostitutes higher up the hierarchy who worked in brothels exerted a certain amount of agency *vis-à-vis* both their madams and clients. They might, for example, take their madams to court for breach of contract in order to leave and set up their own business (often buttressing their case by claiming they had been kidnapped or abducted by their madams, which may or not have been true). They also compelled clients to undergo 'courtship rituals' (involving gifts and the hosting of banquets) before they made available their sexual services, or, in a strategy known as 'taking a bath', they might leave the brothel to become the concubine or mistress of a client as a means of acquiring money and jewellery to pay off debts and enable them eventually to abandon their lover and set up their own brothel business (Hershatter, 1992, pp. 258–9).[26] In Canton, a similar hierarchy of prostitution developed, with higher-class prostitutes imposing on their clients the obligation to undergo expensive and time-consuming rituals, although even lower-class Tanka (boat people) prostitutes were, according to a contemporary Cantonese song, reputed to be 'snobbish' and impolite to customers (Ho, 2005, pp. 252, 256).[27]

From the 1920s onwards prostitutes of all kinds faced increasing competition from dance-hall hostesses (*wunü*) or taxi-dancers (from whom male clients purchased tickets per dance), a new phenomenon that emerged with a burgeoning entertainment industry symbolised by the cabaret; some *wunü*, like the Cantonese Lilly Yang (who, like some others, was a former courtesan), achieved public celebrity and became icons of modernity, but others eked out routinised lives or were portrayed as sources of temptation and corruption. By 1930 there were thousands of *wunü* in Shanghai (Field, 1999; 2010, pp. 64–9, 119–51). Lower down the entertainment ladder was the 'sing-song girl' (*genü*) who performed in teahouses, where the line between selling songs and selling sexual services was blurred. In the 1930s leftist film-makers appropriated the persona of the sing-song girl (often portrayed in the press as the pathetic plaything of male predators) as the symbol of national oppression and humiliation (Jones, 2001). The most celebrated example was the 1937 film directed by Yuan Muzhi (1909–78), *Street Angel* (*Malu tianshi*). In an allegory of the national crisis, the film depicted the sad plight of two sisters who had been forced to flee their homeland in the north-east (Manchuria), occupied by the Japanese since 1931. In Shanghai their cruel guardians force the older sister into prostitution and the younger to be a sing-song girl in a teahouse (the character is played by Zhou Xuan (1918–57), herself a famous singer of Mandarin popular music). Together with some neighbourhood male friends they foil the guardians' plot to 'sell' the younger sister to a wealthy patron, but not before the elder sister sacrifices her life in the endeavour; and thus, as in

the case of the earlier film *The Goddess*, ultimately investing the character of the streetwalking prostitute with a heroic status.

Multiple meanings of the 'modern woman' in the city

Although the filmic depiction of prostitutes and sing-song girls could draw upon traditional notions of female self-sacrifice or allegorise their plight as symptoms of national weakness, discourses of the 'modern woman' in the 1920s and 1930s were far more ambivalent and contradictory. Up until the 1920s 'modern' or 'new' woman could suggest the earlier politically motivated woman (such as the suffragists), the independent career woman, the educated woman of high morals who retained personal autonomy in marriage (Hu Shi's 1918 definition), or even the skilled, knowledgeable and diligent household manager and mother, exploited by entrepreneurs like You Huaigao, who, in advertising their products (in this case dairy goods), exalted the 'modern' middle-class housewife and savvy consumer as the very epitome of urban modernity (Glosser, 1995). By the late 1920s, however, the 'modern woman' had also become a symbol of glamour, fashion and desirability. Yet the term coined for 'modern woman' (*modeng nüxing*) – sometimes also referred to as the 'modern girl' (transliterated as *modeng gou'er*, which borrowed from the Japanese transliteration *modan garu* or *moga*) – had negative connotations of shallow westernisation and selfish hedonism, especially for male intellectuals (of both left and right) anxious to revive their traditional role as the moral guardians of society (Edwards, 2000b, p. 115).[28]

Short stories by avant-garde male writers of the 1930s such as Mu Shiying and Liu Na'ou depicted the 'modern woman' as a dangerous but alluring 'femme fatale' leading an unrestrained lifestyle in the city, who invariably seduces and then abandons the hapless male narrator (sometimes relieving him of his money) (Shih, 1996; Lee, 1999, pp. 28, 193; Dong, 2008). On the other hand, in a women's journal of the 1930s, *Linglong* (*Elegance*), the modern woman is depicted as self-assured, eloquent and high-minded, while men are caricatured as false, vulgar and greedy (Mittler, 2007).[29] The 1935 film *New Woman* (*xin nüxing*) reintroduced the idea of the politically conscious woman (Zhang, 1994; Harris, 1997). The main character, Wei Ming, played by Ruan Lingyu, is an ambiguous figure; a modern student who elopes with a man against her family's wishes (he then abandons her), she tries, and ultimately fails, to build an independent career for herself through teaching and writing fiction. She falls victim to male exploitation and malicious slander and finally commits suicide (in real life Ruan Lingyu became embroiled in a messy marriage dispute and was the target of press gossip that resulted in her own suicide shortly after the film was released). The character of Wei Ming is contrasted with that of her housemate, Li Aying, a factory worker with a 'social conscience' who teaches at a workers' night school (introducing the workers to class-conscious adaptations of popular songs that she has composed). The finale of the film juxtaposes the scene of Wei Ming's death in hospital (her desperate last words being 'I want to live') with that of Li Aying leading her fellow female workers out on strike and singing of the future end to class and gender division.

Discussion of the 'modern woman' was also closely linked to the question of dress, and this was especially evident in the case of the *qipao* (in Cantonese, *cheongsam*), which became a contested symbol in the 1920s and 1930s (Finnane, 1996; 2008, pp. 134–41; Szeto, 1997; Clark, 1999). Originating in the 1920s as a single-piece robe, it evolved from the 'banner gown' worn by Manchu women and the long gown (*changpao*) worn by men. As already noted (in Chapter 3), the loosely fitted and ankle-length *changpao* actually began to be worn by female students in the 1910s and was much criticised by conservative male observers who thought it unseemly that girls should adopt men's dress. This changed when Song Qingling wore a plain *qipao* at the funeral of her husband, Sun Yatsen, in 1925; it soon became a symbol of national identity for women. During the next decade, however, the *qipao* was progressively 'feminised' and 'eroticised' – cut close to the body with long slits up the sides and more colourful patterns. 'Modern' women in revealing *qipao* increasingly adorned advertisements, fashion magazines and calendar posters (Del Lago, 2000). Although the GMD government proclaimed the *qipao* as the national dress for women in 1928, its erotic appeal continued to trouble some GMD conservatives. After the communist revolution in 1949 the *qipao* was associated with a decadent and bourgeois lifestyle and it fell out of use (although until the early 1960s the wives of top party and government leaders wore it for certain state functions).

Legal change and women's rights in city and countryside

Although the GMD after 1927 had clamped down on the women's movement, it was still committed to the modernisation of the family. Family legislation, in effect, was to be harnessed to the GMD's state-building project (Glosser, 2003, p. 83). A 1931 family law declared that henceforth marriages would be based on the free choice of the partners concerned, while guidelines were drawn up prescribing simple wedding ceremonies, in which participants and (non-kin) witnesses would bow to the Nationalist flag and portrait of Sun Yatsen *before* the bride and groom bowed to their ancestors (the marriage oath was also to include an expression of loyalty to the people and the state) (Glosser, 2003, pp. 87–9, 92). Later, in 1935, the GMD even promoted group wedding ceremonies (in which there would be no mention of ancestors) as a more effective way of consolidating people's loyalty to the party and the state.[30]

Also, the new GMD Civil Code (1929–30) – on the basis that all citizens were equal before the law – accorded women the same divorce rights as men, allowing them to initiate a divorce on ten different grounds (including bigamy, adultery, ill-treatment, incurable disease or mental illness).[31] The Civil Code additionally allowed 'no fault' divorce by mutual consent (in some cases couples announced the dissolution of their marriage in the newspapers) (Bernhardt, 1994). In cities, at least, women seem to have taken advantage of these new rights. Records from the early 1940s indicate that women filed for divorce more frequently than men. In Shanghai, for example, women initiated 74 per cent of divorce suits in 1940–1, while in Beijing 77 per cent of divorce suits were filed by women in 1942 (Bernhardt, 1994, pp. 195, 198).[32]

Another important feature of the GMD Civil Code was the principle of equal inheritance rights for women. Daughters were now legally entitled to inherit as well as sons, although this only took effect *post-mortem*; a father could still give property to his sons while still alive (under the guise of bestowing a 'gift'). Widows also were entitled to receive an equal share of property with sons and daughters. In some ways, however, these new provisions disadvantaged women. Since property was now considered the *individual* possession of the father (i.e. no longer perceived as belonging to the family or patriline), widows no longer had the custodial powers (or protection) they had enjoyed under the old patrilineal system;[33] sons and daughters could demand division of the property to acquire their statutory share and thus leave a widow potentially vulnerable (Bernhardt, 1999, pp. 126–31). In practice, too, daughters might receive less; their rights were already undermined by *pre-mortem* household division (in which they had no legal right to a share), but even in the case of *post-mortem* inheritance they often had to press their claims in court.[34]

One of the most significant legal changes was to do with adultery. The new GMD Criminal Code in 1928 (which replaced the provisional one promulgated by the new republic in 1912) made adultery a crime only for the wife, even though the Civil Code was to make adultery on the part of either party in marriage acceptable grounds for divorce. This in fact had been the situation since 1912; due to the gender-specific language defining adultery (having sex with a married woman), a married woman was always guilty of adultery for having sex with another man (whether married or not), whereas a married man was only liable for having sex with a married woman (he was thus exempt from the law for keeping a concubine).[35] A vigorous lobbying campaign by women's groups sought to persuade GMD legislators to amend the law; skilfully presenting their case by holding press conferences and citing the GMD's own rhetoric of gender equality before the law, they succeeded in getting the adultery clause amended in 1935. For the first time a married man could be punished for committing adultery and/or keeping a concubine (which was now criminalised as 'adulterous') (Huang, 2001, p. 33; Tran, 2009). As a recent study notes, the revision was more concerned with regulating male sexuality (the 'cheating' husband was now perceived as a threat to family and social order) than with enacting gender equality *per se* (during the course of the debate, moreover, the need to regulate a woman's extramarital activities was never questioned) (Tran, 2009, p. 194).[36]

There was another intriguing case of gender, public opinion and the law during the period of GMD rule. In 1935, in the northern city of Tianjin, Shi Jianqiao assassinated an ex-warlord whom she held responsible for the death of her father several years previously. She elicited what has been termed widespread 'popular sympathy' by justifying her act as one of a filial daughter exacting 'righteous vengeance' (a concept that has a long history in Chinese culture) (Lean, 2007). In the debate that took place in the newspaper press during her trial she was also likened to a modern female knight-errant embodying the virtues of a new martial nation. Although a lower court sentenced Shi to life imprisonment for homicide, the verdict was later

reversed in 1936 by the Supreme Court in Nanjing, which reduced the sentence to seven years because of 'mitigating' circumstances deserving judicial compassion. Shortly afterwards the Nationalist government granted Shi a pardon; in this particular case, 'popular sympathy' that deemed 'righteous vengeance' in the name of filial piety and sentiment a *moral* act trumped official law.

The GMD's legal provisions granting women marriage, divorce and inheritance rights did not have a significant impact in China's vast rural hinterland (it should also be noted that the Nationalist government's political control over large areas of the country was very limited anyway). There was another region, however, that witnessed an equally ambitious attempt to change traditional marriage practices and enhance women's status. After the breakup of the United Front many communists (including Mao Zedong) had retreated to the countryside and over the next few years a number of rural soviets were created in south-central China, the largest one situated along the border of Jiangxi and Fujian provinces (the Jiangxi Soviet), which Mao formally established in 1931. An All-China Congress of Soviets held that year in Ruijin (the capital of the Jiangxi Soviet) promulgated a provisional constitution that promised the complete emancipation of women (Meijer, 1983).[37]

Shortly afterwards, a series of marriage 'regulations' were issued which allowed absolute freedom of marriage and divorce. Henceforth marriage was to be freely consented to by both parties without interference from a third party, and was to be registered with local soviet authorities (the legal age of marriage was also set at 20 and 18 for groom and bride respectively). Divorce was permitted if only one party desired it (no specific grounds for divorce were stated), the sole proviso being that a man had to guarantee his ex-wife's subsistence (she was also free to take her children with her) until such time as she remarried.[38] Significantly, also, the regulations banned the custom of giving bridegifts (brideprice) and dowries. This was seen as especially beneficial for poor peasant men unable to marry because they could not afford to pay brideprice, and in fact Mao stated at this time that 'finding a wife' was one of the benefits of the revolution (Hu, 1974, p. 480). This may have encouraged extreme action on the part of local cadres, with reports of them forcing widows to remarry within days of their bereavement (Hu, 1974, pp. 483–4).

In 1934 a more formal Marriage Law was passed by the Jiangxi Soviet, which reaffirmed the provisions of the 1931 regulations with a few revisions/additions.[39] As the Jiangxi Soviet from 1932 onwards had to confront military attacks from GMD forces, it was essential to maintain morale within the CCP Red Army (mainly comprising poor peasant men). The 1934 law now insisted that wives of Red Army soldiers had to seek their husbands' consent if they wished a divorce. Such a provision would be included in all subsequent CCP marriage regulations in the regions it controlled, especially when most of the CCP forces had to evacuate the Jiangxi Soviet in 1935 (in what became known as the Long March)[40] and retreat to the more desolate and poor region of the north-west (Shaanxi province), where it was even more crucial not to alienate poor peasant men.[41]

Women, rural revolution and war

The full-scale invasion of China by Japan in 1937 brought untold suffering to the Chinese people. During the course of the eight-year War of Resistance against Japan, over 20 million soldiers and civilians perished. There was a dramatic increase in the number of widows and orphans, families were torn asunder, and a tide of refugees fled westwards away from the eastern coastal regions occupied by the Japanese. Many made their way to Chongqing in western China (Sichuan province), where the Nationalist government retreated in 1938 following the brutal capture of Nanjing in 1937. Chongqing endured heavy Japanese aerial bombardment throughout the war, but the Nationalist government held out. In other parts of China (such as Shandong province in the east) scattered Nationalist forces continued to resist the Japanese. Meanwhile, the CCP conducted a guerrilla campaign against the Japanese from several rural base areas (or 'Border Regions') in north-west, north and central China. The principal base area (where Mao and other leaders were located) was centred on Yanan (Shaanxi province in the north-west).[42] Yanan became a symbolic centre of the resistance to which thousands of intellectuals, students, writers and artists from eastern regions flocked (including a little-known actress in Shanghai, Jiang Qing, who was to become Mao's third wife). Although a second United Front between the GMD and CCP had been formalised at the end of 1936 to confront the Japanese threat, mutual suspicion and hostility characterised their relations during most of the war, which meant that very little cooperation occurred. The two parties would once again battle for national supremacy in a civil war (1946–9) that broke out within a year of the Japanese surrender that marked the end of World War Two in Asia.

What were women's experiences during the war? Long overlooked by historians, the everyday lives of Chinese women in the wartime capital of Chongqing have been brought to light by a recent collection of memoirs based on interviews (conducted between 1994 and 2007) with twenty women who lived in Chongqing during the war (Li, 2010). Such memoirs testify to the courage, determination and adaptability displayed by Chinese women in order to survive the suffering and destruction of the war; in many ways, their efforts in keeping their families alive were as important an element of the resistance as military conflict (Li, 2010, p. 7). A women's journal published (and edited by female CCP members) in Japanese-occupied Shanghai in 1938 likewise bore testimony to the abuse, deprivations and hardship experienced by women as well as to their 'heroic' and 'patriotic' endeavours to survive and feed and clothe their families; they also (whether lowly taxi-dancers or educated upper-class women) actively participated in fund-raising initiatives for the war effort (Glosser, 2004).

Surprisingly, the war gave Chinese female suffragists the opportunity to advance their cause. Throughout the 1930s, in fact, women's associations (now firmly integrated within the GMD party structure) had continued to demand voting and election rights; in 1936, finally, the constitution promulgated by the GMD regime provided for a National Assembly (to be convened in 1937) whose delegates would be elected by universal and equal suffrage.

These constitutional plans had to be put on hold following the Japanese invasion; Madame Chiang Kai-shek, furthermore, in a much heralded speech in 1938 called on women to devote all their energies to supporting the war effort, insisting that all women's activities be channelled through the Women's Advisory Committee of the New Life Movement, which she headed (thus preempting the development of any independent women's movement).[43] This did not prevent a number of female professionals (including Wu Yifang, China's first female university president) from lobbying for a minimum quota of seats for women in all future national legislative bodies on the basis of 'women's difference' and hence need for separate representation; they also justified their demands on the grounds of women's patriotic service to the nation. Taking advantage of representation on the People's Political Council set up by the government in 1938 (between 1938 and 1947 up to fifteen women sat on the Council), the women's lobbying campaign was ultimately successful when Chiang Kai-shek sanctioned the convening of a National Assembly in November 1946 that proposed minimum quotas for women in the Assembly; an electoral law passed the next year guaranteed in the future 168 National Assembly seats for women (to be filled by delegates from women's organisations). In elections for a new Assembly in 1947 (the last to be held under the GMD regime), 201 women were elected (out of a total of 3,045). Such constitutional developments were soon overtaken by events (the Civil War) and the sweeping away of the GMD regime (which would retreat to the island of Taiwan in 1949 and declare itself the Republic of China), but the achievements of the pre-1949 Chinese suffragists should not be underestimated.

The CCP also encouraged women's political participation in the areas it controlled. The first Congress of the Chinese Soviet Republic in Jiangxi (1931) had guaranteed female suffrage, although there was considerable local variation in the implementation of voting rights and women's actual participation (Walker, 1978). Scattered reports during the Jiangxi Soviet period indicate growing female political representation; Mao, in a 1933 report on a 'model' township in Caixi (southwest Fujian), noted that 30 per cent of representatives in the district congress were women, rising to 64 per cent by 1933 (it was probably the case that, with increasing numbers of men joining the Red Army to combat GMD offensives, there was more scope for women to become politically involved) (Davin, 1973, p. 75). Also at this time, in Xing'guo county, one-quarter of the membership of another township congress was composed of women (Walker, 1978, p. 69). In Yanan after 1936 encouragement of women's political activism continued; an electoral law allowed everyone over 16 to vote and stand for election in local and district congresses. In 1949, on the eve of the CCP's victory in the civil war, Deng Yingchao reported that 30 per cent of elected village representatives were women, while at district level 20 per cent of cadres were women (Edwards, 2008, pp. 226–7). More focused recent research into the relationship between the CCP and women at grass roots level indicates that women's political role varied considerably from county to county depending on existing political and economic conditions. In another CCP base area in south-east Shanxi (part of the Shanxi–Hebei–Shandong–Henan Border Region), for example, where the existence of a women's organisation pre-dated

the establishment of a CCP presence in any one county, women tended to play a more active political role and even achieved parity with men on the county party committee (Goodman, 2000).

During the course of the war, however, the Party toned down its rhetoric on women's emancipation in order to adapt to local conditions and pre-empt hostile reaction from peasant men. In 1941 there was more talk of achieving liberation *within* the family, while equality, the Party insisted, would result from everyone supporting the war effort (although women did not participate in the war as regular Red Army soldiers, they played key supporting roles in all-women medical teams or as members of local defence units) (Spakowski, 2005, pp. 134–5). The idea that 'struggling' against men was a prerequisite for emancipation was explicitly criticised (Hua, 1981, p. 12; Stranahan, 1983a, pp. 43–4). Women's associations were instructed to coordinate childcare and production in order to avoid popular perceptions that they were simply vehicles for encouraging 'family disruption'. All this meant that the Party had to carefully calibrate its marriage reform policy. Marriage customs and practices in the region in which the CCP found itself after 1936 (in Shaanxi province) took several forms, ranging from polyandry to the custom of *zhaofu yangfu* ('invite a husband to raise a husband'), where a 'second' husband was taken by a wife to help support an ill or incapacitated first husband (see Introduction) (Hua, 1981, pp. 25–6).[44] The man 'invited in' was often a poor peasant unable to pay brideprice for a wife of his own; the plight of such men fated to remain unmarried because of their inability to 'find a wife' is well illustrated at the beginning of Chen Kaige's path-breaking 1984 film, *Yellow Earth* (set in a remote area of the Yanan border region during the war).[45]

Three legal texts on marriage were published by the CCP in Yanan (other communist border regions issued their own marriage regulations). All three (1939, 1944, 1946) affirmed the principle of monogamy and called for an end to 'marriage by barter', but also aimed to place more restrictions on the absolute freedom of divorce (now seen as potentially harmful for poor peasant men) originally guaranteed in the 1931 Jiangxi marriage regulations. By 1944 it was also specifically confirmed that divorce between soldiers and their wives was not allowed (except in cases where the husband deserted or went over to the enemy).

Party policy on women was very publicly criticised in 1942 by the writer Ding Ling, when she wrote an article in an official party newspaper calling into question the party's commitment (or ability) to change popular attitudes towards women. In particular, she satirised male double standards concerning women, who were ridiculed as 'Noras returning home' if they focused on household and maternal duties, while often being the target of malicious gossip and rumours if they remained unmarried and worked alongside men in the public sphere (she also pointedly referred to the arbitrary manner in which male cadres made use of divorce provisions in the law to 'rid' themselves of 'backward' wives).[46] Ding Ling's article was roundly condemned by Mao and the party leadership, and she was forced to retract her views and undergo a public 'self-confession', a graphic illustration of how difficult it was to advance a critique of, or an alternative view to, the CCP's stated policy on women (Evans, 2008a, p. 74).

It was very much in response to Ding Ling's critique that the party issued a formal policy statement on 'women's work' (passed by the Central Committee) in February 1943 that insisted women's liberation would come about through participation in production (which would bring material benefits to families). With the Yanan border region having to face a hostile economic blockade imposed by the GMD after 1942, it was also important for the border region to achieve self-sufficiency in basic materials. It was not the time, Cai Chang commented, to engage in 'empty talk' of women's emancipation, and she insisted that slogans should no longer refer to 'free choice marriage' or 'equality of the sexes', but rather should emphasise the importance of a 'flourishing family' and the promotion of 'health and prosperity'. Shortly afterwards a 'production drive' campaign was launched, which succeeded in mobilising large numbers of women (in a region where traditionally women did not work 'outside' the home) to join together in spinning and weaving groups and workshops to make clothes and shoes for the CCP army and local populace. In 1944 it was estimated that up to 60,000 women in the Yanan border region were engaged in weaving, while 153,000 were employed in spinning (Davin, 1973, p. 22).[47]

During the course of the production drive campaign the party publicised the 'heroic' efforts of a number of 'labour heroines' who through their hard work and patriotism (rather than revolutionary fervour) had contributed to increased economic production (by January 1945 the Yanan border region had recorded 12,000 such 'labour heroines'). The first of them was a fifty-one-year-old widow, Liu Guiying, who had supported her family by spinning large amounts of cotton and earning considerable income, as well as taking the lead in organising all-women spinning groups (Stranahan, 1983b, p. 230). Interestingly, while earlier female role models publicised in spoken drama and film to encourage resistance against the Japanese had drawn on traditional figures like Hua Mulan because of their dedication to the collective interest of the nation (Hung, 1989),[48] details of the 'labour heroines' (many of whom came from poor families) published in the press during the production campaign indicated that self-interest and a desire to raise their standard of living was an important motivation for them.

Just as during the early 1940s, when the CCP encouraged women to support the war effort and participate in production (as a means of achieving emancipation), so at the height of the civil war (1946–9) the CCP-led women's movement was subordinated to the larger cause of revolutionary victory; thus in 1948 a Central Committee directive warned against 'excessive' promotion of women's liberation at the expense of class struggle against landlords and village elites. At 'speak bitterness' (*siku*) meetings and rallies orchestrated by local party activists to encourage peasants to confront and denounce their landlord oppressors, women's associations were advised to encourage village women to denounce landlords rather than husbands (many of whom reacted with hostility to their wives attending meetings of the local women's association, scornfully referring to them as 'prostitutes' meetings') (Davin, 1973, p. 81). Nevertheless, women continued to give vent to their own suffering in arranged marriages and abusive marital relationships. In a classic

first-hand account of revolutionary struggles in a north China village (Long Bow Village, in Shanxi province) during the spring and summer of 1948, the American agronomist William Hinton (1919–2004) tells the story of a seventeen-year-old peasant woman who sought the assistance of the women's association in securing a divorce. Encouraged to recount her life at a public meeting of village women, she accused her husband and father-in-law of cruel and inhumane treatment since her marriage (she had been betrothed at the age of ten and married at age fourteen, regularly beaten and confined to the home); the public meeting sanctioned the divorce (Hinton, 1997, pp. 157–60).

Meanwhile, in cities such as Shanghai during the late 1940s women's strikes and protests graphically illustrated the GMD's loss of credibility and growing inability to maintain social order in urban centres. In early 1948, for example, women were involved in a large-scale strike at the Shenxin Number 9 cotton mill (one of many protesting against runaway inflation and the rise in the cost of living). The mill (most of whose workers were women) was occupied for three days, before it was stormed by police; in the ensuing violence three female workers were killed (Honig, 1986; Roux, 2002).[49] Coinciding with the strike at the Shenxin Number 9 mill, there was a huge demonstration of dance hostesses (*wunü*) reacting angrily to a government ban on cabarets the previous year (part of the GMD's plan, ultimately unsuccessful, to 'clean up' the city). Up to 3,000 dance hostesses marched on the government's Social Affairs Bureau, clashing with police and smashing up the premises; hundreds were subsequently arrested, but the government rescinded its ban (Field, 2010, pp. 234–51).

With the CCP's victory in the civil war, and the formal establishment of the People's Republic of China in October 1949, women's lives were to undergo dramatic changes, although continuities persisted in the way policy towards women after 1949 was to be consistently tailored to fit other political, economic or social priorities.

6

The New Communist State and Marriage Reform in the 1950s: 'Public Patriarchy' in Practice?

In the classic account of the Chinese communist revolution, *China Shakes the World* (first published in 1949), the journalist and war correspondent Jack Belden (1910–89) recounted the story of a twenty-one-year-old peasant woman called Kinhua (Gold Flower) whom he had met while staying in a village in Hebei province (north China) in 1947 (Belden, 1970, pp. 275–307).[1] Forced by her parents at the age of fifteen to marry a man many years her senior, Gold Flower suffered cruel and abusive treatment from her husband and father-in-law. Her salvation came in the shape of the village Women's Association that had been formed with the encouragement of a male communist cadre recently arrived in the village (shortly before, a unit of the communist 8th Route Army had also passed through the village). The father-in-law was confronted by several members of the Women's Association and hauled off to a mass meeting of women to face public criticism. Gold Flower herself was emboldened to denounce her father-in-law openly:

> The crowd groaned. In the heavy swelling voices, the sound of shuffling feet could be heard. Gold Flower felt herself being pushed aside. A fat girl was at her elbow and others were crowding close. 'Let us spit in his face', said the girl. She drew back her lips over her gums and spat between the old man's eyes. Others darted in, spat in his face, and darted away again. The roar of voices grew louder. The old man remained standing with his face red and beard matted with saliva. His knees were trembling and he looked such a poor object that the women laughed and their grumbling and groaning grew quieter. (Belden, 1970, p. 293)

With the father-in-law publicly humiliated and 'confessing' to his bad behaviour, Gold Flower gained in confidence, becoming a leading member of the village Women's Association (and vowing vengeance on her husband, who in the meantime had been away working in a city further north). On his return,

he too, once it became clear he had no intention of altering his behaviour, was publicly denounced and beaten up at a meeting of the Association. Although the husband repented, Gold Flower ultimately decided to divorce him because he could not bring himself to accept his wife's joyful embrace of the coming 'new society', which, in Gold Flower's view, was synonymous with gender equality. For Belden, Gold Flower's story illuminated one of the principal causes of communist success:

> In the women of China, the Communists possessed, almost ready-made, one of the greatest masses of disinherited human beings the world has ever seen. And because they found the key to the heart of these women, they also found one of the keys to victory over Chiang Kai-shek. (Belden, 1970, p. 317)

As an indication of how important gender issues had been in the Chinese communist revolution, one of the first legislative acts implemented by the People's Republic of China inaugurated by Mao Zedong in October 1949 was the Marriage Law of 1950. Together with the Land Reform Law in the same year, such legislation formed the central plank in the CCP's programme to create a 'new democratic' society. The 1950 Marriage Law, however, represented in some ways the culmination (rather than the starting point) of attempts by the CCP from the 1930s on to provide women more freedom in marriage and divorce, as well as to abolish 'feudal' practices of concubinage, child betrothal and brideprice. The 1950 Law, nevertheless, was the first effective nationwide campaign to implement marriage, divorce and inheritance rights for women (previous initiatives in marriage reform had been either piecemeal and confined to specific regions under communist control, or enacted in law by the *Guomindang* state but with little practical impact in large areas of the country because of the regime's limited political and military control beyond the principal urban centres and eastern seaboard). As a law guaranteeing women's equality with men, the Marriage Law, along with state support of women via employment in the state sector, and making women's reproduction a public rather than a private concern (illustrated by state provision of maternity leave and day care facilities during the 1950s), thus constituted what might be termed 'state feminism' (Yang, 1999, p. 37).

The Law also represented a significant event in China's modern state-building process, since marriage – in former times essentially a 'private' transaction between family male heads and/or lineage elders – now clearly came under the purview of the state (a development that had originated with the *Guomindang* regime in the 1930s). As the new 'public patriarchs', the CCP also used the Marriage Law to enforce its own prescriptions concerning marriage, divorce and sexuality; for the CCP heterosexual monogamous marriage was considered the absolute norm. This chapter analyses the significance and impact of the Marriage Law in the early and mid-1950s, as well as the role of the Women's Federation, established by the CCP in 1949 to promote women's interests – which were often subordinated to national economic priorities in the early years of the People's Republic.

Women, marriage and the 'new democratic patriarchy'

The Marriage Reform Law was a key item in the new communist government's agenda of abolishing 'feudal' customs and practices. Although it aimed to improve and enhance women's status within the family and marriage, the law did not target the family *per se* as an institution; in fact, the law was designed to reknit or restore peasant communities after decades of civil war, foreign invasion and agrarian crisis had led to the break-up of families and increasing impoverishment. Family life was to be sustained, not abolished, by the introduction of what has been termed a 'new democratic patriarchy' in which women were granted more rights while men (especially poor peasant men) had the opportunity to fulfil their family ambitions (Stacey, 1983, p. 13).[2] In a wider sense, the revolution of 1949, although undercutting the power of patriarchs, in fact created the demographic and material conditions (improvements in health care that reduced the mortality rate and restrictions on internal migration that tied most adult men to villages of their birth) that were *conducive* to multigenerational households in close contact with nearby kin (Davis and Harrell, 1993, p. 1). There was a certain irony to this, given the fact that the defeated *Guomindang* regime now established on the island of Taiwan (and which portrayed itself as the sole 'authentic' and legitimate China) frequently condemned the 'communist bandits' on the mainland for invidiously seeking to undermine Chinese family life. On the other hand, as another study has noted, the law's targeting of sexist and oppressive family practices represented a 'reassertion of the more radical anti-patriarchal, anti-Confucian impulses of the May Fourth tradition' (Johnson, 1983, p. 95).

The Marriage Law took its cue from the Common Programme drawn up by delegates to the People's Political Consultative Conference convened by Mao Zedong in September 1949. The Common Programme represented a kind of manifesto for the new regime, and, in addition to guaranteeing certain rights to the 'people' ('political reactionaries' such as former landlords and supporters of the *Guomindang* regime were excluded), outlining a plan for land reform, and calling for the development of heavy industry, it specifically promised to improve women's situation:

> The PRC (People's Republic of China) abolishes the feudalistic institutions which hold women in bondage. In political, economic, cultural, educational and social aspects of life women possess equal rights and privileges with men. Freedom of marriage is adopted for both men and women. (Yang, 1959, p. 121)

Less than a year later, on 1 May 1950, the Marriage Law was formally promulgated.[3] On the one hand, the law clearly proscribed all forms of arranged marriage in favour of a 'new democratic' marriage system based on the free choice of the partners (article 1), while article 2 abolished 'feudal' practices such as brideprice (although no mention was made of dowries),[4] concubinage and child betrothal – one example of which was taking in a 'foster daughter-in-law' (*tongyangxi*), whereby a young girl was 'adopted' (i.e. usually sold by her parents) and raised by a family in order later to become the wife of a son when he reached marriageable age (until then she fulfilled the role of a maidservant).

'Minor marriage', as this latter practice has been called, was prevalent amongst the poor in southern provinces such as Fujian and Guangdong; in some cases a *tongyangxi* was actually bought into the household *before* the birth of a son (Wolf and Huang, 1980, pp. 2–6).[5] Such practices would also be curtailed by article 4 of the law, which prescribed minimum ages for marriage of 18 for women and 20 for men. In abolishing arranged marriages, the new communist government sought to end women's dependence on male kin; the law also proscribed the elaborate series of traditional marriage rituals designed to symbolise a bride's separation from her natal home and her subsequent subordinate position within her husband's kin group (Croll, 1984b, p. 45). Women were also given the right to keep their own family name after marriage, and to enjoy equal rights in the possession and management of family property. In terms of divorce, either party had the right to petition for divorce (precise grounds were not specified), although the law insisted that in cases of *ex parte* (unilateral and contested) requests a process of mediation had to take place first; only when this failed would a divorce be granted (Huang, 2005, p. 154).[6] Significantly, also, article 19 (which represented a continuity with the Jiangxi Soviet Marriage Law of 1934 rather than the 1931 Marriage Regulations) insisted that wives of soldiers had to seek their permission first before applying for divorce – an enjoinder that could be waived in the event that a soldier did not maintain correspondence with his or his wife's family for over two years (either prior or subsequent to the promulgation of the Marriage Law). In cases of disagreement over the division of family property in the event of divorce, the law allowed the courts to take into account the 'principle of benefiting the development of production' – signalling that economic needs in certain cases might take priority over ensuring equality in property (Ocko, 1991, p. 324).[7]

On the other hand, the Marriage Law (in contrast to the Jiangxi Soviet 1931 regulations on marriage) was as much concerned with the viability of the family, which was directly associated with the creation of a new society. Thus article 8 declared:

> Husband and wife are duty bound to love, respect, assist and support each other; they shall unite in harmony, while working and producing, rearing and educating their children, and struggling jointly for the happiness of the family and the establishment of a new society. (Meijer, 1978, p. 449)

Article 13 of the law likewise enjoined parents to rear and educate their children, while also insisting that children had 'the duty to support and assist their parents'. An indication that the law also placed importance on marital harmony was the enjoinder that a man or woman might not marry if either of them were sexually impotent (article 5);[8] given the fact also that sterility was *not* considered a cause in itself for withholding official sanction of a marriage, this suggested that sexual relations at this time were closely linked with a fulfilling marital relationship as well as with procreation, although in official interpretations of the law sex was frequently conflated with reproduction (as evidenced, for example, in the state's eugenic concern for the reproductive health of potential partners, and in the fact that contraception was officially

recommended only for married women who already had children). In the final analysis, the new communist state perceived a harmonious sexual relationship and procreation as interdependent, rather than separate, aspects of marriage.[9] Furthermore, contrary to conventional assumptions, sex-related issues *were* discussed in the 1950s; publications on the 1950 Marriage Law, for example, dealt with such matters as adolescent hygiene, contraception and the meaning of love (Evans, 1997, p. 2). At the same time, scientific authority was often drawn upon (just as had been done during the May Fourth period) to highlight (and naturalise) differences between the sexes.[10] Also, as in the 1910s and 1920s, much of the official discourse on sexual matters was as much about *controlling* people's (for the most part, women's) sexual conduct – a feature of post-Maoist discourse in the 1980s and 1990s as well.

Finally, article 6 of the Marriage Law declared that a marriage had to be registered with the local people's government for it to be considered legitimate. In effect, the new communist government had replaced the clan or lineage head as the public face of patriarchy;[11] in transforming what had essentially been a 'private' arrangement between families and lineages into a state-sanctioned ceremony, the government had tied individuals directly to the state. As one scholar points out, by voluntarily registering their marriage a couple both accepted the principle of government sanction of their marriage and demonstrated their loyalty to the new state (Meijer, 1978, p. 457).[12] This was not entirely unprecedented, since the Nationalist (*Guomindang*) regime in the 1930s had aimed to impose on the population a more state-sponsored marriage ceremony, as well as to clamp down on 'feudal' practices such as expensive weddings and dowries. Just as marrying couples after 1949 during a simple ceremony were expected to bow deferentially to a portrait of Mao Zedong and perform a song praising the achievements of the Chinese Communist Party in improving the lives of the Chinese people (wonderfully illustrated at the beginning of Tian Zhuangzhuang's 1993 film, *The Blue Kite/ Lan fengzheng*), so in the 1930s bride and groom were expected to bow three times before the Nationalist flag and the portrait of Sun Yatsen.

Overall, the 1950 Marriage Law established the premise that monogamous, heterosexual marriage was the *only* acceptable relationship (the privileged model of monogamous heterosexuality continues to be unquestioned today). As the absolute norm, in other words, marriage was deemed a necessary and natural step for everyone (Croll, 1981, p. 2). Not surprisingly, all gender relationships and practices not conforming to this model (such as the traditional sisterhoods and 'marriage resistance' customs discussed in Chapter 5) were suppressed. It might also be noted that, in discourses of sexuality after 1949, the monogamous union that was now so loudly trumpeted as a socialist principle of marriage was represented as a mostly *female* standard of marital conduct. As in the imperial past, it would be *women's* behaviour that served as the principal benchmark of sexual and marital morality.

The clampdown on local marriage customs was a particularly striking illustration of the new regime's determination to be the sole arbiter of gender norms (not unlike the Qing dynasty; see Chapter 1). The practice of extended natal residence amongst newly married women, for example, was especially targeted.

When CCP cadres entered the villages of Hui'an (eastern Fujian province) they were shocked to see wives residing in their natal communities and contributing labour to their natal, rather than conjugal, families (see Chapter 5). Such a practice was condemned as 'feudal' (along with the same-sex female networks common in the region, as well as the unique dress and elaborate headpiece styles worn by Hui'an women); for the authorities these 'abnormal relations' threatened social order, production and reproduction. Wives were ordered to live immediately with their husbands after marriage and, as with the forcible shearing of men's queues after the Republican revolution in 1911–12, attempts were made to forcibly change women's headdress (known locally as *gin'a*) in favour of the simpler headscarf (*hoegin*). Young Hui'an women, however, continued to live apart from their husbands right up until the 1990s, when a growing trend towards married couples setting up house on their own apart from parents prompted women to move in with their husbands straight after marriage; ironically, at a time of market reform in the post-Mao period, these very same 'feudal' practices and dress were portrayed as 'exotic', enhancing the local appeal of the region for Han Chinese consumers and tourists ('ethnic tourism') (Friedman, 2006, pp. 6, 12, 67–70, 74–96).

The CCP demonstrated its persona as 'public patriarch' in two other ways. First, as the People's Liberation Army (PLA) was extending Beijing's control over the far western province of Xinjiang (home to the Turkic-speaking and Moslem Uyghur people), the CCP recruited women as teachers, nurses and agricultural workers to settle on the 'oasis farms' the PLA were establishing. Since Han Chinese PLA soldiers were not permitted to intermarry with non-Han Chinese women, and the Party was concerned that soldiers might resort to banditry and other illegal activities if they did not enjoy the stability that came with having a family, Party officials in some cases 'arranged' marriages between the incoming (Han Chinese) female recruits and PLA soldiers.

Second, in Shanghai the newly installed communist authorities actively sought not only to clamp down on prostitution, but also to rehabilitate prostitutes by finding them suitable employment after a period of appropriate vocational and moral training, and, in some cases, even to arrange 'suitable' marriages for them. This was part of a larger campaign to eliminate all forms of 'decadent' pastimes and activities throughout the city (dance-halls, for example, which had been such a prominent feature of city life in the 1920s and 1930s, were closed down definitively in 1954).[13] The campaign was not carried out immediately; Cao Manzhi, head of the Civil Administration Department and vice-secretary of the people's Government in Shanghai, allowed the Public Security Bureau to continue licensing brothels and prostitutes until 1951 (when all remaining brothels were finally closed), although a series of regulations before then greatly restricted the ability of brothel owners to run their businesses (Hershatter, 1992a, p. 169). The number of licensed prostitutes in Shanghai declined from nearly 2,000 in 1949 to just over 650 in 1951 (with the number of brothels falling from 518 to 158) (Hershatter, 1997, p. 308).[14]

Significantly, the party's anti-prostitution campaign at this time was underpinned by the assumption that a woman's proper place was within the family.

In 1951, for example, a Women's Labour Training Institute (*funü jiaoyangsuo*) was set up in Shanghai to teach former prostitutes the virtues of manual work – with the head of the institute describing the 'reform' process as 'sweeping garbage' (*saoji*) – and then either reunite them with their families (usually in rural areas) or find them suitable husbands (Institute staff would actually 'vet' applications sent by unmarried men looking for a spouse) (Hershatter, 1997, pp. 304–5). It is significant that the term used for 'getting married' amongst 'reformed' prostitutes was *congliang* (following the good or right path). In keeping with CCP propaganda that the new regime sought to reform society and customs through education and 'gentle persuasion', the location of the Institute was not kept secret, nor was it policed or guarded in any heavy-handed way (it was thus not too difficult for any woman unwilling to undergo 'rehabilitation' to escape from the Institute). As with poor peasants during the Land Reform campaign in 1949–51, when they had been encouraged to confront and criticise landlords at public meetings, former prostitutes while at the Institute were encouraged to gather together and speak openly about their former lives, and express their anger at the various groups of people (gang bosses, abductors, pimps and madams) responsible for their exploitation and suffering. All this accorded with the Party narrative that portrayed all 'subalterns' as the thoroughgoing victims of an oppressive class order.

For the new communist authorities, the reported declaration by a former prostitute at a Shanghai police station perfectly illustrated the desired 'narrative':

> Sisters, we are liberated, we are born anew. Sisters, why have our pure bodies been trampled on by others? ... It was the Guomindang reactionaries who harmed us! Today we are excited and happy! The people's government, under the leadership of chairman Mao is helping us to turn over (*fanshen*). (Hershatter, 1992a, p. 173)[15]

Yet the reaction amongst prostitutes to the reform campaign may have been more ambivalent than this rhetoric would suggest. Cao Manzhi, in an interview during the 1980s, remembered that prostitutes were not always enthusiastic about leaving their madams and place of work, often weeping as they were led away.[16] A 1994 film portraying the dramatic lives of two former prostitutes, *Blush* (*hongfen*), also provides an alternative perspective to the master narrative. Directed by Li Shaohong, one of the few female members of the 'Fifth Generation' of film-makers that emerged after the Cultural Revolution, the film questions the efficacy of the rehabilitation process. One prostitute (Qiuyi) is unwilling to be 'reformed' and escapes from the retraining centre (the film is set in Suzhou, near Shanghai) to live with a former client and lover; the other (Xiao'E), seemingly submits to rehabilitation but later unsuccessfully attempts suicide (due to exhaustion induced by physical labour and anxieties about the future, rather than because of the degradations of her past life). The melodramatic *denouement* of the film likewise subverts the master narrative. While Qiuyi eventually becomes a self-sacrificing and caring mother, it is out of affection for her former lover and not in recognition of CCP-inspired moral

reform. Xiao'E, meanwhile, eventually reverts to her old ways and lifestyle, abandoning her child to the care of Qiuyi and running off with a man.

In 1953 the Institute began 'releasing' some of its inmates. Some were found jobs in Shanghai factories, while others were 'married off', reunited with their families in the countryside, or sent to work on state farms in the far west of the country (in the provinces of Gansu, Ningxia and Xinjiang). By the time the Institute closed down it had retrained more than 7,000 women. Communist paternalism, as illustrated in the rehabilitation of prostitutes, was strikingly similar to late nineteenth and early twentieth-century Confucian paternalism as demonstrated by the Hall for Spreading Benevolence established by gentry elites in Tianjin (see Chapter 2). The Shanghai Women's Labour Training Institute, like its Confucian antecedent, comprised a workshop and a school (for the children of former prostitutes), as well as buildings that could accommodate up to 1,500 people. As with the case of the destitute women at the Hall for Spreading Benevolence, the former prostitutes, now dressed in appropriate 'workers'' clothes, received a symbolic salary for the labour they performed (such as textile manufacture) and, after 1954, were paid piece-wages (Henriot, 1995, pp. 477–80).[17]

In its representations of the 'new society', therefore, and contrasting it with the 'backward' and 'feudal' society before 'liberation' in 1949, the CCP in the early 1950s deployed women's bodies and stories. One example of the CCP's representation of women as both the principal victims of the old society and beneficiaries of the new occurred in Zhejiang province, where an exhibition devoted to the revolution featured a woman as a 'live exhibit' recounting to visitors her previous misfortunes and how her life had changed since 1949. Chased out of the marital family home by a cruel husband and mother-in-law, she and her daughter were left to fend for themselves in grinding poverty for several years. With the promulgation of the 1950 Marriage Law she was able to appeal her case in court and the mother-in-law was punished; at the same time her economic livelihood was secured when the authorities allocated her a job in a factory. An official report on the exhibition portentously summed up the significance of the woman's story:

> She is now a happy woman, full of gratitude to the Communist government and deep conviction for the principles of the Marriage Law as well as the wickedness of the traditional family institution. Whenever a crowd of visitors gather in front of her, she gives her talk and wipes away her tears as she tells her heartrending story of mistreatment by the mother-in-law and husband, and her listeners are deeply moved. (Yang, 1959, p. 203)[18]

On the other hand, the CCP used the symbol of the 'female model worker' (*nüjie diyi*) as a dramatic illustration of the new society and of how female subjectivity had been fundamentally redefined (Chen, 2005).[19] One such 'icon' was the female tractor driver, usually visually depicted as a physically imposing young peasant woman with a confident expression. As a 1952 article on China's first female train despatcher exclaimed: 'from her stalwart body [and] robust arms, I saw the form of China's new women' (Chen, 2005, p. 274).[20]

Exhibiting strength, self-confidence and familiarity with new technology and machinery (and, in some cases, 'instructing' their less enlightened male colleagues), these female model workers were depicted as the polar opposites of pre-1949 women. Although they represented in many ways a *state*-sponsored female agency, it is quite possible that many of them were provided with a new kind of subjectivity – even though this female model worker iconography in effect entailed the universalisation of a 'masculine' ideal. Liang Jun, China's first female train driver, for example, in interviews during the 1990s looked back to the early 1950s with a wistful nostalgia, taking pride in her contributions to the development of agricultural technology and training, and praising the 'new society' for ushering in gender equality (Chen, 2005, p. 281).[21]

It is also important to note that many of the early female model workers were described as having been guided or advised by Soviet experts (in fact, the Chinese iconography of the female model worker drew heavily on the Soviet model). This was especially the case with the first group of female tractor drivers and locomotive engineers, who all came from the north-east (Manchuria), a region that had witnessed a considerable Soviet presence from 1945 to the early 1950s. In August 1945 Soviet troops had advanced into Japanese-controlled Manchukuo (Manchuria) following the Soviet Union's declaration of war against Japan, and, although the troops were eventually withdrawn in 1947 as the entire region soon came under the control of Chinese communist forces, Soviet experts and advisers remained in key urban and industrial centres such as Dairen.[22] Tang Guiying, China's first female train driver, remembered that she had originally been inspired to embark on a training programme after visiting an exhibition in Dairen illustrating the role of female train drivers in the Soviet Union (she was working at the Dairen City Railway Depot at the time). Since Tang in her new role as a train driver continued to look to the Soviet Union as guide and mentor, a recent study has suggested that she may very well have felt part of a female internationalist community (Chen, 2005, p. 286).[23]

Implementation of the Marriage law: winners and losers

The impact of the Marriage law was multifarious and its consequences often unintended; moreover, its effects were often more dramatic in the country-side (or rural counties near cities) than in urban centres. Perhaps the most significant consequence of the law was the encouragement it gave women to make use of its provisions to annul arranged marriages or end abusive relationships. Within a year of the law's promulgation thousands of divorce suits had been filed, the overwhelming majority of which were initiated by women (in September 1951 the official CCP newspaper *People's Daily* reported a total of nearly 21,500 divorce cases in thirty-two cities and thirty-four rural county seats, in which 77 per cent of the plaintiffs were women) (Stacey, 1975, p. 71; Johnson, 1983, pp. 117–18).[24] Between 1950 and 1953 courts granted on average 800,000 divorces a year; thereafter the rate decreased slightly, with 510,000 divorces granted in 1956 (Davin, 1976, p. 101). It should be noted, however, that even under the Marriage Law divorce was not always so straightforward. If only one party desired divorce it could only be granted when

mediation by a district people's court (described by a recent study as 'coercive marriage counselling') had failed to bring about a reconciliation – and this was *after* more informal mediation at the level of the village or work unit had first been undertaken (Huang, 2005, p. 174).

In the beginning, the Marriage Law was implemented simultaneously with land reform, which aimed to complete the process (begun in north China during the late 1940s) of confiscating land owned by non-cultivating landlords and redistributing it primarily to poor and middle peasants.[25] 'Speak bitterness' (*siku*) meetings, at which peasants were encouraged to physically confront land-lords and denounce the exploitation suffered at their hands, were paralleled by similar staged events in which young married women accused parents-in-law of mistreatment and abuse.[26] In some areas local cadres and village officials inter-preted the Marriage Law as a political movement akin to that of land reform, which sometime resulted in the targeting of the older generation (rather than landlords *per se*) as the principal oppressors. Women seeking divorce, however, faced stiff resistance from husbands and parents-in-law. A government report in 1953 estimated that between 70,000 and 80,000 women per year had been murdered or driven to suicide as a result of divorce disputes (Johnson, 1983, p. 87; Stacey, 1983, p. 178). Thousands more suffered physical assault.

In 1953 the party launched a campaign to publicise further the Marriage Law. By this time, however, the leadership was beginning to modify its radical message. Thus the National Committee for the Thorough Implementation of the Marriage Law (of which Deng Yingchao and He Xiangning were key members) proposed that even a divorce application requested by both parties be submitted to the district court for mediation (as in the case of *ex parte* applications) (Meijer, 1978, p. 464).[27] In early 1953, also, a directive from the Government Administrative Council criticised the disruptive potential of the law, which threatened 'family and village cohesion and social stability'. It further advised that education and persuasion should be used to change the 'feudal' outlook of families rather than 'class struggle' methods (Johnson, 1983, pp. 141–2; Croll, 1995, pp. 98–9). Shortly afterwards the Central Committee of the CCP itself warned against 'leftist' tendencies in the imple-mentation of the law. By 1956–7 the 'excesses' of marriage reform were being associated with 'bourgeois individualism'.

Such a shift in approach has led to the assumption that the post-1949 Chinese state (represented by high-level party officials and local cadres) was not fully committed to changing fundamentally gender relations within the family, thereby allowing rural patriarchy to reassert itself (Diamant, 2000b).[28] Recent research has described a more complex scenario (Diamant, 2000a, b). The horrific violence perpetrated against women notwithstanding, rural women demonstrated considerable agency *vis-à-vis* their families and commu-nities in pursuing their rights under the Marriage Law. Taking advantage of the fact that the state was not, in fact, a homogeneous and monolithic entity, women often took their divorce suits higher up the administrative ladder in order to bypass unaccommodating local cadres and village officials, appealing directly to district and county courts (in some cases, village officials, untrained in dealing with cases of marital disputes, were quite happy to see higher-level

courts handle such matters). Generally, higher-level courts were staffed by male personnel who themselves wished to take advantage of the new law to break off their own arranged marriages; they were thus more prone to grant women's applications for divorce (it might be noted that in a wider sense the CCP occupation of urban areas in the 1940s was often seen by communist cadres as an opportunity to acquire 'modern' women and rid themselves of their 'rustic' wives) (Ip, 2003, p. 345).

It was also significant that the most aggressive litigants suing relatives or husbands in court during the early 1950s were rural or working suburban women. Unlike middle-class urbanites, they were less inhibited in speaking out openly and frankly about marriage and sexual matters (Diamant, 2000b, pp. 52–63).[29] This is not entirely surprising, since evidence suggests that even in imperial times urban and rural commoners – including women – were not averse to litigation in the courts (Bernhardt and Huang, 1994, pp. 4–6).[30] Thus in some ways poor peasant men (as well as the older generation initially targeted in the campaign and whose authority was undermined) might be seen as 'victims' of the law as well as 'oppressors'; even PLA (People's Liberation Army) soldiers might have lost out, since, although the law insisted their prior approval was necessary before their wives filed for divorce, such a requirement was often violated by rural women in collaboration with village cadres (with whom they might be having affairs) (Diamant, 2000a, p. 195). Furthermore, although the divorce rate overall declined after 1953 (especially with the stricter imposition of the mediation requirement and the abolition of district courts), women continued to make use of the law and its 'liberationist' implications throughout the 1950s and 1960s in order to secure a better deal within the marriage. In many rural areas there were as many divorces in the early 1960s as in 1953 (Diamant, 2000b, pp. 114–16, 228–9; 2000a, pp.191–2).

Finally, in terms of the freedom of marriage that the 1950 law championed, it should be noted that throughout the 1950s and 1960s what was in fact called 'free choice marriage' inevitably always entailed use of a go-between, especially in rural areas (due to the lack of opportunities for social interaction and continued parental influence). In 1955 the government asserted that marriage contracts between partners who had been introduced to each other by a third party, and then gave consent, constituted a form of 'marriage by free will', and that 'consultation' with parents did not amount to parental 'interference' (Croll, 1981, pp. 31–2).[31]

The role of the Women's Federation

A key organisation involved in the implementation of the 1950 Marriage Law was the All-China Democratic Women's Federation (henceforth WF), formally established in April 1949 when it held its first congress.[32] Affirming that only through active participation in production would women be able to free themselves from the 'feudal yoke' and raise their status, the Congress went on to declare:

> We should mobilise and organise all labouring women masses to participate actively in the democratic movement to exercise their democratic rights, to

eradicate feudal oppression, to join in varied government work, so as to raise and guarantee their political and social position. (Croll, 1974, p. 9)[33]

In the final analysis, the WF was officially an adjunct of the CCP designed to publicise and promote Party policy on women (it assisted, for example, in the CCP programme to rehabilitate prostitutes in the early 1950s). Not until the 1980s would the WF see its major role as the protector of women's and children's legal rights rather than simply functioning as a 'transmission belt' for party policy (Wang, 2007, p. 77).[34]

The WF soon became a nationwide organisation when it oversaw the creation of provincial and county branches (subordinate to the Party Committee at the same levels), as well as representative women's congresses at grass roots level in the villages and residential areas (Wang, 2007, pp. 59–60).[35] This was not always a smooth process; recent evidence demonstrates that in a city such as Shanghai some male cadres in the early 1950s were not entirely convinced that a separate women's organisation was necessary, while as late as 1956 at the party's 8th Congress Deng Yingchao (vice-president of the WF) criticised local party committees for not taking 'women's work' seriously (Croll, 1974, pp. 16–17; Wang, 2005a). By 1953, nevertheless, the WF employed over 40,000 officials nationwide. In places like Shanghai the WF contributed to socialist state-building, helping to organise lane and street (or residents') committees – mainly comprising housewives and older women and responsible for between 100 and 600 households – that oversaw neighbourhood affairs such as ensuring public hygiene and sanitation, or mediating minor civil disputes (later, residents' committees were made responsible for marriage registration and the running of kindergartens) (Davin, 1976, p. 161; Andors, 1983, pp. 37–8; Wang, 2005b). In effect, urban neighbourhoods became a 'domesticated' social space run by older women (Wang, 2005b, p. 525). WF branches could also mobilise large numbers of women for political campaigns; in March 1951 the Shanghai WF branch was able to coax 300,000 women onto the streets to participate in official rallies denouncing the US rearmament of Japan.

In other respects the WF might be involved in the policymaking process itself. It played a role, for example, in modifying the party's extreme pronatalist policy. After 1949 the Ministry of Public Health had imposed strict restrictions on access to contraceptives (perceived as encouraging promiscuity), while in 1952 both sterilisation and abortion were outlawed (except in cases where a woman's health was threatened) (White, 1994, pp. 251–4).[36] By 1953 even the importation of contraceptives was banned. WF cadres raised concerns about these restrictions, arguing that they could have serious health consequences for women. CCP leaders thereupon moderated their stance, and in 1954 the Ministry of Public Health issued new directives sanctioning voluntary birth control (although contraceptives were still off limits in minority nationality regions and rural areas) (White, 1994, p. 258).

The CCP's limited sanction of birth control at this time was not entirely the result of WF lobbying, but was also linked to the ongoing debate about economic planning. The 1953 census reported a population total of

583 million, which had taken the party by surprise (since 1949 official esti-mates had given a figure of 475 million). Excessive demographic growth was seen as a potential threat to realising the aims of the First Five Year plan launched in 1953; hence the party's softening of its pronatalist approach. In 1954 the Ministry of Public Health actually submitted a proposal to the State Planning Commission specifically calling for control of the birth rate. Liu Shaoqi, the Party vice-chairman, also agreed in 1954 that endorsement of birth control should be extended to the countryside, although one elderly woman interviewed at the turn of the twenty-first century remembered that access to contraceptives in her village only occurred in 1971 (Hershatter, 2005, pp. 315–16). In 1956 Mao himself, in his Twelve Year Plan for Agricultural Development, referred to the need to popularise birth control in densely populated areas (White, 1994, p. 268).[37]

Women and the economy

Although the WF at its first congress (echoing the party line) had underlined the crucial importance of women's participation in production as the route to emancipation, by the mid-1950s the urban sector witnessed a slowing down of women's employment in the urban labour force. This was principally because the First Five Year Plan prioritised heavy industry (in which men predomi-nated) in terms of investment, while light industry (such as textiles and food processing), in which women were more usually employed, had a low invest-ment priority. From 1953 to 1957 the proportion of the non-agricultural labour force comprised of women increased only slowly, from 11.7 per cent to 13.4 per cent (Andors, 1983, pp. 36–3).[38] Subsequent WF Congresses sought to rationalise the slowdown. Thus at its Second Congress in 1953 the offi-cial line was that no woman should be forced to work outside the home.[39] By the time of the WF Third Congress in 1957 the importance of 'thrifty house-hold management' was highlighted; if the family was run well, the Congress noted, household members would be free of anxiety and would thus be able to contribute positively to socialist construction.

This policy line was echoed in the 'Five Goods Campaign' launched in 1955 to promote the virtues of the 'socialist housewife' – one who managed the household well, ensured harmony amongst family members, and brought up children conscientiously (Davin, 1976, p. 152). Intriguingly, the valorisation of the socialist housewife coincided with a 'clothes reform' campaign (1955–6) that began with a call to recycle old clothes because of the shortage of cotton cloth (greater diversity of dress was seen as economical). It soon went further than this, encouraging women to wear 'prettier' clothes (including skirts and dresses, as opposed to the plain 'Mao suit' that many wore at this time), in line with the aim of 'beautifying' dress based on principles of 'attractiveness' and 'usefulness'. Even the *qipao* was adapted to a frock design, and in the spring of 1956 fashion 'exhibitions' were held around the country (Davin, 1976, pp. 108–9; Evans, 1997, p. 130; Finnane, 2008, pp. 217–20). One of the key participants in the campaign and a pioneer in Chinese women's fashion design was Yu Feng (b. 1916), a graduate of Beijing University Fine Arts Academy in

the 1930s, and exhibitions curator at the Beijing Central Academy of Fine Arts after 1949.[40]

Ironically, while urban women in the mid-1950s were being urged to stay at home, in the countryside collectivisation of the land in 1955–7 mobilised women's labour, although this was not meant in any way to lessen their domestic responsibilities. As the official CCP newspaper, *People's Daily*, insisted in 1956:

> Participation in agricultural production is the inherent right and duty of rural women. Giving birth to children and raising them up, as well as preoccupation with household chores are also the obligations of rural women. These things set women apart from men. (Andors, 1983, p. 42)

The agricultural collectives (in which land and labour were pooled, and wages paid according to a daily workpoint system) were actually based on natural villages, which in many ways reinforced male kinship ties. In some cases where a village comprised members of the same lineage, the collective was referred to by the lineage surname. All this had a detrimental impact on women's status within the collective; since the 1950 Marriage Law had not altered the patrilocal marriage system, married women remained 'outsiders' with little opportunity to gain a high leadership position within the collective (by the same token, young unmarried women had limited scope to exercise any kind of influence, since they would have been regarded as 'temporary' members before 'marrying out') (Diamond, 1975b). In a wider context, a study of the political and social transformations in a north Chinese village from the 1930s to the late 1950s draws attention to an aspect of the communist revolution to which little attention has been paid. In some cases revolution in the villages promoted a 'macho-military' culture characterised by close bonds among young men; such a male culture may have reduced the opportunities for female bonding, especially as collective labour that began to be institutionalised in the mid-1950s left women little time to build on their informal networks – a feature of pre-1949 rural life that had allowed women to use 'gossip' and the threat of public exposure to check the abusive behaviour of village men (Friedman *et al.*, 1991, pp. 271–72, 277–88).[41]

Women interviewed in the 1990s and early 2000s remembered that collectivisation had simply lengthened their working day; improvements in maternal health and lower levels of infant mortality (which meant more children survived) also added to their domestic burdens. They further recalled that, since in many cases collective and household work was often blurred (such as making clothes and shoes at home), their contributions were neither given recognition nor valued – although many considered themselves more fortunate than their mothers because of greater access to public space and more opportunities to improve literacy (Hershatter, 2005; 2007b).[42] Still, by 1957 there was a cutback in women's employment even in the countryside. Yet barely one year later, with a radical change in priorities enunciated by Mao Zedong's Great Leap Forward campaign, women were to be mobilised as never before in the cause of ideological and economic development.

7

'Women Hold Up Half the Sky': The Great Leap Forward and the Cultural Revolution

Two of Mao Zedong's major initiatives in his quest to build a 'Chinese road to socialism' were the Great Leap Forward (1958–61) and the Cultural Revolution (1966–76). In both, ultimately disastrous, movements women and gender issues occupied – wittingly or unwittingly – a significant place. The Great Leap was an audacious attempt to break with the Soviet model of development by decentralising economic decision-making, industrialising the countryside through the agency of rural communes (amalgamations of producers' collectives), and shifting educational and health resources from urban centres to rural areas. An integral aspect of the Great Leap was the wholesale mobilisation of women in production (especially in the countryside), both to take advantage (in Mao Zedong's view) of China's untapped reservoir of human labour and to fulfil the Engelsian prediction that women's participation in productive labour would inevitably lead to gender equality. During the course of the Great Leap an interesting difference arose between the 'maternal socialism' of male cadres and the Party leadership, and the more radical approach to women's labour exhibited by grass roots female activists from the Women's Federation, who insisted that women be treated exactly the same as men in terms of work allocation. In many ways, however, Great Leap practices and innovations merely reinforced existing gender attitudes and assumptions.

The political and economic failures of the Great Leap (which contributed to a catastrophic famine in 1959–61), and the attempts by Mao's colleagues in the Party, such as Liu Shaoqi and Deng Xiaoping, to reverse a number of Great Leap policies, directly led to Mao Zedong's last political initiative – his movement to kick-start the revolution and eliminate dangerous 'revisionist' (i.e. counter-revolutionary) trends in ideology and practice that he was convinced had taken hold over the party leadership in the aftermath of the Great Leap. The Cultural Revolution, as it became known, entailed an appeal to youth (especially students) by Mao to confront and criticise all forms of authority, whether Party, bureaucratic or academic, and was described very

much in terms of *class* struggle. The movement also involved a condemnation of 'feudal' beliefs and practices (such as religion) and of any interest shown (primarily amongst intellectuals) in western (i.e. 'capitalist') art, literature and music. In engaging with such confrontational activities, Mao hoped that high school and university students (who were organised into units known as the Red Guards) would gain the experience and credentials required of 'revolutionary successors'.

Historians in the past described the Cultural Revolution as a time when gender was totally subordinated to class. Thus the pervasive image of young girls and women, described as 'holding up half the sky' (i.e. women were the absolute equals of men), was androgynous, while 'women's issues' in general were deemed both irrelevant and redundant at a time of 'class struggle'. It was also a time when sex and sexuality (associated with 'bourgeois revisionism') apparently disappeared from the official and public discourse. In fact, as this chapter demonstrates, gender (as well as discourses of sexuality) continued to be significant during this period. Visual evidence such as Cultural Revolution posters, for example, reveals very clear differentiations between men and women in terms of their representation (clothing, tasks being performed, and spatial arrangement in the picture). Furthermore, sexuality was integral to the Cultural Revolution because it was often linked to *political* 'revisionism' or deviance. Red Guard memoirs also show that sex was ever-present during the Cultural Revolution, whether in the encounter between urban youth 'sent down' to the countryside and their peasant counterparts, or in the sexual exploitation and abuse of young women (especially female Red Guards sent to the countryside) by unscrupulous and corrupt local officials and cadres.

Dining halls, nurseries and Engels: women and the Great Leap

As early as 1956 Mao Zedong had indicated his dissatisfaction with the Soviet model as a guide to China's development (the first Five Year Plan of 1953–7, for example, was very much based on the Soviet model, with its emphasis on both heavy industry and centralised planning). In a speech given that year ('On the Ten Great Relationships'), Mao stressed the importance of light industry and agriculture, the industrialisation of the countryside, the decentralisation of planning, labour-intensive, as opposed to capital-intensive, projects, and the use of moral incentives rather than material ones in stimulating revolutionary commitment. The Great Leap Forward was launched in 1958, in effect, to realise these objectives, and represented Mao's utopian vision of a uniquely Chinese form of socialism – one that entailed a renewed emphasis on the key role of the peasantry and the achievement of a collectivist community in which all forms of personal egoism would become extinct. First used at the end of 1957 in connection with a water conservancy campaign that had required a greater mobilisation of manpower than that provided by the collectives, the slogan 'Great Leap Forward' (*da yuejin*) quickly took on a much wider meaning to reflect Mao's boundless confidence that radical social, economic and ideological change would lead not only to a communist society but also to an increase in industrial and agricultural production.

Economically, Mao hoped that the Great Leap Forward would reduce the gap between town and countryside (in which, by November 1958, nearly all rural households had been enrolled in 26,500 communes, which were amalgamations of collectives) through the promotion of small-scale industry such as crop-processing and tool manufacture in the rural areas. Labour-intensive projects, in particular, would, in Mao's view, utilise China's one advantage *vis-à-vis* the more prosperous and developed West – a surplus of manpower. The Great Leap Forward, in fact, brought a temporary halt to the nascent debate over the need to control China's birth rate that had broken out in the early 1950s (see Chapter 6), although it was to be revived in the early 1960s. At the same time, the Great Leap Forward brought in its wake tighter state controls on population movement from the rural areas to the cities (in the early 1950s rural migrants had moved to urban centres in large numbers); this involved the creation of a household registration system (*hukou*) that clearly differentiated agricultural and urban populations with the aim of keeping peasants on the land. The gap between town and countryside would be further reduced by an expansion of rural health and educational facilities (clinics, use of paramedic personnel known as 'barefoot doctors' and who had a training in traditional Chinese medicine, half-work-half-study schools); thousands of students and intellectuals from urban centres were also 'sent down' (*xiafang*) to the countryside to live and work amongst peasants.

It was against this background that the CCP returned to the Engelsian approach to women's liberation that it had apparently abandoned in the mid-1950s. With Mao's call for the mass mobilisation of China's population in productive labour, it was once again confidently predicted that women's participation in production would enhance their status and allow them to break the shackles of 'feudal' ideology. It was also expected that the creation of communal dining halls, day care centres and nurseries under the aegis of the communes would allow women to benefit from the socialisation of housework. In a sense, however, the near-total mobilisation of women during the Great Leap (unprecedented in world history before the use of labour-saving devices and technology in the household would allow this) and the use of their labour was a substitute for capital investment – despite the frequent directives of the Women's Federation that emphasised the goal of such mobilisation as one of ensuring equality between the sexes (Andors, 1983, p. 47).[1] Another study has noted that the Great Leap represented an attempt by the CCP to break with the model of democratic patriarchy; in addition to mobilising women for outside labour, their workpoint earnings were to be increased, while calls to have income paid directly to individual workers threatened the unofficial power of the household head (Stacey, 1983, pp. 212–13).

Although an August 1958 resolution by the party's central leadership sanctioning the creation of the communes insisted that the arrival of communism was still a long-term eventuality, and urged local cadres to exercise restraint in their dealings with peasants, commune administrators quickly became caught up in an over-enthusiastic dash to usher in the communist utopia they believed lay just around the corner. Such an imagined utopia was symbolised by the communal dining hall, where everyone (at least in theory) could eat their fill;

the joyous and euphoric atmosphere generated by the communal dining halls is wonderfully illustrated in Zhang Yimou's 1994 film *To Live* (*Huozhe*).

During the Great Leap Forward a clear division emerged between young female activists (recruited and trained in grass roots party organisations) on the one hand, and CCP and Women's Federation leaders on the other, over the meaning and significance of sexual equality. At the turn of the twenty-first century, the former, in fact, remembered that the Great Leap Forward was a kind of 'golden age' of unprecedented liberation for women; memories and reminiscences, however, are never uniform, since age, gender or occupational status might determine how an individual remembers the past or particular political movements. Thus, other (for example, non-activist) women remember the period as one of loss, unremitting toil and a constant battle with illness, especially as in some areas activists ignored, or paid little attention to, the setting up of health care facilities and services for women mandated by the Party (Manning, 2007, p. 98).[2] While official 'Marxist maternalism' embraced by the CCP and leaders of the Women's Federation promoted the idea that women would achieve liberation via an opportunity to work (at the same time retaining the social centrality of the family and ensuring work protection for women based on their physiological difference), for young grass roots female activists true 'liberation' implied a necessary break from patriarchal villages and husbands (by working away from home and family, for example, on large irrigation projects) (Manning, 2006a). In their almost fanatical and voluntarist zeal to implement the ideal of egalitarian gender equality (inspired by the Maoist revolutionary ethic calling on everyone to struggle equally) and demonstrate women's willingness and ability to match men in the performance of collective labour, local women's leaders often forced rural women to carry out heavy field work while pregnant, a situation that often made these grass roots activists the target of popular wrath (Manning, 2006a, p. 350).[3] Disdainful of 'women's work', they questioned the need for special health care for labouring women and even the necessity of having separate women's organisations to represent the interests of women *qua* women. During the summer of 1958 many women's organisations in the communes were actually disbanded.

Such an outlook differed markedly from the CCP's brand of 'Marxist maternalist equality', which assumed not only that women required special protection at work (e.g. pregnant or lactating women were not expected to do any kind of 'heavy' work), but also that women were naturally invested with a 'maternal instinct' (*muxing*) and that motherhood therefore was women's sacred duty. As early as 1942, in fact, Zhou Enlai in Yanan had argued that motherhood was 'a natural duty' for women, crucial to the well-being of society and nation (Manning, 2006a, pp. 356–7).[4] Of course, in this Zhou Enlai was saying nothing new, since an emphasis on women's key role in maintaining the household, ensuring family harmony, and bringing up sons as the very foundation of a strong state and economy had animated debate on the 'woman question' since the early years of the twentieth century. An example of Marxist maternalism in practice was the decision taken by the Sichuan provincial branch of the Women's Federation in 1956 to assign menstruating,

pregnant or lactating women collective work that was light, dry and close to home (known as the 'three transfers'). Yet, despite calls by the Women's Federation leaders and Party officials that collectives allow women to take a month off after giving birth and not subject them to physically strenuous work, during the Great Leap women (by choice or by compulsion) pushed themselves to the point of utter exhaustion as they overextended themselves within the home, in the fields and on construction sites.

Thus, although the Party frequently cited Engels' *The Origin of the Family, Private Property and the State* (1884) during the Great Leap to argue that the abolition of the private ownership of land and means of production would facilitate the reform of the marriage system and that women's mobilisation in social productive labour would guarantee their emancipation (while at the same time insisting that the family would continue to exist) (Davin, 1987a, pp. 155–6), the reality of women's lived experiences in the communes was decidedly more ambivalent. Celebratory rhetoric in the Party press in 1958–9 certainly suggested that the Great Leap had wrought dramatic transformations in women's lives. In Henan, for example, where the communes had originated, it was claimed that women had access to 100,000 maternity centres and were allowed forty-five days of maternity leave; at the same time 6 million women had apparently been freed from domestic labour. By 1959, also, it was estimated that in rural areas there were nearly 5 million nurseries and kindergartens and over 3 million communal dining halls. In the communes individual women referred to as 'bumper crop maidens' or 'women innovators' were also said to be making significant contributions to dramatic increases in agricultural productivity; during the Great Leap it was reported that 13 million women were active members of experimental groups testing out new methods of cultivation, pest control, and seed mixing. At the same time, all-female work teams were heroically engaged in building dams, dykes and reservoirs (Andors, 1983, pp. 38, 51; Croll, 1985a, pp. 227, 237). Likewise, in the popular songs the collectives were encouraged to write at the time to laud the achievements of the Great Leap, the new-found freedom of young men and women working together in public, as well as competing with one another to gain the honour of being designated a 'model worker', was especially celebrated (Blake, 1979).[5] In a lighter vein, the comedy film *Li Shuangshuang* in 1962 (which garnered a number of official prizes) recounted the determination of a rural woman (Li Shuangshuang) to respond to the empowering opportunities that the commune movement brought by engaging publicly in collective affairs; while she is portrayed as a politically conscious and 'progressive' character fully committed to collective life, her husband is depicted as a weak and vacillating character held back by his ingrained patriarchal and conservative attitudes (Tang, 2003).[6] As such, the film anticipated the Chinese cinema of the 1980s and 1990s that explored the impact of social and economic change through the figure of a rural woman.

Overall, the Great Leap witnessed a massive increase in women's participation in agriculture, especially as in many areas men were drawn away to work on construction projects; this led to what some have termed the 'feminisation' of agriculture, representing a new gender division of labour between

agricultural and non-agricultural employment (as opposed to the usual one *within* agriculture).[7] Such a situation was to become especially noticeable again during the post-Mao period. By late 1958 it was reported that in most places up to 90 per cent of women were involved in collective labour. This meant, however, that they worked longer hours and more days than ever before. Also, conventional notions of the 'appropriate' gender division of labour disadvantaged women. Certain activities such as weeding, subsidiary crop production or working on small irrigation projects were designated as 'women's tasks' – as indeed was employment in the communal dining halls and nurseries – and thus allocated fewer workpoints than supposedly 'heavier' and more skilled work performed by men (Croll, 1985a, pp. 225–6). Thus, while men often received between nine and ten workpoints per day (the maximum was ten), women usually earned no more than six or seven. One significant difference from the collectives in 1955–7 benefiting women was that wages in the commune (in cash or kind) were paid directly to them as individuals rather than to the heads of their households.

In the urban areas, the commune movement encouraged the development of 'street industries' (production of daily consumer items such as electric switches or cooking implements) that principally employed women, usually housewives. By March 1959 over 500,000 women in twenty-two cities had set up 40,000 small plants and workshops (Andors, 1983, p. 58). Since street industries were not considered part of the formal collective economy, they received no state funds; neither did the women employed in them enjoy the same privileges or pay as workers in the formal state sector. In the state sector itself, where a gender division of labour was already apparent from the early and mid-1950s (i.e. women were concentrated in light industry such as textiles, whereas men were mostly employed in higher-status heavy industry such as iron and steel), the number of female employees increased during the Great Leap and its immediate aftermath (in 1963 they constituted 25 per cent of all state workers compared with 15 per cent in 1959) (Andors, 1983, pp. 62–3).[8] Even in the Anshan Iron and Steelworks (in the north-eastern province of Liaoning), which employed no women in 1949, there were 600 female engineers, technicians and managers. On the eve of the Cultural Revolution in the early 1960s (unlike the period *prior* to the Great Leap) women had become highly visible in factories and government offices. In cities such as Beijing and Shanghai, for example, women comprised a significant proportion of the public health sector (Andors, 1983, p. 69).[9] Women also branched out into other forms of employment; in Beijing at this time female bus drivers began to make an appearance.

By the early 1960s, also, women had made modest gains in education and political representation. In 1964 the percentage of women in higher education had risen to 25 per cent (in 1949 women comprised 19.8 per cent of higher education enrolment) (Rosen, 1992, p. 259). At the Third National People's Congress in 1964 nearly 18 per cent of the representatives were women, in contrast to the First and Second Congresses (in 1954 and 1959) in which women constituted 12 per cent of the membership. Gains at lower levels, however, were more modest; the number of women at basic level People's Congresses comprised just over 22 per cent of the total membership,

compared with just over 17 per cent in 1953 and 20 per cent in 1958 (Croll, 1985a, pp. 234–5).

The onset of the Cultural Revolution

Amidst the background of a catastrophic famine in 1959–61, the result of both natural calamities and the organisational chaos of the Great Leap that had led to food shortages, the CCP leadership began to reverse many of the radical Great Leap policies by, among other things, the reduction of the socio-economic functions of the communes and the restoration of private plots in the countryside (confiscated during the Leap) and free rural markets. Another post-Great Leap development would have a considerable impact on women's lives. On the eve of the Great Leap a tentative family planning programme had been mooted. A National Agricultural Development Plan in 1956–7 under-lined the necessity of promoting birth control and encouraging planned child-bearing in densely populated areas.[10] In 1957 abortion and sterilisation were legalised. One of the most outspoken proponents of family planning was Ma Yinchu (1882–1982), a demographer who had studied economics in the US during the early years of the twentieth century and became president of Beijing University in 1951. In the mid-1950s he published a work (*New Demography*) and submitted a report to the NPC in the summer of 1957 warning that uncontrolled population growth would threaten the country's economic development. The Great Leap temporarily ended this ongoing debate, as Mao insisted that China's huge population represented a valuable and untapped source of labour power, and he denounced Ma Yinchu as a Malthusian and rightist (Ma had to resign his university presidency in 1960 and was not to be fully rehabilitated until 1979).

Yet even Mao in the past had conceded the need for 'planned births', a doctrine that was unequivocally accorded approval after the Great Leap when a party directive in 1962 confirmed that birth control and planning were neces-sary for socialist development. Less than a year later, in September 1963, the Central Committee of the CCP and the State Council produced the first series of short-term and long-term planning targets for urban population growth; by 1965 premier Zhou Enlai announced China's *first* long-range goal for nation-wide population growth – to reduce the rate of growth to 1 per cent or less by the end of the twentieth century (White, 1994, pp. 274–6).[11]

The reversal of radical Great Leap policies (with which Mao had closely identified) led to growing suspicion on Mao's part that his party colleagues – especially Liu Shaoqi, the party vice-chairman who had succeeded Mao as state president in 1959, and Deng Xiaoping, the party's secretary-general – were guilty of ideological 'revisionism' that threatened his vision of China's socialist future. The Cultural Revolution that Mao launched in 1966 aimed to put 'class struggle' back on the agenda, and had significant repercussions for women right from the start.

As a sign of things to come, for example, the wide-ranging debate on women's personal and working experiences that had animated the readers of *Zhongguo funü* (*China's Women*), the principal publication of the Women's

Federation, was brought to an end in 1964. In 1962 the journal had high-lighted women's 'special problems' in balancing their productive and repro-ductive responsibilities, and one year later it encouraged its readers to submit letters in answer to the question 'What Do Women Live For?', providing details of their individual experiences *as women* and how traditional gender assumptions (such as male superiority) affected their lives. The journal received more than 2,000 letters, which were edited and published in 1964. The letters demonstrated not a little uncertainty amongst women concerning their primary responsibilities in the transition to socialism, with some suggesting that their natural role was that of nurturing mother and supportive wife, while others linked personal happiness with collective well-being.[12] Ominously, in the same year the journal (and its editor, Dong Bian) came under attack in the Maoist press, which accused it of an inappropriate and indulgent focus on women's 'special problems' divorced from a class analysis, while an October 1964 editorial responded to the 'double burden' problem for women raised by some letters to *China's Women* by bluntly noting that if women had 'true revo-lutionary proletarian consciousness' they would easily be able to balance their roles in production and household labour (Croll, 1974, p. 22). Shortly after-wards the journal was closed down and the Women's Federation disbanded, on the grounds that women did not need a separate organisation (Dong Bian was also accused of discriminating against contributions sent to the journal by peasant and working women).

The growing stress on the importance of class struggle on the eve of the Cultural Revolution was also illustrated by official negative reaction to the 1965 film *Stage Sisters* (*wutai jiemei*), directed by Xie Jin (1923–2008). Primarily set in Shanghai during the 1930s, the film depicted the friendship between two female opera singers in an all-female opera troupe whose outlooks on life gradually diverge, with one (Chunhua, originally a poor peasant girl fleeing from an arranged marriage) becoming more politically conscious and committed to the revolution, while the other (Yuehong) is increasingly tempted by the 'bright lights' of the city and becomes the mistress of a corrupt GMD official (the end of the film sees the two former friends reconciled with the establishment of a 'new' China after 1949). The film was criticised for its indulgent focus on the individual stories of two female friends in the theat-rical world of urban Shanghai – portrayed in loving detail – and its sympa-thetic depiction of 'middle' characters (such as the older female opera star ruthlessly cast aside by the theatre manager to make way for the two younger singers, and even Yuehong herself), considered a display of 'bourgeois' western sensibility, when it was felt that the portrayal of the revolutionary struggle waged by the heroic peasant and working masses (under the leadership of the party) was a more appropriate cinematic subject.[13] This was not the first time gender and film had aroused political controversy. In 1954 Mao Zedong had condemned as 'reactionary' the 1948 film *Sorrows of the Forbidden City* (*Qing'gong mishi*), an intimate portrayal of life in the Qing imperial court in the 1890s that focused on the attempts by the loyal concubine Zhen Fei to convince the Emperor Guangxu of the benefits of reform in strengthening the dynasty (Wu, 2009).[14] Another film that was to be banned during the Cultural

Revolution was the previously praised *Li Shuangshuang*, criticised for its attention to 'petty bourgeois' matters such as the heroine's concern with gender equality and housework.

Cultural Revolution androgyny

With women exhorted to uphold 'half of heaven' (a phrase first used by Mao in 1964) and the priority now given to class struggle, the Cultural Revolution ushered in a period of apparent androgyny (Young, 1989, pp. 255–6). As the *People's Daily* declared in July 1966:

> Times have changed and men and women are on an equal footing. The women comrades can do what the male comrades do. (Andors, 1976, p. 89)[15]

What androgyny entailed for women ultimately, however, was that they were required to push themselves as never before into the public realm in order to appropriate conventional male roles in politics and production, while little consideration was given in the ideological propaganda, or few concessions made, to easing their marriage, family and reproductive roles (in other words, androgyny meant women becoming more 'masculinised' rather than men becoming more 'feminised'). In a larger context, the subordination of gender to class so prevalent at this time in a sense represented the culmination of a discursive trend in communist texts about and for women since the 1920s which subordinated the 'women's movement' to the cause of national and social revolution (Evans, 1998).[16]

In the art, literature, film, revolutionary ballet and opera, and propaganda posters produced during the Cultural Revolution women were featured as political activists and militant fighters (Evans, 1999). Cultural Revolution androgyny was also exemplified by the female Red Guards and the 'Iron Girls'. The former, dressed like their male counterparts and hair cut short, participated enthusiastically in the public shaming (and sometimes physical assault) of 'revisionist' enemies such as party bureaucrats, teachers and intellectuals (Honig, 2002). Random and arbitrary violence was rife, however. Rae Yang, from an aristocratic Manchu family whose father had been a diplomat in the early 1950s, became a Red Guard in 1966 when she was sixteen; in her autobiography she remembers witnessing a female Red Guard (the same age as herself) beating an old 'bad element' woman (who had bound feet) with her belt (Yang, 1997, p. 133). In the 1980s Li Xiaochang recalled how she had joined a Red Guard organisation and taken part in violent activities:

> We caught the members of street gangs too, like the 'Nine Dragons and a Phoenix'. They sounded frightening, but when we caught them we beat them until they begged us 'Red Guard ladies' for mercy. (Zhang and Sang, 1989, p. 56)

Another former female Red Guard likewise remembers joining in with the beating up of 'rightists' and raiding their homes (Zhang and Sang, 1989, pp. 279–84).[17]

It may be the case that the violence perpetrated by female Red Guards (including beating people to death) constituted a rebellion against previously experienced social repression or was seen as the means to extirpate outdated stereotypes of appropriate feminine behaviour (Young, 1989, p. 259). On the other hand, in recent memoirs, women who grew up during the 1950s do not recall being especially victimised or discriminated against (as females) (Zhong *et al.*, 2001). It might also be noted that an older generation of women who began their working lives in the early 1950s remembered this time in positive terms. Former female silk weavers at a Hangzhou factory, for example, when interviewed during the mid-1980s and early 1990s, took pride in themselves as heroic working subjects transgressing traditional taboos against women working outside the home and employed in an occupation usually dominated by men (Rofel, 1999).

'Iron girls' were model female workers (usually young and unmarried, many of whom were urban youth 'sent down' to the countryside) who, in the propaganda, were deemed as capable as men in performing heavy and dangerous work such as climbing up telegraph poles to repair wires, joining oil-drilling teams, and driving diesel locomotives. The phenomenon was not entirely unprecedented, since the model female workers promoted in the early 1950s (see Chapter 5) were described in a similar way. Iron girls made their first appearance in 1963, when they were organised into a work unit helping with flood control in the model commune brigade of Dazhai (Shanxi province). Specialised brigades of 'iron maidens' in subsequent years appeared at a number of industrial work sites situated in rural regions (such as coalmines and oilfields) helping to fill the shortage of local rural labour as a result of male migration to non-agricultural sectors. Later testimonies of former 'iron maidens' noted how their experience had empowered them (Honig, 2000; Jin, 2006).

Yet this Cultural Revolution androgyny was decidedly ambivalent. Although, for example, the female Red Guards were compared in Cultural Revolution propaganda (in 1967 and later in the early 1970s) to the Red Lanterns (see Chapter 2) in that both had 'dared to rebel' against the constraints of the Confucian ethical code – although no mention was made of the magical powers the Red Lanterns were reputed to possess (Cohen, 1997, pp. 264–8, 283) – the very comparison drew attention to their *female* identity. Furthermore, female Red Guards were organised in their own units, and their uniform was differentiated from that of their male counterparts in nuanced ways (e.g. in the number of pockets or a more tightly fitting waistline). Memoirs also testify to the pleasure they took in their appearance (criticised as a bourgeois vice in the propaganda). Rae Yang remembers that:

> People noticed our new uniform: faded army uniforms that had been worn by our parents, red armbands, wide canvas army belts, army caps, the peaks pulled down by girls in the style of boys…. (Yang, 1997, p. 122)

Cultural Revolution posters subtly suggested a gender hierarchy (in the way, for example, men and women were positioned in the picture), and by the

early 1970s some posters had begun to 'refeminise' images of the 1960s, with stern faces being replaced by softer and rounder features and greater use of patterned and pastel-shaded blouses.

Dress and colour also functioned as a gender marker in the revolutionary ballets and operas produced during the Cultural Revolution. Theatrical costume, for example, 'gendered' and 'sexualised' its wearers to a greater extent than previously thought (Roberts, 2006).[18] Female rural characters, for example, were invariably dressed in pink, peach or turquoise, while their male counterparts appeared in primary colours (red, blue, yellow). Even the colour red had different gender connotations. Although women might appear in red jackets – symbolising conversion to communism – traditionally, women dressed in red signified sexual attractiveness and allure (for men it denoted courage and loyalty). In the model operatic ballet *The Red Detachment of Women*, the female soldiers wear uniforms tailored closely to the breasts, waist and hips. Even Jiang Qing, Mao's wife and one of the most outspoken supporters of the Cultural Revolution, oversaw the design of a new national dress for women (drawing on the Tang dynasty style for court women) in the early 1970s that would be more fetching than plain uniforms and cadre suits (the 'Jiang Qing dress' did not catch on) (Finnane, 2008, pp. 247–55).

Even the experiences of the 'iron girls' may not always have been entirely positive. A former female brigade leader recalled in the 1990s that they tended to be allocated work that was both shunned and arduous. Those working in urban areas, for example, were often assigned transportation work, which was held in low esteem. One young Beijing woman sent to Inner Mongolia remembered that she and her comrades were not allowed to perform the 'real' work of threshing grain (the domain of young men) but instead were occupied with collecting cotton stalks for kindling or doing the laundry (Honig, 2000, p. 106).[19] In the final analysis, the gender division of labour was not fundamentally restructured during the Cultural Revolution (Jin, 2006, pp. 620–1). In this context it is significant that a revolutionary ballet such as *The Red Detachment of Women* actually reinscribed certain forms of female subordination. Although based on the historical experience of female guerrillas on Hainan island in the 1920s who were led by a woman who taught them firearm skills, the female soldiers in the ballet are trained and led by a male commissar (Honig, 2000, pp. 100–1).

It is clear, also, that sex and sexuality (although little discussed in official state discourse) continued to play a role in various ways during the Cultural Revolution. This was a time, first, when sexual behaviour was directly related to class status, what has been termed a 'sexualisation of political critique' (Diamant, 2000b, p. 285). Sexuality, in other words (including how one dressed), could potentially be viewed by puritanical urban Red Guards as a symptom of political deviance. Thus young women who continued to wear make-up or skirts might be criticised as bourgeois deviants, while teachers and officials who were known to have engaged in extramarital affairs were publicly humiliated (sexual immorality was one of the most commonly invoked 'errors' committed by 'class enemies'). Violence against individuals often took the form of *sexual* humiliation. A prominent victim of such humiliation was Wang

Guangmei (1921–2006), the wife of president Liu Shaoqi (himself charged with being the 'number one' revisionist in the party, who was purged at the beginning of the Cultural Revolution). Accused of decadent bourgeois revisionism and described as an 'evil vixen-spirit' who infatuated men because she had worn a *qipao* while accompanying her husband on a state visit to Indonesia in 1963, she was forced in front of a baying crowd to wear an ill-fitting *qipao*, high-heeled shoes and a necklace of pingpong balls (signifying she was a prostitute) (Diamant, 2000b, pp. 291–2, 305).

Second, although Rae Yang in her autobiography remarked that female Red Guards like herself covered their bodies so completely that they forgot they were girls, and that although they often slept in the same rooms as boys 'we did not have sex or even think about it' (Yang, 1997, pp. 135–6), other recent testimonies and memoirs suggest that both young male and female Red Guards at this time – notwithstanding the sexual puritanism that characterised much of the personal attacks on perceived counter-revolutionaries – took the opportunity to engage in sexual experimentation, especially at a time (particularly after 1968) when Red Guard youth were 'sent down' to the countryside (Honig, 2003, p. 143). A notorious example of such a memoir is *Red Azalea*, a 1993 fictionalised autobiography by Anchee Min, who towards the end of the Cultural Revolution became a 'starlet' of the film propaganda studio overseen by Jiang Qing and her associates (she was eventually to leave China for the US in 1984). Drawing attention to the existential importance of sexual desire as the key to personal liberation (at a time when the free expression of love, heterosexual or homosexual, was officially prohibited), Anchee Min's memoir charts the evolution of a lesbian relationship she surreptitiously enjoys with a team leader of the state farm to which she had been sent (Min, 1993).[20] Given the fact, however, that Anchee Min's memoir – like quite a few others published in the 1980s and 1990s (for the most part by women) purporting to uncover the 'hidden face' of Maoist China – was written in English while living in the US, it is a moot point to what extent such memoirs specifically catered to a western audience and its taste for the exotic and controversial.[21]

Nevertheless, recently accessible documentary evidence suggests that for many 'sent down' youth during the Cultural Revolution the time spent in the countryside (where rural folk tended to be more open about sexual matters) provided them with their first informal sex education.[22] Underground literature that was widely circulated amongst them included stories of love, romance and sex. It was not uncommon either for young women to cohabit with rural men, in some cases becoming pregnant; babies were often left in the care of a local peasant family when they eventually returned to the city (Honig, 2003, p. 157). There was a darker side to all this, since in many cases 'sent down' women were sexually abused by locals or corrupt officials. In the north-eastern province of Jilin between 1970 and 1972 there were a reported 2,000 incidents of harm caused to sent down youth, the majority of which involved rape of women (Honig, 2003, p. 164).

In the final analysis, what political and economic benefits did the Cultural Revolution decade (1966–76) bring women? In terms of representation within the party, some modest gains were achieved. Whereas at the 8th CCP Congress

in 1956 only four women had been elected to the party's Central Committee (4 per cent of total membership), at the 10th Party Congress in 1973 twenty women were elected to the Central Committee (10 per cent of the total) (Edwards, 2004b, p. 124).[23] Women also gained access for the first time to the highest organ of the party when, at the CCP's 9th Congress in 1969, Jiang Qing and Ye Qun were elected to the nineteen-member Politburo. Given the fact, however, that both were married to party leaders (Ye Qun was the wife of Lin Biao, Mao's 'second-in-command' and chosen successor) – continuing a trend dating back to the Party's earliest years when only women with 'marital connections' were able to gain some influence within the organisation – the significance of their election to the Politburo was somewhat diminished. There were more substantial gains in the National People's Congress (NPC), a legislative body under the State Council that ordinarily met every five years (it did not meet between 1964 and 1975). At the NPC's 4th Congress in 1975 there were 653 female delegates, comprising over 22 per cent of the total; the proportion of previous female membership of the NPC, by way of contrast, ranged from 12 per cent in 1954 to nearly 18 per cent in 1964. In 1975, also, thirty-nine women were appointed to the NPC's Standing Committee, comprising just over 17 per cent of the total (Edwards, 2004b, pp. 121–2).[24]

At the commune level, there might also have been a slight improvement. In the province of Guangdong, for example, most commune production teams and brigades by 1973–4 had at least one female cadre, although (as was the case elsewhere) most female cadres were primarily involved with 'women's work' (such as birth planning propaganda) (Parish and Whyte, 1978, p. 242). During the Cultural Revolution, also, a number of individual women were promoted as 'labour heroines' and role models demonstrating wholehearted commitment to the Maoist project. One such 'heroine' was Wu Guixian, a textile worker in the 1950s, who was elected to the Central Committee at the 10th *party* Congress and subsequently (in 1975) became a vice-premier (Witke, 1975). Another was Wang Xiuzhen, a worker at a Shanghai cotton mill who was elected to the Central Committee at the 9th Party Congress (Sheridan, 1976). In many ways these individuals were no more than tokens, and their temporary prominence in the Cultural Revolution did not affect in any significant way continued male hegemony in the higher echelons of the party (see Chapter 8).

The fact that Wu Guixian and Wang Xiuzhen were textile mill workers, however, highlighted the fact that the Cultural Revolution may have provided more opportunities for female factory workers to acquire industrial skills through in-plant training. In a wider educational sense, by the end of the Cultural Revolution female enrolment in both higher and lower schools had attained relatively high levels. In 1975, for example, girls comprised 32.6 per cent of the total enrolment at tertiary level, 39.3 per cent at secondary level and 45.2 per cent at primary level – compared with 23.3 per cent, 30.8 per cent and 34.5 per cent, respectively, in 1957 (Hooper, 1991, p. 354). Thereafter female enrolments declined across the board and were not to reach similar levels until the late 1980s.

Finally, the last stages of the Cultural Revolution witnessed the first attempt since 1949 to tackle in a direct way the *ideological* (as opposed to structural)

constraints on women (Croll, 1977). This was the indirect result of a political movement in 1973–4 (the 'Criticise Lin Biao, Criticise Confucius' campaign). In 1971 Lin Biao, the head of the People's Liberation Army and Mao's chosen successor – who had begun to question a number of Mao's initiatives, such as the rehabilitation of purged party cadres, the diminution of army influence in party affairs, and seeking *rapprochement* with the United States – apparently engineered an abortive coup and was killed in an air crash (along with his wife, Ye Qun) while attempting to flee the country. The 1973–4 campaign (orchestrated by Jiang Qing and her radical supporters in the party, later referred to as the 'Gang of Four') aimed to link Lin's reactionary 'crimes' (interpreted as the evil ambition to restore capitalist rule) to those of Confucius, whose philosophy had upheld feudal rule. The campaign also associated Confucian misogyny with Lin Biao's imputed backward and dismissive attitude towards women (linked directly to his political crimes).

A flurry of articles and editorials were subsequently published that examined the ways in which Confucian philosophy had given rise to deep-rooted prejudices against women, thereby buttressing the patriarchal system.[25] Editorials also insisted that male superiority was not heaven-ordained or biologically determined but simply the product of a historical period when Confucian ideology was being consolidated. On this basis there were even calls for an end to contemporary gender differentials in pay, and criticism of male reluctance to perform housework. The patriarchal (or virilocal) marriage system was also highlighted as a contributor to women's low status; in some areas of Hebei province encouragement was given to matrilocal marriage (i.e. in which the husband moves in with the bride's family) as the means to allay the concerns of couples with only a daughter (who would normally 'marry out' and thus leave couples with no-one on whom to rely when older). Matrilocal marriage was thus also seen as an effective way of encouraging birth control, since couples would no longer be desperate to have sons. In 1975 it was reported that nearly 7,000 matrilocal marriages had taken place in one Hebei county alone.[26]

Ironically, however, in the post-Mao period after 1976, when much of the Maoist ideological legacy was rejected by the CCP and market reform encouraged in all areas of the economy, many of the gender stereotypes rooted in biological essentialism and dating from the early years of the twentieth century were to be revived (if indeed they had ever been entirely eliminated in the Maoist period) in reaction against Cultural Revolution androgyny. In a further ironical twist, while Confucius and his 'patriarchal' ideology had been condemned during the Cultural Revolution, the post-Mao period (especially from the 1990s on) saw the valorisation of Confucius and his teachings as an integral element of Chinese national and cultural identity; since the early years of the twenty-first century China's government has also sponsored the creation of 'Confucian Institutes' abroad to promote the study of Chinese language and culture.

8
Women and Socio-economic Change in the Post-Mao Era

In the 1994 Chinese film *Ermo* (directed by Zhou Xiaowen), the female protagonist of the title is a determined woman who supports her physically disabled and sexually impotent husband (a former village chief who has now lost all authority) and son by making noodles and selling them in the local market. She becomes obsessively fixated on acquiring a television set that will be 'bigger and better' than that of her neighbour, the sole possessor of a television set in the village, thereby making her household the principal social attraction for all the villagers (including Ermo's son, much to her annoyance and envy). Ermo becomes progressively more desperate to earn and save money, relying on her neighbour's husband (with whom she has a brief affair) to drive her into the nearby town to sell her handmade noodles as well as working for wages at a restaurant (ironically supervising the making of in-house noodles). She even resorts to selling her own blood to acquire extra cash. Although she finally succeeds in purchasing the television, and invites the whole neighbourhood in to watch, she herself is completely exhausted and drained (literally and metaphorically) of all energy and enthusiasm. The overpowering drive of consumerism that has obliterated Ermo's self-dignity as a person and autonomous worker is also graphically symbolised by the villagers' appropriation of Ermo's ladle (with which she had made her noodles) to serve as the television antenna. Furthermore, the television programmes presented to the excited village audience are an American football match and a dubbed American soap opera, clearly having no relevance or meaning to the increasingly bemused and puzzled spectators. The film ends with Ermo asleep alone in front of a crackling screen of snowy static.

The film illuminates significant developments in the post-Mao era, especially the 1980s and 1990s. Within two years of Mao Zedong's death in 1976, the CCP began to implement a series of market-oriented reforms designed to raise the people's living standards, enhance national economic growth, and restore the public credibility and legitimacy of the party following the disaster of the Cultural Revolution. These reforms were accompanied by an 'open door' policy of encouraging inward foreign investment and the setting up of joint Sino-foreign enterprises, and closer trading and commercial links with the capitalist world. In the countryside, the rural collectives were gradually dismantled after 1978, while in the cities the first steps were taken to introduce

management autonomy in state enterprises. By 1983 most peasant households had converted to a 'household responsibility system' in which the individual household (rather than the production team) was the unit of production and able to sign contracts with, and lease land from, the production team. All investment and production decisions were now taken by the individual household, which, after meeting its obligations to the state, could dispose of its crops (no longer restricted to grain, as had previously been mandated by the state) in an expanded free market. In 1984 new regulations allowed households to lease land for up to fifteen years (and to permit the hiring of non-farm labour), which was extended to fifty years in 1987, by which time contracted land could be passed on (more or less 'inherited') to other family members instead of reverting back to the production team. Post-Mao reforms also sanctioned the creation of 'specialised households' in the countryside, which engaged solely in private rural industry and commerce or provided rural services (while 'leasing' their contracted land to other peasant households).

Meanwhile, in urban centres autonomy granted to state enterprise managers allowed them to make redundancies, thus breaking with the hallowed principle of the 'iron rice bowl' (i.e. guarantee of permanent employment) which had prevailed in the state sector. Loss-making state-owned enterprises were now expected to be both efficient and profitable, with the result that during the 1980s and 1990s increasing numbers of workers were made redundant (referred to as 'restructuring'). At the end of 1997, in addition to a reported total of 5.8 million jobless in the cities, a further 6.5 million had been laid off (although technically they were not classified as 'unemployed'). Urban vagrancy was exacerbated in the 1980s and 1990s by a dramatic rise in the numbers of rural migrants – taking advantage of the loosening of state controls on internal migration (the *hukou* system) – entering the cities looking for work. By the end of the 1990s there were nearly 130 million 'surplus' rural labourers and migrants in urban areas. Since they were not classified as urban residents (and thus not eligible for welfare and other benefits enjoyed by urban citizens) they were, in a sense, legal 'non-persons' (similar to 'illegal aliens' in developed countries) and highly vulnerable to exploitation. At the same time a private enterprise sector emerged in the urban centres; most of the restaurants, retail stores and service shops opened after 1978 were privately owned (and could hire labour). By the end of 1986 there were over 12 million urban private enterprises.

The market-oriented rural and urban reforms were accompanied by a shift in foreign policy that aimed to engage more fully with the western and capitalist world. Although during his last years Mao had sanctioned rapprochement with the US (relations with which had been frozen since 1950), it was not until after 1978 that a substantial 'open door' policy, as it was called, was put into effect. In 1979 a law on joint ventures allowed direct foreign investment in Chinese enterprises such as hotels; in 1980 the first Special Economic Zones were created in the southern provinces of Guangdong and Fujian (Shenzhen, Zhuhai, Xiamen, Shantou) as export-processing sites utilising foreign capital and technology and in which foreign-owned enterprises could operate. Foreign investors were offered incentives (low rates of tax, ability to remit

after-tax profits) and were guaranteed a cheap labour force – much of which was to comprise young female migrants from the countryside. In addition to the Special Economic Zones, in 1984 a number of coastal cities (Shanghai, Guangzhou, Ningbo, Fuzhou) were declared 'open' to direct foreign investment, where foreign capital might be utilised to set up foreign-owned subsidiaries. By the end of the 1980s the open door policy represented by the Special Economic Zones was being applied all along China's coast.

Underpinning these market-oriented reforms was a significant change in ideology (without, however, calling into question the legitimacy of one-party rule). In 1981, following the arrest (in 1976, shortly after Mao's death) and public 'trial' (in 1980) of the Gang of Four – Mao's wife Jiang Qing and three party colleagues, who had been the most radical supporters of the Cultural Revolution – Mao was officially 'demythologised' as the CCP rejected the Maoist stress on class struggle and the concept of permanent revolution, insisting that that the priority was now to resolve the 'contradiction' between the 'backward' productive forces (i.e. the undeveloped state of the economy) and the socialist system. Premier Zhao Ziyang observed in 1986 that, since China was currently at 'the primary stage of socialism', which would last for some time in the future because of the country's low productivity and undeveloped 'commodity economy', *any measure* that would enhance the productive forces (economy) was to be considered beneficial for the socialist system. In 1988 an amendment to the 1982 state constitution specifically declared that the state allowed the private economy to exist and develop 'within the limits of the law'. People were exhorted by party and state authorities 'to get rich', now viewed as a 'glorious task' in the construction of a prosperous country. Not surprisingly, accompanying the emergence of a market economy was a consumer boom, aided by the appearance of advertisement hoardings on the streets (replacing Maoist propaganda slogans) and commercial advertising on state-run television.

Finally, the CCP itself in a sense opened up to the private sector. In a series of speeches during 2000–1, party secretary-general Jiang Zemin referred to the concept of the 'Three Represents' (*sange daibiao*); henceforth, Jiang declared, the Party had to represent 'the advanced productive forces in society', 'advanced modern culture' and 'the interests of the vast majority of the people'. The first 'represent' signalled a sharp break with the past, since it implied that in the future party membership would be open to entrepreneurs and intellectuals from the private sector of the economy (previously, emphasis had been placed on the recruitment of workers and peasants, although it should be noted that intellectuals had already been 'reclassified' as members of the working class in 1978). At the 16th Party Congress in 2002 the 'Three Represents' were added to the CCP Constitution.

This chapter explores the multifaceted impact (both positive and negative) of these socio-economic changes on the lives of women. The female protagonist of the film *Ermo* in some ways symbolises these dramatic transformations, illustrating in the process that women were both agents and victims of the post-Mao market reforms. It is she, for example, who is the ambitious entrepreneur, while her husband remains on the sidelines, pathetically regretting

his loss of authority as the former village chief and criticising his wife's relentless quest to accumulate income to enhance their lifestyle. At the same time, however, Ermo's quest is ultimately fruitless and meaningless; physically and mentally drained, and shorn of her own self-dignity, Ermo is as much a victim as a player in the headlong rush (sanctioned by the state) to indulge in material consumption. While Ermo's enjoyment of economic and sexual autonomy might be construed as a positive sign of the future, as a recent analysis of the film maintains (McGrath, 2008, p. 115),[1] in society at large in the post-Mao era the market reforms brought in their wake the commodification of women and the sexualisation of their image in the media.

In the same vein, ideological change had ambivalent consequences for women. The CCP's denunciation of the 'chaos' (*luan*) of the Cultural Revolution was accompanied by official rejection of Maoist androgyny (including the notion that what men could do, women could do also) in favour of an approach that accentuated differences between the sexes – although it should be noted that, even at the height of Maoist androgyny during the Cultural Revolution, gender 'difference', contrary to the view advanced recently by one scholar (Yang, 1999), had never been fully 'erased'. Post-Mao discourse, nevertheless, in various ways reasserted a rigid gender binary based on biological sex that invariably highlighted or implied women's physical, intellectual and emotional inferiority to men – not unlike aspects of May Fourth gender discourse of the 1910s and 1920s.

Finally, this chapter examines the significance of the CCP's one-child policy and its consequences for women. While the last two decades of the twentieth century witnessed a loosening of the party-state's control over the economy and cultural life, the one-child policy represented one of the most ambitious and intrusive attempts by any state to regulate private behaviour (and specifically that of women).[2]

New wine in old bottles? Gender ideology and politics in the post-Mao period

The change in gender ideology after 1976 was first signalled by the holding of the Fourth Congress of the Women's Federation (WF) in September 1978, marking the organisation's rebirth after it had been disbanded on the eve of the Cultural Revolution in 1966 (Croll, 1983). Significantly, the Congress took place against a background in which women's political participation had begun to decline (and would continue to do so). In effect, the CCP in the years following the Cultural Revolution decade (1966–76) became very much a male-dominated body. During the Cultural Revolution women had achieved their highest participation rate in party and legislative organisations since 1949 (see Chapter 7). Women's political presence was gradually to decline after 1976. At the 11th Party Congress in 1977 only fourteen women were elected to the Central Committee (7 per cent of the total), while twelve were elected at the 14th Party Congress in 1992 (6.4 per cent of the total). At the Party's 15th Congress in 1997, its last of the twentieth century, just eight women (out of a total of 193) appeared on the Central Committee. With the death

of Ye Qun in 1971 and the arrest of Jiang Qing in 1976 (as the leader of the 'Gang of Four' identified as the principal instigators of Cultural Revolution violence), only one woman remained on the Politburo at the beginning of the 1980s – Deng Yingchao (the widow of former premier Zhou Enlai), who had been elected in 1978. With Deng's retirement at the Party's 13th Congress in 1987 there was no female presence on the Politburo for the rest of the century (during this period there were two female 'alternate' members of the Politburo, Wu Guixian from 1973 to 1977 and Chen Muhua from 1977 to 1987). Numbers of female delegates to the NPC also gradually fell, from 742 at the 5th NPC in 1978 to 650 at the 9th NPC in 1998, although the proportion remained relatively stable at just under 22 per cent of total membership (at the 9th NPC, however, only sixteen women were appointed to the NPC Standing Committee, less than half the number of those appointed in 1975). In terms of membership of the CCP as a whole, it is also striking that female membership peaked in 1973 at just over 10 per cent; by 1992 women comprised just 7.5 per cent of total party membership (Davin, 1996, p. 96).

Not coincidentally, women's declining political participation rate during the 1980s occurred at a time when existing quotas and special targets in place since the 1950s that had guaranteed women representation in lower-level people's congresses were being removed, ironically the by-product of a certain liberalisation of the political structure (e.g. after 1987 members of Village Committees, which had replaced the communes in 1982, were to be directly elected, with a limited choice of candidates on offer). With competitive elections replacing a quota system, women found themselves inexperienced in areas outside accepted 'women's work' (public health, family planning) and thus were put at a disadvantage *vis-à-vis* their male counterparts (Rosen, 1995, p. 327). Not surprisingly, by the early 1990s very few women occupied lower-level government posts; they comprised, for example, only 3.84 per cent of small town heads or deputy heads, 5.9 per cent of county chiefs or deputy chiefs, and 5.8 per cent of city mayors or deputy mayors (Rosen, 1995, p. 325).

It may also be the case that, with the official denunciation of the Cultural Revolution after Mao's death and the widespread aversion to its gender ideology, women's relatively prominent participation in politics during the period was perceived as an aberration. This was certainly the liminal message underpinning the demonisation of Jiang Qing after her arrest in 1976 and during her state-orchestrated trial in 1980–1, which resurrected hoary stereotypes of 'ambitious', 'cunning, 'self-serving' and 'dangerous' women in positions of political authority as the harbingers of disaster.[3] (Jiang was sentenced to death, a sentence that two years later was changed to life imprisonment.[4]) Film portrayals of the Cultural Revolution in the 1980s often depicted female political figures as especially authoritarian, brutal and vindictive. The best example is Xie Jin's 1986 film, *Hibiscus Town*, depicting an ambitious and uncompromising female cadre who victimises several popular members of a village community because of their 'political crimes' (while not being averse to seducing a dim-witted peasant subordinate into becoming her 'sex slave'). How else, also, does one explain that during the course of the Tian'anmen

student-led protest movement of May–June 1989 – the most significant in the post-Mao period – there was no reference to the gender imbalance in politics amidst all the calls for greater democracy and Party accountability?[5]

In a more general sense, it has been argued that women's participation and initiative in politics since the beginning of the People's Republic in 1949 have been significantly limited by the fact that feminist political action has never meant to go beyond authorised 'women's work' (*funü gongzuo*) mandated by the Party (Edwards, 2004b, p. 111). It is significant, for example, that the twelve women on the party's Central Committee elected in 1992 were mostly involved with 'women's work' (six were leaders or held important positions in the Women's Federation, while another, Peng Peiyun, was Minister of the State Family Planning Commission). Perhaps the most important woman of the post-Mao reform period was Chen Muhua; as an alternate member of the Politburo between 1977 and 1987 she served as a vice-premier and Minister of Family Planning. Her accession to head of the Women's Federation in 1987 occurred at precisely the time when her tenure as a Politburo member and state counsellor ended, an indication of the relatively low status of 'women's work' (Rosen, 1995, p. 318). Long-held beliefs about 'appropriate' gender spheres, furthermore, clearly continued to influence grass roots opinion. In fieldwork amongst rural women (some of whom were involved in the management of village enterprises) in three villages in Shandong province during the 1980s, one western scholar discovered that, although they felt more autonomous and exercised more agency than before (especially when men were not around), they still felt that men had more 'ability' (*benshi*) in the more valued (and traditionally male) spheres of politics and business (Judd, 1990, p. 47).[6]

The assumption that women's political activism during the Cultural Revolution had been excessive and at the expense of fulfilling more important (and 'natural') duties was very much in evidence at the Fourth Congress of the Women's Federation, which witnessed the return of the 'old guard' – those who had exercised leadership of the Federation before 1966 (Cai Chang, Song Qingling, Deng Yingchao, Dong Bian). A foretaste of a change in direction of CCP gender policy appeared in an editorial in a party journal published several months earlier; declaring that 'women workers, commune members and women scientists need to work and study hard, but they have to spend a considerable portion of their time tending to housework and children,' the editorial clearly implied that any further discussion of the possible reconfiguration of the sexual division of labour suggested during the 'anti-Lin Biao, anti-Confucius' campaign of 1974–5 was now redundant (Andors, 1981, p. 45).

At the Congress itself this agenda was reaffirmed in a report submitted by another of the 'old guard', Kang Keqing (widow of Zhu De, co-founder of the Red Army). Signifying a clear departure from the Cultural Revolution mantra that 'anything a man can do, a woman can do,' Kang's report suggested that in the current era of reform women's role was to be 'secondary and supportive'; rather than acquiring new technical skills, Kang opined, women's 'traditional' skills needed to be harnessed in order to construct a wide network of childcare institutions, public canteens and laundries (and other services in the collective sector) (Andors, 1983, p. 153). Kang also repeated the conventional

assumption (prevalent in the mid-1950s, for example) that household chores and childcare were the responsibility primarily of the wife:

> Mothers' duties are the most glorious natural duties for women in human society....Women can do anything that human beings can do. However, since mothers' duties are inevitable...women may do fewer things. This is not only permissible, but also necessary in the division of labour. (Li, 1992, p. 116)[7]

Clearly, although the Congress stressed the unity of women of all classes (which might have provided the opportunity for the Federation to speak up in the interests of women *qua* women), the Federation still viewed its primary role (as had been the case before 1966) as the transmitter of party policy and mobiliser of women in the support of party objectives. In 1990 Chen Muhua, chair of the Federation, admonished women to be aware of the limits of women's liberation under socialism as long as the productive forces (i.e. the economy) were not fully developed, and warned against the temptation of importing western feminism that avoided the issue of class exploitation (Rosen, 1995, pp. 333–4).

On the other hand, the Women's Federation over the next two decades was to become more vociferous in highlighting negative trends (in party policy or public attitudes) that disadvantaged women (see later).[8] The Federation also, for the first time, encouraged theoretical research on women; in 1979, for example, it inaugurated a project on the women's movement between 1919 and 1949 (although underpinned by party orthodoxy emphasising the central importance of CCP-influenced women's organisations to the liberation of women), while in 1984 it held the first national conference on Theoretical Research on Women and exhorted its local branches to recruit female researchers (Gilmartin, 1984; Wang, 1997, pp. 127–8). This did not prevent the development of a startlingly new trend in the 1980s – the emergence of a group of independent female scholars who critiqued the Women's Federation as no longer relevant to women. The most prominent critic was Li Xiaojiang, who in 1985 organised an Association of Women's Studies based in Henan province (the formal establishment of a Women's Studies Centre at Zhengzhou University in Henan in 1987 was the first of its kind in Chinese universities and colleges), as well as helping to establish a 'women's museum' in Zhengzhou.[9] Li rejected the CCP's major narrative on women, questioning whether women had had any female identity available to them after the socialist revolution, and sought through her 'women's studies' programme to separate gender from class and thereby retrieve women's uniqueness (Li also argued that the post-Mao economic reforms had been facilitated by inequality between the sexes). All this demonstrated that the state no longer monopolised the definition of 'women'; it was not long before commercialism and market forces were to have a say.

Discursive and visual representations of women

With the market reforms in the 1980s and 1990s, images of women became one of the most ubiquitous features of public visual space – on magazine

covers, television advertisements and street billboards (Evans, 2000a, b).[10] The 'commodification' of women's bodies had already been anticipated with the republication of the WF's magazine, *Women of China*, in 1978 after it had been closed down during the Cultural Revolution. From the start, images featured beautiful women in suitably 'feminine' pastel-shaded dresses; increasingly thereafter women's bodies were to be celebrated as emblems of modernity and material success. The first fashion magazine, *Shizhuang* (*Fashion*), appeared in 1980 and by the mid-1980s fashion shows had become very popular. While this may have represented a reaction against the androgyny of the Cultural Revolution period, such a focus on feminine beauty was not entirely unprecedented. During the 1950s propaganda films had used images of women trying on new clothes to highlight the state's economic growth, while beauty tips (such as advice on skin care) filled the pages of *Women of China* (Ip, 2003).[11] In the post-Mao period, however, women more than ever were not only the object of the male gaze but also perceived as naturalised 'consumers of beauty' (Evans, 2000a, p. 126). In the 1990s, for example, advertisements for skin-whitening creams in women's magazines illustrated women's avid desire for fair skin (which traditionally in Chinese culture denoted high social status); other advertisements for breast enhancers appealed to women's apparent wish for large breasts – now seen as a mark of prosperity and modernity (Johannson, 1998).[12] As one study notes, the masculinist 'iron maiden' of the 1960s had by the 1990s been replaced by a female image emphasising 'fashion, sensuality, sexuality, social mobility and the fast moving tempo of a post-socialist consumerist society' (Zhang, 2000).[13]

At the same time, however, state and public discourse revived essentialist assumptions about women's character and 'appropriate' role in society that dated from the early years of the twentieth century. Again, in reaction against the Cultural Revolution period, attempts were made in the official rhetoric as well as in press articles, school texts, and advice books to lay down clear gender roles based on biologically determined sexual differences (which in effect denoted a gender hierarchy). While the advertisements for skin care products referred to earlier often employed representations of marriage and domesticity,[14] school texts implied that girls were inferior to boys in intellect, physical ability and emotional stability. An advice book entitled *Letters to Young Women* (published in 1984) perfectly illustrated this mindset:

> the thinking of male classmates is comparatively quick. They have wide ranging interests, a strong ability to get to work, and they like to think things out for themselves.... Female classmates often have stronger memory and language ability, and are more diligent and meticulous. But they have one track minds and do not think dynamically enough, have a rather narrow range of activity, and easily become interested in trivial matters. Their moods fluctuate easily, they are shy, and they don't dare to raise questions boldly. (Honig and Hershatter, 1988, pp. 15–16)

Official and educational texts in the 1980s also revived and adapted the 'virtuous wife and good mother' model (just as the GMD had done in the

1930s) so much discussed in the earlier years of the twentieth century. The ideal wife was one who had a 'gentle and soft character' (*wenrou*), was not too career-minded, and took domestic and nurturing duties seriously (Honig and Hershatter, 1988, pp. 177–81).[15] As with the earlier May Fourth discourse, however, texts also stressed the importance of the wife having an 'interesting' and 'attractive' personality. In the realm of popular culture, the embodiment of *wenrou* was Huifang, the heroine of a popular television soap drama (a new phenomenon in post-Mao China) broadcast in 1991. The drama, *Yearnings* (*Kewang*) – one of the first during the reform era to focus on family life and domestic space – symbolically constructed women (via the character of Huifang) as the long-suffering maternal figure who stoically endures privation in a typically 'female' spirit of self-sacrifice for the cause of the family (a very traditional trope) (Rofel, 1995).[16] Valorisation of women in these tradition-alist terms, in a sense, was part of a wider campaign by the Party after the Tian'anmen student demonstrations of 1989 to appropriate Confucian values of filial piety and harmony to cement political and social order (although as early as 1984 party ideologues had praised the 'Confucian' virtues of those women who had demonstrated their patriotism by staying at home to educate their children) (Wolf, 1985, pp. 267, 270).

In discourses of sexuality, too, earlier gender stereotypes and assumptions were revived (although it could be argued they had never gone away in the first place). In some respects, the immediate post-Mao reform period witnessed more open, enquiring and frank discussions of sexuality and sex, with less insistence on achieving unanimity of opinion; in other words, discourses in the 1980s seemed to indicate less obsession with categorising and control-ling modes of sexual and gender behaviour than in the past (Evans, 1992, p. 155).[17] Symbolising this new openness was the public discussion that followed the publication of a semi-fictionalised autobiography in 1980. Entitled *A Winter's Tale*, and written by Yu Luojin (b. 1946), a graduate of the Beijing Academy of Industrial Arts 'sent down' to the countryside during the Cultural Revolution (her parents had been labelled as 'rightists' in the 1950s and her brother was executed in the early 1970s for 'subversive' criticism of Cultural Revolution policies), the book described in candid detail her sexual experiences with a man she had been pressured into marrying (by her parents); description of the wedding night, for example, raised the issue of marital rape (Yu, 1986). She divorced and remarried in 1977, but a few years later applied for another divorce in order to marry for a third time. Public discussion of Yu's memoir variously portrayed her as a social victim, liberated woman, and morally defi-cient opportunist. Yu's account, however, had highlighted for the first time the importance of both sexual autonomy for the individual woman and emotional/ physical fulfilment in a marriage (Honig, 1984).[18] The revised Marriage Law of 1980, in fact, made an absence of love and affection (*ganqing*) or emotional incompatibility possible grounds for divorce.

Yet the state continued in many ways to define 'appropriate' marital and sexual behaviour (and especially that of women). Sex education in schools after 1985 primarily consisted of warning pupils (again with girls very much in mind) of the dangers of unrestrained sexual activity. Chastity for *women*, in

fact, was defined as a socialist ideal (Honig and Hershatter, 1988, pp. 53–6; Evans, 1997, pp. 37, 66).

Paralleling the discourse of the *wenrou* woman in the 1980s and 1990s was an obsession amongst writers and film-makers to discover the cultural roots of 'real' Chinese masculinity, seemingly dissipated with the socialist revolution that had transformed men into obedient tools of the party-state (Zhong, 2000). Perhaps the most powerful (and poignant) cinematic portrayal of CCP 'emasculation' of the male, and how this impacted on one individual family, is *The Blue Kite*, directed by Tian Zhuangzhuang in 1993. The three 'fathers' of the child protagonist, Tietou (his real father and two stepfathers), all begin as strong masculine figures but are all in one way or the other rendered weak and ineffectual by the Party (and all come to a sorry end) (Nielsen, 1999).[19] Stimulated by a 1988 work by Fan Yang entitled *The Decline of Masculine Power* (which coined the phrase 'rise of the feminine and decline of the masculine' to critique Maoist rhetoric on women's liberation, which was felt somehow to have 'diminished' men), writers such as Mo Yan, Jia Pingwa and Wang Shuo, and film-makers such as Zhang Yimou (e.g. in his 1988 film, *Red Sorghum*), depicted 'rough and ready' tough men (*yinghanzi*), drawing on traditional models of the *haohan* (typified by the bandit hero, a fearless 'he-man' who does not stand on ceremony and acts spontaneously out of friendship or a sense of justice) (Louie, 2002, pp. 83–4, 94–5; Song, 2010, pp. 406–10).[20] By the turn of the twenty-first century, however, images of the masculine had become more varied, with rock stars, for example, personifying 'delicate manhood' or wealthy entrepreneurs and businessmen embodying power and virility (in Shanghai referred to as 'big monies'/*dakuan*).

Ironically, despite the exaltation of the 'real' male, it was *female* sporting figures who in the wake of the Cultural Revolution became the icons of rejuvenated national pride and patriotism (Brownell, 1998; 1999). In 1981 the Chinese Women's Volleyball team defeated Japan (in Tokyo) to win the world cup, perhaps the most significant event in the realm of public culture in the immediate post-Mao period. They became national heroines overnight (and went on to win five more consecutive world and Olympic titles), representing a reinvigorated Chinese nation shedding its nineteenth-century western stereotype as the 'sick man of Asia' (*dongya bingfu*) – a striking contrast with indigenous gender discourse at the beginning of the twentieth century when the 'backward', long-suffering and oppressed Chinese 'Woman' became a ubiquitous trope for the country's weakness and victimisation at the hands of imperialist powers (Brownell, 2000). Featured in calendars and magazine covers (gymnasts in leotards, swimmers in bathing suits), Chinese sportswomen also became virtually the first site for the reassertion of the male gaze in the popular media of the 1980s. Throughout the 1980s and 1990s Chinese female athletes continued to outshine their male colleagues on the international stage (Riordan and Dong, 1996). At the 1984 Los Angeles Olympics (the first in which the People's Republic participated) Chinese women won seven gold medals, and Chinese men eight. At the 1992 Barcelona Olympics Chinese women won twelve gold medals, and Chinese men four.[21] In 1993 alone, Chinese female long-distance runners won three world titles, while at

the World Swimming Championships in Rome in 1994 Chinese women won twelve of the sixteen swimming and diving world titles (Chinese men did not win any medals).

However, the way Chinese female track and field athletes in particular were represented deployed male-imposed gender standards. Trained predominantly by men (sporting administration was, and continues to be, monopolised by men), Chinese female athletes – many of whom came from a rural and less well-educated background (such as Wang Junxia, world record holder of the 1,500 and 10,000 metres) – were portrayed as Chinese first, and women second; they were also expected to dress moderately (e.g. no make-up or high heels) and were discouraged from having boyfriends. At the same time, their gender identity was highlighted to explain their success; thus, the ability of Chinese female athletes to respond well to rigorous training programmes was attributed to the fact that Chinese women were more accustomed to 'eating bitterness' and enduring hard labour. Such virtues were now trumpeted as enhancing China's international image; in 1989 Party chairman Jiang Zemin noted that 'Chinese women's ability to bear hardship [is] well-known throughout the world' (Friedman, 1995, p. 152). Also, it was made clear that, at the end of the day, these 'masculinised' and competitive athletes were, deep down, gentle and compliant females who were all destined for marriage after retirement.

By the 1990s many former athletes had become runway models, representing a new female image of a 'consumerist' nationalism displaying slender and graceful Chinese urban women; the first Chinese 'supermodel' contest was held in 1991, ostensibly to showcase fashion and skills (care was always taken not to describe such events as 'beauty' contests) (Brownell, 2001). In this context, it is interesting to note that the *qipao* once again became fashionable in the 1990s (hotel and restaurant female staff had begun to wear the *qipao* in the 1980s), although it has not (as in 1928) been designated formal national dress (Chew, 2007).[22]

Finally, images of *ethnic minority* women in the post-Mao period have played a role in defining the Han Chinese 'modern' (Gladney, 1994; 2004). Ethnic minorities (there are officially fifty-six ethnic minority groups in China) rarely appeared in pre-1949 Chinese cinema (the West was considered 'exotic' enough for Chinese audiences), while in the 1950s, a time when China's links with the capitalist West were minimal, China's ethnic minorities offered an alternative 'foreign' setting of the exotic; many of the films of the time were love stories complemented by much dancing and singing (Clark, 1987).[23] During the 1980s, however, Han Chinese depiction of ethnic minority women – invariably located in 'natural' surroundings, colourfully dressed, characterised by a childish spontaneity, and engaging in uninhibited interaction with members of the opposite sex – not only catered to the voyeuristic (Han Chinese) male fascination with the alluring (and slightly dangerous) exotic (thereby contributing to the growth of 'ethno-tourism') (Schein, 2005), but also served to contrast with the modern, urban and restrained Han Chinese majority culture, a type of 'internal orientalism' that constructed an evolutionary ladder of civilisational 'development' in which ethnic minorities were placed at the bottom.

A wonderful illustration of this 'internal orientalism' is the 1985 film, *Sacrificed Youth* (directed by Zhang Nuanxin, one of the very rare female film-makers at this time). The film depicts the encounter between a young Han Chinese woman and a Dai community in south-west China, where she has been 'sent down' during the Cultural Revolution. Although in many ways the film portrays the Dai and their culture positively and without condescension, it cannot escape entirely the assumptions and stereotypes that underpinned this civilisational discourse (e.g. the film wastes no time in depicting the Dai women swimming naked in a river, while the 'superstitious' beliefs of the villagers are contrasted negatively with the more scientific and rational approach to medicine displayed by the Han Chinese protagonist). Of course, ethnic minority men and women themselves participate in this discourse, often appropriating it to their own advantage and to fashion their own identities and histories (Schein, 1996; 1997; 2000).[24] Even Han Chinese women appropriate the 'exoticising' discourse of internal orientalism to their own advantage. In an ethnic minority area in southern Yunnan province marked as a tourist site (the Xishuang banna Dai Nationality Autonomous Prefecture, or Sipsongbanna), the fantasies of Han Chinese males who flock there to 'consume' Dai minority women are in fact often fulfilled by Han Chinese prostitutes (dressed in Dai costume) (Hyde, 2007).

Gains and pitfalls for women in the new market economy

The post-Mao economic reforms have dramatically changed women's lives. In the countryside, the virtual dismantling of the collectives and the devolving of economic decision-making to the individual household meant that after 1983 peasant households could hire labour, while after 1984 peasant families could engage in non-agricultural production and subcontract their land to others. With the mushrooming of village and township enterprises in rural areas, a new gendered division of labour emerged in which many of those employed outside agriculture were men, while much of the farming was performed by women (the 'feminisation of agriculture'). By the mid-1990s 60 per cent of all agriculture was performed by women (Jacka, 1997, p. 128).[25] Female labour became more valuable (in the 1980s brideprice rocketed) and represented even more a 'commodity' (Jacka, 1997, p. 62). This had a detrimental effect on girls' education, since many families preferred daughters to be helping out with farm labour (or looking after younger children) than 'wasting' time at school.

Not surprisingly, the rate of female school enrolment declined in the 1980s (compared with the mid-1970s), despite a nine-year compulsory education law that went into effect in 1986. This had a knock-on impact on both female illiteracy rates and female enrolment in higher education. In 1990, for example, about 70 per cent of the country's 182 million illiterates aged fifteen and over were female (and of these 84 per cent were rural residents) (Jacka, 1997, p. 73).[26] As of 1997 women still comprised just over 70 per cent of the country's total number of illiterates. Since the enrolment rate for girls at primary school and secondary school was low (as late as 1993, 80 per cent of the nearly 3 million unschooled primary-age children were girls), female enrolment in

higher education did not attain levels comparable to 1975 (when the female enrolment rate was 32.6 per cent) until the late 1980s (Hooper, 1991; Rai, 1992; Rosen, 1992). By 1997 the female enrolment rate in higher education had (slowly) increased to 36.4 per cent.[27] Nevertheless, at the turn of the twenty-first century girls' opportunities in poor rural regions continued to be limited by household education decisions that were clearly gender-differentiated (Li and Tsang, 2003).[28]

Market reform in the countryside also gave women more opportunity to earn extra income (and enjoy a certain autonomy) with involvement in what was referred to as the 'courtyard economy' (*xiaoyuan jingji*, a term first used in 1984) – another name, in fact, for domestic sidelines (which might also include handicrafts). While allowing married women more agency, however, the 'courtyard economy' may also have deprived them of the opportunity of communicating and interacting with other women outside the confines of the family enjoyed during the collective era (Davin, 1987b, pp. 137–8). In some rural areas the WF sponsored technical training for women in horticulture and animal husbandry, as well as arranging bank credit for the purchase of raw materials and livestock feed. In one rural township (near Shenyang in the north-east) women's earnings from 'greenhouse production' (located within the courtyard of the household) by the early 1990s was comparable to men's (Beaver *et al.*, 1995, pp. 221–3). Women also played a role in running 'specialised households' (*getihu*), family-based enterprises engaged in non-agricultural production, commerce or retail (although in many cases it was often the husband who represented the household to the outside world, arranging loans or signing contracts, for example).[29]

During the 1990s increasing numbers of rural women began migrating to the cities, being employed either as nannies/maidservants (*baomu*) in well-to-do households or as factory workers in the Special Economic Zones. Rural migration in the immediate post-Mao period (when stringent controls on rural–urban migration were loosened) had comprised mostly males, who were employed on construction sites. In 1995, however, a Ministry of Agriculture report noted that the percentage of female migrants had increased from 30 per cent in 1987 to 40 per cent in 1995 (Solinger, 1999, p. 22).[30] Such an increase in the female component of what was perceived as a 'floating population' was especially noticeable in Beijing and Shanghai; by the mid-1990s in Beijing over 36 per cent of the migrant population was female (compared with 12.5 per cent in 1988), while in Shanghai 40 per cent of migrants were women (compared with just over 29 per cent in 1988). Moreover, a number of studies in the early 1990s indicated that male migrants were more likely to return home earlier than female migrants once they had earned sufficient income, an indication perhaps that the latter found it easier to acclimatise to life in the cities and had more contact with locals (because of the nature of the work in which they were engaged) (Solinger, 1999, pp. 243–4).

With increasing wealth and material consumption in urban centres, and the emergence of what one might call a 'middle class', demand for domestic service boomed, and it was rural women who met this demand (the phenomenon is not entirely unprecedented, since in the early 1950s it was not uncommon

for the families of diplomats, intellectuals and even high-ranking cadres to hire domestic maids). As early as 1983 the WF opened a 'domestic service centre' in Beijing, which functioned as a kind of employment exchange. By 1988 there were 3 million women working as nannies/maidservants; officially referred to as 'domestic workers' (in 1997 the Ministry of Labour stated that 'domestic work' was an officially recognised profession), many of them hailed from Anhui province, although today they face increasing competition from locals who are entering the sector. While initially subject to exploitation and ill-treatment, in recent years – as testified to by frequent complaints amongst employers about their employees' work attitudes (Anhui maids, in particular, are criticised for being 'cunning' and 'disingenuous') – it would appear that the dynamics of the employer–employee relationship are undergoing subtle shifts (Sun, 2004).[31]

Income earned by housemaids (many of whom no longer live in with their employers' families) has also dramatically increased. Zhao Ruiqin, for example, from the poor western province of Gansu, who first went to Beijing in 1997, changing jobs several times before settling on working for the households of retired government employees, became her family's principal provider. The money she earned not only helped pay for her husband's medical bills, but also enabled the family to hire labourers for the farm and purchase fertiliser (as well as contributing to the building of a new house) (Pan, 2008). All of this, of course, came at a price; rural women like Zhao Ruiqin spend years in the city away from their families, and are only able (if at all) to return home once a year during the Chinese New Year's holiday in February.

The other avenue for rural migrant women was factory work, especially in the Special Economic Zones such as Shenzhen, just north of Hong Kong. By 1985, in fact, 70 per cent of the labour force in Shenzhen was composed of women, mostly young unmarried rural migrants employed in textiles, electronics, toy manufacture and service industries (Andors, 1988).[32] Residing in company-owned dormitories patrolled by security guards, these migrant workers (most of whom did not have permanent contracts) endured hazardous working conditions, with health and safety standards not always rigorously or consistently adhered to; as a result of a fire at a toy factory in Shenzhen in 1993, for example, eighty workers died – all but two of whom were women. Within the factories, similarly to the situation in the Shanghai textile mills of the 1920s and 1930s, a hierarchy of labour based on native place developed, with most of the unskilled work being performed by migrants from outside the province (Guangdong), while factory line leaders and supervisors tended to be women from other regions of Guangdong. As with those employed in the domestic service sector, these female migrant workers were collectively referred to as *dagongmei* ('working sisters'), a term that identified them as subalterns (or menials) 'selling their labour'.[33] Their own self-representation, however, especially in recent times, bespeaks a more assertive perception of themselves as 'modern' women participating in a consumerist society (Jacka, 1998; Pun, 1999).

For urban women, the post-Mao market reforms brought mixed benefits. State enterprises were now expected to be more efficient and profitable;

management, for example, was given more autonomy to make investment decisions and more flexibility in the hiring and firing of personnel. By the mid-1980s the hallowed principle of permanent employment for state sector workers, known as the 'iron rice bowl' (*tie wanfan*), was well and truly breached. This, together with the fact that unprofitable state enterprises reduced their operations or were closed down completely, meant that throughout the 1990s millions of state sector workers were laid off. Since women occupied most of the auxiliary departments of state sector enterprises, they were especially vulnerable, and were often the first to be laid off. In other cases they were 'encouraged' or pressured into working part-time, or taking early retirement or an extended 'holiday'. Official discourse trumpeted the virtues of women 'staying at home' to fulfil their duties as housekeeper and mother – a notion that the WF vociferously denounced (Robinson, 1985; Jacka, 1990). Commentators even argued that Maoist egalitarianism and large-scale employment of women in the 1950s and 1960s had imposed a brake on the country's economic development and productivity (Wang, 2000, p. 67). Ironically, this situation was exacerbated by revised regulations on the protection of female workers issued in 1988 that included provision of ninety days' maternity leave (before, it had been fifty-six) and childcare facilities at work. Employers became increasingly reluctant to employ female workers (too 'costly' and too 'much trouble').[34] Despite the regulations also proscribing gender discrimination, women faced increasing discrimination at senior professional level, where recruitment requirements were set higher for women (a trend that applied also to universities, where women were expected to achieve higher marks for entrance examinations than their male counterparts) (Rai, 1992).

On the other hand, an expanding non-state sector (including the service and entertainment industries) provided increasing opportunities for women. Statistics in 1998, for example, indicated that over 18 million registered private enterprise owners were women (40 per cent of the total) (Wang, 2000, p. 72). Younger college-educated women gained employment as bilingual secretaries or 'public relations ladies' (*gongyuan xiaojie*) – a profession that was considered 'appropriate' for women, with a mushrooming of training classes being set up to train young women in 'culture and etiquette'.[35] Many also obtained clerical and managerial positions in foreign or joint-venture companies; it is significant that by the end of the 1990s in Shanghai nearly 50 per cent of personnel departments in foreign enterprises were run by women, a phenomenon that is no doubt linked to the fact that a majority of students studying foreign languages at university were female (Wang, 2000, pp. 74–5).

The one-child policy: intrusion and resistance

While in many areas of economic and cultural life the post-Mao period witnessed a loosening of state controls, the 'one-child' policy implemented after 1980 represented a massive intrusion into women's conjugal lives, one of the most 'ambitious regulatory policies ever undertaken in China' (White, 1987, p. 284). Although official encouragement of later marriage and fewer

births during the 1970s had actually resulted in a decline of the fertility rate (from thirty-seven births per thousand head of population in 1971 to twenty-one per thousand head of population by the end of the 1970s) (Davin, 1987c, pp. 111–12), this was not considered sufficient by the post-Mao leadership, which decided that demographic growth had to be more rigorously controlled in order not to endanger future economic growth. The revised Marriage Law of 1980 not only raised the legal age of marriage (to twenty-two and twenty for men and women respectively) but also specifically enjoined couples to practise birth control. An open letter to party members issued by the Party's Central Committee in 1980 also urged them likewise to practise birth control. Such an injunction was incorporated into the revised state constitution of 1982, which for the first time stressed the duty of citizens to carry out family planning. Meanwhile, a State Family Planning Commission (headed by Chen Muhua, future president of the WF), created in 1981, prescribed the norm of a one-child family, with the aim of restricting population growth to 1.2 billion by the turn of the twenty-first century (in 1981 the population had already reached 1 billion). No specific national law or legislation was passed at this time; the aim was to increase the proportion of one-child families over time, with the provinces expected to draw up regulations and guidelines to bring about the central government's aim – in what has been described as a 'decentralised regulatory process' (Wang, 1997, p. 512). In general, a system of incentives and penalties was initially used. Those couples restricting themselves to one child would receive cash bonuses, larger allotments of land leased by the collective, and medical and educational benefits for the child; on the other hand, those having a second child would lose such benefits, while couples insisting on having a third child would be subject to fines.[36]

There was another aspect to the state's family planning policy, which increasingly took the form of a eugenicist discourse on the 'quality' (*suzhi*) of the population. The 1980 Marriage Law insisted that all couples submit to a medical examination, and those with congenital diseases were not allowed to have children. A State Council report on rural poverty in 1985 attributed China's 'backwardness' to the 'poor quality' of the people (Anagnost, 1997, p. 121). In 1988 the province of Gansu passed China's first eugenics law, prohibiting mentally disabled couples from having children; other provinces followed suit in the 1990s. The central government itself in 1995 passed the euphemistic-sounding Maternal and Infant Health Care Law, which sanctioned extensive premarital medical check-ups and sterilisation of those deemed 'unsuitable' (Dikotter, 1998, pp. 122–32, 172–4).

During the 1980s there was huge resistance to the one-child policy, especially in rural areas, where sons were especially valued (because of patrilocal marriage practices and daughters thus 'marrying out', sons were relied upon for the care of elderly parents) (Wasserstrom, 1984; Bianco and Hua, 1987; White, 2010). Ironically, also, the one-child policy clashed (at least initially) with the desire of peasant households to take advantage of the economic incentives provided by the state's market-oriented reforms (such as the lifting of price controls on agricultural products, ending compulsory state purchases at fixed prices, and sanctioning free markets) by *increasing* their pool of family

labour. In urban areas, by way of contrast, many couples had already begun to limit births before 1979 (due to the greater availability of contraceptives, more opportunities for female employment, and the fact that they were less likely to be living with grandparents who could take care of the children). Certain groups of urban women, moreover, asserted initiative of their own; in Chengdu (Sichuan province) interviews with women who were managers of household businesses in the late 1980s revealed that they 'negotiated down' the number of children they would bear for their husbands' families (Gates, 1993, p. 253).

Resistance took a variety of forms. Peasant families refused to pay fines or assaulted birth planning officials, unauthorised pregnancies were concealed (women often left their village to give birth elsewhere), and contraceptive devices like IUDs were illegally removed (it should be noted that women were expected to take primary responsibility for contraception, even though the WF from time to time publicly exhorted men to take more responsibility by wearing condoms or undergoing sterilisation). First-born daughters were especially vulnerable, and in the 1980s official reports referred to cases of female infanticide or abandonment.[37] By the 1990s there was clear evidence of increasingly skewed sex ratios (officially acknowledged for the first time in 1993). In 1996 the national sex ratio was estimated at 111 boys to 100 girls (demographers usually posit a ratio of 106:100 as the normal average). There were, of course, enormous regional variations, with Beijing recording a ratio of 105:100, while the poor south-western province of Guangxi had a ratio of 115:100 (Edwards, 2000a, p. 75). Such imbalanced sex ratios were also due to the fact that female births were often not registered. During the 1990s, too, couples increasingly made use of ultrasound equipment for prenatal sex determination (even though this was formally banned by the government), which led to induced abortions if the fetus was female.[38]

The one-child campaign also resulted in violence (physical and symbolic) against women. Women whose pregnancies were unauthorised were subject to enforced abortions,[39] while female factory workers had charts of their menstrual cycles publicly displayed in the workplace. As publicised by the WF, which published their letters, women who gave birth to daughters and/or failed to produce a son were sometimes abused by husbands and parents-in-law. A letter submitted to a national newspaper by several mothers of daughters from Anhui province in 1983 declared:

> We simply cannot understand why thirty-two years after China's liberation, we women are still weighted down by such backward feudal concepts....We long for a second liberation. (Croll, 1995, p. 116)[40]

Over the course of the 1980s and 1990s, however, in what has been described as the 'peasantisation' of population policy, provinces introduced exceptions to the one-child norm in the event of certain conditions or extenuating circumstances (Greenhalgh, 1993).[41] In Shaanxi, for example, rural couples were allowed to have a second child if their first child had serious health problems or if the wife was an only child herself; by 1986 couples were permitted a second

child if they only had a daughter (a double-edged sword as far as women were concerned, since the concession implied that girls were less 'valuable' than boys). Such an exemption was adopted by other provinces in the late 1980s. With rising rural incomes and the weakening of the collective's coercive power (and the diminution of collective funds), the system of incentives and penalties also gradually became unworkable; transgressing couples simply paid the fines with impunity or did not pay them at all (the cash bonuses for having one child were also meagre compared with household income and thus were not much of an incentive). By the early 1990s in Shaanxi a kind of 'accommodation' had been reached; cadres concentrated on preventing third or further births, while couples were quite happy to stick with a two-child family (as long as one was a son). Significantly, in both rural and urban areas at the turn of the century daughters were increasingly valued, perceived as potentially more reliable and compassionate than sons in providing emotional (and even material) support for parents in old age.

Legislation and women

The abuse and discrimination suffered by women in the post-Mao reform era were clearly a cause of concern for the Party almost from the beginning. In 1983 the WF began to raise the issue of women's rights; in the same year the CCP Central Secretariat convened a special meeting to discuss women's issues and how to protect women's rights and interests. Between 1983 and 1989 many provinces issued regulations specifically addressing this issue, culminating in the National Law on the Protection of Women's and Children's Rights in 1992, the first central government legislation specifically to define such rights (Davin, 1996).[42] The law not only affirmed women's equal rights in political, economic, cultural and family life, but also specifically banned all forms of discrimination against, and ill-treatment of, women (the revised Marriage Law of 2001 was also to make domestic violence a crime and grounds for divorce). Female infanticide was made a capital crime and the kidnapping and trafficking of women and children forbidden.

At the same time, provisions in the law concerning discrimination in the workplace drew attention to women's physiological limitations by noting that work units were not to deny women employment except in 'special types of work' not 'suitable' for women (these provisions echoed 'protective' regulations in 1986 and 1988 that forbade employers from assigning work or physical labour that was 'unsuitable' for women). Such provisions were often used by employers as a pretext not to hire women, as well as seeming to confirm that a gendered division of labour was both natural and desirable (Woo, 1994, pp. 280, 282–5). The enforcement of rights enumerated in the 1992 law, moreover, remained poorly defined, and abuses continued; a 1995 Amnesty International report in 1995, for example, noted that 33,000 women had been 'abducted and sold' between mid-1993 and early 1995 (Evans, 1997, pp. 170–1). This disturbing phenomenon was the subject of a powerful film directed by Li Yang in 2007, *Blind Mountain*, which depicted the plight of a college graduate kidnapped and sold as a bride in a remote village.

Yet in 1994 the State Council issued a Programme for the Development of Chinese Women which repeated the official mantra that liberation since 1949 had ushered in an era of gender equality (it conceded that there was a need to expand women's participation in government decision-making). Although the State Council admitted that women's condition at present was not 'wholly satisfactory', this was attributed entirely to the 'constraints' of social development or the lingering influence of 'feudal' ideas (Edwards, 2000a, pp. 64–5). Neither government policy itself nor entrenched (and contemporary) gender stereotypes in politics, education or employment were considered an issue. The following year Beijing hosted the Fourth UN World Conference on Women – the largest international gathering ever held in China before the 2008 Beijing Olympics. Any chance, however, that the considerable number of international and domestic non-governmental organisations (NGOs) also due to meet in Beijing to coincide with the conference might play a role in stimulating debate about women's issues in China was scotched by the government when it insisted that all NGO fora were to be held outside Beijing and well away from any publicity. In the final analysis, although the CCP's 'master narrative' of women's liberation had been undermined and questioned in the post-Mao period, the party-state still in many ways retained for itself the right to set the parameters of the debate and to define the issues involved in 'the woman question'.

Conclusion

In October 2010 the Miss World Pageant was held in Sanya, Hainan province (the fifth time, in fact, that China had hosted the event since the beginning of the twenty-first century); Miss China, the six-foot-tall Zhang Zilin (a graduate in business administration), won the title, the first Miss World of East Asian origin. Although the Women's Federation as early as 1993 had criticised beauty contests for their commercialised objectification of women, the regime itself had continued to promote beauty contests (and fashion shows) for their showcasing of 'oriental female virtue'. In a sense, the Chinese official valorisation of 'oriental female virtue' in the early twenty-first century harked back to Shimoda Utako's educational ideal of a particular 'Asian womanhood' at the turn of the twentieth century.

Thus, in a tribute to the Chinese actress Bai Yang (1920–97), who had played the long-suffering wife and mother in the 1948 film *Spring River Flows East* and the doomed widow in the 1956 film *New Year's Sacrifice*, the Ministry of Culture declared in 2003 that the roles she had played symbolised quintessential Chinese womanhood, 'a woman with dignified behaviour, sincere and rich inner feelings, and the traditional Chinese womanhood of a good wife and a caring mother'. Whereas in the 1950s official commentaries on such films would have highlighted their vivid portrayal of oppressed and victimised women in 'feudal' (i.e. pre-liberation) China, the Ministry of Culture preferred to emphasise the special characteristics of Bai Yang's acting:

> Her movements and facial expressions were in conformity with the temperaments of the characters she performed and the requirements of the films, making the audience realise her innate refinement and gentleness – charm unique to women in the orient.[1]

The early years of the twenty-first century have also witnessed attempts by both the state and increasingly commercialised media to valorise 'female virtues' and motherhood in the cause of moral regeneration and social harmony. In 2006 the WF and a variety of media organisations promoted a campaign to discover and celebrate 'China's Ten Outstanding Mothers' (a smaller and less publicised campaign had been launched in 2001). Women deemed ideally qualified for such an accolade were to be patriotic, efficient household managers, rigorous educators of their children, contributors to family and social harmony, *as well as* independent and self-supporting professionals (Guo, 2010).[2] Such a discourse echoed both the early twentieth-century emphasis on the skilled household manager/mother as the foundation of political and social order,[3] and the early 1960s assumption that women could, and should, combine their role as principal carers of the household with active participation in socialist production.

In a similar vein, since the late 1990s the media have publicised the cases of mostly rural migrant women who desperately seek to escape from forced prostitution (by, for example, leaping out of high-storey buildings and thereby suffering severe physical injuries) as 'chastity heroines' – harking back to traditional notions of ideal womanhood and female purity associated with the historical *lienü* (chastity martyrs). In calling for both official and private assistance for these victims of sexual exploitation, the media in effect appropriate the bodies of these 'chastity heroines' to encourage individual Chinese citizens' greater involvement in public charity (Jeffreys, 2010).

Perhaps not coincidentally, such 'traditionalist' gender rhetoric deployed by the state and the media (reports of the 'outstanding mothers' campaign frequently referred to 'traditional Chinese virtues') has been accompanied by the continuing decline (or stagnation) of women's political participation in recent years. By 2002, for example, China had slumped from twelfth (in 1994) to twenty-eighth in the international league table of 'women in politics' (Edwards, 2007). In 2006 China fell even further to forty-ninth position, despite the fact that since 1978 there had been no noticeable decline in the percentage of female representation in the National People's Congress. Nevertheless, it is striking that the number of female delegates at the 10th NPC in 2003 (604 delegates comprising 20.2 per cent of the total) was still less than that of the 4th NPC in 1975 (653 delegates comprising 22.6 per cent of the total).[4] Perhaps more significantly, twenty-one women were elected to the NPC Standing Committee in 2003 (13 per cent of the total), only a slight increase in comparison to the thirteen women elected to the 6th NPC Standing Committee in 1983 (comprising 9.4 per cent of the total). Within the Party itself, the decline of female participation was more dramatic. The 16th Central Committee, elected in 2002, contained only five full female members out of 198 (2.5 per cent), fewer than the 8th Central Committee elected in 1956 (which had four female members). In 2002, too, women's representation in the CCP as a whole had not grown significantly since the early 1970s (17.3 per cent of total membership compared with 10 per cent in 1973). As with other areas of life, however, the WF continued to be constrained in its ability to promote sex-specific programmes (such as expanding women's political participation) since this would be perceived as a challenge to the Party's overall economic plan (which in the long term, it is assumed, will bring about any improvements required to enhance women's status).[5]

This gendered political landscape was not static, however, and several intriguing developments during the last decade may have the potential to shift its configuration. In 2002 Wu Yi (b. 1938) became the first woman to be elected to the Politburo since the late 1970s. More significantly, unlike the three previous incumbents (Jiang Qing, Ye Qun, Deng Yingchao), who were all married to top Party leaders at the time of their appointment, Wu Yi had not relied on marital connections (in fact she was unmarried). Previously a deputy mayor of Beijing (1988–91) and Minister of Foreign Trade and Economic Cooperation (1993–8),[6] Wu Yi's media persona (which she herself probably had a hand in cultivating) highlighted both her independence and her open and transparent official style, as well as her tough negotiation skills on behalf

of China's national interests in international encounters. By ensuring also that she was always elegantly dressed and appropriately modest in demeanour to accentuate her femininity (a stylish appearance was now linked to China's international image and hence a demonstration of patriotism, a stark contrast to Cultural Revolution attitudes), Wu Yi avoided being tagged as a dangerously masculinised woman threatening to usurp male space (Edwards, 2006). It may be that she advanced the cause (however limited) of *competent* feminine power that will in the future subvert deep-rooted prejudices against women at the centre of political power.

At local levels there have been substantial efforts to increase women's political engagement in recent years, especially with regard to the election of village committees, sanctioned by a 1987 law (an additional law in 1998 made it mandatory for villages to hold such elections every three years). In Shaanxi province a non-governmental organisation, the Shaanxi Research Association for Women and Children (set up in 1986), collaborated with the WF in devising training programmes for potential female village leaders, initially concentrating on one particular county (Heyang). In the 2006 elections an unprecedented twenty women were elected as village heads, while 324 more were elected as village committee members (constituting 25.2 per cent of the total, compared with 10.5 per cent in previous elections in 2002). In Shaanxi province as a whole, 291 women were elected as village heads in 2006 and 12,549 as village committee members (16.1 per cent of the total) (Gao, 2010).[7] Another significant aspect of the Heyang programme was that the Shaanxi Research Association was also funded by the Ford Foundation, reflecting increasing interaction between Chinese women's NGOs and international organisations.[8]

It is perhaps in the realms of the economy, family and marital relationships, and sexual mores that gender change since the 1990s has been especially noticeable. The burgeoning private sector, for example, is producing growing numbers of female entrepreneurs. In 1997 there were 20 million private entrepreneurs in the country, 25 per cent of whom were women. The Beijing-based China Association of Women Entrepreneurs (established in 1985) recorded a membership of 7,000 nationwide in 2000 (Wylie, 2004, pp. 42–3). In the northern province of Shanxi by the late 1990s many of the new enterprises (in transportation, hotels, retail) were in effect family affairs (husband and wife teams) in which the wife was the accountant or business manager, although in many cases the 'public' profile of the enterprise was represented by the husband (Goodman, 2004). This reflected a new trend in masculinity discourse that identified the challenging world of entrepreneurship and business (requiring the ability to take risks and forge widespread contacts) as a particular masculine space. Women also still have to confront a widespread prejudice against the independent career woman. As early as 1991, an article in the WF magazine *Women of China* suggested that these *qiang nüren* (strong women) were unfeminine and hence unsuitable as wives (Evans, 2000, p. 123).

In the countryside, women in many ways are agents of change in the family and physical landscape, as their growing insistence on having their *own* homes

after marriage, in a bid both to break away from their husbands' families and to construct an identity for themselves as 'modern', has led to increasing numbers of nuclear households and the marketisation of rural areas as a result of a construction boom (Sargeson, 2004).[9] Increasingly, also, bridegifts and dowries are paid directly to young couples to enable them to buy a new home and furniture (whereas in the 1980s the most sought after wedding gifts were principally the 'three new things' – washing machine, television, fridge). On the other hand, while rural married women seek to assert independence *vis-à-vis* husbands' families, they tend now to have closer ties with their own parents than ever before (Zhang, 2009).[10] This is paralleled in urban centres such as Beijing, which are witnessing growing emotional ties and attachments between mothers and daughters (Evans, 2008a).

Finally, since the late 1990s sexual mores in cities such as Shanghai have become more relaxed and uninhibited. Yet, as a recent study of youth sex culture and the stories that are told of Shanghai's 'sexual opening' (*xingkaifang*) notes, such a phenomenon does not necessarily equate with a western 'narrative' of sexual revolution as a 'romantic saga of liberated desire' but rather constitutes 'an ironic melodrama of increasing temptation, sexualisation of public life, commodification of sexuality, and Westernisation of local sexual culture' (Farrer, 2002, p. 22). In other ways, sexuality has become a key aspect of individual identity; whereas in the 1980s and early 1990s the emphasis was very much on essential gender differences and heterosexuality, representations of sexuality since then have explored quite different trajectories (such as lesbian sexuality in fiction or the ambivalence of gender in performative art). This has not impacted (so far), however, on official and established notions of gender identities and gendered relationships (e.g. official sex education materials used in schools continue to circulate the image of the active, strong and protective male and the passive, weak and dependent female) (Evans, 2008b). A relaxation of sexual mores is also occurring in the countryside, where a new form of post-engagement dating has emerged in which sex is no longer considered taboo. Whether this trend, in the words of one scholar, correlates to a 'rise of the individual and the development of individual rights' (Yan, 2002, p. 51),[11] remains to be seen, but it is clear that gender representation and practice will continue to be a significant barometer of political and sociocultural change in twenty-first-century China, just as it was in the twentieth.

Notes

Introduction

1. It has been described as the most compelling encounter between a member of the dominant class (the narrator of the story, an intellectual who is compelled to engage in conversation with the widow, does not feature in the film) and a downtrodden 'other' (Chow, 1991, pp. 107–12).
2. For an overview of recent research on Chinese women during the twentieth century, see Hershatter (2007a).

1 Women in Pre-Twentieth-Century China

1. For example, in such matters as the organisation of domestic space, attitudes towards marriage, dowry custom and practice, and inheritance rights.
2. Goldin argues that such texts call into question the accepted scholarly view that traditional Confucian thought perpetuated repressive and negative stereotypes of women, as well as demonstrating that early Confucian thinkers accepted the moral equality of the sexes (although not their social equality).
3. The possibly earliest criticism of the practice appeared in the writings of a late Song scholar in the thirteenth century (Ebrey, 1990, p. 217).
4. See also Blake (1994).
5. Ko also notes that female friendships among the elite were sealed with the exchange of shoes.
6. Hakka women also tended to be more prominent in outside farm work than their neighbours.
7. For an illustration of Manchu women's shoes with high platform wooden soles covered with cloth, see Roberts (1997, p. 37).
8. On Der Ling, see Hayter-Menzies (2008).
9. Goldin also points out that it is never entirely clear in any early Confucian text *how* authors conceived of the difference between *nei* and *wai*, and thus what they considered to be appropriate subjects for women to discuss.
10. For a study (based on ethnographic fieldwork in rural Hong Kong) of naming practices that sharply distinguish between the sexes, with girls' names (*ming*, given one month after birth) being less flattering than those of boys, see Watson (1986).
11. A study of the Song period (tenth to thirteenth centuries) notes that an upper class woman's 'talents' might well include knowledge of medicine, music and history (Ebrey,1993, pp. 121–2).
12. Anthologies of Chinese women's writings include Chang and Saussy (1999) and Idema and Grant (2004). Schmidt (2008, p. 130) also points out that it is likely more poetry was produced by women in the eighteenth century than in the twentieth.
13. See also Idema (2009), which includes the first English translations of some of these ballads. In total some 500 texts in 'women's script' have been preserved, ranging from four-line poems to long autobiographical songs and ballads (many, however, probably date from the 1980s, when the few women still acquainted with *nüshu* were asked to rework the texts from memory).
14. Liu points out that *nüshu* texts reveal how the decision by peasant widows to remarry or not was conditioned by priorities not always discussed in male elite texts; such priorities might be economic security (in the decision to remarry) or to protect daughters (in the decision not to remarry).

15. In contrast to male suspicion of women participating in religious pilgrimages, Confucian scholars often praised women who took up Buddhism *within* the home as a contribution to family harmony (Ebrey, 1993, p. 171). See also Zhou Yiqun (2003).

16. Guanyin (the Chinese translation of Avolokitesvara, a male Buddhist saint) was metamorphosed into a woman during the tenth century.

17. Sangren argues that, as idealisations of womanhood, female deities like Guanyin and Mazu had to overcome the stigma of pollution associated with menstruation, sexual intercourse and childbirth. At the same time they symbolised inclusive and universal 'motherhood' compassionate to all who sought their help. Such a dichotomy paralleled women's unifying (as mothers ameliorating fraternal competition) and divisive (young daughters-in-law who pressed for early household division) roles within the domestic group.

18. It was men and women worshipping the deity together (on a relatively equal basis) that led officials to accuse the White Lotus sects of 'lewdness' and 'debauchery'. Another symbolically powerful female deity was the Queen Mother of the West (*xiwang mu*), a Daoist goddess whose origins may go back as far as the fifteenth century BCE; as the upholder of cosmic harmony and creator of the world, she had the power to grant longevity and was known for her protective relationship with women, especially those outside the formal kinship group (Cahill, 1993).

19. Her principal statue and pre-1949 images of her depicted her with small bound feet, calling attention to her femininity and sexual allure (Pomeranz, 1997, p. 195). Interestingly, by the early twentieth century Bixia Yuanjun was also worshipped as the protector of young wives visiting their parents, suggesting that women *did* maintain contact with their natal families after marriage.

20. Buddhism had first entered the Chinese world in the first century CE. In operas and novels Buddhist and Daoist temples were often portrayed as promiscuous sites precisely because they were frequented by women (Bray, 1997, p. 144). On the social significance of Buddhist nuns, see Li (1994). As Li points out, Buddhist convents opened up new possibilities for women, giving them access to education, more mobility, and experience in administration.

21. As Mann notes, concerns about boundary crossing in the domestic realm were symbolic of a wider anxiety about the growing porousness of boundaries in society as a whole during the eighteenth century.

22. By the end of the sixth century the idea of *physical* rectitude had become one of the most widely accepted meanings of *zhen*, a word hitherto used to denote a 'virtuous' woman.

23. The earliest known Chinese woman to support the Catholic enterprise was Candida Xu (1607–80), the granddaughter of Xu Guangqi (1562–1633), a Ming dynasty bureaucrat and astronomer who collaborated with Matteo Ricci (1552–1610), one of the first Jesuits to work in China. On Candida Xu, see Collani (2010).

24. Menegon argues that the Dominicans legitimised Christian female virginity by associating it with Chinese values of both filiality and female chastity.

25. See also Tiedemann (2010), and Entenmann (2010).

26. On women painters in China, see Weidner (1990a) and Laing (1990). For gentry women, painting skills were often socially and financially advantageous.

27. Although courtesans were specialised entertainers and artists (and *not* primarily paid for sexual services), the general Chinese term to refer to them – *jinü* – was equally applied to common lowly prostitutes.

28. Spontaneity and sincerity were characteristics often attributed by male literati to women's writings in general, because women were perceived as being 'uncorrupted' and 'unsullied' by having to compete and compromise in the official world monopolised by men. Some male literati in the seventeenth century even argued that such a situation meant that women were potentially morally and intellectually superior to men (Ko, 1994a, p. 52).

29. The female knight errant has remained a potent symbol in Chinese popular culture throughout the twentieth century. The extraordinary film, *A Touch of Zen* (with the Chinese title *Xia nü* /Female Knight Errant), directed by King Hu in 1971 and which put Chinese cinema on the international map, was loosely based on a short story ('The Lady Knight Errant') by Pu Songling (1640–1715). See Teo (2007). Pu Songling's original short story is translated in Shimer (1982, pp. 77–84).

30. At the same time, a strict differentiation was imposed between the courtesan's private residence and the 'inner quarters' in which the *guixiu* resided. The latter was viewed as a timeless realm of stability and purity.

31. In the White Lotus rebellion of 1796 women did indeed assume positions of sect leadership; in some cases a widow might succeed to her husband's position as sect or group leader; according to Qing documents of the time one such widow fought on horseback and headed a battalion comprising 'several hundred women cavalry' (Shek and Noguchi, 2004).

32. See Murray (1987, pp. 71–3, 133–42, 147–53) on the early nineteenth-century female pirate leader Cheng I-sao. Cheng I-sao (literally, 'wife of Cheng I), a former prostitute, took over formal leadership of a pirate force of 300 junks and up to 40,000 men after her husband's death. She surrendered to Qing authorities in 1810 and eventually died (in Guangzhou) in 1844 at the age of sixty nine. As Murray notes (p. 78), the presence of women alongside their husbands on Chinese pirate vessels and their participation in fighting contrasted with western piracy, which considered women's presence on boats as taboo.

33. Although no *official* references to Hua Mulan exist before the Song dynasty (960–1279), a local gazetteer later compiled during the Qing dynasty noted that Hua Mulan had lived during the Sui dynasty (589–618).

34. In a wider sense, it has been argued that powerful female myth figures were an essential component of Chinese patriarchy, which depended on such figures to narrate and embody its values (Mann, 2000a).

35. On the other hand, excavations of a Shang tomb in Anyang (Henan province) in 1976 indicated that Fuhao, consort of a Shang king who reigned in the thirteenth century BCE, was a prominent political and military figure in her own right (Lai, 1999, p. 80).

36. An anthropological study of a village in south China in the 1920s noted the continuing attraction of ballads and stories of 'female heroines' such as Hua Mulan amongst adolescent peasant women (Croll, 1995, p. 14). On changing images of Hua Mulan, see Edwards (2010).

37. Although foxes might metamorphose into both handsome young men and beautiful women, over time they came to be primarily associated with seductive women and the danger of female sexuality.

38. On the hypersexual female ghost portrayed in seventeenth-century popular fiction, see Zeitlin (2007). On the vengeful female ghost, see Zamperini (2001, pp. 87–96). See also Wolf (1974, pp. 145–54).

39. McLaren attributes more significance to this than Ahern (1975, pp. 205–6), who simply notes that women were relegated to the worship of lowly spirits at home or at special altars in the back rooms of temples.

40. Even in north China women worked in the fields (Judd, 1994, pp. 41–50).

41. See also Mann (2000b).

42. Before the Song period in the eleventh century most textiles were simple weaves made by rural women; in effect, knowledge and organisation of production at this time were controlled and managed by women.

43. Women's dowries, however, continued to comprise cloth made by the bride herself, and so could be considered a kind of 'social capital' (Bray, 1997, p. 188).

44. Also, because outside activities in which women continued to play a role, such as tea-picking, were viewed as transgressing gender divisions, they were simply not included in a listing of women's virtues.

45. See also Walker (1993; 1999, pp. 37–8, 40–41, 51); Bray (1997, pp. 214–15).

46. See also McDermott (1990), which highlights the wife's important role in the management of family finances. For an example, see the memoirs of Zeng Jifen (1852–1942), the daughter of the nineteenth-century statesman Zeng Guofan, in Kennedy and Kennedy (1993).

47. On the phenomenon (and historical significance of) sojourning men in imperial China, see Mann (2000c).

48. See also Judd (1989). Fieldwork for the article was carried out in three villages in Shandong province in 1986 and 1987–8. Village residents declared that daily visits by wives to their natal families were based on 'custom' (*xiguan*) and 'tradition' (*chuantong*). On the continuing importance of the natal family and affinal ties for married women (both elite and non-elite), see also Bossler (2000).

49. See also Mann (2007, pp. 113–15, 147–8).

50. Mrs Ning may have remarked that it 'was no light thing' for a woman to step outside the home (Pruitt, 1967, pp. 55, 62), but she did so anyway.

51. The poison was reputedly made from venomous insects. After 1949 the Miao were classified as China's fifth largest minority group (nearly 7.5 million in 1990), distributed over seven provinces, with the densest concentrations in Yunnan, Guizhou and Hunan. In present-day slang Miao also continues to connote 'wild' or 'barbarian'.

52. During the course of the eighteenth century a uniform standard of sexual morality was extended across old status boundaries, whereby everyone was expected to conform to gender roles strictly defined in terms of marriage. The chaste wife, in particular, stood on the front line defending the family order (Sommer, 2000, p. 14).

53. Such an arrangement was often formalised with written contracts and the second husband changing his surname. Uxorilocal marriage was not just confined to commoners, but also occurred amongst elite families (as a way of moving up the social ladder) (Lu, 1998; see also McGough, 1981).

54. See also Elvin (1984).

55. On changes in the definition of 'womanly virtue' over time, and culminating in the chastity ideal of the late imperial period, see Du and Mann (2003).

56. Although the widow fidelity ideal had existed since early times, it was only during the Ming period that the deeds and ordeals of 'heroic' widows were recorded in local histories, and shrines and arches erected in their honour. On the Ming literati's praise of faithful widows, often bound up with their own self-representation and desire for a literary reputation, see Carlitz (1997).

57. During the eighteenth century especially large numbers of *Manchu* women were canonised as chaste widows, a demonstration of what has been termed a 'bifurcated ethnic strategy' pursued by the Qing dynasty, whereby Manchu (and Mongol) men were expected to adhere to a specific ethnic ideal differentiating them from Han Chinese men, while chaste widowhood (a Han Chinese practice) was valorised for Manchu women in order to enhance the dynasty's legitimacy as the upholder of Confucian norms (Elliot, 1999, p. 63).

58. See also Theiss (2001). For an excellent introduction to the subject, see Ropp (2001).

59. Early Qing rulers discouraged widow suicide for another reason – to shed inconvenient reminders of their 'barbarian' past, since Manchu widow suicide had long constituted an Inner Asian (Altaic) custom unrelated to Confucian practice (Elliot, 1999, pp. 43–7).

60. On the literary significance of *qing* and its connection to widow suicide, see Carlitz (1994, pp. 117–18) and Zamperini (2001).

61. See also Sommer (1996, pp. 81–2). It meant also that women were *expected* to be moral agents, as it was they who took the initiative in interpreting any slight as a 'stain' on their virtue.

62. In other cases members of the woman's family might take the law into their own hands and assault alleged perpetrators themselves (or destroy their property). One of the first scholars to highlight the significance of female suicide as a means of wreaking revenge for mistreatment by men or in-laws was Wolf (1975).

63. Young married women were especially vulnerable to sexual assault, in most cases perpetrated by neighbours or relatives.

64. The first such court award dates from 1430. It should be noted, however, that there was always fierce debate amongst male scholars over the ritual propriety of such acts.

65. In their suicide notes (*jueming ci*) faithful maidens interpreted their action as commitment to the ideal of honour-bound duty.

66. For a general discussion of widows in the Qing period, see Mann (1987). During the Song period a widow could take her dowry with her into a second marriage (Ebrey, 1993, p.113).

67. In other respects, the emphasis on patrilineal succession disadvantaged daughters born into families with no surviving sons; during the Song period, and even before, an unmarried only daughter might inherit all the property of a sonless couple (if she was married she might inherit up to a third of the property, with the rest taken over by the state). See also Bernhardt (1996). Moreover, during the Song, even in families with living sons, daughters might be allocated a share of family property equivalent to half the share of a son, and which would be set aside for their dowries.

68. It was not only birth mothers who were able to establish a uterine family; a close bond might be forged between the formal mother (*dimu*) and the son of a secondary wife or concubine.

69. A study of women and the family in the Song period similarly argues that many elite women found it advantageous to respond to the opportunities and rewards that the patrilineal and patriarchal system presented (Ebrey, 1993, p. 8). See also Fong (2004a, pp. 3–5), which notes that the performance of 'women's work' (*nügong*), associated primarily with embroidery, became for elite women a positive display of 'virtuous conduct' that encompassed learning, skill and talent.

70. By the seventeenth century, women were also editing and publishing works produced by other female writers. On women's literary networks (which might include male friends and patrons), see also Widmer (1989).

71. Gentry women painters also attained status and success *within* the system. For an example, see Weidner (1990b), a discussion of Chen Shu (1660–1736), who had her paintings presented to the Qianlong Emperor and was celebrated as a virtuous mother and filial daughter.

72. As one study notes, such a phenomenon demonstrated how the patriarchal system *accommodated* resistant discourses as an institutionalised element of village exogamous marriage (Silber, 1994, p. 64).

73. Bridal (as well as funeral) laments also revealed how marriage had very different connotations for men and women. For men marriage was associated with life, prosperity and fertility, while for women it might just as well be associated with death, darkness and absence of human warmth (Martin, 1988, pp. 170–1; see also Johnson, 1988).

74. In another context, the anthropologist Margery Wolf has drawn attention to the informal influence of the 'women's community' in Chinese villages, which used gossip to great effect in shaming the menfolk (Wolf, 1974, p. 162).

75. As a living oral genre, bridal laments have virtually died out today. See also McLaren (2008).

76. Lee also contrasts the *nei–wai* binary in Chinese culture, which was 'permeable and graduated', with the domestic–public sphere binary in the western tradition, which was 'impermeable and categorical'. Ropp (1981, p. 129) describes Li as one of China's first 'feminists'.

77. See also Ropp (1981, pp. 143–6).

78. In one story the wife of a perpetually unsuccessful examination candidate takes the examinations dressed as a man and attains the highest degree.

79. Another female character in the novel escapes from becoming a concubine and is able to live alone by selling her poetry and calligraphy.

80. See Wu (1995), which notes that the 'shrew' is more often than not the primary wife in an elite household who is subject to jealous rage aimed at her husband's concubine(s). See also Paderni (1999) and Theiss (2007). In their depiction of women, other works of popular fiction, such as the fourteenth-century vernacular novel *Shuihu zhuan* (*The Water Margin*), were deeply misogynistic, in line with a prevalent trend in folklore that associated an ultra-masculine ideal (*wu*) with the rejection of female 'charms' and even overt sexual antagonism towards women. On this, see Louie (2002, pp. 24–35).

81. The idea of the 'women's kingdom' (*nü'er guo*), characterised by an absence of men or a reversal of male–female roles, is a common one in the Chinese cultural imaginary (Hu, 1997, p. 72).

82. For a recent analysis of the novel, see Epstein (1996). Epstein moves the discussion away from Li's 'feminist' motivations, preferring to see his depictions of women as a 'metaphorical projection of his ambivalence toward the literati's place in society as moral and political leaders' (p. 108).

83. The article was published in *The Chinese Social and Political Science Review* 8.2 (1924), pp. 105–7.

84. The article is reprinted in Li (1992, pp. 35–58).

85. By the early nineteenth century fictional narrative aimed specifically at a female audience had become an important element in elite women's lives. See also Widmer (2006a), which argues that by the turn of the twentieth century women were becoming increasingly linked to the novel either as readers or as writers/editors.

86. Women's memoirs testify to parents' desire to re-imagine their daughters as sons. See Croll (1995, pp. 38–40) and Wang (1999, pp. 148, 225, 261).

2 Reform, Nationalism and the 'Woman Question' (1897–1912)

1. Excerpts from the narrative, *Stones of the Jingwei Bird* (which remained unfinished at the time of Qiu Jin's death), are translated in Dooling and Torgeson (1998, pp. 43–78) and Idema and Grant (2004, pp. 786–93). A more complete translation (in French) is by Gipoulon (1976).

2. This was in contrast to the situation in Britain, France and the US, where issues of female education and sexual equality were addressed only *after* considerable time had elapsed since modern ideas of nationhood had first been advanced (Judge, 2008, p. 8).

3. See also Kwok (1996).

4. Dunch further argues that Protestant texts were not simply a translation of late Victorian gender ideology into a Chinese context, but rather also aimed to introduce new ideals and concepts such as women's agency (albeit within the domestic sphere) and companionate marriage. Dunch fails to recognise that *neither* of these ideals/concepts was especially new in the Chinese context.

5. On the Shanghai McTyeire School, see Ross (1996).

6. See also Cong (2007, pp. 34–5). By 1922 there were 60,000 female students in Protestant mission schools.

7. Kwok (1992, p. 30) also notes that the increase of female missionaries in China was accompanied by a gradual 'feminisation' of the Christian message in mission work at this time. This was illustrated by the emphasis on God's compassion and on Jesus' relations and work with women, while also downplaying the sinfulness of Eve.

8. Kwok (1992, p. 200) also makes the interesting point that *rural* commoner women were more likely to respond positively to Christianity because they were less bound to Confucian tradition and less secluded than their elite counterparts.

9. Another intriguing aspect of the encounter was that, while missionary women tended to 'feminise' Chinese male servants because of their 'unmanly servility', Chinese men 'masculinised' single missionary women because of their perceived lack of 'appropriate' feminine qualities.

10. Nevertheless, single women rationalised their desire for self-liberation (i.e. to be an overseas missionary) in the conventional and socially acceptable rhetoric of dutiful self-sacrifice rather than in terms of gaining glory or seeking adventure.

11. On western attitudes towards footbinding, see Kwok (1992, pp. 111–15); Ebrey (1999); and Ko (2005, pp. 14–18).

12. A recent article (Fiske, 2009) has highlighted the complexity of Alicia Little's attitude towards China and Chinese culture, arguing that her vision of cross-cultural harmony is not typical of western 'orientalist' assumptions. See also Thurin (2007).

13. The ideal of the 'social housekeeper' and efficient household manager was very much in vogue at this time in the US (Kwok, 1992, p. 108).

14. As Graham notes (p. 45), 'a woman on a bicycle was capable of choosing her own path and escaping the watchful eyes of those who would monitor her behaviour'.

15. For many Chinese observers at the time, this distinction between gender equality on the one hand, and the need to maintain separate spheres on the other, was somewhat confusing.

16. On the first group of Chinese women studying in the US, see Ye (1994; 2001, pp. 114–29). The first Chinese woman to receive a medical degree in the US (from the Women's Medical College of New York Infirmary in 1885) was Jin Yunmei (1864–1934).

17. Allowing missionaries to adopt Chinese children was a way for some Chinese families to relieve financial burdens. Kang herself apparently came from a family of six daughters.

18. On the significance of Kang Cheng as a bilingual and bicultural Asian woman who saw no contradiction between her Christian faith (and wanting to 'Christianise' China) and her nationalist agenda of challenging Anglo-Saxon hegemony, see Shemo (2009).

19. On Shi Meiyu's later contributions to medical care in China, see Shemo (2010).

20. For a good example of this, see the hagiographical account of their lives in Burton (1912, pp. 115–58, 161–218).

21. Zhang Zhujun, a medical doctor and one of the first Chinese women to receive a western medical training in China (in Guangzhou), reportedly preached in her church in 1906.

22. See also Hunter (1984, pp. 257–61). Hunter argues that the story highlights different Chinese and western approaches to gender. While for the Chinese gender could be *adopted as a role* rather than inherited as sex, in the West at this time sex was considered as the essence of identity itself, which permeated the self to actually determine temperament.

23. Thus the 1895 society in Shanghai has been described as China's first 'marriage bureau' (Beahan, 1976, pp. 135–6).

24. A phenomenon I personally observed when I was in China in 1980. On a mountain trail just outside the town of Kunming (Yunnan province) leading to a popular temple, I saw a number of elderly women (aged between 50 and 60), unable to climb the trail because of their previously bound feet, being carried on the backs of their sons (or possibly grandsons).

25. She was apparently taken everywhere by her father dressed as a boy with short hair.

26. Ironically, many of the men involved in founding the Chinese Girls' School had concubines.

27. For a translation, see Thompson (1958). On Kang's ideas in the *Datong shu*, see Ono (1989, pp. 40–6).

28. Tan Sitong, another participant in the Hundred Days Reform who was subsequently executed in the wake of the conservative reaction at court that put an end to the movement, also called for free and open intercourse between the sexes, thereby ending the treatment of women as sex objects (Ono, 1989, pp. 34–9).

29. Kang asserted that such relationships were to be based on 'the satisfaction of human feelings' rather than on the need to ensure posterity, a very un-Confucian outlook.

30. Such an idea would have seemed normal to many Chinese, given the tradition of female knight-errants and women adopting male dress (and thus able to perform male roles).

31. Cixi (1835–1908), a member of the Manchu Yehe Nara clan and daughter of a minor military official, was a consort (first concubine) of Emperor Xianfeng (r. 1850–61) and mother of Emperor Tongzhi (r. 1861–75).

32. The leading Red Lantern in Tianjin, Lin Hei'er, known as *huanglian shengmu* (Holy Mother of the Yellow Lotus), could also magically heal wounds and restore the dead to life.

33. Boxer casualties were also blamed on foreigners placing naked women in their front lines, thus breaking Boxer magic. Significantly, most female Boxers (aged between 11 and 17) had not experienced menarche, sex or childbirth, and were thus not associated with the ritual 'uncleanliness' of adult women (Cohen, 1997, pp. 131, 141).

34. On the Beiyang Women's Normal School (later known as Zhili First Women's Normal School), see McElroy (2001). On the significance of female teachers' schools during the last years of the Qing, see Cong (2008).

35. See also Bailey (2001).

36. See also Judge (2002c).

37. As such, the *ryōsai kenbo* ideal represented a 'reinvention of tradition', since it implied a *new* kind of domesticity different from traditional practice. On Meiji gender ideology, see Sievers (1983, pp. 11–13, 22–3, 50–60, 111–13) and Nolte and Hastings (1991).

38. A number of later memoirs written by women, nevertheless, remembered the 'struggle' they had had with parents who fiercely opposed them attending school (Croll, 1995, pp. 40–3).

39. After 1949, the term *funü* re-emerged, but this time it was used as the collective word for women identified solely as the Maoist national subject. It dropped out of use or was specifically rejected in the post-Mao period.

40. Xue Shaohui published the first systematic introduction to 'famous' western women, in 1906 (Qian, 2004).

41. Chengdu police also established the 'House of Cultivation and Education' (*jiliang suo*) to help prostitutes 'make good' (*congliang*) – anticipating later measures carried out by the Chinese Communist Party to 'reform' prostitutes (see Chapter 6).

42. These proscriptions lasted through the 1910s and 1920s.

43. See also Luo (2005).

44. The first female *jingju* ensemble theatre appeared in Shanghai in 1894, although mixed performances of what was known as 'obscene opera' or 'southern-style' Peking opera had taken place in the Shanghai foreign settlements as early as the 1870s. On women in Peking opera, see Goldstein (2007, pp. 110–14).

45. All-female troupes were especially prominent in the performance of *yue* opera, a genre that had its origins in rural folk art in southern China (especially the province of Zhejiang). See Jiang (2009).

46. Sai Jinhua was fictionalised in a 1905 novel, *Niehai hua* (Flower in a Sea of Retribution) by Zeng Pu. In this fictional account it is Sai Jinhua (in the person of the concubine, Caiyun) who interacts with foreign dignitaries (and takes male lovers), while her diplomat husband is shown to be completely ignorant of international politics (Hu, 1997, pp. 78–9; Hu, 2000).

47. Ironically, Sai Jinhua herself died in poverty just as the play was making its premiere.

48. On Shan Shili, see also Widmer (2006b; 2007, pp. 23–4).

49. By 1914 more than 200 Chinese women had studied at Shimoda's school.

50. The Races of Man pavilion was eventually abandoned, although the Taiwan pavilion at the Trade Fair continued to 'exhibit' women with bound feet.

51. Interestingly, a 1984 film made by the renowned director Xie Jin (1923–2008) on the life of Qiu Jin opens with her actually *witnessing* the entry of foreign troops into Beijing in order to illustrate its galvanising impact on Qiu Jin's emerging patriotism.

52. For a translation of one of these poems written while she was in Beijing, see Idema and Grant (2004, pp. 774–5). These poems also expressed admiration for Chinese 'female warriors' of the past such as Qin Liangyu (1574–1648), who had commanded a military unit that repelled invading Manchu forces in 1629–30. After 1903 Qiu Jin adopted as her courtesy name Jianhu nüxia (female knight-errant from Jianhu), while her pen-name after 1904 was Jinxiong (competing with the male).

53. These women's journals also published foreign and domestic news, as well as information on western women, science and hygiene. Strictly speaking, Chen Xiefen's 1903 journal was not the first Chinese women's journal, since the 1898 reformers had published one of their own.

54. See also Judge (2002b).

55. This analysis is based on my own translation of the Chinese text printed in *Geming wenxian* (*Documents of the Revolution*) (Taibei: Zhongguo Guomindang zhongyang dangshi bianzuan weiyuanhui, 1953), 2.266–267. For another English translation, see Idema and Grant (2004, pp. 774–5).

56. This discussion is based on my own translation of the Chinese text in *Xinhai geming* (*The 1911 Revolution*) (Shanghai: Shanghai renmin chubanshe, 1957), 2.182–183.

57. See also Wang (2004, pp. 30–9, 53–60).

58. Chen also pointed out that for too long Chinese women had had to accept male ideas of feminine beauty, which had kept them physically weak.

59. Another study has argued that feminist discourse at this time was *not* necessarily subsumed or constrained by the nationalist project. Female literary fantasies, for example, such as Qiu Jin's *Stones of the Jingwei Bird* or a 1903 novel by Wang Miaorou (1877–1903), *Nüyu hua* (*Flowers in the Female Prison*), equated a vision of female liberation with the creation of a radically altered and more perfect nation in the future (Dooling, 2005, pp. 38–41).

60. See also Cheng (2001).

61. See also Prazniak (1999, pp. 214–15).

62. It should be stressed that Chinese suffragists did not necessarily take issue with the assumption that education and property should be taken into account in the granting of voting rights; they just argued that *gender* should not be an issue.

3 Gender Discourses in the Early Republic

1. For the later reminiscences of Deng Yingchao, a female student leader in Tianjin at the time who later became a prominent leader of the women's movement, see Teng (1992).

2. See also Roberts (1997, pp. 17–18, 20–1).

3. Although the *changpao* took on more negative connotations by the 1930s, as it came to represent reactionary conservatism, it still possessed a legitimising aura. In 1968, at the height of the Cultural Revolution, a widely circulating poster (based on an oil painting) portrayed a youthful Mao in a long blue scholar's robe; by depicting himself as a scholar, Mao was enhancing his political credibility.

4. The rise of militarism in the early twentieth century also influenced male civilian dress, especially that of students, who began to wear close-fitting jackets and high collars (Finnane, 1999, pp. 122–7).

5. On Han Chinese women's clothing during the Qing, see Garrett (1994, pp. 84–94). For an illustration of the 1912 government-approved female dress, see Laing (2003, p. 76).

6. Western high-heeled shoes gave the visual illusion of smaller feet and may have eased the move away from the bound foot ideal.

7. Over time after 1912, sartorial practices and codes were very much linked to the representation of female and male roles. For an analysis of the dress styles of three spouses of national leaders (Sun Yatsen, Chiang Kai-shek and Mao Zedong), Song Qingling, Song Meiling and Jiang Qing, see Wilson (2002).

8. On the other hand, a foreign observer in Shanghai noted in 1916 that the 'ultra-stylish' young women of Shanghai were wearing tight trousers and short tight jackets with short sleeves, a sight that was neither 'pretty' nor 'modest' in western eyes (Laing, 2003, p. 79).

9. On calendar posters, see Laing (2004).

10. For examples of these cigarette card illustrations, see Szeto (1997, p. 55).

11. For illustrations of schoolgirls circa 1900, see also Garrett (1994, p. 154).

12. Such male concern with women's sartorial proclivities was not unprecedented. During the Tang dynasty in the eighth century, for example, male commentators expressed alarm at the tendency of women in the capital (Chang'an) to adopt 'foreign' clothing and hairstyles (mainly from Central Asia) (Cahill, 1999).

13. The origins of the Association lay in the national products movement that emerged in the wake of the anti-American boycott of 1905. Led initially by traditional silk and satin guilds, the movement later incorporated domestic manufacturers of western-style items such as buttons and hats (Gerth, 2003, pp. 66, 72–3).

14. It should be noted that this criticism was primarily aimed at young urban women, especially students.

15. By the same token, those advocating any change in gender relationships and roles were portrayed as favouring non-Han (i.e. western) practices that would contaminate cultural identity.

16. It is significant, also, that, while a political activist like Shen Peizhen was portrayed in *yeshi* in totally negative terms as 'unfeminine', a well-known prostitute of the time (associated with a prominent military general), who did not transgress accepted gender boundaries, was portrayed in positive terms, as a virtuous, modest and loyal woman.

17. Carrie Chapman Catt wrote that she had found the Chinese suffragists very 'spirited', and that they 'understood the full import of the woman's campaign for justice as well as any western leader' (Chin, 2006, p. 510).

18. During the same period (1912–13 to 1922–3), the total number of male students increased from nearly three million to just over 6.5 million (Bailey, 2007, pp. 84–9). The great majority of female students at this time were in primary school.

19. The virtues of domesticity were also promoted by missionary educators; see Schneider (2009).

20. On the *Funü zazhi*, see Nivard (1984).

21. Also referred to as the May Fourth movement, which takes its name from large-scale student demonstrations in Beijing on 4 May 1919 in protest against China's treatment at the Versailles Peace Conference; student protest later spread to other Chinese urban centres, and in cities such as Shanghai workers also participated in demonstrations.

22. Chen's article, 'The Way of Confucius and Modern Life', is translated in de Bary and Chan (1960, pp. 153–6) and in Lan and Fong (1999, pp. 5–8). In contrasting the subordinated status of Chinese women and their lack of independence with the freedom of western women to enjoy independent economic livelihoods, Chen was perhaps demonstrating a certain naïveté concerning the situation of women in the West.

23. It may be the case that widespread disillusion with the lack of political change following the 1911 Revolution and the subsequent focus on cultural transformation gave 'the woman question' more centrality in radical discourse than was the case with an earlier generation of reformers (Gilmartin, 1999, xii; see also Borthwick, 1985).

24. In February 1917 *New Youth* began a column specifically devoted to the 'woman question'.

25. Lu Lihua and the other women discussed in this section were interviewed by the author in the early 1990s. Lu's school was taken over by the communist government in 1950, after which she set up a knitwear factory. The factory was nationalised in 1956 and Lu herself became a worker in the newly designated 'Fifth Woollen Sweater Factory'.

26. In 1924, at the National Games in Wuchang, women took part for the first time in the basketball and volleyball competitions. Chinese women also participated in the seventh (Manila, 1925), eighth (Shanghai, 1927), ninth (Osaka, 1930) and tenth (Manila, 1934) Far Eastern Games; at the tenth Games Chinese women won all the swimming events, foreshadowing Chinese women's Olympic successes in the 1980s and 1990s.

27. Wang Yiwei, like the other women referred to here, expressed resentment that the post-1949 regime had not recognised the contributions of women like herself. Belatedly, one *was* recognised when Chen Yongsheng was 'discovered' as an 'old patriot' (at a time when the government was campaigning in the 1990s to host the 2004 Olympics) who had devoted her life to the teaching of physical education. In 1993 she attended the opening ceremony of the East Asian Games in Shanghai.

28. Hu also aimed to create a new kind of female 'martyr', unable to overcome the obstacles in the way of her emancipation.

29. For translations of Mao's articles, see Lan and Fong (1999, pp. 79–88) and Schram (1992, pp. 421–44).

30. See also Witke (1970, p. 331).

31. On this, see Glosser (2003). Glosser makes the provocative point (pp. 13–16) that it was May Fourth reform discourse (and *not* 'tradition', 'feudal thinking' or sensitivity to male peasant sensibilities) that was the true predecessor of the CCP's later agenda of maintaining traditional family and gender hierarchies.

32. Seitô women, by way of contrast, openly described themselves as 'new women' as a source of pride.

33. See also Hu (2000, p. 208, fn 11). On images of American women in Chinese women's journals in the early twentieth century, see Chin (2006).

34. Lu Xun's talk is translated in Lan and Fong (1999, pp. 69–76).

35. Medical science in late nineteenth and early twentieth-century Europe gave rise to theories and concepts that would be considered absurd today. One such theory, which became popular in Republican China, was that of 'recapitulation', advanced by the German biologist and naturalist Ernst Haeckel (1834–1919), which claimed that social hierarchies were preordained by nature since certain groups of people (including women) would never evolve through higher stages of biological development (Dikotter, 1995, pp. 82–3).

36. Kang (2009, p. 85) suggests that male same-sex relations were similarly stigmatised in the early twentieth century.

37. The story is translated in Dooling and Torgeson (1998, pp. 91–9).

38. On women's autobiography in twentieth-century China, see Ng (2003, chs. 1–2); Wang Lingzhen (2004; 2008).

39. A good example of which is 'Soap', written in 1924. See Brown (1993) and Lyell (1976, pp. 156–9).

40. See also Decker (1993, pp. 211–30).

41. Representative writings by these women are included in Dooling and Torgeson (1998).

42. See her autobiography (Chen, 1990).

43. See also Tulliver (2008).

44. Xiang was one of forty Chinese women who went to France on the scheme. Unlike their male counterparts, many of them had already received a higher education (as graduates of normal school); over twenty of them also stayed on in France after the scheme ended in 1921 to pursue studies at university level (Barman and Dulioust, 1987).

4 'A World Turned Upside Down': Mobilising Women for the Revolution

1. Early male communists, for example, contributed a flurry of articles on women's emancipation in journals such as *New Youth*, some of which (like Engels) critiqued marriage as a kind of prostitution.

2. Strictly speaking, Yang was Mao's second wife, since Mao had been compelled to undergo an arranged marriage at the age of fourteen to a kinswoman from his village, whom he soon abandoned. Yang was the daughter of Yang Changji, one of Mao's teachers at the Hunan provincial normal school he attended in the early 1910s. Yang Kaihui was later to be executed by *Guomindang* authorities.

3. As noted earlier, Gao Junman was the live-in partner of Chen Duxiu, the party's first secretary-general, while Wang Huiwu, a graduate of a missionary school, had entered into a 'free marriage' with the prominent CCP ideologue, Li Da. Li was elected to the three-man central bureau at the first congress.

4. In a speech she gave on her return to the US, Sanger mentioned that she addressed 2,500 students at Beijing University. The typed draft of her speech, entitled 'Birth Control in China and Japan' (31 October 1922) can be accessed at www.nyu.edu/projects/sanger/webedition/app/documents/show.php?sanger (accessed 2 November 2010).

5. On the school, see Gilmartin (1995, pp. 59–65). One of the students was the future writer Ding Ling.

6. In any event, it is likely that both the CCP and the GMD were inspired by the Bolshevik model; in 1919 the Bolshevik Party created a women's section (*Zhenotdel*) within its organisation, headed by Alexandra Kollontai (1872–1952); it was abolished in 1930.

7. On Xiang Jingyu, see Gipoulon (1984; 1986); McElderry (1986); Gilmartin (1989; 1995, pp. 78–9, 81–2, 84–5, 94, 128–31).

8. See, for example, McElderry (1986).

9. See the studies by Gipoulon and Gilmartin noted in footnote 7.

10. Those seeking radical political change, such as female suffrage activists, were not the only ones who could play the 'global card', however. Chinese critics of 'unrestrained' women in the early years of the Republic often pointed to gender conservatism in the West to bolster their arguments (Bailey, 2007, p. 103).

11. This is why she proposed that women set up their own trade unions. Intriguingly, in a 1923 article Xiang referred to the need for a 'Triple Alliance' comprising women, oppressed ethnic groups and the working class (Gipoulon, 1984, p. 37).

12. As with most prominent female activists within the CCP, Deng Yingchao and Cai Chang were linked to influential male communists. In 1925 Deng married Zhou Enlai, who was to be elected to the party's Central Committee in 1927 and later to become premier and foreign minister after the establishment of the People's Republic in 1949. Cai Chang was the sister of Cai Hesen, a Central Committee member in the 1920s, and the wife of Li Fuchun, who was to become a vice-premier of the People's Republic after 1949.

13. Harmony, however, between an older generation of Cantonese-speaking women like He Xiangning, who preferred to focus on 'practical' improvements to women's lives (such as the setting up of literacy classes), and younger activists from the north like Deng Yingchao, who called for a robust championing of free-choice marriage and the right to divorce, was not always maintained.

14. Mao's report is translated in De Bary and Chan (1960, pp. 210–12).

15. Mao also noted that the authority of the husband had always been comparatively weak among poor peasants since their wives were compelled to participate in outside work and had obtained 'more right to speak and more power to make decisions in family affairs'.

16. See also Gilmartin (1994).

17. Province-wide membership of county women's associations in Hubei rose from 2,000 to 60,000 during the first half of 1927.

18. International Women's Day was originally inaugurated on the suggestion of the German socialist and feminist Clara Zetkin (1857–1933) at the International Congress of Socialist Women in Copenhagen in 1910 (first celebrated in Germany in 1911), although socialist women in the US had initiated a 'Women's Day' in 1908 to demand the vote and economic rights.

19. Xie later saw active service on the front line (as a member of a Red Cross unit) in the anti-Japanese War in the late 1930s.

20. Huang later became an underground communist worker. After 1949, like many others who had worked underground in GMD-controlled areas before 1949, Huang was regarded with suspicion. During the Cultural Revolution she was beaten and imprisoned by Red Guards, and was not fully rehabilitated until 1980.

21. The incident was known as the 'March 18 Massacre'. Lu Xun, who was teaching at Beijing Women's Normal College at the time, wrote a commemorative article for one of the two dead female students, Liu Hezhen (Spence, 1982, pp. 195–7).

22. Earlier, it was also alleged that communist men in Wuhan had staged a naked women's parade during the celebration of Women's Day (Strong, 1928, pp. 18–19).

5 Women in the City and Countryside before 1949

1. The dual image of the woman as mother and whore is captured by the Chinese title itself. *Shen'nü* means both 'divine woman' and (as a colloquial euphemism) 'streetwalker'.

2. For analyses of *The Goddess,* see Rothman (1993); Chow (1995, pp. 23–6); Cui (2003, pp. 15–18); and Harris (2008).

3. In this China was not unique. In Russian, French and Scandinavian cinema, too, the contradictions of modernity were enacted through the figure of the *woman*, who functioned as an allegory or 'metonymy' of urban modernity (Hansen, 2000).

4. Further south, in some areas of the Canton (or Pearl River) Delta (Guangdong province), women *outnumbered* men as agricultural labourers, a phenomenon that a Chinese investigator referred to in 1936 as the 'feminisation' of local agriculture (Watson, 1994, p. 29).

5. The *Guomindang* central government estimated in 1934 a total of nearly 450,000 women in the factory workforce nationwide (Bailey, 2007, pp. 90–1).

6. The numbers of female workers in Tianjin were probably underestimated, since many factories employed women as 'outworkers' (such as match manufacturers, which hired home-based women to glue matchboxes), which meant they were not included in official surveys.

7. Such a phenomenon was not unique to *female* workers. See, for example, McIsaac (2000), which analyses fraternal associations amongst male dockworkers, coalminers and factory workers in China's wartime capital of Chongqing. Unlike sisterhoods, however, violence was integral to these brotherhoods as a way of demonstrating loyalty.

8. Although even in the silk weaving industry, dominated by Jiangnan women, there was regional segmentation. Thus in the larger factories the more skilled female weavers generally originated from eastern Zhejiang, had an elementary education and were younger than their older, less well educated counterparts in smaller factories, many of whom came from more traditional handicraft areas around Suzhou (southern Jiangsu) and Hangzhou (northern Zhejiang) (Perry, 1993, p. 186).

9. By the same token, the Shanghai middle classes at this time preferred to employ more 'acceptable' women from Changzhou (southern Jiangsu) or Shaoxing (Zhejiang) as domestic maids.

10. A report noted that there were 70,000–80,000 female contract workers in all of Shanghai's cotton mills in 1937 (Honig, 1986, p. 126). Many of these workers would either continue working in the mill after the expiry of their contract or seek employment in another mill (much to the frustration of mill owners). The exploitative nature of the contract labour system should not be underestimated, however; it was not unusual, for example, once the women had arrived in Shanghai, for unscrupulous labour contractors to sell them into prostitution.

11. Another factor was the divisive impact of imperialism, with Subei women, for example, more willing than others to work in Japanese-owned mills. It might be noted that regional or native place ties might at times have *facilitated* solidarity and strike action; women from the same native place in a particular department of the factory, for example, would on occasion walk out in sympathy if one of their number was ill-treated or fired (Smith, 1994, p. 157).

12. Older and less skilled women in the smaller silk filatures tended to engage in briefer disputes (in 1936–7, for example) aimed at reclaiming lost ground rather than claiming new rights (Perry, 1992).

13. Silkworms fed on the mulberry leaves.

14. Yang, from a landlord family, had participated in the May Fourth discourse on women's rights and later became the second wife of the future CCP leader, Qu Qiubai (1899–1935), a Marxist intellectual who was to be executed by the GMD (note again how influential CCP women are often associated with male leaders). Reflecting the current interest in the

personal lives of historical communist figures (rather than their politics), a new Chinese film that began production in 2010, and is due to be released in 2011 to commemorate the 100th anniversary of the 1911 Revolution, has as its central plot the 'pure' love story of Qu Qiubai and Yang Zhihua; the film has as its English title *Romance of the Revolution* (*Qiuzhi baihua*).

15. Walker refers to this process – in which the sexual division of labour in peasant households was reconstituted and peasant women transformed into an undervalued hired labour force as a result of commercialisation – as 'subproletarianisation'. See also Walker (1993, pp. 357–9).

16. Delayed transfer marriage had existed in some Guangdong counties from at least the eighteenth century; it was especially prominent amongst upwardly mobile elites in commercialised areas, for whom it represented a badge of status (large dowries and other provisions, including land, would often be set aside for continued support of married daughters). The practice is still very much in evidence today amongst various ethnic minority communities in the region, such as the Yao (Guangdong province), Zhuang (Jiangxi province) and Miao (in Guizhou province) (Siu, 1990, pp. 36–7).

17. In the highlands of Hunan and Fujian, where Han Chinese settlers moved during imperial times, it was not uncommon for the women of Han Chinese households living close to non-Han ethnic communities (in which women often participated in outside labour) to work outside the home as tea-pickers for wages (and under the supervision of non-kin) (Pomeranz, 2005, p. 251).

18. On the practice of extended natal residence marriage in Hui'an, see Friedman (2006). This was also a region in which women played a key role in agriculture (many of the men were engaged in fishing) and where they experienced solidarity in powerful same-sex networks.

19. Since some *zishu nü* did, in fact, eventually marry, a recent study prefers not to use the expression 'sworn spinsterhoods' but rather to emphasise the importance of the 'daughterhood' ideal amongst these young women; in other words, the self-identity of these women (even after marriage) was very much associated with their role as dutiful daughters within their natal families (Ye, 2008).

20. On death, a 'spirit marriage' might be arranged for a *zishu nü*, in which her 'spirit' was married to the spirit of a deceased unmarried man, thus allowing her to be enshrined as part of a family. Others might be treated as 'sons', thus allowing their tablets to be placed in the natal family's ancestral shrine.

21. On *mui-tsai* in Guangdong and Hong Kong, see Jaschok (1988); Watson (1991); Jaschok and Miers (1994). Colloquially, the term might mean 'little sister' or 'little servant girl'. In addition to being exploited for domestic services, a *mui-tsai* might be purchased by well-off families to become part of a daughter's 'dowry' (serving as a permanent servant to the daughter after she married), or sold on by her owners into prostitution. Single women (such as Daoist nuns) might also adopt a *mui-tsai* as a foster daughter.

22. See also Henriot (1994).

23. Even the Empress-Dowager participated in this 'performativity' of gender; as early as 1903 she had her photograph taken portraying her as the Buddhist deity Guanyin (symbol of the caring and kind mother), which was widely circulated.

24. For a recent translation of the novel, see Han (2005).

25. As with female textile workers, the upper levels of the hierarchy tended to come from Jiangnan, while streetwalkers were generally from Subei.

26. Nicknames given to clients included 'beancurd guest', meaning one who would do a woman's bidding.

27. See also Ho (1993).

28. See also Harris (1995); Stevens (2003); and Sang (2008, pp. 181–3).

29. Mittler notes that the new woman in the journal is defined by her distaste for men (misandria), a counterpoint perhaps to the male 'scopophilia' (erotic pleasure derived from looking at women) that characterised the stories of Mu Shiying and Liu Na'ou (Lee, 1999, p. 197).

30. A uniform dress code was also prescribed for these ceremonies – brides were to wear pink dresses and veils, grooms blue robes and black vest-jackets (Glosser, 2003, pp. 128–9).

31. In the Qing period, a woman could basically only nullify a marriage in the case of a husband's desertion, and even then this had to be initiated by her natal family. By way of contrast, a man

could divorce his wife relatively easily on seven grounds (adultery, unfilial behaviour towards parents-in-law, loquacity, theft, jealousy, incurable disease, and failure to bear a son). The only circumstances in which a man could not divorce his wife were if she had observed the three-year mourning period for her in-laws, the husband had become wealthy during the course of the marriage, and the woman had no family or relatives to return to.

32. See also Glosser (2003, pp. 113–18).

33. Under the new system female chastity was no longer recognised as an ideal, thus again removing some of the protections Qing law had accorded widows (such as strictures against forcing them to remarry).

34. A widowed daughter-in-law whose husband died before his father was in an even more disadvantaged situation when her father-in-law eventually died, since she was not entitled to a share of the property (which went to other sons and daughters, the statutory heirs).

35. During the Qing, the crime of 'illicit sex' had applied to all sexual relations outside wedlock (with heavier penalties if the woman was married; the man was punished not for his own adultery but for 'abetting' the woman to violate her marital bond). By 1912, adultery (sex with a married woman) and fornication (sex with an unmarried woman) were clearly differentiated (Yeung, 2003).

36. In reality, too, the law had only a minimal impact on a man's ability to engage in extramarital affairs.

37. At the same time women were to be provided economic security by allocating them shares during a land redistribution campaign.

38. The 1931 Marriage Regulations are in Butler (1983, pp. 177–9).

39. The text of the law is in Butler (1983, pp. 180–1). One change was that cohabitation between couples was now recognised as *de facto* marriage (thus according women some protection).

40. Only thirty women accompanied the main CCP force on the Long March, including He Zizhen, Mao's second wife, and Kang Keqing, the wife of Zhu De, co-founder with Mao of the Red Army in 1928. Other CCP army units that made their way to Yanan comprised nearly 2,000 female soldiers (Lee and Wiles, 1999).

41. Throughout the Jiangxi Soviet period, moreover, the party was always anxious to point out that freedom of marriage did not entail sexual licence or the stirring up of acrimony between the sexes (Davin, 1976, p. 30).

42. Officially termed the Shaan–Gan–Ning Border region after the three provinces (Shaanxi, Gansu, Ningxia) in which the CCP held sway.

43. CCP female activists in Chongqing who enrolled in Madame Chiang's organisation, however, were able to gain useful experience under its auspices. For the reminiscences of one such activist, Ren Zaiyi (b. 1920), see Li (2010, pp. 133–48).

44. Another custom involved a poor peasant hiring himself out to a farming family (for no pay) for a number of years in order to eventually marry the family's daughter without having to pay brideprice.

45. In a sense, the film *Yellow Earth*, in its depiction of a CCP cadre who has little understanding or awareness of the plight of young girls forced to go through an arranged marriage and is powerless to change entrenched village custom, began the process of 'deconstructing' the CCP's 'master narrative' of communist-led women's liberation in twentieth-century China.

46. This discussion is based on my own translation of Ding Ling's article, published in *Jiefang ribao* (*Liberation Daily*, 9 March 1942). For another translation, see Benton and Hunter (1995, pp. 78–82). See also Hua (1981, p. 102) and Stranahan (1983a, p. 55).

47. Women were also involved in the production of vegetable oil and manufacture of paper.

48. While pre-twentieth-century tales and plays of Hua Mulan had implied a tension between family demands and those of the central state, by the twentieth century plays, novels and films of the Hua Mulan story had clearly subsumed filial piety into statist discourse – it was unambiguously assumed that service to one's family found its proper expression through service to the state (Edwards, 2010).

49. Although most of the strike leadership was comprised of men, the strike was significant in demonstrating the ability (and willingness) of CCP female activists to infiltrate sisterhoods amongst the workers.

6 The New Communist State and Marriage Reform in the 1950s: 'Public Patriarchy' in Practice?

1. Belden first went to China in 1933 and later covered the first years of China's war against Japan. He returned in late 1946 to cover the civil war.
2. Studies of Chinese women produced by western gender or feminist historians, such as Judith Stacey in the early and mid-1980s, in exploring the ambivalences and contradictions in Chinese Communist Party policy on women, were reacting against overly optimistic (and some might say naïve) accounts of women's emancipation in the 'new' China written by non-specialist western feminists in the 1970s. See, for example, Broyelle (1977).
3. The text of the Marriage Law is in Yang (1959, pp. 221–6); Meijer (1978, pp. 478–83); and Johnson (1983, pp. 235–9). See also Meijer (1971, pp. 70–82).
4. The revised Marriage Law of 1980 repeated the 1950 law's injunction against marriage by sale, but property and money given directly without compulsion to the bride were considered simply as 'gifts' (Ocko, 1991, pp. 320–21).
5. In the wake of the 1950 law in Hubei province, a twenty-eight-year-old woman carried her eight-year-old 'husband' into court seeking divorce; she had been taken in as a *tongyangxi* by a couple in anticipation of them having a son (Yang, 1959, p. 27).
6. Not until the 1980 Marriage Law did the CCP recognise the absence of love as grounds for divorce.
7. In practice male control over property was respected in the 1950 law, despite Article 23, which stated that in the event of divorce a woman would 'retain such property as belonged to her prior to marriage'. This was because it proved difficult for the courts in the 1950s to distinguish premarital property from family property.
8. The law also proscribed marriage in the event that either party suffered from mental illness or if the man had contracted venereal disease.
9. In other words, contraception was *not* recommended in contexts that undermined the absolute importance attached to reproductive sex (Evans, 1997, pp. 42–4). Also, at a time (the 1950s) when the private hiring of agricultural labour was prohibited by law, marriage (and subsequent procreation) became virtually the only means to directly recruit labour (Croll, 1981, p. 156).
10. In the view of one scholar, the 1950 law was premised on a naturalised and hierarchical view of gender relations (Evans, 1997, p. 6).
11. Stacey (1983, p. 186) refers to the CCP as the 'public patriarchs of the new democratic state'.
12. See also Wolf (1984).
13. By the end of 1954 the fourteen remaining cabarets in Shanghai had been transformed into businesses or handed over to the government for the construction of 'cultural palaces'; 'dance parties', however, continued above or underground (at least until the Cultural Revolution), often organised by the Communist Youth League (Field, 2010, pp. 269–84). Between 1947 and 1951 prostitution was successfully banned in a number of other cities under communist control (Beijing, Shijiazhuang, Tianjin, Nanjing, Suzhou, Yangzhou and Hangzhou). It may be that the process took longer in Shanghai because of the pervasive influence of underworld gangs (like the Green Gang), whose power had to be broken first. A recent study argues that the CCP suppression of 'decadent' popular entertainment in Shanghai after 1949 constituted a reversal of the dynamic mixture of the feminine, mercantile and foreign that had defined the city during the previous 100 years (Yeh, 2007, p. 206).
14. In 1952 and 1953 there were further anti-prostitution 'sweeps' in Shanghai (which included the apprehension of bar hostesses and masseuses) leading to the arrests of over 1,000 women. In fact, between 1953 and 1958 another nearly 6,000 prostitutes (now perceived as criminals rather than victims as in the past) were arrested in Shanghai; it was only the efficient running of the street and neighbourhood committees that finally put an end to prostitution (Henriot, 1995, p. 475).
15. The term *fanshen* was mainly used during the land reform campaigns of the 1940s and early 1950s to describe a change in status and world view amongst poor peasants as a result of their 'liberation'.
16. Rumours apparently also abounded at the time that prostitutes would be 'distributed' amongst People's Liberation Army personnel, or that they would be used as live minesweepers

in the military campaign to take the island of Taiwan, to where the defeated *Guomindang* had retreated in 1949.

17. The previous *Guomindang* regime, in its quest to institutionalise 'vagrants' and increase production, had also established prostitution rehabilitation centres in Nanjing, which gave instruction in embroidery and weaving, as well as arranging marriages for the 'inmates' (Lipkin, 2006, pp. 167–71).

18. Such a narrative parallels Lu Xun's story, *New Year's Sacrifice* (see Introduction), although in Lu Xun's story the widow's repeated lamentations of her suffering and bad luck do not meet with much sympathy from surrounding villagers. Interestingly, the exhibition was organised in Shaoxing, Lu Xun's home town.

19. Chen refers to these female model workers as 'everyday icons' because they appeared in mass-circulating media as the epitome of socialist China. See also Croll (1995, pp. 70–5). In the 'new' China of the 1950s men and women were to be addressed equally as 'comrade' (*tongzhi*), while husbands and wives were to call each other *airen* (literally, 'loved one') instead of a wife, as in traditional times, being referred to as *neiren* ('the one inside'). With ordinary men and women alike dressed similarly in cotton trousers and simple Mao-jackets, public life was marked by a certain visual androgyny.

20. On images of socialist realist art in the 1950s and 1960s, which portrayed both male and female bodies in 'biologically unrealistic proportions' to symbolise the strength of workers and peasants, see Chen (2003).

21. At the same time, Liang noted that she never specifically championed women's rights, insisting that her main priority was always to work for a better country in which gender equality would be accepted.

22. Significantly, it was also in the north-east that large numbers of Chinese women were employed for the first time in heavy industry. By 1951, for example, over 1,000 were employed in technical and skilled occupations (operating lathes, metal casting) in Dairen and Lushun, while the Fushun Coal Mining Company employed over 800 women (Yang, 1959, p. 145).

23. It is also interesting to note that, out of the 2,400 Chinese students studying in the Soviet Union in 1954, over 25 per cent (602) were women (Chen, 2005, p. 295, fn 45); the contrast with the small proportion of Chinese female students in Japan in the early twentieth century (see Chapter 2) is striking.

24. In Shanghai in 1950, 75 per cent of the 13,349 divorce suits were filed by women.

25. Women were also granted rights to land, although title deeds were rarely issued to women directly. Land allotted to unmarried women was distributed to the male head of the household, while married women's portions were simply added to the share allocated to their husbands. Like the Marriage Law, land reform had the 'restorative' aim of rebuilding the family peasant economy.

26. On the significance of 'speak bitterness' meetings in the early 1950s, which brought the 'subaltern' into being whilst also cementing a symbiotic link between the party and the masses, see Anagnost (1994; 1997, pp. 31–7).

27. Meijer (1978, p. 464). The Committee also described marriage reform as a means to *revive* previously elusive ideals of harmony and security.

28. Diamant (2000a). Diamant refers to this conventional wisdom (manifested in the earlier studies of J. Stacey and K. Ann Johnson, for example) as the 'conservative betrayal thesis'.

29. Making use of recently accessible archival sources, Diamant focuses on Beijing, suburban counties near Shanghai, and a rural county in the south-west province of Yunnan.

30. Reginald Johnston, High Commissioner of the British leasehold territory of Weihaiwei in Shandong province, complained in 1910 that 'unreasonable and noisy' peasant women constantly resorted to court litigation (Wolf, 1974, pp. 160–1).

31. The custom of lavish wedding feasts hosted by the groom's family (and proscribed by the 1950 law) also continued, thus helping to reinforce kinship solidarity.

32. After 1957 the reference to 'Democratic' was removed.

33. The honorary president of the WF was Song Qingling, with Cai Chang and Deng Yingchao president and vice-president respectively.

34. See also Judd (2002).

35. The WF, in fact, was the only mass organisation in Mao's China that reached down to the rural villages and urban neighbourhoods.
36. No woman at this time was eligible for sterilisation until she was over thirty-five and had six children or more.
37. 'Births according to plan' by this time was a commonly accepted priority.
38. In Shanghai in 1957 women comprised 21 per cent of the labour force, lower than in 1931. Even so, many women later recalled that entering the work force (rather than marriage) had become the defining moment (or rite of passage) in their lives (Croll, 1995, p. 76).
39. One year earlier the State Council had pointed out that housework was not to be despised.
40. During the Cultural Revolution Yu was to be imprisoned for seven years.
41. Of course, male bonds might threaten patriarchy as well. Stacey (1983, p. 154) notes that ties between young peasant men and boys during the Anti-Japanese War could have threatened patriarchy, since these male fraternities transcended kinship relationships and generational authority.
42. Seventy women from four villages in Shaanxi province were interviewed between 1996 and 2004. See also Hershatter (2011).

7 'Women Hold Up Half the Sky': The Great Leap Forward and the Cultural Revolution

1. See also Andors (1975).
2. The author based her analysis on the recollections of seventy-five women in three counties in the provinces of Henan and Jiangxi in 2001 and 2004.
3. See also Manning (2006b).
4. Zhou did not think that the future socialisation of housework would obviate women's obligations as mothers. It is also significant that in 1958 both Mao and Women's Federation leader Cai Chang clearly differentiated between old feudal families of the past and the new 'harmonious' and 'democratic' families of the present; furthermore, Mao insisted that a family still needed a 'head', even if such a head was the most capable rather than the most senior.
5. The songs also used metaphors of 'sexual love' to express revolutionary goals. It was just such a freedom that female activists of the Leap would later remember in the 1990s.
6. On the film *Li Shuangshuang*, see Cui (2003, pp. 63–4).
7. Although in some areas such as Hui'an (Fujian province) young unmarried women too were involved in massive labour projects (e.g. reservoir construction) that took them away from home for long periods of time; this provided the opportunity to revive the same-sex bonds that the state had tried to eliminate in the early 1950s (Friedman, 2006, pp. 44–7).
8. In 1960 the Ministry of Labour reported a total of 12 million plus female workers and employees, compared with 8.25 million in 1959 (Davin, 1976, p. 165).
9. In Beijing women comprised 40 per cent of the doctors, while in Shanghai two-thirds of the city's medical workers (including doctors) were women (Andors, 1983, p. 70).
10. In 1956–8 also an Office of Birth Control had been set up within the State Council, and the use of contraceptives promoted.
11. White argues that what WF leaders had begun in the early 1950s – to modify the party's pronatalist policy – would become by the early 1970s an 'intrusive programme of state-enforced contraception and birth limits' (1994, p. 277). The early 1960s also saw official encouragement of later marriage and more widely spaced births.
12. Interestingly, letters dealing with mate selection indicated that the prospect of a 'good livelihood' after marriage was an important factor in assessing a spouse's suitability (rather than matching political consciousness, stressed by the authorities in the early 1950s) (Croll, 1984a, p. 184).
13. Criticism of the film may also have been due to its association with Xia Yan (who helped Xie Jin with the script), a leftist film-maker from the 1930s who in 1961 called for greater autonomy for artists.
14. Since, according to popular histories published in the early Republic, Zhen Fei had tried to persuade Guangxu to remain in the capital in 1900 to negotiate with the invading foreign powers, she was deemed after 1949 to have committed an act of national betrayal.

15. See also Jin (2006, p. 617).

16. H. Evans, 'The Language of Liberation: Gender and *Jiefang* in Early Chinese Communist Party Discourse', *Intersections*, issue 1 (September 1998). In so doing, Evans notes, the CCP established the *only* language available for the public discussions of gender issues.

17. It is also intriguing to note that female Red Guards tended to be more violent than female worker–rebels (Honig, 2002).

18. See also Roberts (2010), which argues that, rather than being 'erased', gender parameters in Cultural Revolution operas and ballets were simply shifted along political lines, with the 'revolutionary' identified with the masculine end of the gender continuum and the 'counter-revolutionary' with the feminine end.

19. By way of contrast, other female 'sent down' youth resorted to a strategy of marrying local peasant men in order to avoid heavy work (Honig, 2000, p. 109).

20. See also Larson (1999).

21. A point made by Zhong *et al.* (2001). Ironically, these memoirs of women growing up in the Maoist era were also written in English, their authors themselves all living and working in the US.

22. Some female youth later recalled also the shock they had initially felt at the uninhibited display of nakedness amongst peasant men.

23. It might be noted, as a matter of interest, that in 1973 no woman sat in the US Senate, while there were only sixteen women in the House of Representatives (3.7 per cent of the total).

24. At the 2nd NPC Congress in 1959, just four women had been appointed to the Standing Committee, 6.5 per cent of the total.

25. For a representative article, entitled 'On Confucian Persecution of Women in History' and published in 1975, see Croll (1974, pp. 107–9). The article claimed that the degradation of women was in direct proportion to the exaltation of Confucianism. He Zhen, at the beginning of the twentieth century, it might be recalled, had been one of the first critics of Confucian 'misogyny' (see Chapter 2).

26. In one model village there was also an increase in the number of intravillage (as opposed to exogamous) marriages (Johnson, 1983, pp. 202–3).

8 Women and Socio-economic Change in the Post-Mao Era

1. See also Notar (2001) and Tang (2003). Another film of the time, *Women From the Lake of Scented Souls*, directed by Xie Fei in 1992, likewise portrays a dynamic entrepreneurial rural woman who suffers abuse from an alcoholic husband and makes use of a male lover to make business contacts and expand her enterprise.

2. For a comparison of population policy in China, the Soviet Union and Eastern Europe, see Davin (1992).

3. While studying at Beijing University in 1980–1, I was able to watch edited 'highlights' of the trial on Chinese television (in the male dormitory common room) and remember vividly the nods of approval amongst Chinese students present whenever the judges and prosecutors denounced Jiang Qing in highly personal (and misogynistic) terms.

4. Jiang Qing apparently committed suicide in 1991 while on prison release for hospital treatment. On Jiang Qing, see Witke (1977), based on interviews the author had with Jiang Qing in 1972, and Terrill (1999).

5. It is also striking that the student leadership of the movement only had one female representative, Chai Ling. Gender issues in general, it has to be said, did not figure in the protests (such as the impact of the one-child policy on women or the continuing discrimination against women in employment) (Lee, 1994).

6. It was also significant that these women saw themselves as active agents, but only as long as this did not place them in competition with men.

7. Cited in Li Yu-ning, 'Historical Roots of Changes in Women's Status in Modern China', p. 116. In 1980, not coincidentally, Zhou Enlai's 1942 article valorising motherhood was reprinted to commemorate Women's Day.

8. On the initiatives of the WF in the 1980s and 1990s to enhance the position of women in the rural economy (through training and education programmes), see Judd (2002). It also gave

a positive spin to the idea of the 'strong woman' (*nüqiangren*) able to compete with men in politics and business – a phenomenon that aroused more negative feelings in some quarters.

9. On Li Xiaojiang, see Rofel (2007, pp. 65–83). The museum displayed samples of *nüshu* (written on fans); it was unfortunately closed down after several years.

10. See also Evans (2006).

11. Before the Cultural Revolution women in urban areas wore make-up, while young rural women often tied ribbons in their hair.

12. Not surprisingly, the 1990s witnessed the entrance of multinational cosmetic companies into the Chinese market.

13. See also Andrews and Shen (2002).

14. There was an intriguing tension between these kinds of advertisements (often aimed at the male gaze) and those for breast enhancers aimed at women, which associated the freedom and 'naturalness' of large breasts with a life outwith the domestic context (Johannson, 1998, pp. 74–5).

15. See also Evans (2002, pp. 335–40).

16. The tragedies that befall the female characters in *Yearnings* are also meant to represent the miseries undergone by male intellectuals and the nation during the Cultural Revolution.

17. See also Evans (1995).

18. The question of marital rape, however, did not feature in the debate.

19. It is striking how often male impotence features in many of the films of the 1980s and 1990s. See, for example, *Hibiscus Town* (1986, dir. Xie Jin), *Ju Dou* (1990, dir. Zhang Yimou), *The True Story of Qiu Ju* (1993, dir. Zhang Yimou), *Red Firecracker, Green Firecracker* (1994, dir. Ping He), and *Ermo* (1994, dir. Zhou Xiaowen).

20. See also Jenner (1996). On pre-twentieth-century models of Chinese masculinity, see Louie (2002) and Song (2004). By the late 1980s masculinity discourse, which had initially implied political resistance, had evolved into more of a concern that Chinese men did not match up to western and Japanese men, linked to a more general anxiety over China's 'virility' (i.e. its power and influence) in a globalising world.

21. Significantly, at the 1988 Seoul Olympics, China had the highest percentage of women in its national team (46 per cent, compared with 37 per cent for the US and 33 per cent for the Soviet Union). In the early 1990s, however, Chinese female athletic and swimming success was blighted by a series of drug scandals.

22. On the other hand, the government has officially promoted a traditional *male* sartorial form, the *Tangzhuang* (Chinese traditional jacket). At the 2001 APEC (Asia-Pacific Economic Co-operation) meeting in Shanghai in 2001, all leaders were expected to wear it.

23. See also Zhang (1997).

24. See also White (1997) and Hillman and Henfry (2006).

25. In some areas, however, such as Hui'an in Fujian, increasing numbers of women sought employment further afield on construction sites (Friedman, 2006, p. 59).

26. See also Billard (1999). Figures for 1990 graphically illustrate the gender divide. While 13 per cent of the male population were deemed illiterate in that year, 32 per cent of the female population were illiterate (Croll, 1995, p. 135).

27. By this time female enrolment at primary school had reached 50 per cent (compared with 45.2 per cent in 1975).

28. Fieldwork was carried out in four poor rural counties in Gansu and Hebei provinces.

29. On the impact of such 'specialised households' on women's greater sense of autonomy, see Judd (1994). Fieldwork was carried out in several villages in Shandong province.

30. See also Gaetano and Jacka (2004).

31. See also Yan (2008) and Sun (2009).

32. See also Lee (1998) and Pun (2005). Managerial staff, as well as most of the skilled technical labour, were men.

33. *Dagongmei* is a Cantonese term imported from Hong Kong. *Dagong* literally means 'working for the boss' or 'selling [one's] labour', while *mei* refers to a younger unmarried (and low status) sister.

34. In 1997, even though women comprised only 39 per cent of the work force, they made up nearly 61 per cent of the country's 10 million laid off workers (Woo, 2002, p. 313).

35. On how the retail and service industries are creating new forms of gender inequality, however, see Hanser (2008) and Otis (2011).
36. On the evolution and implementation of birth control policy from the 1950s to the turn of the twenty-first century, see Greenhalgh and Winckler (2005) and White (2006).
37. For a general historical overview of female infanticide in China, see Mungello (2008). On the abandonment of young girls in orphanages during the post-Mao period, see Johnson (2004).
38. For a comparative analysis of a growing imbalance in sex ratios in contemporary Asia (China, Taiwan, South Korea, India, Pakistan), see Croll (2000).
39. Between 1979 and 1987, 269 million abortions were performed nationwide (Greenhalgh, 1994, p. 8). Greenhalgh notes (p. 3) that by world historical standards China's birth control programme has been exceptional in its hostility to women.
40. See also Gilmartin (1990).
41. See also Greenhalgh and Li (1995).
42. The law is printed in Croll (1995, pp. 184–92). See also Keith (1997).

Conclusion

1. 'Bai Yang – A Woman with Oriental Charm', Chinadaily.com.cn (accessed 20 October 2009).
2. The '100 Excellent Mothers' selected, from amongst whom the ten were chosen, were mostly aged between forty-one and sixty, were employed in the professions (school and university teachers, company managers), were 'good' at educating their children (without 'spoiling' them), and performed most of the housework.
3. On the intimate connections stressed by officials and educators between domestic management and nation-building during the Nationalist period (1920s to 1940s), see Schneider (2011).
4. Over the entire post-1949 period, however, there was an increase, since at the 1st NPC in 1954 there had only been 147 female delegates (12 per cent of the total) (Edwards, 2007, p. 383).
5. Although there is evidence that this orthodoxy is being questioned. The WF in 2002, for example, suggested that economic development alone might not necessarily solve all of women's problems (Edwards, 2007, p. 388).
6. In her capacity as acting Health Minister in 2003, Wu Yi also gained considerable kudos as a result of her handling of SARS (severe adult respiratory syndrome).
7. Problems remain, however. Many of the female village heads elected in 2006 were not re-elected in subsequent elections, while attempts to expand the 'Heyang model' further up the administrative level have been met with indifference or resistance.
8. On this, see Milwertz and Wei (2007).
9. The study is based on fieldwork in several villages in Zhejiang province.
10. The study is based on three rural counties in Hebei province, where, interestingly, many couples with only one daughter did not plan on having more children.
11. Fieldwork was carried out in a village in Heilongjiang province. See also Yan (2003). Friedman (2010) argues that by the 1990s many village youth were openly seeking marriage partners in line with their own romantic and personal desires – in a sense actualising the ideals of free spousal choice based on mutual affection that had been promoted by state reformers in the early 1950s.

Bibliography

E. Ahern, 'The Power and Pollution of Chinese Women', in M. Wolf and R. Witke (eds), *Women in Chinese Society*, pp. 193–214.

A. Anagnost, 'Who is Speaking Here? Discursive Boundaries and Representations in Post-Mao China', in J. Hay (ed.), *Boundaries in China* (London: Reaktion, 1994), pp. 257–79.

A. Anagnost, *National Past-Times: Narrative, Representation and Power in Modern China* (Durham, NC: Duke University Press, 1997).

P. Andors, 'Social Revolution and Women's Emancipation: China During the Great Leap Forward', *Bulletin of Concerned Asian Scholars*, 7, 1 (1975): 33–42.

P. Andors, 'Politics of Chinese Development: The Case of Women 1960–1966', *Signs*, 2, 1 (1976): 89–119.

P. Andors, '"The Four Modernizations" and Chinese Policy on Women', *Bulletin of Concerned Asian Scholars*, 13, 2 (1981): 44–56.

P. Andors, *The Unfinished Liberation of Chinese Women 1949–1980* (Bloomington: Indiana University Press, 1983).

P. Andors, 'Women and Work in Shenzhen', *Bulletin of Concerned Asian Scholars*, 20, 3 (1988): 22–41.

J. Andrews and Shen Kuiyi, 'The New Chinese Woman and Lifestyle Magazines', in P. Link, R. Madsen and P. Pickowicz (eds), *Popular China: Unofficial Culture in a Globalizing Society* (Lanham: Rowman and Littlefield, 2002), pp. 137–61.

P. Bailey, 'Active Citizen or Efficient Housewife? The Debate over Women's Education in Early Twentieth-Century China', in G. Peterson, R. Hayhoe and Y. Lu (eds), *Education, Culture and Identity in Twentieth-Century China* (Ann Arbor: University of Michigan Press, 2001), pp. 318–47.

P. Bailey, '"Women Behaving Badly": Crime, Transgressive Behaviour and Gender in Early Twentieth Century China', *Nan Nü*, 8, 1 (2006): pp. 156–97.

P. Bailey, *Gender and Education in China: Gender Discourses and Women's Schooling in the Early Twentieth Century* (Abingdon, Oxon: Routledge, 2007).

B. Baptandier, *The Lady of Linshui: A Chinese Female Cult* (Stanford: Stanford University Press, 2008).

T. Barlow, 'Theorizing Woman: *Funü, Guojia, Jiating* (Chinese Woman, Chinese State, Chinese Family)', in A. Zito and T. Barlow (eds), *Body, Subject and Power in China* (Chicago: University of Chicago Press, 1994), pp. 253–89.

T. Barlow, *The Question of Women in Chinese Feminism* (Durham, NC: Duke University Press, 2004).

G. Barman and N. Dulioust, 'Un groupe oublié: les étudiantes-ouvrières chinoises en France', *Etudes chinoises*, 6, 2 (1987): 9–45.

C. Beahan, 'Feminism and Nationalism in the Chinese Women's Press 1902–1911', *Modern China*, 1, 4 (1975): 379–416.

C. Beahan, 'The Women's Movement and Nationalism in Late Ch'ing China' (PhD Thesis: Columbia University, New York, 1976).

C. Beahan, 'In the Public Eye: Women in Early Twentieth Century China', in R. Guisso and S. Johannesen (eds), *Women in China: Current Directions in Historical Scholarship* (Lewiston, NY: Edwin Mellen Press, 1981), pp. 215–38.

J. Beaver, Lihui Hou and Xue Wang, 'Rural Chinese Women: Two Faces of Economic Reform', *Modern China*, 21, 2 (1995): 205–32.

J. Belden, *China Shakes the World* (New York: Monthly Review Press, 1970).

L. Bell, 'For Better or Worse: Women and the World Market in Rural China', *Modern China*, 20, 2 (1994): 180–210.

L. Bell, *One Industry, Two Chinas: Silk Filatures and Peasant-Family Production in Wuxi County 1865–1937* (Stanford University Press, 1999).

L. Bell, 'Of Silk, Women and Capital: Peasant Women's Labor in Chinese and Other Third World Capitalisms', *Journal of Women's History*, 11, 4 (2000): 82–105.

G. Benton and A. Hunter (eds), *Wild Lily, Prairie Fire: China's Road to Democracy, Yan'an to Tian'anmen 1942–1989* (Princeton: Princeton University Press, 1995).

D. Berg, 'Amazon, Artist and Adventurer: A Courtesan in Late Imperial China', in K. Hammond and K. Stapleton (eds), *The Human Tradition in Modern China* (Lanham: Rowman and Littlefield, 2008), pp. 15–32.

K. Bernhardt, 'Women and the Law: Divorce in the Republican Period', in K. Bernhardt and P. Huang (eds), *Civil Law in Qing and Republican China*, pp. 187–214.

K. Bernhardt, 'A Ming-Qing Transition in Chinese Women's History? The Perspective from Law', in G. Hershatter, E. Honig, J. Lipman and R. Stross (eds), *Remapping China: Fissures in Historical Terrain* (Stanford: Stanford University Press, 1996), pp. 42–59.

K. Bernhardt, *Women and Property in China, 960–1949* (Stanford: Stanford University Press, 1999).

K. Bernhardt and P. Huang, 'Civil Law in Qing and Republican China: The Issues', in K. Bernhardt and P. Huang (eds), *Civil Law in Qing and Republican China* (Stanford: Stanford University Press, 1994), pp. 1–12.

L. Bianco and Chang-ming Hua, 'Implementation and Resistance: The Single-Child Family Policy', in S. Feuchtwang, S. Hussain and T. Pairault (eds), *Transforming China's Economy in the Eighties, vol.1* (London: Zed Books, 1987), pp. 147–68.

E. Billard, 'The Female Face of Illiteracy in China', *China Information*, 13, 4 (1999): 27–48.

B. Birge, *Women, Property and Confucian Reaction in Sung and Yuan China (960–1368)* (Cambridge: Cambridge University Press, 2002).

C. F. Blake, 'Love Songs and the Great Leap: The Role of Youth Culture in the Revolutionary Phase of China's Economic Development', *American Ethnologist*, 6, 1 (1979): 41–54.

C. F. Blake, 'Footbinding in Neo-Confucian China and the Appropriation of Female Labour', *Signs*, 19, 3 (1994): 676–712.

S. Borthwick, 'Changing Concepts of the Role of Women from the Late Qing to the May Fourth Period', in D. Pong and E. Fung (eds), *Ideal and Reality: Social and Political Change in Modern China 1860–1949* (Lanham: University Press of America, 1985), pp. 63–91.

L. Bossen, Xurui Wang, M. Brown and H. Gates, 'Feet and Fabrication: Footbinding and Early Twentieth Century Rural Women's Labor in Shaanxi', *Modern China*, 37, 4 (2011): 347–83.

B. Bossler, '"A Woman is a Daughter all her Life": Affinal Relations and Women's Networks in Song and Late Imperial China', *Late Imperial China*, 21, 1 (2000): 77–106.

F. Brandauer, 'Women in the *Ching-hua yuan:* Emancipation Toward a Confucian Ideal', *Journal of Asian Studies*, 36, 4 (1977): 647–60.

F. Bray, *Technology and Gender: Fabrics of Power in Late Imperial China* (Berkeley: University of California Press, 1997).

C. Brown, 'Woman as Trope: Gender and Power in Lu Xun's "Soap"', in T. Barlow (ed.), *Gender and Politics in Modern China* (Durham, NC: Duke University Press, 1993), pp. 74–89.

S. Brownell, 'The Body and the Beautiful in Chinese Nationalism: Sportswomen and Fashion Models in the Reform Era', *China Information*, 13, 2/3 (1998): 36–57.

S. Brownell, 'Strong Women and Impotent Men: Sports, Gender and Nationalism in Chinese Public Culture', in M. Mei-hui Yang (ed.), *Spaces of Their Own*, pp. 207–31.

S. Brownell, 'Gender and Nationalism at the Turn of the Millennium', in T. White (ed.), *China Briefing 2000: The Continuing Transformation* (Armonk, NY: ME Sharpe, 2000), pp. 195–232.

S. Brownell, 'Making Dream Bodies in Beijing: Athletes, Fashion Models and Urban Mystique in China', in N. Chen, C. Clark, S. Gottschwang and L. Jeffery (eds), *China Urban: Ethnographies of Contemporary Chinese Culture* (Durham, NC: Duke University Press, 2001), pp. 123–42.

S. Brownell and J. Wasserstrom (eds), *Chinese Femininities, Chinese Masculinities: A Reader* (Berkeley: University of California Press, 2002).

C. Broyelle, *Women's Liberation in China* (Hassocks: Harvester Press, 1977).

M. Burton, *The Education of Women in China* (New York: Fleming H. Revell, 1911).

M. Burton, *Notable Women of Modern China* (New York: Fleming H. Revell, 1912).

W. Butler (ed.), *Legal System of the Chinese Soviet Republic 1931–1934* (Dobbs Ferry, NY: Transnational Publishers, 1983).

S. Cahill, *Transcendence and Divine Passion: The Queen Mother of the West in Medieval China* (Stanford: Stanford University Press, 1993).

S. Cahill, 'Our Women Are Acting Like Foreigners' Wives: Western Influences on Tang Dynasty Women's Fashion', in V. Steele and J. Major (eds), *China Chic: East Meets West* (New Haven: Yale University Press, 1999), pp. 103–17.

K. Carlitz, 'Desire, Danger and the Body: Stories of Women's Virtue in Late Ming China', in C. Gilmartin, G. Hershatter, L. Rofel and T. White (eds), *Engendering China: Women, Culture and the State*, pp. 101–24.

K. Carlitz, 'Shrines, Governing-Class Identity and the Cult of Widow Fidelity in Mid-Ming Jiangnan', *Journal of Asian Studies*, 56, 3 (1997): 612–40.

P. Carroll, *Between Heaven and Modernity: Reconstructing Suzhou 1895–1937* (Stanford: Stanford University Press, 2006).

V. Cass, *Dangerous Women: Warriors, Grannies and Geishas* (Lanham: Rowman and Littlefield, 1999).

Kang-I Sun Chang, 'Ming-Qing Women Poets and the Notions of "Talent" and "Morality"', in T. Huters, R. Bin Wong and P. Yu (eds), *Culture and State in Chinese History: Conventions, Accommodations and Critiques* (Stanford: Stanford University Press, 1997), pp. 236–58.

Kang-I Sun Chang and H. Saussy (eds), *Women Writers of Traditional China: An Anthology of Poetry and Criticism* (Stanford: Stanford University Press, 1999).

Mo-chün Chang, 'Opposition to Footbinding', in Yu-ning Li (ed.), *Chinese Women Through Chinese Eyes*, pp. 125–8.

P. Chatterjee, 'Colonialism, Nationalism and Colonialized Women: The Contest in India', in *American Ethnologist*, 16, 4 (1989): 622–33.

T. Mai Chen, 'Proletarian White and Working Bodies in Mao's China', *positions*, 11, 2 (2003): 361–93.

T. Mai Chen, 'Female Icons, Feminist Iconography? Socialist Rhetoric and Women's Agency in 1950s China', *Gender and History*, 15, 2 (2005): 268–95.

Xuezhao Chen, *Surviving the Storm: A Memoir* (Armonk, NY: M. E. Sharpe, 1990).

Weikun Cheng, 'The Challenge of the Actresses: Female Performers and Cultural Alternatives in Early Twentieth Century Beijing and Tianjin', *Modern China*, 22, 2 (1996): 197–233.

Weikun Cheng, 'Going Public Through Education: Female Reformers and Girls' Schools in Late Qing Beijing', *Late Imperial China*, 21, 1 (2000): 107–44.

Weikun Cheng, 'Creating a New Nation, Creating New Women: Women's Journals and the Building of Nationalist Womanhood during the 1911 Revolution', in G. Wei and Xiaoyuan Liu (eds), *Chinese Nationalism in Perspective: Historical and Recent Cases* (Westport, CT: Greenwood Press, 2001), pp. 15–32.

M. Chew, 'Contemporary Re-Emergence of the *Qipao*: Political Nationalism, Cultural Production and Popular Consumption of a Traditional Chinese Dress', *China Quarterly*, 189 (2007): 144–61.

Yung-Chen Chiang, 'Womanhood, Motherhood and Biology: The Early Phases of the *Ladies Journal* 1915–1925', *Gender and History*, 18, 3 (2006): 519–45.

C. Chin, 'Translating the New Woman: Chinese Feminists View the West 1905–1915', *Gender and History*, 18, 3 (2006): 490–518.

Rey Chow, *Women and Chinese Modernity: The Politics of Reading Between East and West* (Minneapolis: University of Minnesota Press, 1991).

Rey Chow, *Primitive Passions: Visuality, Sexuality, Ethnography and Contemporary Chinese Cinema* (New York: Columbia University Press, 1995).

H. Clark, 'The Cheungsam: Issues of Fashion and Cultural Identity', in V. Steele and J. Major (eds), *China Chic: East Meets West* (New Haven: Yale University Press, 1999), pp. 155–65.

P. Clark, 'Ethnic Minorities in Chinese Films: Cinema and the Erotic', *East-West Film Journal*, 1, 1 (1987): 15–32.

P. Cohen, *History in Three Keys: The Boxers as Event, Experience and Myth* (New York: Columbia University Press, 1997).

P. Cohen, *China Unbound: Evolving Perspectives on the Chinese Past* (London: Routledge Curzon, 2003).

Xiaoping Cong, *Teachers' Schools and the Making of the Modern Chinese Nation-State 1897–1937* (Vancouver: University of British Columbia Press, 2007).

Xiaoping Cong, 'From *Cainü* to *Nü jiaoxi:* Female Normal Schools and the Transformation of Women's Education in the Late Qing Period 1895–1911', in Nanxiu Qian, G. Fong and R. Smith (eds), *Different Worlds of Discourse: Transformations of Gender and Genre in Late Qing and Early Republican China* (Leiden: Brill, 2008), pp. 115–46.

E. Croll (ed.), *The Women's Movement in China: A Selection of Readings 1949–1973* (London: Anglo-Chinese Educational Institute, 1974).

E. Croll, 'A New Movement to Redefine the Role and Status of Women', *China Quarterly*, 71 (1977): 591–7.

E. Croll, *Feminism and Socialism in China* (London: Routledge and Kegan Paul, 1978).

E. Croll, *The Politics of Marriage in Contemporary China* (Cambridge: Cambridge University Press, 1981).

E. Croll, *Chinese Women Since Mao* (London: Zed Books, 1983).

E. Croll, (a) 'Marriage Choice and Status Groups in Contemporary China', in J. Watson (ed.), *Social Stratification in Post-Revolution China* (Cambridge: Cambridge University Press, 1984), pp. 175–97.

E. Croll, (b) 'The Exchange of Women and Property: Marriage in Post-Revolutionary China', in R. Hirschron (ed.), *Women and Property—Women as Property* (London: Croom Helm, 1984), pp. 44–61.

E. Croll, (a) 'The Sexual Division of Labor in Rural China', in L. Benaria (ed.), *Women and Development: The Sexual Division of Labor in Rural Societies* (New York: Praeger, 1985), pp. 223–47.

E. Croll, (b) *Women and Rural Development in China* (Geneva: ILO, 1985).

E. Croll, 'Like the "Chinese Goddess of Mercy": Mrs Little and the Natural Foot Society', in D. Goodman (ed.), *China and the West: Ideas and Activists* (Manchester: Manchester University Press, 1990), pp. 41–56.

E. Croll, *Changing Identities of Chinese Women: Rhetoric, Experience and Self-Perception in Twentieth-Century China* (London: Zed Books, 1995).

E. Croll, *Endangered Daughters: Discrimination and Development in Asia* (London: Routledge, 2000).

Shuqin Cui, *Women Through the Lens: Gender and Nation in a Century of Chinese Cinema* (Honolulu: University of Hawaii Press, 2003).

D. Davin, 'Women in the Liberated Areas', in M. Young (ed.), *Women in China*, pp. 73–91.

D. Davin, *Woman-Work: Women and the Party in Revolutionary China* (Oxford: Clarendon, 1976).

D. Davin, (a) 'Engels and the Making of Chinese Family Policy', in J. Sayers, M. Evans and N. Redclift (eds), *Engels Revisited: New Feminist Essays* (London: Tavistock, 1987), pp. 145–64.

D. Davin, (b) 'The Implications of Contract Agriculture for the Employment and Status of Chinese Peasant Women', in J. Sayers, M. Evans and N. Redclift (eds), *Transforming China's Economy in the Eighties, vol.1* (London: Zed Books, 1987), pp. 137–46.

D. Davin, (c) 'Gender and Population in the People's Republic of China', in H. Afshar (ed.), *Women, State and Ideology: Studies From Africa and Asia* (London: Macmillan, 1987), pp. 111–28.

D. Davin, 'Population Policy and Reform: The Soviet Union, Eastern Europe and China', in S. Rai, H. Pilkington and A. Phizacklea (eds), *Women in the Face of Change: The Soviet Union, Eastern Europe and China* (London: Routledge, 1992), pp. 79–103.

D. Davin, 'Chinese Women: Media Concerns and the Politics of Reform', in H. Afshar (ed.), *Women and Politics in the Third World* (London: Routledge, 1996), pp. 96–108.

D. Davis and S. Harrell, 'Introduction: The Impact of Post-Mao Reforms in Family Life', in D. Davis and S. Harrell (eds), *Chinese Families in the Post-Mao Era* (Berkeley: University of California Press, 1993), pp. 1–22.

W. De Bary and Wing-tsit Chan (eds), *Sources of Chinese Tradition, vol.2* (New York: Columbia University Press, 1960).

M. Decker, 'Living in Sin: From May Fourth via the Anti-Rightist Movement to the Present', in E. Widmer and D. Der-wei Wang (eds), *From May Fourth to June Fourth: Fiction and Film in Twentieth Century China* (Cambridge, MA: Harvard University Press, 1993), pp. 221–48.

F. Del Lago, 'Crossed Legs in 1930s Shanghai: How "Modern" is the Modern Woman?', *East Asian History*, 19 (2000): 103–44.

N. Diamant, (a) 'Re-Examining the Impact of the 1950 Marriage Law: State Improvisation, Local Initiative and Rural Family Change', *China Quarterly*, 161 (2000): 171–98.

N. Diamant, (b) *Revolutionizing the Family: Politics, Love and Divorce in Urban and Rural China* (Berkeley: University of California Press, 2000).

N. Diamond, (a) 'Women Under Kuomintang Rule: Variations on a Feminine Mystique', *Modern China*, 1, 1 (1975): 3–45.

N. Diamond, (b) 'Collectivization, Kinship and the Status of Women in Rural China', in R. Reiter (ed.), *Toward an Anthropology of Women* (New York: Monthly Review Press, 1975), pp. 372–95.

N. Diamond, 'The Miao and Poison: Interactions on China's Southwest Frontier', *Ethnology*, 27, 1 (1988): 1–25.

N. Diamond, 'Defining the Miao: Ming, Qing and Contemporary Views', in S. Harrell (ed.), *Cultural Encounters on China's Ethnic Frontiers* (Seattle: University of Washington Press, 1995), 92–116.

F. Dikotter, *Sex, Culture and Modernity in China: Medical Science and the Construction of Sexual Identities in the Early Republican Period* (Honolulu: University of Hawaii Press, 1995).

F. Dikotter, *Imperfect Conceptions: Medical Knowledge, Birth Defects and Eugenics in China* (London: Hurst, 1998).

M. Yue Dong, 'Unofficial History and Gender Boundary Crossing in the Early Republic: Shen Peizhen and Xiaofengxian', in B. Goodman and W. Larson (eds), *Gender in Motion*, pp. 169–88.

M. Yue Dong, 'Who is Afraid of the Modern Chinese Girl?', in A. Weinbaum, L. Thomas, P. Ramamurthy, U. Poiger, M. Yue Dong and T. Barlow (eds), *The Modern Girl Around the World: Consumption, Modernity and Globalization* (Durham, NC: Duke University Press, 2008), pp. 194–219.

A. Dooling, *Women's Literary Feminism in Twentieth-Century China* (New York: Palgrave Macmillan, 2005).

A. Dooling and K. Torgeson (eds), *Writing Women in Modern China* (New York: Columbia University Press, 1998).

A. Drucker, 'The Influence of Western Women on the Anti-Footbinding Movement 1840–1911', in R. Guisso and S. Johannesen (eds), *Women in China: Current Directions in Historical Scholarship* (Lewiston, NY: Edwin Mellen Press, 1981), pp. 179–99.

Fangqin Du and S. Mann, 'Competing Claims on Womanly Virtue in Late Imperial China', in D. Ko, J. Haboush and J. Piggott (eds), *Women and Confucian Cultures in Pre-modern China, Korea and Japan* (Berkeley: University of California Press, 2003), pp. 219–47.

R. Dunch, 'Christianizing Confucian Didacticism: Protestant Publications for Women 1832–1911', *Nan Nü*, 11, 1 (2009): 65–101.

L. Eastman, *Family, Fields and Ancestors: Constancy and Change in China's Social and Economic History 1550–1949* (New York: Oxford University Press, 1988).

P. Ebrey, 'Women, Marriage and the Family in Chinese History', in P. Ropp (ed.), *Heritage of China: Perspectives on Chinese Civilization* (Berkeley: University of California Press, 1990), pp. 197–223.

P. Ebrey, *The Inner Quarters: Marriage and the Lives of Chinese Women in the Song Period* (Berkeley: University of California Press, 1993).

P. Ebrey, 'Gender and Sinology: Shifting Western Interpretations of Footbinding 1860–1927', *Late Imperial China*, 20, 2 (1999): 1–34.

K. Edgerton-Tarpley, 'Family and Gender in Famine: Cultural Responses to Disaster in North China 1876–1879', *Journal of Women's History*, 16, 4 (2004): 119–47.

L. Edwards, 'Women Warriors and Amazons of the Mid-Qing Texts *Jinghua yuan* and *Honglou meng*', *Modern Asian Studies*, 29, 2 (1995): 225–55.

L. Edwards, (a) 'Women in the People's Republic of China: New Challenges to the Grand Gender Narrative', in L. Edwards and M. Roces (eds), *Women in Asia: Tradition, Modernity and Globalisation* (St. Leonards: Allen and Unwin, 2000), pp. 59–84.

L. Edwards, (b) 'Policing the Modern Woman in Republican China', *Modern China*, 26, 2 (2000): 115–47.

L. Edwards, 'Narratives of Race and Nation in China: Women's Suffrage in the Early Twentieth Century', *Women's Studies International Forum*, 25, 6 (2002): 619–29.

L. Edwards, (a) 'Chinese Women's Campaigns for Suffrage: Nationalism, Confucianism and Political Agency', in L. Edwards and M. Roces (eds), *Women's Suffrage in Asia* (London: Routledge, 2004), pp. 57–79.

L. Edwards, (b) 'Constraining Women's Political Work with "Women's Work": The Chinese Communist Party and Women's Participation in Politics', in A. McLaren (ed.), *Chinese Women – Living and Working*, pp. 109–30.

L. Edwards, 'Opposition to Women's Suffrage in China: Confronting Modernity in Governance', in M. Leutner and N. Spakowski (eds), *Women in China*, pp. 107–28.

L. Edwards, 'Sport, Fashion and Beauty: New Incarnations of the Female Politician in Contemporary China', in F. Martin and L. Heinrich (eds), *Embodied Modernities: Corporeality, Representation and Chinese Cultures* (Honolulu: University of Hawaii Press, 2006), pp. 146–61.

L. Edwards, (a) 'Dressing for Power: Scholars' Robes, School Uniforms and Military Attire in China', in L. Edwards and M. Roces (eds), *The Politics of Dress in Asia and the Americas* (Brighton: Sussex Academic Press, 2007), pp. 42–64.

L. Edwards, (b) 'Strategizing for Politics: Chinese Women's Participation in the One-Party State', *Women's Studies International Forum*, 30, 5 (2007): 380–90.

L. Edwards, *Gender, Politics and Democracy: Women's Suffrage in China* (Stanford: Stanford University Press, 2008).

L. Edwards, 'Transformations of the Woman Warrior Hua Mulan: From Defender of the Family to Servant of the State', *Nan Nü*, 12, 2 (2010): 175–214.

E. Eide, *China's Ibsen: From Ibsen to Ibsenism* (London: Curzon, 1987).

K. Eiermann, '"When I Entered Middle School I Was a Great Pessimist": The Autobiographies of Chinese Communist Women in Moscow During the 1920s', *Twentieth-Century China*, 33, 2 (2007): 4–28.

M. Elliott, 'Manchu Widows and Ethnicity in Qing China', *Comparative Studies in Society and History*, 41, 1 (1999): 33–71.

M. Elvin, 'Female Virtue and the State in China', *Past and Present*, 104 (1984): 111–52.

R. Entenmann, 'Christian Virgins in Eighteenth Century Sichuan', in D. Bays (ed.), *Christianity in China: From the Eighteenth Century to the Present* (Stanford: Stanford University Press, 1996), pp. 180–94.

R. Entenmann, 'Christian Virgins in Early Qing China', in J. Lutz (ed.), *Pioneer Chinese Christian Women*, pp. 141–61.

B. Entwisle and G. Henderson (eds), *Re-Drawing Boundaries: Work, Households and Gender in China* (Berkeley: University of California Press, 2000).

M. Epstein, 'Engendering Order: Structure, Gender and Meaning in the Qing Novel *Jinghua yuan*', *Chinese Literature*, 18 (1996): 101–27.

H. Evans, 'Monogamy and Female Sexuality in the People's Republic of China', in S. Rai, H. Pilkington and A. Phizacklea (eds), *Women in the Face of Change: The Soviet Union, Eastern Europe and China* (London: Routledge, 1992), pp. 147–63.

H. Evans, 'Defining Difference: The Scientific Construction of Sexuality and Gender in the PRC', *Signs*, 20, 2 (1995): 357–94.

H. Evans, *Women and Sexuality in China: Dominant Discourses of Female Sexuality and Gender Since 1949* (Cambridge: Polity Press, 1997).

H. Evans, 'The Language of Liberation: Gender and *Jiefang* in Early Chinese Communist Party Discourse', *Intersections*, 1 (1998).

H. Evans, '"Comrade Sisters": Gendered Bodies and Space', in H. Evans and S. Donald (eds), *Picturing Power in the People's Republic of China* (Lanham: Rowman and Littlefield, 1999), pp. 63–78.

H. Evans, (a) 'Fashioning Identities, Consuming Passions: Public Images of Women in China', *New Formations*, 40 (2000): 113–27.

H. Evans, (b) 'Marketing Femininity: Images of the Modern Chinese Woman', in T. Weston and L. Jensen (eds), *China Beyond the Headlines* (Lanham: Rowman and Littlefield, 2000), pp. 217–43.

H. Evans, 'Past, Perfect or Imperfect: Changing Images of the Ideal Wife', in S. Brownell and J. Wasserstrom (eds), *Chinese Femininities, Chinese Masculinities*, pp. 335–60.

H. Evans, 'Fashions and Feminist Consumption', in K. Latham, S. Thompson and J. Klein (eds), *Consuming China: Approaches to Change in Contemporary China* (London: Routledge, 2006), pp. 173–89.

H. Evans, (a) 'Gender in Modern Chinese Culture', in K. Louie (ed.), *Cambridge Companion to Modern Chinese Culture* (Cambridge: Cambridge University Press, 2008), pp. 68–90.

H. Evans, (b) *The Subject of Gender: Daughters and Mothers in Urban China* (Lanham: Rowman and Littlefield, 2008).

H. Evans, (c) 'Sexed Bodies, Sexualised Identities and the Limits of Gender', *China Information*, 22, 2 (2008): 361–86.

J. Farrer, *Opening Up: Youth Sex Cultures and Market Reform in China* (Chicago: University of Chicago Press, 2002).

Yi-tsi Feuerwerker, 'Women as Writers in the 1920s and 1930s', in M. Wolf and R. Witke (eds), *Women in Chinese Society*, pp. 143–68.

Yi-tsi Feuerwerker, 'The Changing Relationship Between Literature and Art: Aspects of the Writer's Role in Ding Ling', in M. Goldman (ed.), *Modern Chinese Literature in the May Fourth Era* (Cambridge, MA: Harvard University Press, 1977), pp. 281–307.

A. Field, 'Selling Souls in Sin City: Shanghai Singing and Dancing Hostesses in Print, Film and Politics 1926–1929', in Yingjin Zhang (ed.), *Cinema and Urban Culture in Shanghai 1922–1943* (Stanford: Stanford University Press, 1999), pp. 99–127.

A. Field, *Shanghai's Dancing World: Cabaret Culture and Urban Politics 1919–1954* (Hong Kong: University of Hong Kong Press, 2010).

A. Finnane, 'What Should Chinese Women Wear? A National Problem', *Modern China*, 22, 2 (1996): 99–131.

A. Finnane, 'Military Culture and Chinese Dress in the Early Twentieth Century', in V. Steele and J. Major (eds) *China Chic: East Meets West* (New Haven: Yale University Press, 1999), pp. 119–31.

A. Finnane, *Changing Clothes in China: Fashion, History, Nation* (New York: Columbia University Press, 2008).

A. Finnane and A. McLaren (eds), *Dress, Sex and Text in Chinese Culture* (Clayton: Monash Asia Institute, 1999).

S. Fiske, 'Asian Awakenings: Alicia Little and the Limits of Orientalism', *Victorian Literature and Culture*, 37 (2009): 11–25.

J. Flath, *The Cult of Happiness: Nianhua, Art and History in Rural North China* (Vancouver: University of British Columbia Press, 2004).

G. Fong, (a) 'Female Hands: Embroidery as a Knowledge Field in Late Imperial and Republican China', *Late Imperial China*, 25, 1 (2004): 1–58.

G. Fong, (b) 'Alternative Modernities, or a Classical Woman of Modern China: The Challenging Trajectory of Lü Bicheng's (1883–1943) Life and Song Lyrics', *Nan Nü*, 6, 1 (2004): 12–59.

G. Fong, *Herself an Author: Gender, Agency and Writing in Late Imperial China* (Honolulu: University of Hawaii Press, 2008).

E. Friedman, *National Identity and Democratic Prospects in Socialist China* (Armonk, NY: ME Sharpe, 1995).

E. Friedman, P. Pickowicz and M. Selden, *Chinese Village, Socialist State* (New Haven: Yale University Press, 1991).

S. Friedman, *Intimate Politics: Marriage, the Market and State Power in South-Eastern China* (Cambridge, MA: Harvard University Press, 2006).

S. Friedman, 'Women, Marriage and the State in Contemporary China', in E. Perry and M. Selden (eds), *Chinese Society: Change, Conflict and Resistance* (London: Routledge, 2010, 3rd ed.), pp. 148–70.

C. Furth, *A Flourishing Yin: Gender in China's Medical History* (Berkeley: University of California Press, 1999).

A. Gaetano and T. Jacka (eds), *On the Move: Women in Rural-to-Urban Migration in Contemporary China* (New York: Columbia University Press, 2004).

Xianxian Gao, 'From the Heyang Model to the Shaanxi Model: Action Research on Women's Participation in Village Governance', *China Quarterly*, 284 (2010): 870–98.

V. Garrett, *Chinese Clothing: An Illustrated Guide* (Oxford: Oxford University Press, 1994).

H. Gates, 'Cultural Support for Birth Limitation Among Urban Capital-Owning Women', in D. Davis and S. Harrell (eds), *Chinese Families in the Post-Mao Era* (Berkeley: University of California Press, 1993), pp. 251–74.

K. Gerth, *China Made: Consumer Culture and the Creation of the Nation* (Cambridge, MA: Harvard University Press, 2003).

C. Gilmartin, 'Recent Developments in Research About Women in the PRC', *Republican China*, 10, 1b (1984): 57–66.

C. Gilmartin, 'Gender, Politics and Patriarchy in China: The Experiences of Early Women Communists 1920–1927', in S. Kruks, P. Rapp and M. Young (eds), *Promissory Notes: Women in the Transition to Socialism* (New York: Monthly Review Press, 1989), pp. 82–105.

C. Gilmartin, 'Violence Against Women in Contemporary China', in J. Lipman and S. Harrell (eds), *Violence in China: Essays in Culture and Counterculture* (New York: SUNY Press, 1990), pp. 203–25.

C. Gilmartin, 'Gender in the Formation of a Communist Body Politic', *Modern China*, 19, 3 (1993): 299–329.

C. Gilmartin, 'Gender, Political Culture and Women's Mobilization in the Chinese Nationalist Revolution', in C. Gilmartin, G. Hershatter, L. Rofel and T. White (eds), *Engendering China: Women, Culture and the State*, pp. 195–225.

C. Gilmartin, *Engendering the Chinese Revolution: Radical Women, Communist Politics, and Mass Movements in the 1920s* (Berkeley: University of California Press, 1995).

C. Gilmartin, 'Introduction: May Fourth and Women's Emancipation', in Hua Lan and V. Fong (eds), *Women in Republican China*, pp. ix–xxvii.

C. Gilmartin, 'Inscribing Gender Codes: Male-Feminists in the Early CCP', in M. Leutner, R. Felber, M. Titarenko and A.Grigoriev (eds), *The Chinese Revolution in the 1920s: Between Triumph and Disaster* (London: Routledge Curzon, 2002), pp. 244–60.

C. Gilmartin, G. Hershatter, L. Rofel and T. White (eds), *Engendering China: Women, Culture, and the State* (Cambridge, MA: Harvard University Press, 1994).

D. Gimpel, 'Freeing the Mind Through the Body: Women's Thoughts on Physical Education in Late Qing and Early Republican China', *Nan Nü*, 8, 2 (2006): 316–58.

D. Gimpel,'Chen Hengzhe and the Uses of History', in Hong Shen (ed.), *When China Meets the West* (Hangzhou: Zhejiang University Press, 2010), pp. 199–211.

C. Gipoulon, *Qiu Jin, pierres de l'oiseau jingwei* (Paris: Editions des femmes, 1976).

C. Gipoulon, 'Integrating the Feminist and Workers' Movement: The Case of Xiang Jingyu', *Republican China*, 10, 1 (1984): 29–41.

C. Gipoulon, 'Xiang Jingyu, ou les ambiguités d'une carrière entre communisme et féminisme', *Etudes Chinoises*, 5, 1–2 (1986): 101–29.

C. Gipoulon, 'The Emergence of Women in Politics in China 1898–1927', *Chinese Studies in History*, 23, 2 (1989/1990): 46–67.

D. Gladney, 'Representing Nationality in China: Refiguring Majority/Minority Identitities', *Journal of Asian Studies*, 53, 1 (1994): 92–123.

D. Gladney, *Dislocating China: Muslims, Minorities and Other Subaltern Subjects* (Chicago: University of Chicago Press, 2004).

S. Glosser, 'The Business of Family: You Huaigao and the Commercialization of a May Fourth Ideal', *Republican China*, 20, 2 (1995): 86–116.

S. Glosser, '"The Truths I Have Learned": Nationalism, Family Reform and Male Identity in China's New Culture Movement 1915–1919', in S. Brownell and J. Wasserstrom (eds), *Chinese Femininities, Chinese Masculinities*, pp. 120–44.

S. Glosser, *Chinese Visions of Family and State 1915–1953* (Berkeley: University of California Press, 2003).

S. Glosser, '"Women's Culture of Resistance": An Ordinary Response to Extraordinary Circumstances', in C. Henriot and Wen-hsin Yeh (eds), *In the Shadow of the Rising Sun: Shanghai Under Japanese Occupation* (Cambridge: Cambridge University Press, 2004), pp. 302–24.

P. R. Goldin, 'The View of Women in Early Confucianism', in Chenyang Li (ed.), *The Sage and the Second Sex: Confucianism, Ethics, and Gender* (Chicago: La Salle and Open Court, 2000), pp. 133–61.

J. Goldstein, *Drama Kings: Players and Publics in the Re-Creation of Peking Opera 1870–1937* (Berkeley: University of California Press, 2007).

B. Goodman, (a) 'The New Woman Commits Suicide: The Press, Cultural Memory and the New Republic', *Journal of Asian Studies*, 64, 1 (2005): 67–101.

B. Goodman, (b) 'Unvirtuous Women: Women and the Corruptions of the Shanghai Stock Market in the Early Republican Era', in M. Leutner and N. Spakowski (eds), *Women in China*, pp. 351–73.

B. Goodman and W. Larson (eds), *Gender in Motion: Divisions of Labor and Cultural Change in Late Imperial and Modern China* (Lanham: Rowman and Littlefield, 2005).

B. Goodman and W. Larson, 'Axes of Gender: Divisions of Labor and Spatial Separation', in B. Goodman and W. Larson (eds), *Gender in Motion*, pp. 1–28.

D. Goodman, 'Revolutionary Women in the Revolution: The CCP and Women in the War of Resistance to Japan 1937–1945', *China Quarterly*, 164 (2000): 915–42.

D. Goodman, 'Why Women Count: Chinese Women in the Leadership of Reform', in A. McLaren (ed.), *Chinese Women – Living and Working*, pp. 19–40.

G. Graham, 'Exercising Control: Sports and Physical Education in American Protestant Schools in China 1880–1930', *Signs*, 20, 1 (1994): 23–48.

B. Grant, 'Women, Gender and Religion in Pre-Modern China: A Brief Introduction', *Nan Nü*, 10, 1 (2008): 2–21.

S. Greenhalgh, 'The Peasantization of the One-Child Policy in Shaanxi', in D. Davis and S. Harrell (eds), *Chinese Families in the Post-Mao Era* (Berkeley: University of California Press, 1993), pp. 219–50.

S. Greenhalgh, 'Controlling Births and Bodies in Village China', *American Ethnologist*, 21, 1 (1994): 3–30.

S. Greenhalgh and Jiali Li, 'Engendering Reproductive Power and Practice in Peasant China: For a Feminist Demography of Reproduction', *Signs*, 20, 3 (1995): 601–41.

S. Greenhalgh and E. Winckler. *Governing China's Population: From Leninist to Neoliberal Biopolitics* (Stanford: Stanford University Press, 2005).

Yingjie Guo, 'China's Celebrity Mothers: Female Virtues, Patriotism and Social Harmony', in L. Edwards and E. Jeffreys (eds), *Celebrity in China* (Hong Kong: University of Hong Kong Press, 2010), pp. 45–66.

Bangqing Han (ed. E. Hung), *The Sing-Song Girls of Shanghai* (New York: Columbia University Press, 2005).

J. Handlin, 'Lü Kun's New Audience: The Influence of Women's Literacy in Sixteenth-Century Thought', in M. Wolf and R. Witke (eds), *Women in Chinese Society*, pp. 13–38.

M. Hansen, 'Fallen Women, Rising Stars, New Horizons: Shanghai Silent Film as Vernacular Modernism', *Film Quarterly*, 54, 1 (2000): 10–22.

A. Hanser, *Service Encounters: Class, Gender and the Market for Social Distinction in Urban China* (Stanford: Stanford University Press, 2008).

P. Harrell, *Sowing the Seeds of Change: Chinese Students, Japanese Teachers 1895–1905* (Stanford: Stanford University Press, 1992).

P. Harrell, 'The Meiji "New Woman" and China', in J. Fogel (ed.), *Late Qing China and Meiji Japan: Political and Cultural Aspects* (Norwalk, CT: Eastbridge, 2004), pp. 109–50.

K. Harris, 'The New Woman: Image, Subject and Dissent in 1930s Shanghai', *Republican China*, 20, 2 (1995): 55–79.

K. Harris, 'The New Woman Incident: Cinema, Scandal and Spectacle in 1936 Shanghai', in S. Hsiao-peng Lu (ed.), *Transnational Chinese Cinemas: Identity, Nationhood, Gender* (Honolulu: University of Hawaii Press, 1997), pp. 277–302.

K. Harris, '*The Goddess*: Fallen Woman of Shanghai', in C. Berry (ed.), *Chinese Films in Focus* (Basingstoke: Palgrave Macmillan, 2008), pp. 128–36.

H. Harrison, *The Making of the Republican Citizen: Political Ceremonies and Symbols in China, 1911–1929* (Oxford: Clarendon, 2000).

R. Harrist, 'Clothes Make the Man: Dress, Modernity and Masculinity in China ca.1912–1937', in Wu Hung and K.Tsiang (eds), *Body and Face in Chinese Visual Culture* (Cambridge, MA: Harvard University Press, 2005), pp.171–96.

G. Hayter-Menzies, *Imperial Masquerade: The Legend of Princess Der Ling* (Hong Kong: Hong Kong University Press, 2008).

C. Henriot, 'Chinese Courtesans in Late Qing and Early Republican Shanghai', *East Asian History*, 8 (1994): 33–52.

C. Henriot, 'La Fermeture: The Abolition of Prostitution in Shanghai 1949–1958', *China Quarterly*, 142 (1995): 467–86.

C. Henriot, '"From a Throne of Glory to a Seat of Ignominy": Shanghai Prostitution Revisited (1849–1949)', *Modern China*, 22, 2 (1996): 132–63.

C. Henriot, *Prostitution and Sexuality in Shanghai: A Social History 1840–1949* (Cambridge: Cambridge University Press, 2001).

G. Hershatter, *The Workers of Tianjin 1900–1949* (Stanford: Stanford University Press, 1986).

G. Hershatter, 'The Hierarchy of Shanghai Prostitution 1870–1949', *Modern China*, 15, 4 (1989): 463–98.

G. Hershatter, 'Prostitution and the Market in Women in Early Twentieth Century Shanghai', in R. Watson and P. Ebrey (eds), *Marriage and Inequality in Chinese Society*, pp.256–85.

G. Hershatter, (a) 'Courtesans and Streetwalkers: The Changing Discourse on Shanghai Prostitution 1890–1949', *Journal of the History of Sexuality*, 3, 2 (1992): 245–69.

G. Hershatter, (b) 'Regulating Sex in Shanghai: The Reform of Prostitution in 1920 and 1951', in F. Wakeman and Wen-hsin Yeh (eds), *Shanghai Sojourners* (Berkeley: Institute of East Asian Studies, 1992), pp.145–85.

G. Hershatter, *Dangerous Pleasures: Prostitution and Modernity in Twentieth Century Shanghai* (Berkeley: University of California Press, 1997).

G. Hershatter, 'Virtue at Work: Rural Shaanxi Women Remember the 1950s', in B. Goodman and W. Larson (eds), *Gender in Motion*, pp.309–28.

G. Hershatter, (a) *Women in China's Long Twentieth Century* (Berkeley: University of California Press, 2007).

G. Hershatter, (b) 'Forget Remembering: Rural Women's Narratives of China's Collective Past', in Ching Kwan Lee and Guobin Yang (eds), *Re-envisioning the Chinese Revolution: The Politics and Poetics of Collective memories in Reform China* (Stanford: Stanford University Press, 2007), pp.69–92.

G. Hershatter, *The Gender of Memory: Rural Women and China's Collective Past* (Berkeley: University of California Press, 2011).

B. Hillman and L.-A. Henfry, 'Macho Minority: Masculinity and Ethnicity on the Edge of Tibet', *Modern China*, 32, 2 (2006): 251–72.

B. Hinsch, *Women in Early Imperial China* (Lanham: Rowman and Littlefield, 2002).

W. Hinton, *Fanshen: A Documentary of Revolution in a Chinese Village* (Berkeley: University of California Press, 1997).

Hsiang-ning Ho, 'When I Learned How to Cook', in Yu-ning Li (ed.), *Chinese Women Through Chinese Eyes*, pp.135–43.

V. Ho, 'Selling Smiles in Canton: Prostitution in the Early Republic', *East Asian History*, 5 (1993): 101–31.

V. Ho, *Understanding Canton: Rethinking Popular Culture in the Republican Period* (Oxford: Oxford University Press, 2005).

J. Holmgren, 'Myth, Fantasy or Scholarship: Images of Women in Traditional China', *Australian Journal of Asian Affairs*, 6 (1981): 147–70.

J. Holmgren, 'The Economic Foundations of Virtue: Widow-Remarriage in Early and Modern China', *Australian Journal of Chinese Affairs*, 13 (1985): 1–27.

Fan Hong, *Footbinding, Feminism and Freedom: The Liberation of Women's Bodies in Modern China* (London: F. Cass, 1997).

E. Honig, 'The Contract Labor System and Women Workers: Pre-Liberation Cotton Mills of Shanghai', *Modern China*, 9, 4 (1983): 421–54.

E. Honig, 'Private Issues, Public Discourse: The Life and Times of Yu Luojin', *Pacific Affairs*, 57, 2 (1984): 252–65.

E. Honig, 'Burning Incense, Pledging Sisterhood: Communities of Women Workers in the Shanghai Cotton Mills 1919–1949', *Signs*, 10, 4 (1985): 700–14.

E. Honig, *Sisters and Strangers: Women in the Shanghai Cotton Mills 1919–1949* (Stanford: Stanford University Press, 1986).

E. Honig, 'Christianity, Feminism and Communism: The Life and Times of Deng Yuzhi', in D. Bays (ed.), *Christianity in China: From the Eighteenth Century to the Present* (Stanford: Stanford University Press, 1996), 243–62.

E. Honig, 'Iron Girls Revisited: Gender and the Politics of Work in the Cultural Revolution 1966–1976', in B. Entwisle and G. Henderson (eds), *Re-Drawing Boundaries*, pp. 97–110.

E. Honig, 'Maoist Mappings of Gender: Reassessing the Red Guards', in S. Brownell and J. Wasserstrom (eds), *Chinese Femininities, Chinese Masculinities*, pp. 255–68.

E. Honig, 'Socialist Sex: The Cultural Revolution Revisited', *Modern China*, 29, 2 (2003): 143–75.

E. Honig and G. Hershatter (eds), *Personal Voices: Chinese Women in the 1980s* (Stanford: Stanford University Press, 1988).

B. Hooper, 'Gender and Education', in J. Epstein (ed.), *Chinese Education: Problems, Policies and Prospects* (New York: Garland, 1991), pp. 352–74.

Ping-chen Hsiung, 'Constructed Emotions: The Bond Between Mothers and Sons in Late Imperial China', *Late Imperial China*, 15, 1 (1994), 87–117.

Ping-chen Hsiung, *A Tender Voyage: Children and Childhood in Late Imperial China* (Stanford: Stanford University Press, 2005).

Chi-hsi Hu, 'The Sexual Revolution in the Kiangsi Soviet', *China Quarterly*, 59 (1974): 477–90.

Ying Hu, 'Re-configuring *Nei/Wai*: Writing the Woman Traveller in the Late Qing', *Late Imperial China*, 18, 1 (1997): 72–99.

Ying Hu, *Tales of Translation: Composing the New Woman in China 1898–1918* (Stanford: Stanford University Press, 2000).

Ying Hu, 'Naming the First "New Woman"', in R. Karl and P. Zarrow (eds), *Rethinking the 1898 Reform Period: Political and Cultural Change in Late Qing China* (Cambridge, MA: Harvard University Press, 2002), pp. 180–211.

Ying Hu, 'Writing Qiu Jin's Life: Wu Zhiying and her Family Learning', *Late Imperial China*, 25, 2 (2004): 119–60.

Chang-ming Hua, *La condition féminine et les communistes en action: Yan'an 1935–1946* (Paris: Editions de l'Ecole des Hautes Etudes en Sciences Sociales, 1981).

P. Huang, 'Women's Choices Under the Law: Marriage, Divorce and Illicit Sex in the Qing and the Republic', *Modern China*, 27, 1 (2001): 3–58.

P. Huang, 'Divorce Law Practices and the Origins, Myths and Realities of Judicial "Mediation" in China', *Modern China*, 31, 2 (2005): 151–203.

Chang-tai Hung, 'Female Symbols of Resistance in Chinese Wartime Spoken Drama', *Modern China*, 15, 2 (1989): 149–72.

J. Kai-sing Hung and D. Yiu-fei Lee, 'Women's Contribution to the Household Economy in Pre-1949 China: Evidence from the Lower Yangzi Region', *Modern China*, 36, 2 (2010): 210–38.

J. Hunter, *The Gospel of Gentility: American Women Missionaries in Turn of the Century China* (New Haven: Yale University Press, 1984).

S. Hyde, 'Sex Tourism and the Lure of the Ethnic Erotic in Southwest China', in L. Jensen and T. Weston (eds), *China's Transformations: The Stories Behind the Headlines* (Lanham: Rowman and Littlefield, 2007), 216–39.

W. Idema, *Heroines of Jiangyong: Chinese Narrative Ballads in Women's Script* (Seattle: University of Washington Press, 2009).

W. Idema and B. Grant (eds), *The Red Brush: Writing Women of Imperial China* (Cambridge, MA: Harvard University Press, 2004).

Hong-yuk Ip, 'Fashioning Appearances: Feminine Beauty in Chinese Communist Revolutionary Culture', *Modern China*, 29, 3 (2003): 329–61.

T. Jacka, 'Back to the Wok: Women and Employment in Industry in the 1980s', *Australian Journal of Chinese Affairs*, 24 (1990): 1–23.

T. Jacka, *Women's Work in Rural China: Change and Continuity in an Era of Reform* (Cambridge: Cambridge University Press, 1997).

T. Jacka, 'Working Sisters Answer Back: The Representation and Self-Representation of Women in China's Floating Population', *China Information*, 13, 1 (1998): 43–76.

M. Jaschok, *Concubines and Bondservants: A Social History* (London: Zed Books, 1988).

M. Jaschok and S. Miers (eds), *Women and Chinese Patriarchy: Submission, Servitude and Escape* (Hong Kong: University of Hong Kong Press, 1994).

M. Jaschok and S. Miers, 'Women in the Patriarchal System: Submission, Servitude, Escape and Collusion', in M. Jaschok and S. Miers (eds), *Women and Chinese Patriarchy*, pp. 1–24.

E. Jeffreys, 'Accidental Celebrities: China's Chastity Heroines and Charity', in L. Edwards and E. Jeffreys (eds), *Celebrity in China* (Hong Kong: University of Hong Kong Press, 2010), pp. 67–84.

W. Jenner, 'Tough Guys, Mateship and Honour: Another Chinese Tradition', *East Asian History*, 12 (1996): 1–34.

Jin Jiang, *Women Playing Men: Yue Opera and Social Change in Twentieth-Century Shanghai* (Seattle: University of Washington Press, 2009).

Yihong Jin, 'Rethinking the "Iron Girls": Gender and Labour During the Chinese Cultural Revolution', *Gender and History*, 18, 3 (2006): 613–84.

P. Johannson, 'White Skin, Large Breasts: Chinese Beauty Product Advertising as Cultural Discourse', *China Information*, 13, 2/3 (1998): 59–83.

E. Johnson, 'Grieving for the Dead, Grieving for the Living: Funeral Laments of Hakka Women', in J. Watson and E. Rawski (eds), *Death Ritual in Imperial and Modern China* (Berkeley: University of California Press, 1988), pp. 135–63.

K. A. Johnson, *Women, the Family and Peasant Revolution in China* (Chicago: University of Chicago Press, 1983).

K. A. Johnson, *Wanting a Daughter, Needing a Son: Abandonment, Adoption and Orphanage Care in China* (St Paul, MN: Yeong and Yeong Book Co., 2004).

A. Jones, 'The Sing-Song Girl and the Nation: Music and Media Culture in Republican Shanghai', in Kai-wing Chow, K. Doak and P. Fu (eds), *Constructing Nationhood in Modern East Asia* (Ann Arbor: University of Michigan Press, 2001), pp. 317–41.

E. Judd, '*Niangjia*: Chinese Women and their Natal Families', *Journal of Asian Studies*, 48, 3 (1989): 525–44.

E. Judd, '"Men Are More Able": Rural Women's Conceptions of Gender and Agency', *Pacific Affairs*, 63, 1 (1990): 40–61.

E. Judd, *Gender and Power in Rural North China* (Stanford: Stanford University Press, 1994).

E. Judd, *The Chinese Women's Movement Between State and Market* (Stanford: Stanford University Press, 2002).

J. Judge, 'Talent, Virtue and the Nation: Chinese Nationalisms and Female Subjectivities in the Early Twentieth Century', *American Historical Review*, 106, 3 (2001): 765–803.

J. Judge, (a) 'Reforming the Feminine: Female Literacy and the Legacy of 1898', in R. Karl and P. Zarrow (eds), *Rethinking the 1898 Reform Period: Political and Cultural Change in Late Qing China* (Cambridge, MA: Harvard University Press, 2002), pp. 158–79.

J. Judge, (b) 'Citizens or Mothers of Citizens? Gender and the Meaning of Modern Chinese Citizenship', in M. Goldman and E. Perry (eds), *Changing Meanings of Citizenship in Modern China* (Cambridge, MA: Harvard University Press, 2002), pp. 23–43.

J. Judge, (c) '"Good Wives and Wise Mothers": Meiji Japan and the Formulations of Feminine Modernity in Late Qing China', in J. Fogel (ed.), *Sagacious Monks and Bloodthirsty Warriors: Chinese Views of Japan in the Ming-Qing Period* (Norwalk, CT: Eastbridge, 2002), pp. 218–45.

J. Judge, 'Blended Wish Images: Chinese and Western Women Exemplars at the Turn of the Twentieth Century', *Nan Nü*, 6, 1 (2004): 102–35.

J. Judge, 'Between *Nei* and *Wai*: Chinese Women Students in Japan in the Early Twentieth Century', in B. Goodman and W. Larson (eds), *Gender in Motion*, pp. 121–43.

J. Judge, *The Precious Raft of History: The Past, the West and the Woman Question in China* (Stanford: Stanford University Press, 2008).

J. Judge, 'A Translocal Technology of the Self: Biographies of World Heroines and the Chinese Woman Question', *Journal of Women's History*, 21, 4 (2009): 59–83.

Wenqing Kang, *Obsession: Male Same-Sex Relations in China 1900–1950* (Hong Kong: University of Hong Kong Press, 2009).

Xiaofei Kang, *The Cult of the Fox: Gender and Popular religion in Late Imperial and Modern China* (New York: Columbia University Press, 2006).

R. Keith, 'Legislating Women's and Children's Rights and Interests in the PRC', *China Quarterly*, 149 (1997): 29–55.

T. Kennedy and M. Kennedy (trans.), *Testimony of a Confucian Woman: The Autobiography of Mrs Nie Zeng Jifen* (Athens, GA: University of Georgia Press, 1993).

D. Ko, 'Pursuing Talent and Virtue: Education and Women's Culture in Seventeenth and Eighteenth Century China', *Late Imperial China*, 13, 1 (1992): 9–39.

D. Ko, (a) *Teachers of the Inner Chambers: Women and Culture in Seventeenth-Century China* (Stanford: Stanford University Press, 1994).

D. Ko, (b) 'Lady-Scholars at the Door: The Practice of Gender Relations in Eighteenth-Century Suzhou', in J. Hay (ed.), *Boundaries in China* (London: Reaktion, 1994), pp. 198–216.

D. Ko, (a) 'The Body as Attire: The Shifting Meanings of Footbinding in Seventeenth-Century China', *Journal of Women's History*, 8, 4 (1997): 8–27.

D. Ko, (b) 'The Written Word and the Bound Foot: A History of the Courtesan's Aura', in E. Widmer and Kang-I Sun Chang (eds), *Writing Women in Late Imperial China* (Stanford: Stanford University Press, 1997), pp. 74–100.

D. Ko, 'Jazzing Into Modernity: High Heels, Platforms and Lotus Shoes', in V. Steele and J. Major (eds), *China Chic; East Meets West* (New Haven: Yale University Press, 1999), pp. 141–53.

D. Ko, *Every Step a Lotus: Shoes for Bound Feet* (Berkeley: University of California Press, 2001).

D. Ko, *Cinderella's Sisters: A Revisionist History of Footbinding* (Berkeley: University of California Press, 2005).

Pui-lan Kwok, *Chinese Women and Christianity 1860–1927* (Atlanta, GA: Scholars' Press, 1992).

Pui-lan Kwok, 'Chinese Women and Protestant Christianity at the Turn of the Twentieth Century', in D. Bays (ed.), *Christianity in China: From the Eighteenth Century to the Present* (Stanford: Stanford University Press, 1996), pp. 194–208.

S. Sufen Lai, 'From Cross-Dressing Daughter to Lady Knight Errant: The Origin and Evolution of Chinese Women Warriors', in S. Mou (ed.), *Presence and Presentation: Women in the Chinese Literati Tradition* (Basingstoke: Macmillan, 1999), pp. 77–107.

E. J. Laing, 'Women Painters in Traditional China', in M. Weidner (ed.), *Flowering in the Shadows: Women in the History of Chinese and Japanese Painting* (Honolulu: University of Hawaii Press, 1990), pp. 81–101.

E. J. Laing, 'Reform, Revolutionary, Political and Resistance Themes in Chinese Popular Prints 1900–1949', *Chinese Literature and Culture*, 12, 2 (2000): 123–76.

E. J. Laing, 'Visual Evidence for the Evolution of "Politically Correct" Dress for Women in Early Twentieth Century Shanghai', *Nan Nü*, 5, 1 (2003): 69–114.

E. J. Laing, *Selling Happiness: Calendar Posters and Visual Culture in Early Twentieth Century Shanghai* (Honolulu: University of Hawaii Press, 2004).

Hua Lan and V. Fong (eds), *Women in Republican China: A Sourcebook* (Armonk, NY: M. E. Sharpe, 1999).

W. Larson, 'The End of *Funü wenxue*: Women's Literature from 1925 to 1935', *Modern Chinese Literature*, 4 (1988): 39–54.

W. Larson, '"Never This Wild": Sexing the Cultural Revolution', *Modern China*, 25, 4 (1999): 423–56.

E. Lean, *Public Passions: The Trial of Shi Jianqiao and the Rise of Popular Sympathy in Republican China* (Berkeley: University of California Press, 2007).

Ching Kwan Lee, *China and the South China Miracle: Two Worlds of Factory Women* (Berkeley: University of California Press, 1998).

Feigon Lee, 'Gender and the Chinese Student Movement', in J. Wasserstrom and E. Perry (eds), *Popular Protest and Political Culture in Modern China* (Boulder: Westview Press, 1994, 2nd ed), pp. 125–39.

Haiyan Lee, *Revolution of the Heart: A Genealogy of Love 1900–1950* (Stanford: Stanford University Press, 2007).

L. Ou-fan Lee, *Shanghai Modern: The Flowering of a New Urban Culture in China 1930–1945* (Cambridge, MA: Harvard University Press, 1999).

L. Xiao Hong Lee and S. Wiles, *Women of the Long March* (St Leonards, NSW: Allen and Unwin, 1999).

L. Xiao Hong Lee, 'The Emergence of Buddhist Nuns in China and its Social Ramifications', in L. Xiao Hong Lee, *The Virtue of Yin: Studies on Chinese Women* (Broadway, NSW: Wild Peony, 1994), pp. 47–64.

P. Lee, 'Li Zhi and John Stuart Mill: A Confucian Feminist Critique of Liberal Feminism', in Chenyang Li (ed.), *The Sage and the Second Sex: Confucianism, Ethics and Gender* (Chicago: La Salle and Open Court, 2000), pp. 113–32.

S. Leith, 'Chinese Women in the Early Communist Movement', in M. Young (ed.), *Women in China*, pp. 47–71.

A. Ki Chi Leung, 'To Chasten Society: The Development of Widow Homes in the Qing 1773–1911', *Late Imperial China*, 14, 2 (1993): 1–32.

A. Ki Chi Leung, 'Women Practising Medicine in Pre-modern China', in H. Zurndorfer (ed.), *Chinese Women in the Imperial Past*, pp. 101–34.

M. Leutner and N. Spakowski (eds), *Women in China: The Republican Period in Historical Perspective* (Munster: Lit Verlag, 2005).

I. Lewis, *The Education of Girls in China* (New York: Teachers' College, Columbia University, 1919).

M. Lewis, *The Early Chinese Empires: Qin and Han* (Cambridge, MA: Harvard University Press, 2007).

Danke Li, *Echoes of Chongqing: Women in Wartime China* (Urbana and Chicago: University of Illinois Press, 2010).

Danke Li and Mun C. Tsang, 'Household Decisions and Gender Inequality in Education in Rural China', *China: An International Journal*, 1, 2 (2003): 224–48.

L. Li, *The Virtue of Yin: Studies on Chinese Women* (Broadway, NSW: Wild Peony, 1994).

Ruzhen Li, *Flowers in the Mirror* (London: Owen, 1965).

Yu-ning Li (ed.), *Chinese Women Through Chinese Eyes* (Armonk, NY: M. E. Sharpe, 1992).

Yu-ning Li, 'Historical Roots of Changes in Women's Status in Modern China', in Yu-ning Li (ed.), *Chinese Women Through Chinese Eyes*, pp. 103–22.

Z. Lipkin, *Useless to the State: 'Social Problems' and Social Engineering in Nationalist China 1927–1937* (Cambridge, MA: Harvard University Press, 2006).

Fei-wen Liu, 'The Confrontation Between Fidelity and Fertility: *Nüshu, Nüge* and Peasant Women's Conceptions of Widowhood in Jiangyong County, Hunan Province, China', *Journal of Asian Studies*, 60, 4 (2001): 1051–84.

L. Liu, 'Invention and Intervention: The Making of a Female Tradition in Modern Chinese Literature', in E. Widmer and D. Der-wei Wang (eds), *From May Fourth to June Fourth: Fiction and Film in Twentieth-Century China* (Cambridge, MA: Harvard University Press, 1993), pp. 194–220.

K. Louie, *Theorising Chinese Masculinity: Society and Gender in China* (Cambridge: Cambridge University Press, 2002).

D. Lowy, *The Japanese "New Woman": Images of Gender and Modernity* (New Brunswick: Rutgers University Press, 2007).

Weijing Lu, 'Uxorilocal Marriage Among Qing Literati', *Late Imperial China*, 19, 2 (1998): 64–110.

Weijing Lu, 'Beyond the Paradigm: Tea-picking Women in Imperial China', *Journal of Women's History*, 15, 4 (2004): 19–46.

Weijing Lu, *True to her Word: The Faithful Maiden Cult in Late Imperial China* (Stanford: Stanford University Press, 2008).

Weijing Lu, '"A Pearl in the Palm": A Forgotten Symbol of the Father-Daughter Bond', *Late Imperial China*, 31, 1 (2010), 62–97.

Suwen Luo, 'Gender on the Stage: Actresses in an Actors' World (1895–1930)', in B. Goodman and W. Larson (eds), *Gender in Motion*, pp. 75–95.

J. Lutz (ed.), *Pioneer Chinese Christian Women: Gender, Christianity and Social Mobility* (Bethlehem, PA: Lehigh University Press, 2010).

W. Lyell, *Lu Hsun's Vision of Reality* (Berkeley: University of California Press, 1976).

W. Lyell (trans.), *Diary of a Madman and Other Stories* (Honolulu: University of Hawaii Press, 1990).

J. McDermott, 'The Chinese Domestic Bursar', *Ajia bunka kenkyū* (Studies in Asian Culture), (1990): 15–32.

A. McElderry, 'Woman Revolutionary: Xiang Jingyu', *China Quarterly*, 105 (1986): 95–122.

S. C. McElroy, 'Forging a New Role for Women: Zhili First Women's Normal School and the Growth of Women's Education in China 1901–1921', in G. Peterson, R. Hayhoe and Y. Lu (eds), *Education, Culture and Identity in Twentieth-Century China* (Ann Arbor: University of Michigan Press, 2001), pp. 348–74.

J. McGough, 'Deviant Marriage Patterns in Chinese Society', in A. Kleinman and T. Lin (eds), *Normal and Abnormal Behaviour in Chinese Society* (Dordrecht: D. Reidel, 1981), pp. 171–200.

J. MacGowan, *How England Saved China* (London: T. Fisher Unwin, 1913).

J. McGrath, *Postsocialist Modernity: Chinese Cinema, Literature and Criticism in the Market Age* (Stanford: Stanford University Press, 2008).

T. McIntyre, 'Images of Women in Popular Prints of the Early Modern Period', in A. Finnane and A. McLaren (eds), *Dress, Sex and Text in Chinese Culture*, pp. 58–80.

L. McIsaac, '"Righteous Fraternities" and Honourable Men: Sworn Brotherhoods in Wartime Chongqing', *American Historical Review*, 105, 5 (2000): 1641–55.

A. McLaren, 'Women's Voices and Textuality: Chastity and Abduction in Chinese *Nüshu* Writing', *Modern China*, 22, 4 (1996): 382–416.

A. McLaren, 'On Researching Invisible Women: Abduction and Violation in Chinese Women's Script Writing', in A. Finnane and A. McLaren (eds), *Dress, Sex and Text in Chinese Culture*, pp. 164–79.

A. McLaren (ed.), *Chinese Women – Living and Working* (London: Routledge, 2004).

A. McLaren, (a) 'Women's Work and Ritual Space in China', in A. McLaren (ed.), *Chinese Women – Living and Working*, pp. 169–87.

A. McLaren, (b) 'The Grievance Rhetoric of Chinese Women: From Lamentation to Revolution', *Intersections*, 4 (2004): 1–18.

A. McLaren, *Performing Grief: Bridal Laments in Rural China* (Honolulu: University of Hawaii Press, 2008).

S. Mann, 'Widows in the Kinship, Class and Community Structures of Qing Dynasty China', *Journal of Asian Studies*, 46, 1 (1987): 37–55.

S. Mann, 'Grooming a Daughter for Marriage: Brides and Wives in the Mid-Ch'ing Period', in R. Watson and P. Ebrey (eds), *Marriage and Inequality in Chinese Society*, pp. 204–31.

S. Mann, (a) 'Women's Work in the Ningbo Area 1900–1936', in T. Rawski and L. Li (eds), *Chinese History in Economic Perspective* (Berkeley: University of California Press, 1992), pp. 244–71.

S. Mann, (b) '*Fuxue* [Women's Learning] by Zhang Xuecheng (1738–1801): China's First History of Women's Culture', *Late Imperial China*, 13, 1 (1992): 40–63.

S. Mann, (c) 'Household Handicrafts and State Policy in Qing Times', in J. K. Leonard and J. Watt (eds), *To Achieve Security and Wealth: The Qing Imperial State and the Economy 1644–1911* (Ithaca: East Asia Program, Cornell University, 1992), pp. 75–95.

S. Mann, (a) 'The Education of Daughters in the Mid-Ch'ing Period', in B. Elman and A. Woodside (eds), *Education and Society in Late Imperial China 1600–1900* (Berkeley: University of California Press, 1994), pp. 19–49.

S. Mann, (b) 'Learned Women in the Eighteenth Century', in C. Gilmartin, G. Hershatter, L. Rofel and T. White (eds), *Engendering China*, pp. 27–46.

S. Mann, (c) 'The Cult of Domesticity: Republican Shanghai's Middle Class', *Jindai Zhongguo funü shi yanjiu* (*Research on Women in Modern Chinese History*), 2 (1994): 179–201.

S. Mann, *Precious Records: Women in China's Long Eighteenth Century* (Stanford: Stanford University Press, 1997).

S. Mann, (a) 'Presidential Address: Myths of Asian Womanhood', *Journal of Asian Studies*, 59, 4 (2000): 835–62.

S. Mann, (b) 'Work and Household in Chinese Culture: Historical Perspectives', in B. Entwistle and G. Henderson (eds), *Re-Drawing Boundaries*, pp. 15–32.

S. Mann, (c) 'The Male Bond in Chinese History and Culture', *American Historical Review*, 105, 5 (2000): 1600–14.

S. Mann, 'The Virtue of Travel for Women in the Late Empire', in B. Goodman and W. Larson (eds), *Gender in Motion*, pp. 55–73.

S. Mann, *The Talented Women of the Zhang Family* (Berkeley: University of California Press, 2007).

S. Mann, 'Why Women Were Not a Problem in Nineteenth-Century Chinese Thought', in C. Wing-chung Ho (ed.), *Windows on the Chinese World: Reflections by Five Historians* (Lanham: Lexington Books, 2009), pp. 113–28.

K. Manning, (a) 'The Gendered Politics of Woman-Work: Rethinking Radicalism in the Great Leap Forward', *Modern China*, 32, 3 (2006): 349–84.

K. Manning, (b) 'Making a Great Leap Forward? The Politics of Women's Liberation in Maoist China', *Gender and History*, 18, 3 (2006): 574–93.

K. Manning, 'Communes, Canteens and Crèches: The Gendered Politics of Remembering the Great Leap Forward', in Ching Kwan Lee and Guobin Yang (eds), *Re-envisioning the Chinese Revolution: The Politics and Poetics of Collective Memories in Reform China* (Stanford: Stanford University Press, 2007), pp. 93–118.

E. Martin, 'Gender and Ideological Differences in Representations of Life and Death', in J. Watson and E. Rawski (eds), *Death Ritual in Imperial China* (Berkeley: University of California Press, 1988), pp. 164–79.

M. Meijer, *Marriage Law and Policy in the Chinese People's Republic* (Hong Kong: University of Hong Kong Press, 1971).

M. Meijer, 'Marriage Law and Policy in the PRC', in D. Buxbaum (ed.), *Chinese Family Law and Social Change in Historical and Comparative Perspective* (Seattle: University of Washington Press, 1978), pp. 440–65.

M. Meijer, 'Legislation on Marriage and Family in the Chinese Soviet Republic', in W. Butler (ed.), *Legal System of the Chinese Soviet Republic 1931–1934* (Dobbs Ferry, NY: Transnational Publishers, 1983), pp. 95–106.

E. Menegon, 'Child Bodies, Blessed Bodies: The Contest between Christian Virginity and Confucian Chastity', *Nan Nü*, 6, 2 (2004): 177–240.

E. Menegon, *Ancestors, Virgins and Friars: Christianity as Local Religion in Late Imperial China* (Cambridge, MA: Harvard University Press, 2009).

C. Milwertz and Bu Wei, 'Non-Governmental Organizing for Gender Equality in China: Joining a Global Emancipatory Epistemic Community', *International Journal of Human Rights*, 11, 1–2 (2007): 131–49.

Anchee Min, *Red Azalea* (London: Victor Gollancz, 1993).

B. Mittler, 'In Spite of Gentility: Women and Men in *Linglong* (Elegance), a 1930s Magazine', in D. Berg and C. Starr (eds), *The Quest for Gentility in China: Negotiations Beyond Gender and Space* (Abingdon: Routledge, 2007), pp. 208–34.

S. Mou, *Gentlemen's Prescriptions for Women's Lives: A Thousand Years of Biographies of Chinese Women* (Armonk, NY: M. E. Sharpe, 2004).

D. Mungello, *Drowning Girls in China: Female Infanticide in China since 1650* (Lanham: Rowman and Littlefield, 2008).

D. Murray, *Pirates of the South China Coast 1790–1810* (Stanford: Stanford University Press, 1987).

J. Ng and J. Wickeri (eds), *May Fourth Women Writers: Memoirs* (Hong Kong: Research Centre for Translation, Chinese University of Hong Kong, 1996).

J. Ng, *The Experience of Modernity: Chinese Autobiography of the Early Twentieth Century* (Ann Arbor: University of Michigan Press, 2003).

H. B. Nielsen, 'The Three Father Figures in Tian Zhuangzhuang's Film, *The Blue Kite:* The Emasculation of Males by the Communist Party', *China Information*, 13, 4 (1999): 83–96.

J. Nivard, 'Women and the Women's Press: The Case of the *Ladies Journal* 1915–1931', *Republican China*, 10, 1b (1984): 37–55.

S. Nolte and S. Hastings, 'The Meiji State's Policy Toward Women 1890–1910', in G. L. Bernstein (ed.), *Recreating Japanese Women 1600–1945* (Berkeley: University of California Press, 1991), pp. 151–74.

B. Notar, 'Blood Money: Women's Desire and Consumption in *Ermo*', *Asian Cinema*, 12, 2 (2001): 132–53.

J. Ocko, 'Women, Property and Law in the People's Republic of China', in R. Watson and P. Ebrey (eds), *Marriage and Inequality in Chinese Society*, pp. 313–46.

K. Ono, *Chinese Women in a Century of Revolution 1850–1950* (Stanford: Stanford University Press, 1989).

E. Otis, *Markets and Bodies: Women, Service Work and the Making of Inequality in China* (Stanford: Stanford University Press, 2011).

D. Ownby, 'Approximations of Chinese Bandits: Perverse Rebels, Romantic Heroes or Frustrated Bachelors?', in S. Brownell and J. Wasserstrom (eds), *Chinese Femininities, Chinese Masculinities*, pp. 226–50.

P. Paderni, 'Between Constraints and Opportunities: Widows, Witches and Shrews in Eighteenth-Century China', in H. Zurndorfer (ed.), *Chinese Women in the Imperial Past*, pp. 258–85.

Yihong Pan, 'Zhao Ruiqin: A Peasant Woman in Gansu and Domestic Work in Beijing', in K. Hammond and K. Stapleton (eds), *The Human Tradition in Modern China* (Lanham: Rowman and Littlefield, 2008), pp. 177–93.

Laikwan Pang, 'Photography, Performance and the Making of Female Images in Modern China', *Journal of Women's History*, 17, 4 (2005): 56–85.

Laikwan Pang, *The Distorting Mirror: Visual Modernity in China* (Honolulu: University of Hawaii Press, 2007).

W. Parish and M. K. Whyte, *Village and Family in Contemporary China* (Chicago: University of Chicago Press, 1978).

P. Perdue, 'Nature and Nurture on Imperial China's Frontiers', *Modern Asian Studies*, 43, 1 (2009): 245–67.

E. Perry, 'Strikes Among Shanghai Silk Weavers 1927–1937: The Awakening of a Labor Aristocracy', in F. Wakeman and Wen-hsinYeh (eds), *Shanghai Sojourners* (Berkeley: Institute of East Asian Studies, University of California, 1992), pp. 305–42.

E. Perry, *Shanghai on Strike: The Politics of Chinese Labor* (Stanford: Stanford University Press, 1993).

P. Pickowicz, 'The Theme of Spiritual Pollution in Chinese Films of the 1930s', *Modern China*, 17, 1 (1991): 38–75.

K. Pomeranz, 'Power, Gender and Pluralism in the Cult of the Goddess of Taishan', in T. Huters, R. Bin Wong and P. Yu (eds), *Culture and State in Chinese Society: Conventions, Accommodations and Critiques* (Stanford: Stanford University Press, 1997), pp. 182–204.

K. Pomeranz, 'Women's Work and the Economics of Respectability', in B. Goodman and W. Larson (eds), *Gender in Motion*, pp. 239–59.

R. Prazniak, 'Weavers and Sorceresses of Chuansha: The Social Origins of Political Activism Among Rural Chinese Women', *Modern China*, 12, 2 (1986): 201–29.

R. Prazniak, *Of Camel Kings and Other Things: Rural Rebels Against Modernity in Late Imperial China* (Lanham: Rowman and Littlefield, 1999).

J. Price, 'Women and Leadership in the Chinese Communist Movement 1921–1945', *Bulletin of Concerned Asian Scholars*, 7, 1 (1975): 19–24.

I. Pruitt, *A Daughter of Han: The Autobiography of a Chinese Working Woman* (Stanford: Stanford University Press, 1967).

Ngai Pun, 'Becoming *Dagongmei:* The Politics of Identity and Difference in Reform China', *The China Journal*, 42 (1999): 1–18.

Ngai Pun, *Made in China: Women Factory Workers in a Global Workplace* (Durham, NC: Duke University Press, 2005).

Nanxiu Qian, 'Revitalizing the *Xianyuan* (Worthy ladies) Tradition: Women in the 1898 Reforms', *Modern China*, 29, 4 (2003): 399–454.

Nanxiu Qian, '"Borrowing Foreign Mirrors and Candles to Illuminate Chinese Civilization": Xue Shaohui's Moral Vision in the *Biographies of Foreign Women*', *Nan Nü*, 6, 1 (2004): 60–101.

S. Rai, '"Watering Another Man's Garden": Gender, Employment and Educational Reforms in China', in S. Rai, H. Pilkington and A. Phizacklea (eds), *Women in the Face of Change: The Soviet Union, Eastern Europe and China* (London: Routledge, 1992), pp. 20–39.

M. Rankin, 'The Emergence of Women at the End of the Ch'ing: The Case of Ch'iu Chin', in M. Wolf and R. Witke (eds), *Women in Chinese Society*, pp. 39–66.

L. Raphals, *Sharing the Light: Representations of Women and Virtue in Early China* (Albany: State University of New York Press, 1998).

E. Remick, 'Prostitution Taxes and Local State Building in Republican China', *Modern China*, 29, 1 (2003): 38–70.

J. Riordan and Jinxia Dong, 'Chinese Women and Sport Success, Sexuality and Suspicion', *China Quarterly*, 145 (1996): 130–52.

C. Roberts (ed.), *Evolution and Revolution: Chinese Dress 1700s-1990s* (Sydney: Powerhouse Publishing, 1997).

R. Roberts, 'Gendering the Revolutionary Body: Theatrical Costume in Cultural Revolution China', *Asian Studies Review*, 10 (2006): 141–59.

R. Roberts, *Maoist Model Theatre: The Semiotics of Gender and Sexuality in the Chinese Cultural Revolution* (Leiden: Brill, 2010).

J. Robinson, 'Of Women and Washing Machines: Employment, Housework and the Reproduction of Motherhood in Socialist China', *China Quarterly*, 101 (1985): 32–57.

L. Rofel, '*Yearnings*: Televisual Love and Melodramatic Politics', *American Ethnologist*, 21, 4 (1995): 700–22.

L. Rofel, *Other Modernities: Gendered Yearnings in China After Socialism* (Berkeley: University of California Press, 1999).

L. Rofel, *Desiring China: Experiments in Neo-Liberalism, Sexuality and Public Culture* (Durham, NC: Duke University Press, 2007).

R. Rogaski, 'Beyond Benevolence: A Confucian Women's Shelter in Treaty-Port China', *Journal of Women's History*, 8, 4 (1997): 54–90.

P. Ropp, 'The Seeds of Change: Reflections on the Condition of Women in the Early and Mid-Ch'ing', *Signs*, 2, 1 (1976): 5–23.

P. Ropp, *Dissent in Early Modern China: Ju-lin Wai-shih and Ch'ing Social Criticism* (Ann Arbor: University of Michigan Press, 1981).

P. Ropp, 'Women in Late Imperial China: A Review of Recent English-Language Scholarship', in *Women's History Review*, 3, 3 (1994): 347–83.

P. Ropp, 'Ambiguous Images of Courtesan Culture in Late Imperial China', in E. Widmer and Kang-I Sun Chang (eds), *Writing Women in Late Imperial China* (Stanford University Press, 1997), pp. 17–45.

P. Ropp, 'Passionate Women: Female Suicide in Late Imperial China—Introduction', in P. Ropp, P. Zamperini and H. Zurndorfer (eds), *Passionate Women: Female Suicide in Late Imperial China* (Brill: Leiden, 2001), pp. 3–21.

P. Ropp, P. Zamperini and H. Zurndorfer (eds), *Passionate Women: Female Suicide in Late Imperial China* (Leiden: Brill, 2001).

S. Rosen, 'Women, Education and Modernization', in R. Hayhoe (ed.), *Education and Modernization: The Chinese Experience* (New York: Pergamon Press, 1992), pp. 255–84.

S. Rosen, 'Women and Political Participation in China', *Pacific Affairs*, 68, 3 (1995): 315–41.

H. Ross, '"Cradle of Female Talent": The McTyeire Home and School for Girls', in D. Bays (ed.), *Christianity in China: From the Eighteenth Century to the Present* (Stanford: Stanford University Press, 1996), pp. 209–27.

W. Rothman, '*The Goddess*: Reflections on Melodrama East and West', in W. Dissanayake (ed.), *Melodrama and Asian Cinema* (Cambridge: Cambridge University Press, 1993), pp. 59–72.

A. Roux, 'La "Tragédie du 2 Février 1948" à la Shenxin no 9: une grève des femmes?', in M.-C. Bergère (ed.), *Aux origines de la Chine contemporaine* (Paris: L'Harmattan, 2002), pp. 47–81.

W. Rowe, 'Women and the Family in Mid-Qing Social Thought: The Case of Chen Hongmou', *Late Imperial China*, 13, 2 (1992): 1–41.

W. Rowe, *Crimson Rain: Seven Centuries of Violence in a Chinese County* (Stanford: Stanford University Press, 2007).

Tze-lan D. Sang, 'Feminism's Double: Lesbian Activism in the Mediated Public Sphere of Taiwan', in M. Mei-hui Yang (ed.), *Spaces of Their Own*, pp. 132–61.

Tze-lan D. Sang, *The Emerging Lesbian: Female Same-Sex Desire in Modern China* (Chicago: University of Chicago Press, 2003).

Tze-lan D. Sang, 'Failed Modern Girls in Early Twentieth Century China', in D. Croissant, C. Yeh and J. Mostow (eds), *Performing "Nation": Gender Politics in Literature, Theater and the Visual Arts of China and Japan* (Leiden: Brill, 2008), pp. 179–204.

P. S. Sangren, 'Female Gender in Chinese Religious Symbols: Kuan Yin, Ma Tsu, and the "Eternal Mother"', *Signs*, 9, 1 (1983): 4–25.

S. Sargeson, 'Building the Future Family', in A. McLaren (ed.), *Chinese Women – Living and Working*, pp. 149–68.

L. Schein, 'Multiple Alterities: The Contouring of Gender in Miao and Chinese Nationalism', in B. Williams (ed.), *Women Out of Place: The Gender of Race and the Race of Nationality* (London: Routledge, 1996), pp. 79–102.

L. Schein, 'Gender and Internal Orientalism in China', *Modern China*, 23, 1 (1997): 69–98.

L. Schein, *Minority Rules: The Miao and the Feminine in China's Cultural Politics* (Durham, NC: Duke University Press, 2000).

L. Schein, 'Ethnoconsumerism as Cultural Production? Making Space for Miao Style', in Jing Wang (ed.), *Locating China: Space, Place and Popular Culture* (London: Routledge, 2005), pp. 150–70.

J. Schmidt, 'Yuan Mei (1716–1798) on Women', *Late Imperial China*, 29, 2 (2008), pp. 129–85.

H. Schneider, 'The Professionalization of Chinese Domesticity: Ava B. Milam and Home Economics at Yenching University', in D. Bays and E. Widmer (eds), *China's Christian Colleges: Cross-Cultural Connections 1900–1950* (Stanford: Stanford University Press, 2009), pp. 125–46.

H. Schneider, *Keeping the Nation's House: Domestic Management and the Making of Modern China* (Vancouver: UBC Press, 2011).

S. Schram (ed.), *Mao's Road to Power: Revolutionary Writings 1912–1949, vol. 1* (Armonk, NY: M. E. Sharpe, 1992).

R. Shek and T. Noguchi, 'Eternal Mother Religion: Its History and Ethics', in Kwang-ching Liu and R. Shek (eds), *Heterodoxy in Late Imperial China* (Honolulu: University of Hawaii Press, 2004), pp. 241–80.

C. Shemo, '"How Better to Serve Her Country?" Cultural Translators, US Women's History, and Kang Cheng's "An Amazon in Cathay"', *Journal of Women's History*, 21, 4 (2009): 111–33.

C. Shemo, '"To Develop Native Powers": Shi Meiyu and the Danforth Hospital Nursing School 1903–1920', in J. Lutz (ed.), *Pioneer Chinese Christian Women*, pp. 292–315.

M. Sheridan, 'Young Women Leaders in China', *Signs*, 2, 1 (1976): 59–88.

Shu-mei Shih, 'Gender, Race and Semicolonialism: Liu Na'ou's Urban Shanghai Landscape', *Journal of Asian Studies*, 55, 4 (1996): 934–56.

D. Shimer (ed.), *Rice Bowl Women: Writings By and About the Women of China and Japan* (New York: New American Library, 1982).

S. Sievers, *Flowers in Salt: The Beginnings of Feminist Consciousness in Modern Japan* (Stanford: Stanford University Press, 1983).

C. Silber, 'From Daughter to Daughter-in-Law in the Women's Script of Southern Hunan', in C. Gilmartin, G. Hershatter, L. Rofel and T. White (eds), *Engendering China*, pp. 47–68.

H. Siu, 'Where Were the Women? Rethinking Marriage Resistance and Regional Culture in South China', *Late Imperial China*, 11, 2 (1990): 32–62.

N. Smith, *Resisting Manchukuo: Chinese Women Writers and the Japanese Occupation* (Vancouver: University of British Columbia Press, 2007).

S. Smith, 'Class and Gender: Women's Strikes in St. Petersburg 1895–1917 and in Shanghai 1895–1927', *Social History*, 19, 2 (1994): 141–68.

S. Smith, *Like Cattle and Horses: Nationalism and Labor in Shanghai 1895–1927* (Durham, NC: Duke University Press, 2002).

D. Solinger, *Contesting Citizenship in Urban China: Peasant Migrants, the State and the Logic of the Market* (New York: Columbia University Press, 1999).

M. Sommer, 'The Uses of Chastity: Sex, Law and the Property of Widows in Qing China', *Late Imperial China*, 17, 2 (1996): 77–130.

M. Sommer, *Sex, Law and Society in Late Imperial China* (Stanford: Stanford University Press, 2000).

M. Sommer, 'Dangerous Males, Vulnerable Males and Polluted Males: The Regulation of Masculinity in Qing Dynasty Law', in S. Brownell and J. Wasserstrom (eds), *Chinese Femininities, Chinese Masculinities*, pp. 67–88.

M. Sommer, 'Making Sex Work: Polyandry as a Survival Strategy in Qing Dynasty China', in B. Goodman and W. Larson (eds), *Gender in Motion*, pp. 29–54.

Geng Song, *Fragile Scholar: Power and Masculinity in Chinese Culture* (Hong Kong: University of Hong Kong Press, 2004).

Geng Song, 'Chinese Masculinities Revisited: Male Images in Contemporary Television Drama Serials', *Modern China*, 36, 4 (2010): 404–34.

N. Spakowski, 'Women's Military Participation in the Communist Movement of the 1930s and 1940s: Patterns of Inclusion and Exclusion', in M. Leutner and N. Spakowski (eds), *Women in China*, pp. 129–171.

J. Spence, *The Death of Woman Wang* (London: Weidenfeld and Nicholson, 1978).

J. Spence, *The Gate of Heavenly Peace: The Chinese and Their Revolutions 1895–1980* (Harmondsworth: Penguin, 1982).

J. Stacey, 'When Patriarchy Kowtows: The Significance of the Chinese Family Revolution for Feminist Theory', *Feminist Studies*, 2, 2/3 (1975): 64–112.

J. Stacey, *Patriarchy and Socialist Revolution in China* (Berkeley: University of California Press, 1983).

K. Stapleton, 'Hu Lanqi: Rebellious Woman, Revolutionary Soldier, Discarded Heroine and Triumphant Survivor', in K. Hammond and K. Stapleton (eds), *The Human Tradition in Modern China* (Lanham: Rowman and Littlefield, 2008), pp. 157–76.

S. Stevens, 'Figuring Modernity: The New Woman and the Modern Girl in Republican China', *NWSA Journal*, 16, 3 (2003): 82–103.

S. Stevens, 'Hygienic Bodies and Public Mothers: The Rhetoric of Reproduction, Fetal Education and Childhood in Republican China', in M. Lackner and N. Vittinghoff (eds), *Mapping Meanings: The Field of New Learning in Late Qing China* (Leiden: Brill, 2004), pp. 659–80.

J. Stockard, *Daughters of the Canton Delta: Marriage Patterns and Economic Strategies in South China 1860–1930* (Stanford: Stanford University Press, 1989).

P. Stranahan, (a) *Yanan Women and the Communist Party* (Berkeley: Center for Chinese Studies, 1983).

P. Stranahan, (b) 'Labor Heroines of Yanan', *Modern China*, 9, 2 (1983): 228–52.

D. Strand, 'Citizens in the Audience and at the Podium', in M. Goldman and E. Perry (eds), *Changing Meanings of Citizenship in Modern China* (Cambridge, MA: Harvard University Press, 2002), pp. 44–69.

D. Strand, *An Unfinished Republic: Leading by Word and Deed* (Berkeley: University of California Press, 2011).

A. Strong, *China's Millions* (New York: Coward-McCann, 1928).

Wanning Sun, 'The Maid in China: Opportunities, Challenges and the Story of Being Modern', in A. McLaren (ed.), *Chinese Women – Living and Working*, pp. 65–82.

Wanning Sun, *Maid in China: Media, Morality and the Cultural Politics of Boundaries* (London: Routledge, 2009).

N. Yin-yin Szeto, 'Cheungsam: Fashion, Culture and Gender', in C. Roberts (ed.), *Evolution and Revolution*, pp. 54–64.

Xiaobing Tang, 'Rural Women and Social Change in New Chinese Cinema: From *Li Shuangshuang* to *Ermo*', *positions* 11, 3 (2003): 647–74.

Jinhua E. Teng, 'The Construction of the "Traditional Chinese Woman" in the Western Academy: A Critical Review', *Signs*, 22, 1 (1996): 115–51.

Ying-ch'ao Teng, 'Remembrances of the May Fourth Movement', in Yu-ning Li (ed.), *Chinese Women Through Chinese Eyes*, pp. 144–55.

S. Teo, *King Hu's A Touch of Zen* (Hong Kong: University of Hong Kong Press, 2007).

R. Terrill, *Madame Mao: The White-Boned Demon* (Stanford: Stanford University Press, 1999).

J. Theiss, 'Managing Martyrdom: Female Suicide and Statecraft in Mid-Qing China', in P. Ropp, P. Zamperini and H .Zurndorfer (eds), *Passionate Women: Female Suicide in Late Imperial China* (Leiden: Brill, 2001), pp. 47–76.

J. Theiss, 'Femininity in Flux: Gendered Virtue and Social Conflict in the Mid-Qing Courtroom', in S. Brownell and J. Wasserstrom (eds), *Chinese Femininities, Chinese Masculinities*, pp. 47–66.

J. Theiss, (a) *Disgraceful Matters: The Politics of Chastity in Eighteenth-Century China* (Berkeley: University of California Press, 2004).

J. Theiss, (b) 'Female Suicide, Subjectivity and the State in Eighteenth-Century China', *Gender and History*, 16, 3 (2004): 513–37.

J. Theiss, 'Explaining the Shrew: Narratives of Spousal Violence and the Critique of Masculinity in Eighteenth-Century Court Cases', in R. Hegel and K. Carlitz (eds), *Law and Writing in Late Imperial China* (Seattle: University of Washington Press, 2007), pp. 44–63.

L. Thompson (trans.), *Ta-T'ung Shu: The One-World Philosophy of K'ang Yu-wei* (London: Allen and Unwin, 1958).

S. Thurin, 'Travel Writing and the Humanitarian Impulse: Alicia Little in China', in D. Kerr and J. Kuehn (eds), *A Century of Travels in China: Critical Essays on Travel Writing from the 1840s to 1940s* (Hong Kong: Hong Kong University Press, 2007), pp. 91–103.

R. G. Tiedemann, 'Controlling the Virgins: Female Propagators of the Faith and Catholic Hierarchy in China', *Women's History Review*, 17, 4 (2008): 501–20.

R. G. Tiedemann, 'A Necessary Evil: The Contribution of Chinese "Virgins" to the Growth of the Catholic Church in Late Qing China', in J. Lutz (ed.), *Pioneer Chinese Christian Women*, pp. 87–101.

M. Topley, 'Marriage Resistance in Rural Kwangtung', in M. Wolf and R. Witke (eds), *Women in Chinese Society*, pp. 67–88.

L. Tran, 'Sex and Equality in Republican China: The Debate Over the Adultery Law', *Modern China*, 35, 2 (2009): 191–223.

E. P. Tsurumi, *Factory Girls: Women in the Thread Mills of Meiji Japan* (Princeton: Princeton University Press, 1990).

K. Tulliver, 'Sophia Chen Zen and Westernized Chinese Feminism', *Journal of Chinese Overseas*, 4, 2 (2008): 258–74.

K. Uno, 'Women and Changes in the Household Division of Labor', in G. Lee Bernstein (ed.), *Recreating Japanese Women 1600–1945* (Berkeley: University of California Press, 1991), pp. 17–41.

C. von Collani, 'Lady Candida Xu: A Widow Between Chinese and Christian Ideals', in J. Lutz (ed.), *Pioneer Chinese Christian Women*, pp. 224–46.

K. Le Mons Walker, 'The Party and Peasant Women', in P. Huang, L. Bell and K. Le Mons Walker (eds), *Chinese Communists and Rural Society 1927–1934* (Berkeley: Center for Chinese Studies, University of California, 1978), pp. 57–81.

K. Le Mons Walker, 'Economic Growth, Peasant Marginalization and the Sexual Division of Labor in Early twentieth Century China', *Modern China*, 19, 3 (1993): 354–86.

K. Le Mons Walker, *Chinese Modernity and the Peasant Path: Semicolonialism in the Northern Yangzi Delta* (Stanford: Stanford University Press, 1999).

Di Wang, 'Street Culture: Public Space and Urban Commoners in Late Qing Chengdu', *Modern China*, 24, 1 (1998): 34–72.

Di Wang, *The Teahouse: Small Business, Everyday Culture and Public Politics in Chengdu 1900–1950* (Stanford: Stanford University Press, 2008).

Jing Wang, *When "I" Was Born: Women's Autobiography in Modern China* (Madison: University of Wisconsin Press, 2008).

Lingzhen Wang, *Personal Matters: Women's Autobiographical Practice in Twentieth-Century China* (Stanford: Stanford University Press, 2004).

Shuo Wang, 'Der Ling: Manchu Princess', in K. Hammond and K. Stapleton (eds), *The Human Tradition in Modern China* (Lanham: Rowman and Littlefield, 2008), pp. 73–92.

Yuk-lin R. Wang, 'Dispersing the "Public" and the "Private": Gender and the State in the Birth Planning Policy of China', *Gender and Society*, 11, 4 (1997): 509–25.

Zheng Wang, 'Maoism, Feminism and the UN Conference on Women: Women's Studies Research in Contemporary China', *Journal of Women's History*, 8, 4 (1997): 126–52.

Zheng Wang, *Women in the Chinese Enlightenment: Oral and Textual Histories* (Berkeley: University of California Press, 1999).

Zheng Wang, 'Gender, Employment and Women's Resistance', in E. Perry and M. Selden (eds), *Chinese Society: Change, Conflict and Resistance* (London: Routledge, 2000, 2nd ed.), pp. 62–82.

Zheng Wang, (a) 'State Feminism? Gender and Socialist State Formation in Maoist China', *Feminist Studies*, 31, 3 (2005): 519–51.

Zheng Wang, (b) 'Gender and Maoist Urban Reorganization', in B. Goodman and W. Larson (eds), *Gender in Motion*, pp. 189–209.

Zheng Wang, 'Dilemmas of Inside Agitators: Chinese State Feminists in 1957', in J. Strauss (ed.), *The History of the PRC (1949–1976)* (Cambridge: Cambridge University Press, 2007), pp. 59–78.

J. Wasserstrom, 'Resistance to the One-Child Family', *Modern China*, 10, 3 (1984): 345–74.

J. Watson, 'Standardizing the Gods: The Promotion of T'ien-Hou (Empress of Heaven) on the South China Coast 960–1960', in D. Johnson, E. Rawski and A. Nathan (eds), *Popular Culture in Late Imperial China* (Berkeley: University of California Press, 1985), pp. 292–324.

R. Watson, 'The Named and the Nameless: Gender and Person in Chinese Society', *American Ethnologist*, 13, 4 (1986): 619–31.

R. Watson, 'Wives, Concubines and Maids: Servitude and Kinship in the Hong Kong Region 1900–1940', in R. Watson and P. Ebrey (eds), *Marriage and Inequality in Chinese Society*, pp. 231–55.

R. Watson, 'Girls' Houses and Working Women: Expressive Culture in the Pearl River Delta 1900–1941', in M. Jaschok and S. Miers (eds), *Women and Chinese Patriarchy*, pp. 25–44.

R. Watson and P. Ebrey (eds), *Marriage and Inequality in Chinese Society* (Berkeley: University of California Press, 1991).

M. Weidner, (a) 'Introduction: Images and Realities', in M. Weidner (ed.), *Flowering in the Shadows: Women in the History of Chinese and Japanese Painting* (Honolulu: University of Hawaii Press, 1990), pp. 1–24.

M. Weidner, (b) 'The Conventional Success of Ch'en Shu', in M. Weidner (ed.), *Flowering in the Shadows: Women in the History of Chinese and Japanese Painting*, pp. 123–56.

S. White, 'Fame and Sacrifice: The Gendered Construction of Naxi Identities', *Modern China*, 23, 3 (1997): 298–327.

T. White, 'Implementing the "One Child per Couple" Population Program in Rural China: National Goods and Local Politics', in D. Lampton (ed.), *Policy Implementation in Post-Mao China* (Berkeley: University of California Press, 1987), pp. 284–317.

T. White, 'The Origins of China's Birth Planning Policy', in C. Gilmartin, G. Hershatter, L. Rofel and T. White (eds), *Engendering China*, pp. 250–78.

T. White, *China's Longest Campaign: Birth Planning in the People's Republic of China 1949–2005* (Ithaca: Cornell University Press, 2006).

T. White, 'Domination, Resistance and Accommodation in China's One Child Campaign', in E. Perry and M. Selden (eds), *Chinese Society: Change, Conflict and Resistance* (London: Routledge, 2010, 3rd ed.), pp. 171–96.

E. Widmer, 'The Epistolary World of Female Talent in Seventeenth-Century China', *Late Imperial China*, 10, 2 (1989): 1–43.

E. Widmer, 'Considering a Coincidence: The "Female Reading Public" circa 1828', in J. Zeitlin and L. Liu (eds), *Writing and Materiality in China* (Cambridge, MA: Harvard University Press, 2003), pp. 273–314.

E. Widmer, (a) *Beauty and the Book: Women and Fiction in Nineteenth-Century China* (Cambridge, MA: Harvard University Press, 2006).

E. Widmer, (b) 'Foreign Travel Through a Woman's Eyes: Shan Shili's *Guimao lüxing ji* in Local and Global Perspective', *Journal of Asian Studies*, 65, 4 (2006): 763–91.

E. Widmer, 'Gentility in Transition: Travels, Novels and the New *Guixiu*', in D. Berg and C. Starr (eds), *The Quest for Gentility in China: Negotiations Beyond Gender and Class* (Abingdon: Routledge, 2007), pp. 21–44.

V. Wilson, 'Dressing for Leadership in China: Wives and Husbands in an Age of Revolutions (1911–1976)', *Gender and History*, 14, 3 (2002): 608–28.

R. Witke, 'Mao Tse-tung, Women and Suicide in the May Fourth Era', *China Quarterly*, 31 (1967): 128–47.

R. Witke, 'The Transformation of Attitudes Towards Women During the May Fourth Era of Modern China' (PhD Thesis: University of California, 1970).

R. Witke, 'Wu Kuei-hsien: Labour Heroine to Vice Premier', *China Quarterly*, 64 (1975): 730–41.

R. Witke, *Comrade Chiang Ch'ing* (London: Weidenfeld and Nicolson, 1977).

A. Wolf, 'Gods, Ghosts and Ancestors', in A. Wolf (ed.), *Religion and Ritual in Chinese Society* (Stanford: Stanford University Press, 1974), pp. 131–67.

A. Wolf and Chieh-shan Huang, *Marriage and Adoption in China 1845–1895* (Stanford: Stanford University Press, 1980).

M. Wolf, *Women and the Family in Rural Taiwan* (Stanford: Stanford University Press, 1972).

M. Wolf, 'Chinese Women: Old Skills in a New Context', in M. Rosaldo and L. Lamphere (eds), *Women, Culture and Society* (Stanford: Stanford University Press, 1974), pp. 157–72.

M. Wolf, 'Women and Suicide in China', in M. Wolf and R. Witke (eds), *Women in Chinese Society*, pp. 111–42.

M. Wolf, 'Marriage, the Family and the State in Contemporary China', *Pacific Affairs*, 57 (1984): 213–36.

M. Wolf, *Revolution Postponed: Women in Contemporary China* (Stanford: Stanford University Press, 1985).

M. Wolf and R. Witke (eds), *Women in Chinese Society* (Stanford: Stanford University Press, 1975).

M. Woo, 'Chinese Women Workers: The Delicate Balance Between Protection and Equality', in C. Gilmartin, G. Hershatter, L. Rofel and T. White (eds), *Engendering China*, pp. 279–98.

M. Woo, 'Law and the Gendered Citizen', in M. Goldman and E. Perry (eds), *Changing Meanings of Citizenship in Modern China* (Cambridge, MA: Harvard University Press, 2002), pp. 308–29.

Pei-yu Wu, 'Education of Children in the Sung', in W. de Bary and J. Chaffee (eds), *Neo-Confucian Education: The Formative Stage* (Berkeley: University of California Press, 1989), pp. 307–24.

Shengjing Wu, 'Gendering the Nation: The Proliferation of Images of Zhen Fei (1876–1900) and Sai Jinhua (1872–1936) in Late Qing and Republican China', *Nan Nü*, 11, 1 (2009): 1–64.

Yenna Wu, *The Chinese Virago: A Literary Theme* (Cambridge, MA: Harvard University Press, 1995).

C. Wylie, 'Femininity and Authority: Women in China's Private Sector', in A. McLaren (ed.), *Chinese Women – Living and Working*, pp. 42–64.

Bingying Xie (L. Brissman and B. Brissman, trans.), *A Woman Soldier's Own Story* (New York: Columbia University Press, 2001).

Hairong Yan, *New Masters, New Servants: Migration, Development and Women Workers in China* (Durham, NC: Duke University Press, 2008).

Yunxiang Yan, 'Courtship, Love and Premarital Sex in a North China Village', *The China Journal*, 48 (2002): 29–53.

Yunxiang Yan, *Private Life Under Socialism: Love, Intimacy and Change in a Chinese Village* (Stanford: Stanford University Press, 2003).

Chao Bu-wei Yang, *Autobiography of a Chinese Woman* (Westport, CT: Greenwood Press, 1970).

C. K. Yang, *Chinese Communist Society: The Family and the Village* (Cambridge, MA: MIT Press, 1959).

M. Mei-Hui Yang (ed.), *Spaces of Their Own: Women's Public Sphere in Transnational China* (Minneapolis: University of Minnesota Press, 1999).

M. Mei-Hui Yang, 'Introduction', in M. Mei-Hui Yang (ed.), *Spaces of Their Own*, pp. 1–34.

M. Mei-Hui Yang, 'From Gender Erasure to Gender Difference: State Feminism, Consumer Sexuality, and Women's Public Sphere in China', in M. Mei-Hui Yang (ed.), *Spaces of Their Own*, pp. 35–67.

Rae Yang, *Spider Eaters: A Memoir* (Berkeley: University of California Press, 1997).

Weili Ye, '*Nü liuxuesheng*: The Story of American-Educated Chinese Women 1880s-1920s', *Modern China*, 20, 3 (1994): 315–46.

Weili Ye, *Seeking Modernity in China's Name: Chinese Students in the United States 1900–1927* (Stanford: Stanford University Press, 2001).

Zhiling Ye, '*Zishu nü*: Dutiful Daughters of the Guangdong Delta', *Intersections*, 17 (2008).

C. Vance Yeh, 'Creating the Urban Beauty: The Shanghai Courtesan in Late Qing Illustrations', in J. Zeitlin and L. Liu (eds), *Writing and Materiality in China* (Cambridge, MA: Harvard University Press, 2003), pp. 397–447.

C. Vance Yeh, 'Playing to the Public: Late Qing Courtesans and their Opera Singer Lovers', in B. Goodman and W. Larson (eds), *Gender in Motion*, pp. 145–68.

C. Vance Yeh, *Shanghai Love: Courtesans, Intellectuals and Entertainment Culture* (Seattle: University of Washington Press, 2006).

Wen-hsin Yeh, *Shanghai Splendor: Economic Sentiments and the Making of Modern China 1843–1949* (Berkeley: University of California Press, 2007).

Hsiao-pei Yen, 'Body Politics, Modernity and National Salvation: The Modern Girl and the New Life Movement', *Asian Studies Review*, 29 (2005): 165–86.

A. Sau-chu Yeung, 'Fornication in the Late Qing Reforms: Moral Teachings and Legal Principles', *Modern China*, 29, 3 (2003): 297–328.

M. Young (ed.), *Women in China: Studies in Social Change and Feminism* (Ann Arbor: Center for Chinese Studies, University of Michigan, 1973).

M. Young, 'Chicken Little in China: Some Reflections on Women', in A. Dirlik and M. Meisner (eds), *Marxism and the Chinese Experience* (Armonk, NY: M. E. Sharpe, 1989), pp. 253–68.

Luojin Yu, *A Chinese Winter's Tale: An Autobiographical Fragment* (Hong Kong: Center for Translation Studies, Chinese University of Hong Kong, 1986).

P. Zamperini, 'Untamed Hearts: Eros and Suicide in Late Imperial Chinese Fiction', in P. Ropp, P. Zamperini and H. Zurndorfer (eds), *Passionate Women: Female Suicide in Late Imperial China* (Leiden: Brill, 2001), pp. 77–104.

P. Zarrow, 'He Zhen and Anarcho-Feminism in China', *Journal of Asian Studies*, 47, 4 (1988), pp. 796–813.

J. Zeitlin, *The Phantom Heroine: Ghosts and Gender in Seventeenth-Century Chinese Literature* (Honolulu: University of Hawaii Press, 2007).

Weiguo Zhang, '"A Married Daughter is Like Spilt Water": Women's Increasing Contacts and Enhanced Ties With Their Natal Families in Post-reform Rural China', *Modern China*, 35, 3 (2009): 256–83.

Xinxin Zhang and Sang Ye (eds) *Chinese Lives: An Oral History of Contemporary China* (London: Penguin, 1989).

Yingjin Zhang, 'Engendering Chinese Filmic Discourse of the 1930s: Configurations of Modern Women in Shanghai in Three Silent Films', *positions*, 2, 3 (1994): 603–27.

Yingjin Zhang, 'From "Minority Film" to "Minority Discourse": Questions of Nationhood and Ethnicity in Chinese Cinema', in S. Hsiao-Peng Lu (ed.), *Transnational Chinese Cinemas: Identity, Nationhood, Gender* (Honolulu: University of Hawaii Press, 1997), pp. 81–104.

Zhen Zhang, 'Mediating Time: The "Rice Bowl of Youth" in Fin-de-Siècle Urban China', *Public Culture*, 12, 1 (2000): 93–113.

Xueping Zhong, *Masculinity Besieged? Issues of Modernity and Male Subjectivity in Chinese Literature* (Durham, NC: Duke University Press, 2000).

Xueping Zhong, Wang Zheng and Bai Di (eds), *Some of Us: Chinese Women Growing Up in the Mao Era* (New Brunswick: Rutgers University Press, 2001).

Yiqun Zhou, 'The Hearth and the Temple: Mapping Female Religiosity in Late Imperial China 1550–1900', *Late Imperial China*, 24, 2 (2003): 109–55.

H. Zurndorfer (ed.), *Chinese Women in the Imperial Past: New Perspectives* (Leiden: Brill, 1999).

H. Zurndorfer, 'Wang Zhaoyuan (1763–1851) and the Erasure of "Talented Women" by Liang Qichao', in Nanxiu Qian, G. Fong and R. Smith (eds), *Different Worlds of Discourse: Transformations of Gender and Genre in Late Qing and Early Republican China* (Leiden: Brill, 2008), pp. 29–56.

Index